Towards a Modern Art World

For Michael Kitson

Studies in British Art 1

Towards a Modern Art World

Edited by Brian Allen

Published for
The Paul Mellon Centre for Studies in British Art
The Yale Center for British Art

Yale University Press, New Haven & London

Designed and set in Adobe Garamond by Julie Lavorgna
Printed in Great Britain by BAS Printers Limited, Over Wallop, Hampshire

Library of Congress Catalog Card Number 94-61989
ISBN 0-300-06380-6

A catalogue record for this book is available from the British Library.

Contents

Foreword

In 1970 the Paul Mellon Centre for Studies in British Art was established in London 'to advance the education in, and appreciation and understanding of British art.' Within the year, in direct pursuit of that goal, the Centre signed an agreement with Yale University Press to publish jointly a series of individual titles under the general heading of *Studies in British Art*. At first, priority was given to documents and monographs: Farington's *Diary*, for instance, and the catalogues raisonnés of Blake, Turner, and Constable. Twenty-three years, and more than twice that number of titles later, those efforts continue amidst an expanding list of thematic and critical studies, each one of which in its own particular way has enlarged the appreciation and understanding of British art.

It was our good fortune when, at the end of 1985, the pre-eminent historian of British Art, Professor Michael Kitson, resigned his post as Deputy Director of the Courtauld Institute of Art to become the Director of Studies at the Paul Mellon Centre and Adjunct Professor at Yale. During the seven years of his tenure he succeeded in raising the academic profile of the London Centre, in particular by co-sponsoring and organising interdisciplinary conferences. Among these, *Towards a Modern Art World*, held at the Tate Gallery 14–16 December 1989, was one of the most challenging and successful. It was felt generally, after the event, that the papers which were delivered there deserved the wider distribution and longer shelf life which publication affords.

Coincidentally, at both the Paul Mellon Centre and the Yale Center for British Art discussions were under way about a new joint publication. During the summer of 1990, groups of academic consultants gathered in London and New Haven to debate the merits of launching a serial publication. The advice we received at those meetings was crucial in guiding us towards our subsequent decision to introduce a new series of *Studies in British Art,* and we remain grateful to the colleagues on both sides of the Atlantic who participated in that important process. When Professor Kitson announced his intention to retire at the end of 1992, the idea of inaugurating the new series with *Towards a Modern Art World,* the conference which he inspired, became irresistible. We dedicate this volume to him with gratitude and affection.

The new series of *Studies in British Art* is the joint venture of both centres in collaboration with Yale University Press. As general editors, we believe that, unlike a journal, our serial should not be dominated by a singular, editorial voice or a particular point of view. We have therefore elected to commission each volume separately; each will contain essays by a number of contributors, linked thematically and compiled by guest editors. Like this one, future issues may result from conferences or symposia or may be generated because a group

of scholars join forces to produce an anthology of essays. At this point we are pleased to announce three future volumes. *Albion's Classicism: The Visual Arts in Britain, 1550–1660,* edited by Lucy Gent and derived from the conference organised by the Centre in collaboration with the Warburg Institute in November 1993; *Transports: Imaginative Geographies, 1600–1830,* edited by Chloe Chard and Helen Langdon and based on a series of lectures given at the Paul Mellon Centre in 1992–93; *Landscape and Art,* edited by Michael Rosenthal, Christiana Payne, and Scott Wilcox, which draws upon conferences held in connection with exhibitions on both sides of the Atlantic during 1993–94.

It remains only for us to thank the contributors to this volume, whose patience has been stretched by the lengthy period of gestation which the birth of the new series imposed. We are especially grateful to David Solkin for the introduction he has written, and to Julie Lavorgna, who has copy-edited and designed this book. Thanks to her efforts, *Towards a Modern Art World* establishes a house style with which future volumes in the series will comply. At the London Centre the editor was much assisted by Evelyn Newby, Elizabeth Powis, and Sophie McKinlay. Finally, we acknowledge our continuing debt to our colleagues at Yale University Press, especially to the Director, John Ryden, and to John Nicoll, the Managing Director in London.

Brian Allen, Director of Studies, Paul Mellon Centre for Studies in British Art
Duncan Robinson, Director, Yale Center for British Art

The British and the Modern

David Solkin

The papers contained within this volume range over more than two centuries in the history of British art production, and they permit any number of differ-·ent readings. Since no introduction could ever pretend to serve as a comprehensive assessment or overview, here I shall limit myself to providing a brief and necessarily personal commentary about certain general patterns that the various contributions seem to have shaped.

To speak of 'the British' in conjunction with 'the Modern' is to suggest a linkage that goes against the grain of the narrative which dominates our understanding of the history of western art from the eighteenth century to the present day. Although works produced by British artists do occasionally appear in that story, as a rule they have featured as an insignificant other, or have simply been left out altogether.[1] Doubtless the reasons for such treatment are profoundly ideological—but it does not then necessarily follow that they should be dismissed without further consideration, or that a few revisions to the canon will suffice to set matters aright. I do not believe that any of the participants in *Towards a Modern Art World* would wish to claim a central place for British painters and sculptors within the mainstream of the modern. Instead our purpose has been precisely to try and account for the marginal position of British art, by approaching that marginality as a historical problem. It seems beyond dispute that London can be identified as one of the first metropolitan centres where the various commercial, cultural, and institutional mechanisms characteristic of a distinctively modern art world came into being. Yet why, then, did this modern art world, if indeed that was what Britain had produced, fail to create a significant body of modern art?

Of course this question presupposes the existence of another art world—centred in nineteenth-century Paris—which did manage to come up with the goods. Any discussion of the relationship between the British and the modern cannot help but be overshadowed by the discourse of French modernism, even if the following essays invite the obvious conclusion that its paradigms cannot be applied to events which unfolded on the other side of the English Channel.

At times many of those who read through this volume may find themselves thinking that British and French art have in fact developed in precisely opposite directions. If we place Walter Sickert beside William Hogarth, for example, the 'backwardness' of the English appears almost wilfully perverse. In Sickert's case, as Stella Tillyard informs us, we find a painter working in the most triumphant period of pan-European modernism, someone who both

knew and drew upon the French avant-garde tradition, yet still insisting nonetheless that he be regarded first and foremost as an illustrator, in the tradition of Charles Keene and William Hogarth. And by a strange coincidence, if we look back to Hogarth himself, we encounter a curiously symmetrical situation, albeit in reverse: in this instance an eighteenth-century artist, admired by his contemporaries above all for the richness and complexity of his narratives, asserting the independent status of pictorial language, its irreduceability to writing or speech.

This is only one of several ways in which we might justifiably be impressed by Hogarth's modernity. His mock-heroic subversions of grand-style art, his use of materials drawn from contemporary popular culture, as well as his attempts to create an art that was capable of being appreciated, in howsoever limited a way, by the 'vulgar'—all these strategies opened up a realm of possibilities which were only to be fully exploited in the nineteenth century—though not, as it turned out, by his British successors. Something broadly similar might also be said of James Barry, whose difficult career describes something very like that pattern of radical alienation which was later to become characteristic of the Continental avant-garde. But apart from Haydon there is really nothing to compare in nineteenth-century British art with that cranky, defiantly impolite persona which the Irish-born champion of history-painting inflicted on his enemies and admirers alike. To this day Barry remains the only artist ever to have been honoured with expulsion from the Royal Academy—and this happened as far back as 1799!

I shall want to return to that period and its significance later on. For now I want only to support John Brewer's suggestion that meaningful parallels could indeed be drawn between British art in the eighteenth century, with its striking range of tactical possibilities, and the situation then prevailing in contemporary France. But artists like Hogarth and Barry also shared certain important interests in common that already begin to mark out a peculiarly English path.

One major concern that I have in mind here is for the relationship between the verbal and the visual, which figures as a recurrent theme in many of the papers assembled in this book. It is a well-worn commonplace that the literary bias of English art has kept it outside the mainstream of the modern—which is precisely where Sickert, for one, wanted his art to remain. In a provocative formulation Charles Harrison asks if the reciprocating relations within one pair of terms, 'modern' and 'British', and within another pair, 'artistic' and 'literary', might be seen to fluctuate according to the same historical rhythm. I suspect that the answer is probably not quite, at least not as far as the period before the twentieth century is concerned, but there is something richly suggestive about this hypothesis. Certainly, from Hogarth and Barry through Frith and up to Sickert we can trace a long line of major British artists who

were profoundly, one might even say obsessively, concerned with the connections between images and words. I doubt whether any other modern nation has produced a body of painters who have more consistently and wholeheartedly embraced the narrative as the basic structure of visual communication, whether this involves the telling of original tales or the illustration of pre-existent texts. Furthermore, it appears as though narrativity functioned for a long time in British art as an essential precondition for the representation of themes from modern life; even if, as Tillyard and Caroline Arscott would argue, such pictorial stories were nothing near as neat or seamless as we have generally been led to believe. British artists also seem to have spent an extraordinarily large amount of time at their writing-desks, either to establish their credentials as aesthetic theorists, or to supplement their pictures with textual comments and exegeses. It seems to me entirely in keeping with this overall pattern that J. M. W. Turner, England's dominant artistic personality during the first half of the nineteenth century—and a landscape painter to boot—felt the need to attach fragments of an epic poem that he never actually wrote as a whole to works which more profoundly engage with purely painterly issues than any of his contemporaries ever produced. I wonder, too, whether the literary quality of so much British art might help to explain the evident frustrations of so many London art critics; if it was the critic's task to fill semantic vacuum, how could this be achieved if painters had already done the job?

The fact that ambitious English paintings have so often aspired to the condition of a readable text also suggests a widespread willingness among their creators to accommodate an audience whose members felt far more at ease with writing than they did with visual culture. This seems to have figured as one of the central components in that unwritten compact which the British artistic community, virtually from the moment of its inception as a community, struck with the consumers of its products. Here it should be remembered that pre-commercial Britain supported little or nothing in the way of native artistic production. As Brewer observes, it was the rise of commerce which enabled the creation and proliferation of the visual arts, but which at the same time most gravely threatened their survival, at least in any meaningful form. Even when James Thomson and James Barry projected their dreams into a post-revolutionary future, neither could conceive of a world—at least this side of Elysium—where the importance of art could be fully realised or appreciated. Nor could British artists remember a period in the nation's past which they could look back to or even imagine as a golden age of patronage. Although painters and critics have frequently complained about the tyranny of market forces, in practice we know that art in modern Britain has enjoyed a long and intimate relationship with Blake's 'fiends of commerce'. Those fiends—friends for some—certainly proved far too strong for the hollow rhetoric of resistance that issued from the president's chair at the Royal

Academy, or for that martyr to the cause of the grand manner, Benjamin Robert Haydon. Fatally hampered by a lack of state support, the dream of creating a believably public art—a dream shared by painters elsewhere in Europe, and nourished in the cosmopolitan art scene of eighteenth-century Rome—collapsed at the very moment when the British School began to assert its own identity, in the immediate aftermath of the French Revolution.

Harrison describes how a fear of revolutionary political change registered its presence in the attempts to detach the 'modern' from the 'British' during the 1930s; but the flurry of discursive and institutional activity which took place in the decades on either side of 1800 seems to offer a meaningful precedent. Then, too, the art world rallied to the support of a bourgeoisie which felt threatened by the power of a new collective force, both at home and abroad. Rejecting the despotic 'system' of French Revolutionary art, the British School embraced pluralism and originality as the very stuff of its identity, but only to the extent that this valorised the individualistic ideology and cultural pretensions of the commercial middle class. There seems an element of perfect justice in the fact that the phrase, 'The British School', was first used to describe an existing entity as the heading for an unabashedly commercial form of exhibition enterprise. The appearance of this and so many other art societies in the early nineteenth century should also remind us that the Napoleonic era ushered in an economic boom which bore immediate and profound implications for the production and consumption of contemporary art. The community of artists, the numbers of galleries and shows, the audience for art—all these expanded dramatically within a remarkably concentrated period of time, giving rise to a public response identified above all with the professional art critic—a figure hitherto unheard of in the British cultural arena. Attempts to explain what was then happening in the art world focused less on art itself than on the various subject categories that clustered around it, categories produced at this moment of enormously accelerated capitalist development—subjectivities which had to be asserted, defined, and above all, policed.

Questions about who should sponsor art, who should create it, who should talk about it, and to whom art should speak: these mattered most of all. If aesthetic concerns *per se* were placed off somewhat to one side, this may have been because they seemed incapable of resolution, at least until other issues of more pressing urgency had been gotten out of the way. Andrew Hemingway describes how the perception of art as corrupted by commerce enraged critics on both the right and the left; but neither could imagine their society producing an art of any other sort. Of course, there were important political issues at stake in the debates over whether Reynolds or Hogarth was the true father of the British School, as Martin Postle implies; yet when Hogarth triumphed over Sir Joshua in the years just prior to 1832, in a sense this only meant that one commercial artist gave way to another.

Despite their mutual antipathy, Hogarth and Reynolds were also bound together by their attempts to straddle two distinct types of artistic subject, that of the money-making professional on the one hand and the altruistic gentleman on the other. This second figure, in the person of the amateur, has clearly played a singularly important part in the modern history of British art. Julie Codell speaks of the close and at times competitive relationship between amateur artists and professionals in the late nineteenth and early twentieth centuries—the Society of Parson Painters indeed!—while Hemingway notes the extensive involvement of amateurs in the Society of British Artists almost a hundred years previously. And if we look back even earlier, to the first annual shows organised by the Society of Artists in the 1760s, we find numerous works submitted by various gentlemen and ladies, including a whole sub-category of pictures fashioned out of human hair! The Royal Academy pushed these oddities out of its exhibitions but still continued to include works by so-called honorary members; and gentility remained the bedrock on which the academicians founded their claims to professional dignity. Effectively, British artists seem to have remained caught in a difficult bind between professional and amateur status—that is to say, between those interests which enabled them to survive on the one hand and, on the other, that ideal of disinterestedness to which both gentlemen and serious artists were supposed to aspire. Ann Bermingham has helped to elucidate the discursive process whereby English commercial culture formed the amateur as a subject, and in so doing welded the identity of the artist to that of the bourgeois gentleman. Her analysis takes an important step towards explaining the literary and 'humanist' bias of so much British art in the modern period, as well as the remarkable degree of harmony that has generally characterised the relationship between this country's artists and its middle class.

'The best British painting', wrote the art critic Robin Ironside in 1947, 'relies, for its final justification, upon an amateur stimulus, that is to say, upon a stimulus that may be ethical, poetic or philosophic but not simply plastic'.[2] When I first came across this passage in Charles Harrison's paper I was immediately struck with a sense of how little certain things had changed in English culture, between the beginning of the eighteenth century and the midpoint of the twentieth. In particular, I was reminded of Jonathan Richardson's *Essay on the Theory of Painting,* that clarion call for a native school of pictorial art first published in 1715. Of course Richardson would never have used the word 'plastic'—he would have preferred something like 'mechanick' instead—but in this and in every other important sense he would have fully agreed that the mind and not the hand, the abstract idea and not the formal arrangement of shapes on a canvas, held the key to the production of a truly significant art. If it was to merit its position among the liberal arts, painting had to be practised by individuals who combined the character of a skilled artificer with those of

'a Poet, an Historian, a Mathematician'; even the humble portraitist had to 'think as a Gentleman, and a Man of Sense', and he need feel no more shame than a magistrate or a general at receiving a proper recompense for his labours.[3] This was an ideal construction which flattered both the British artist and British commercial society, and which until well into this century seems to have played a key part in preventing a modern art world from producing a radically modern art, at least in the transgressive sense in which that term has been generally understood.

But should we accept the assumptions of the modernist orthodoxy, even now that the modernist era has effectively come to an end, and despite its evident inappropriateness for the historical work that so many of us do? *Towards a Modern Art World* has no designs to advocate a rearguard action to salvage British greatness, nor would its authors recommend surrendering to the uncritical eclecticism of the post-modernist free-for-all. Yet surely much stands to be gained by reopening the boundaries between modernist and other forms of painterly practice, and from situating all of these practices more securely within the institutional and commercial mechanisms of the modern art world. The essays which follow suggest the need to develop some alternative paradigms, a framework that can help us to achieve a broader understanding of the various and complex relationships between culture, power, and knowledge in the modern period as a whole.

1. A significant exception to this rule is Albert Boime's *Art in an Age of Revolution, 1750–1800* (Chicago: University of Chicago Press, 1987), where the prominence given to Joseph Wright of Derby (as the putative artistic spokesman for Britain's Industrial Revolution) and to Angelica Kauffman (as a leading woman artist of the period) shows how a different set of political priorities can produce an art history that bears surprisingly little resemblance to the standard narratives of this period.
2. Robin Ironside, *Painting since 1939* (London: British Council, 1947).
3. Jonathan Richardson, *An Essay on the Theory of Painting*, 2nd ed. (London, 1725), 21.

Cultural Production, Consumption, and the Place of the Artist in Eighteenth-Century England

John Brewer

This essay examines the British art market between the late seventeenth and late eighteenth centuries in the larger context of cultural production in the same period. Let me explain at the outset that I use the term 'cultural production' as a generic category which includes the visual and plastic arts, the performing arts, including theatre and music, and literature. My aim, in placing the visual arts and the production of images in the context of other types of cultural production is not to lump them all together indiscriminately (I am fully aware that they have their own discrete histories). But I do want to claim that audiences in this period placed these disparate activities into a general category which they, as well as critics, called the culture of 'politeness'.[1]

My paper, like Caesar's Gaul, falls into three parts. The first is largely descriptive; the second deals with the complex critical response to the growth in cultural production and the expansion of the cultural audience; the final section discusses the paradoxical place of the cultural producer in these developments.

I want to begin by examining the radical transformation that occurred in the production of culture from the late seventeenth century: the proliferation of cultural artefacts and performances, the development of new sites for cultural expression, the growth of an audience for culture, and the emergence of an extensive body of literature intended to evaluate this activity. This account relies on the work of recent cultural and social historians who have drawn attention to what has variously been called 'the commercialisation of leisure', the growth of a consumer society, and the emergence of a culture of politeness.[2]

This historiography has been invaluable in reconstructing the changing nature of cultural practice. It has not shied away from treating culture as a commodity with a market value; its researches have unearthed an extensive and complex world of concert series, theatrical performances, art collections, print shops, and literary journals whose archaeology, still incomplete, is now gradually being recovered. It has also, with varying degrees of explicitness, seen the culture that it describes as 'modern'.[3]

What does this historiography reveal? We can best understand the changes in the nature of the culture of the eighteenth century that this interpretation has charted by drawing a contrast, albeit a slightly exaggerated one, between the late seventeenth and late eighteenth centuries. In 1660 literary and artistic

endeavour was largely confined to a royal court whose patronage was severely constrained by lack of funds, a church whose protestantism militated against the making of music and the display of art, and a publishing industry which was cramped by prior censorship and legal monopoly. In the late seventeenth century it was illegal to import foreign works of art into England, theatrical performance was restricted to two patent companies, there were only eighteen organs in London parish churches, and the legal number of printing presses was limited to twenty.[4] Culture was starved for lack of funds, slighted by its puritanical opponents, and strangled by state censorship and restrictive trade practices. There were no concert series, operas, public art exhibitions, and precious little theatre; no daily newspapers, weekly journals and reviews; no critics, theatrical and operatic impresarios, no picture dealers, almost no publishers, professional authors, artists, and musicians and therefore no public, in the modern sense of the term, and no market for culture.

During the next century, however, the situation was totally transformed. The market for the visual arts flourished as never before: numerous classical antiquities, as many as 50,000 paintings, and half a million etchings and engravings were imported from Italy, France, and Holland. Over 100,000 pictures passed through the newly established auction houses and into the hands of specialist dealers and collectors. Artists from Italy, Holland, Sweden, Germany, and France plied their trade in London's booming market. By the time of the foundation of the Royal Academy in 1768, there were already three other associations of professional artists and painters as well as public exhibitions of contemporary artists' work.[5] Horace Walpole, the connoisseur and historian of English painting, complained that 'the rage to see…Exhibitions is so great, that sometimes one cannot pass through the streets where they are'.[6]

Though at first overshadowed by their foreign rivals and marginalised by the English aristocracy's obsessions with Old Masters and classical antiquity, by the end of the century English artists were a match for their Continental peers. Reynolds's portraiture fees matched the prices of Old Masters; England, a net exporter of prints to Europe, dominated the trade in mezzotints and stipple engravings and made the political cartoon uniquely its own; artists like Hogarth, Woollett, and Reynolds enjoyed European reputations.[7] Underpinning professional practice was a burgeoning amateur tradition, sustained not only by the instruction offered by artists to their (often female) students, but by a flourishing literature in the form of drawing and painting manuals.

Similar developments occurred in music. By the late eighteenth century an astonishing variety of music was on offer. It was possible to attend the opera or a subscription concert at one of London's several concert halls on every night of the week. More than a dozen public pleasure gardens, notably those at Vauxhall and Ranelagh, offered exciting and eclectic programmes of songs,

small-scale operas, overtures, and concertos. The Royal Academy of Music, established in 1719, and the Academy of Ancient Music (1726) sponsored opera and concert series, offering not only contemporary music but retrospective series of musical classics. A steady flow of European composers and performers, including Senesino, Cuzzoni, Farinelli, Glück, J. C. Bach, Haydn, and Mozart, performed in the metropolis. Between 1675 and 1750 eighty-three Italian composers were resident in London; Handel, of course, made it his home. Thriving publishing businesses not only encouraged domestic performance and societies of amateur musicians but brought to the public works by composers who had never visited Britain.[8]

Though there was least change in the position of the theatre—a system of royal patents and licences operated throughout the century, severely restricting the number of playhouses and companies—even here there was considerable improvement. The Restoration was marked by the arrival of women on the stage, by the use of more elaborate props and scenery, and by the provision of entr'acte entertainment in the form of dance and song. From the 1680s a more and more diverse programme was offered to the public, setting a trend that was to last throughout the century. New theatres were constructed in the reigns of Anne and George I, expanded in mid-century and totally rebuilt in the 1790s, so that Drury Lane held an audience of over 3,600 and Covent Garden more than 2,500. In the century after the Glorious Revolution box office receipts trebled; in the 1760s there were over 12,000 theatregoers a week. Despite government restriction, theatrical performance moved beyond the licensed London stage: it flourished at the London fairs and moved out into the provinces. By mid-century provincial towns were building their own theatres.[9]

But the most important changes occurred in the world of publishing and print. The lapse of the Licensing Act in 1695 ended prior censorship and marked the break-up of the old press monopoly held by the Stationers Company. Printers proliferated in the provinces; the London printing industry grew by leaps and bounds. In Charles II's reign fewer than 200 men were employed in the London printing trades. By the end of the eighteenth century over 3,000 employers, apprentices, and journeymen operated more than 600 presses. The newspapers, periodicals, pamphlets, and books they printed were distributed and sold by 300 bookseller/publishers whose capital and organisation secured a national market for every sort of imprint. Over the course of the eighteenth century the publishing industry averaged over 3,000 titles each year; if we make the very conservative assumption that imprints averaged 500, then between 1700 and 1800 over 150 million books had been published at a time when the population of England and Wales was less than nine million.[10]

The explosion of print had several important consequences. First, it made possible new sorts of literature, especially new forms of *prose* literature. The

novel, the newspaper, the literary periodical, and the magazine all flourished in the aftermath of the collapse of the press monopoly. All of these forms required more paper, more type, and more labour.

Secondly, the periodical and newspaper press made it possible to earn a living as an author. Before the eighteenth century only playwrights, whose earnings were boosted by box office receipts, were able to live by the pen. For much of the next hundred years booksellers refused to pay authors royalties and only offered them fixed fees, a practice analogous to that of the printsellers who, until the success of Woollett, refused to pay engravers a proportion of the profits. As a result it was difficult to make ends meet by writing books. Authors had to rely on hack work: essays on literary subjects, reviews of the latest pamphlets and books, short poems or verse, contributions to anthologies, editorial work on great authors whose names ensured good sales, and occasional pieces such as the dedications that Dr. Johnson turned out with such celerity. This piece work, undertaken by what Jonathan Swift called 'the manufacturers of literature', was almost totally dependent on a thriving newspaper and periodical press. Similarly the ordinary engraver depended for his livelihood on an astonishing range of job and hack work, ranging from trade cards to book and magazine illustration.

The burgeoning of printed and graphic material, the use of mechanical means to reproduce word and image, had a third important consequence. The magazine, newspaper, and periodical literature brought together within its pages discrete cultural activities, linking literature, music, painting, and theatrical performance in the minds of its readers. Addison and Steele's *Spectator* provided critical commentary on the English stage, Italian opera, Old Master and modern painting, and on authors, ancient, foreign, and English.[11] Newspapers, especially after 1756, reviewed concerts, art exhibits, theatrical performances, and recent works of literature. Periodicals such as *The Gentleman's Magazine* frequently included prints and engravings, some didactic, topographic, scientific, and cartographic; others, notably frontispieces, were modelled on history painting. *The Universal Magazine* for 1765, for instance, included three engravings of rare and remarkable insects, a number of road and county maps, heads of the actor Barton Booth and James Usher, archbishop of Armagh, a perspective view of Montreal, and an allegorical frontispiece showing George III and Queen Charlotte in Roman garb leading, with the aid of Pallas, a young Prince of Wales towards the palace of wisdom.[12]

The typical eighteenth-century periodical (and there were over eighty in London by the end of the century) was eclectic both in its form and subject matter. *The Spectator* contained fables, moral tales, dreams, visions, allegories, and autobiographical letters; topical periodicals like *The Gentleman's Magazine, The London Museum,* and *The Town and Country Magazine* mixed belles-

lettres, poems, reviews, and literary essays with scientific reports and political debate. All of these periodicals, which enjoyed extensive readership and were to be found on the bookshelves of what *The Universal Magazine*, characterising its clientele in 1765, described as gentry, merchants, farmers, and tradesmen, paid little attention to 'the ordering of the arts', to aesthetic hierarchies either within or between disciplines.

Such publications represented polite culture to an 'imagined community'[13] of readers which absorbed vicariously much that it had never read, seen or heard. Culture was reproduced, again and again, in engraving or in print. The Grand Tour and visits to the collections of the great English houses were not rendered obsolete by the volumes of engravings from Old Masters, contemporary paintings, and major private collections such as Arthur Pond's Italian landscapes and Roman Antiquities series, or John Boydell's *A Collection of Prints Engraved after the Most Capital Paintings in England* (9 vols. to 1792) and *The Houghton Gallery* (1773–1788).[14] But their social cachet was undoubtedly diluted by the growing body of vicarious travellers and visitors. Mechanical reproduction removed many of the constraints on the growth of an audience for culture, and it also provided cultural intermediaries like the book and printseller with the opportunity to shape both the cultural audience and its taste.

Three features of the cultural change that I have been describing stand out: first, the growth in the audience for culture, stimulated by greater capacities for reproducing and disseminating culture; second, the importance of certain cultural spaces or places for cultural activity: not merely the long-standing sites of the court and the theatre but such new loci as the pleasure garden, the coffee house, the assembly room, the concert hall, book and printsellers' shops, and the auction house; and, finally, the subversion or dilution of classical and academic hierarchies in the face of rampant commercialism. All three of these developments were, of course, closely linked to one another.

Though the historiography on which I have drawn for this account of cultural change has many strengths, it also has serious weaknesses. First, the extraordinary spurt in cultural production in the eighteenth century is better described than explained. And, where an explanation is offered, it too often depends crudely on an account of economic growth: the nation got richer and therefore had more money (and leisure time) to spend on culture. Even if it were true that the nation became richer in the early eighteenth century (and the current wisdom of economic historians downplays economic growth before the last quarter of the eighteenth century)[15] such an explanation begs the question of why wealth should be spent on culture rather than in some other way, nor does it explain why some cultural artefacts and activities should be more highly regarded than others.

Secondly, this historiography too often assumes that eighteenth-century

cultural change was an unmitigated good. Commercial society, so the argument goes, spread culture more widely, encouraged cultural variety—including the development of new cultural forms and practices—and reached a larger public. Seen from this point of view, not only does cultural change appear to emanate almost inevitably ('naturally') from a more prosperous economy, but it is portrayed as an incontestable improvement, one which takes place without opposition and without social costs.

This interpretation, though deeply preoccupied with how a living culture was disseminated, also treats culture as if it were immaculately conceived. This may accord well with a criticism that proclaims the death of the author, but, in doing so, it fails to recognise that cultural formation cannot be plausibly separated from politics and society and that cultural change invariably entails conflicts of power. As eighteenth-century commentators knew well, disputes about the character and content of a culture—what we would describe as aesthetic and critical quarrels—were, in turn, connected to the question of who would exercise political and social as well as cultural power.

No doubt the unwillingness of this historiography to tackle the politics of culture is in part explained by the complexity of the problem. Scholars have not found it difficult to identify certain cultural activities with particular political attitudes—the recovery and performance of so-called 'ancient music' with high-church and Tory sentiments for example; the link between neo-palladian architecture and Whiggery and between patriotic anti-Whiggery and the rococo.[16] Similarly the political colouring of certain literary and cultural associations—the Whig Kit-Kat and the Tory Scriblerians for instance—is not hard to find. But the fit between cultural attitudes and party political persuasion is rarely neat or tight, except in the case of very small groups. And even here the link seems stronger at the beginning of our period than at its end. The politics of the members of Dr. Johnson's Club, which included Reynolds, Garrick, Charles James Fox as well as Goldsmith, Burke and Boswell, not to mention the good Doctor himself, could hardly have been more diverse.

Yet, paradoxically, an historiography that neglects politics and emphasises both the commercialisation of leisure and the growth of a culture of politeness embraces (albeit tacitly rather than explicitly) a *Whig* point of view. By this I do not just mean that this interpretation involves the search for what we have now, the recovery of the origins of what we take to be modern high culture. Though it certainly does entail this kind of presentism, it also emphasises certain aspects of eighteenth-century culture—the polite, public, and genteel—at the expense of others. In short its perspective is invariably Spectatorial—that of Addison and Steele—though occasionally refracted through the aristocratic lenses of Shaftesbury and Chesterfield. Such an interpretation therefore assumes that the attempt to refashion English culture after the Glorious Revolution in a 'polite' image, one that excluded clerical controversy

and theological dispute (though it was itself Christian, usually Deist or Anglican), that rejected the court as a focus of culture (though it did not discard aristocratic leadership and patronage), and which hoped to create a public, albeit a restricted one, was not only novel but also totally successful.

Such an account misses a great deal: it fails to appreciate the strength and endurance of a high-church, clerical view which was not merely opposed to a culture of spectacle and public resort but which had a positive agenda of its own;[17] it omits any account of the protracted struggle between popular and polite cultures, which historians of plebeian culture have reminded us was an uneven contest but not an outright victory for the forces of politeness;[18] it neglects the view of many literary scholars, most notably Ronald Paulson and Pat Rogers, who have led us to regard the clash between popular and polite as so fertile in producing new aesthetic forms;[19] and it overlooks the contradictions in a culture that was at once languidly cosmopolitan and fiercely nationalistic.[20] Perhaps all these lacunae stem from a larger omission. The account of the social and economic historians can only treat cultural growth as unproblematic because it does not attend to what, according to one's politics and age, is variously referred to as 'ideas', 'ideology', or 'discourse'.

For it is clear, and this brings me to the second part of my discussion, that the proliferation of cultural markets and audiences was viewed with a complex variety of feelings that was rarely reducible to unqualified enthusiasm. The most usual responses of those who saw themselves as the cultural arbiters of eighteenth-century England ranged from subtle ambivalence through queasy unease to unmitigated revulsion. These responses can be traced through every sphere of cultural production: painting, literature, the performing arts, and music. Though there were supporters of the process of cultural expansion that made the development of a 'polite' culture possible, there were also many who saw the proliferation of cultural practices as a threat: a threat to their powers of cultural arbitration and a threat to the social order that underpinned their cultural authority. Indeed, most major proponents of a culture that was polite, public, and social, explicitly situated outside the court and the academy, were also threatened by the very forces—the commercialisation of culture, the emergence of the cultural entrepreneur, the end of legal constraints on cultural activity—which made the culture they desired possible. What was happening in the eighteenth-century, therefore, cannot be properly characterised simply as expansion: it also entailed contentious processes of cultural redefinition in a period when almost every aspect of culture seemed exceptionally indeterminate.

During much of the eighteenth century, therefore, the debate about the arts and literature was devoted to redefining or reasserting cultural categories. For many critics this amounted to a quest for new fixity, order, hierarchy, and certainty, an attempt to reconstitute culture when it seemed to be dissolving. This entailed the erection of new boundaries, the fencing of new enclosures, a

process of distinguishing and discriminating the polite from the vulgar, a coherent public from the disaggregated body of cultural consumers, the English (and then British) from the foreign, and the true artist from the mere mechanic. Such distinctions were never merely aesthetic and cultural; they were also political and social.

In short, the celebratory literature on cultural expansion in the eighteenth century emphasises 'inclusion', the expansion of cultural boundaries to embrace new sorts of cultural consumers. But the critical and theoretical literature, both eighteenth-century and modern, more usually sets up systems of exclusion and exclusiveness.

Let me now turn to three areas of critical concern to commentators on eighteenth-century culture: the nature of the cultural audience; the sites of cultural practice; and the threat posed to the hierarchical ordering of the arts.

It was a bitter and frequently reiterated complaint of eighteenth-century critics that the cultural audience, which once had been socially homogeneous and culturally discerning—or so it was claimed—had been transformed by the forces of commerce into a motley crew, a peculiar and unnatural (because unhierarchical) mixture of classes whose heterogeneous composition rendered it incapable of good judgement and taste. In such a promiscuous crowd servants and streetsellers, prostitutes and rakes, tradesmen and merchants, women and children were likely to eclipse gentlemen of learning and taste.[21] Thus Alexander Pope refers to the egregious mix of the supporters of Colley Cibber, the exemplar of commercialised and therefore debased literary culture, as

> This Mess, toss'd up of Hockley-hole and White's;
> Where Dukes and Butchers join to wreathe my [i.e. Cibber's] crown.[22]

David Garrick draws a similar picture of a theatrical audience which, though economically separated into pit, boxes, and the gods, was too often united in its determination to interrupt and disorder theatrical performances with a barrage of violent comment and vulgar intervention:

> Above 'twas like Bedlam, all roaring and rattling!
> Below, the fine folk were all curts'ying and prattling:
> Strange jumble together—Turks, Christians, and Jews!
> At the Temple of Folly, all crowd to the pews.[23]

Proponents of the visual arts held a similar view.[24] Members of the Society of Artists charged admission for their 1762 exhibition in order to exclude 'all persons whom they shall think improper to be admitted, such as livery servants, foot-soldiers, porters, women with children etc, and to prevent all disorder in the room, such as smoking, drinking etc by turning the disorderly out'.[25] Reynolds warned his fellow artists about the 'mischievous tendency' of Royal Academy exhibits which seduced 'the Painter to an ambition of pleasing

indiscriminately the mixed multitude of people who resort to them'.[26] The remarks of John Williams, alias Anthony Pasquin, about the Royal Academy in the 1790s, express this hostility to an uninformed audience in a particularly vituperative way:

> the mightiest evil to be regretted is, that the VULGAR, who have no knowledge of propriety, should, from their numbers, their riches, and consequently their power, have the national patronage within their dominion; and yet these bipedal reptiles must be uniformly soothed and solicited, under such a forcible designation, as THE PUBLIC.[27]

The complaint, of course, is that the audience is not properly a public at all, a coherent body whose taste and understanding make them a legitimate object of the artists', writers', and performers' attention, a collectivity capable of validating aesthetically and morally either cultural product or performance. On the contrary, they are a fickle, voracious, greedy, privately motivated, and indiscriminate aggregation, bent merely on amusement, self-gratification, and the mindless pursuit of the latest fashion. In short they are not susceptible to control by the artist and critic. This would not, of course, be a problem if aesthetic validation depended on other sources than the public, but the importance of the public (or, at least, a public) was widely conceded, even by the most 'aristocratic' of critics and commentators.[28] Hence Williams's ferocious remarks and hence, also, the splenetic comments and satiric barbs of commentators earlier in the century.

This revulsion at a culture tainted by the pollutants of moral depravity, social disorder, and vulgar commerce was reinforced by the type of venue associated with much eighteenth-century cultural practice. The theatre, of course, had long been looked at askance as a place of moral depravity and disorder. That it remained so, despite the efforts of the likes of Garrick to restrain the audience, is demonstrated not only by the violence of the 'O.P.' theatrical riots as late as 1809, but by the conduct of James Boswell, attending the playhouse in 1763. Having 'entertained the audience prodigiously by imitating the lowing of a cow' from the pit—'*Encore* the cow!' was the universal cry from the galleries—he left the performance, sought out 'a strong, plump, good-humoured girl called Nanny Baker' with whom he 'performed concubinage', and then returned to see a further performance from the gallery at Drury Lane.[29] In a single evening Boswell, moving from the genteel pit to the vulgar galleries, had evinced every sort of disorder and depravity associated with the theatrical audience.

The new sites, most notably the pleasure garden, were just as tainted as the old. Vauxhall Pleasure Gardens were one of the great cultural sites of eighteenth-century London and their proprietor, Jonathan Tyers, one of culture's most important patrons. The first public rehearsal of George Frederick

Handel's *Music for the Royal Fireworks,* heard by an audience of 12,000, was held at Vauxhall, where Tyers erected the first public statue to a musician (Roubiliac's statue of Handel) and retained Thomas Arne (the composer of 'Rule, Britannia!') as the house musician. Tyers also consulted Hogarth about the decoration of the gardens and employed Francis Hayman, Hubert Grave-lot, and Peter Monamy to design and decorate the boxes and booths in which the garden's patrons dined. By the 1740s over fifty such canvases were on display in the gardens, making it the largest standing exhibition of painting in London.[30]

Yet Vauxhall was yet another cultural venue that was also a seat of depravity. This ambiguity is well captured by a commentator in *The Scots Magazine* of 1739, whose approbation of the art work decorating the dining booths was less than high-minded:

> the paintings at the back of every arbour afford a very entertaining view; especially when the Ladies, as ought ever to be contrived, sit with their heads against them. And, what adds not a little to the pleasure of these pictures, they give an unexceptionable opportunity of gazing on any pleasing fair-one, without any other pretence than the credit of a fine taste for the piece behind her.[31]

Vauxhall was less a place of courtship than of sexual assignation. Described by Casanova as full of 'a crowd of London beauties, both high and low',[32] it was also the venue of that most dangerous and titillating of entertainments, the masquerade. As an occasion of licence and sexual liberty, especially for women, the masquerade was widely condemned as lewd and lubricious. Complaints about its character accurately mirror complaints about the motley nature of the cultural audience as a whole. As *The Weekly Journal* put it in 1724, 'All State and Ceremony are laid aside, since the *Peer* and the *Apprentice,* the *Punk* and the *Duchess* are, for so long a time, upon an equal Foot'.[33]

In general, cultural sites were often tainted ground, and if they were not contaminated with the diseases of social confusion, disorder, and moral licentiousness, they were corrupted by mammon: like the auction house that housed the first Royal Academy exhibition, they were places of private profit rather than public edification.

The escape of culture beyond the circumscribed boundaries of the court and into the protean spaces of urban life and what Shaftesbury called 'the country of the mind' was accompanied by the disintegration of cultural form. The most high-minded and patrician of forms—the epic, history painting, and tragedy—were jostled and sometimes nudged aside by a demotic throng of mock epics, ballad operas, urban pastorals, conversational pieces, comic history painting, and performances and products that could only by described as olios, potpourris, or pastiches. The instability of classical forms is apparent in

the way in which they were parodied or qualified; the absence of fixity and order in aesthetic hierarchies is demonstrated by the intrusion of demotic forms (ballads, songs, the carnival) and by the emergence of mixed genres.

The responses to this aesthetic fragmentation were complex. Literary scholars such as Pat Rogers, Ronald Paulson, and Ralph Cohen have emphasised the creative tension between aristocratic and classical tropes and their demotic and vernacular counterparts. As Rogers has put it:

> Hogarth, Swift and Pope [he might also have added Fielding] had devised their fictions when it was still feasible to apply some of the criteria of high art to the lower-class cousin. Defoe had written when Grub Street still utilised some of the themes, if not the techniques, exploited by the literary aristocracy. This situation made for a degree of mutual commerce; an interaction of 'levels' highly congenial to the Augustan mind, which seems to have preserved an attachment to the 'kinds' precisely to facilitate cross-generic play…. The satirists may not have approved of the rising entertainment industry, but they were sufficiently entertainers themselves to borrow some of its gusto and glamour for their own purposes.[34]

And, we might add, the interplay of demotic and aristocratic forms helped make what their creators saw as distinctively English forms of cultural expression which, like Hogarth's 'modern moral subjects' or comic history painting, combined the universal ideas embodied in the higher forms with the local, national, and particular associated with humbler forms of expression.

Yet for many—indeed, most—eighteenth-century critics the hierarchy remained in place. The criteria determining the ordering of artistic practice might change, as might the grounds on which a public would be defined: thus Reynolds differs from Shaftesbury in defining the public not as independent landed proprietors free from prejudice and partiality but as men (the gender is significant) capable of abstracting general principles from the raw experience of paint. Both, however, concur in retaining history painting at the pinnacle of a remarkably stable theoretical hierarchy. And in both instances the strategy is to link the aesthetic order to a definition of the public which is in turn intended to legitimate the author (in Shaftesbury's case the landed aristocrat, in Reynolds's the enlightened painter) as the arbiter both of taste and public.[35]

The views of Shaftesbury and Reynolds (and we could, of course, add others such as Jonathan Richardson) point to an ineluctable paradox which I will pursue about painting but which could be applied to almost every other form of cultural production in the eighteenth century. I speak, of course, of the tension between the abstractions of aesthetic theory and the pedestrian realm of patrons' purchases and artistic practice. History painting was aesthetically paramount but commercially marginal. As Gainsborough commented on reading Reynolds's Fourth Discourse, 'Sir Joshua either forgets, or does not

chuse see [*sic*] that his Instruction is all adapted to form the History Painter, which he must know there is no call for in this country'.[36] Gainsborough's observation, which can be explained by his antipathy to the grand manner and to painterly learning, is nevertheless borne out by the content of exhibits at the Royal Academy, supposedly the institution designed to exemplify the pursuit of history painting. As Marcia Pointon has shown, Academy exhibits even in the heyday of Reynolds were dominated by landscape and portraiture. Between 1781 and 1785 history painting accounted for only between ten and sixteen per cent of the exhibits.[37] Even if we concede that the square footage of history painting canvas would have been greater, this is a pretty poor showing.

Painters like Romney complained bitterly (and with reason) about the drudgery of portraiture, but they were reluctant, without a carefully arranged deal with a skilled and preferably distinguished engraver, to embark on history painting. (It is one of those revealing paradoxes that the highest form of art was not commercially viable without the aid of a means of mechanical reproduction).[38] When John Boydell in the 1790s offered almost every able artist in England the opportunity to produce history paintings for his Shakespeare Gallery he was met with reluctance, despite the offer of enormous fees. Part of the explanation for this diffidence no doubt lies in Boydell's status as a printseller and former engraver (albeit a fabulously wealthy one) and in the palpably commercial thrust of his enterprise, which was so meanly satirised by James Gillray in *Shakespeare Sacrificed, or the Offering to Avarice* (fig. 1).[39] But it was also based on the knowledge, which almost no one except the likes of Gainsborough was prepared to admit publicly, that the audience for art was not especially interested in history painting, even when it assumed the patriotic guise of representing the greatest moments of the nation's history and literature.

The tension between much practice and much theory leads me to my final remarks, which address the place of the cultural producer. For the cultural producer generally and the painter in particular embodied the contradictions inherent in the eighteenth-century cultural marketplace. At once the beneficiary of the growing demand for cultural products, the artist had also, because of prevailing notions about the nature of art and the artist, to adopt a series of stratagems to distance himself from and obscure or conceal his dependence upon the market. Scholars such as Louise Lippincott have drawn attention to the remarkable range of expedients adopted by those concerned to make a living from art in Georgian London. Arthur Pond, she shows, worked as copyist, restorer, teacher, dealer, importer, and factotum of aristocratic collectors as well as artist in his own right.[40] But the lowly status of the artist in general and of this artist in particular—the sense that they were tradesmen or mechanics—was reinforced by much of this work: buying and selling and

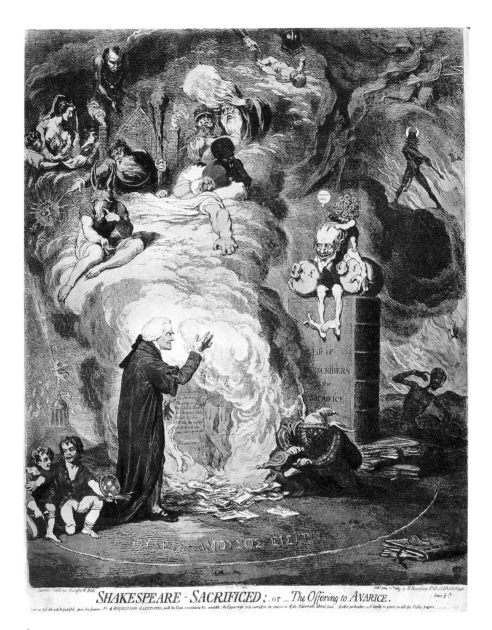

fig. 1

James Gillray

Shakespeare Sacrificed, or The Offering to Avarice, 1789

Engraving, 18 ⅝ x 14 ¾ in. (47.4 x 37.5 cm.)

Yale Center for British Art, Paul Mellon Collection

brokerage of imports, copying Old Masters, and completing decorative painting to commission was not the work of a liberal or independent man.

How then, given the commercial pressures of the market and the hostility to the cultural entrepreneur, was the artist to succeed? The move from impecunious artist to public fame depended on a great deal more than sheer talent; it required the adoption of a manner and guise which, of itself, spoke of detachment from the painter's garret, the visual equivalent of the literary gutter.

The social milieu of the artist, Grub Street hack, opera singer, or actor was far from reputable. Heavy drinking, imprisonment for debt, free and easy sexual manners, long periods of lassitude, idleness, and unemployment, periodic extravagance, and perpetual financial insecurity: these were the life and lot of the minor figures of literary and artistic London. It was this world that the cultural producer had to disguise or deny. Success in large part depended on all or several of three tactics: adding the skills of a critic to the drudgery of a practitioner; acquiring the polished veneer or emollient manner of the man of leisure; and displaying the material appurtenances of a gentleman. (The last two stratagems were designed to distance the artist or author from the sordid world of pecuniary gain.) Perhaps we should add a fourth posture, the espousal of the notion of creative 'genius' which entitled its bearer to overlook or flout the customary rules and constraints of polite society. But the notion of the artist as socially transcendent was not predominant before the nineteenth century.

The first of these tactics was undoubtedly one of the most successful. Humble practitioners—the hack journalist producing pastiche, the humble limner churning out portraits by the score, the minor actor, and the plodding musical performer—could all be accused of providing little more than technical competence, the ability to mimic or imitate in the most pedestrian fashion. They were mere mechanics for hire, lacking the broader vision and taste for the arts, unable to discriminate because of both their narrow competence and their economic servitude. The critic, on the other hand, could claim (albeit with different degrees of success) to distinguish between good and bad, to exercise the powers of distinction which dictated good taste. Of course many critics were little more financially independent than the practitioners they judged—often they were one and the same person—but the claim to interpret as well as create a work of art or literature was vital not only to the career of individuals but to the status of the literary and artistic professions as a whole. Richardson and Hogarth, as well as Reynolds and his successors, were not only in the business of setting standards but of establishing their status. No doubt this is why the adverse and derisive reception of Hogarth's *Analysis of Beauty* was so wounding.

Critics may have achieved a degree of intellectual independence, but it did

not make them gentlemen. (Reynolds, for instance, may have been an ornament of the nation, but it did not prevent opprobrious remarks about his West Country accent and ungenteel demeanour.) To define polite taste did not necessarily make one polite. But politeness, 'the art of pleasing in conversation', was also important in achieving artistic success. Garrick was in demand on the country house circuit because he was an excellent and witty companion. Godfrey Kneller, Joseph Highmore, and Reynolds were all well known for their ease of address and ability to put a sitter at ease. One customer, after agreeing to sit for Highmore, wrote, 'the pleasure he had received this evening at your house, and particularly in your conversation, has greatly contributed to his assent'.[41] The importance of genteel and refined manners in securing custom led some artists to embark on courses of self-improvement. The engraver George Vertue admitted that 'he amusd himself with the practise of drawing—, musick dancing, French a little Italian, in order to polish his education or to become more Sociable amongst his betters'.[42] Others, like Arthur Pond, spent lavishly and often beyond their means to maintain richly furnished apartments and studios. Reynolds had a richly decorated carriage which he rarely used himself but insisted that his sister employ whenever possible in order to advertise his opulence.

The facade of gentility, the legerdemain employed by almost every artist and author, included a constant threnody against cultural middlemen and entrepreneurs: the printsellers, booksellers, theatrical and operatic impresarios, owners of theatres and pleasure gardens who openly engaged in cultural commerce, defied the order of the arts, and had a totally unproblematic attitude towards the public. These figures, for all the opprobrium that was heaped on them, deserve their place in the history of cultural production. Eighteenth-century culture would have been enormously impoverished without the likes of J. J. Heidegger, John Rich, Jonathan Tyers, John Boydell, or the booksellers who cajoled the recumbent Dr. Johnson into writing. Yet these middlemen served a useful purpose for the artist or author; profitmaking was concealed by the veil of righteousness with which the artist surrounded himself. Profits and losses could be blamed on the middlemen; the artist could appear like an independent lady or gentleman, above the squalid pursuit of pecuniary gain.[43]

Similar criticisms were levelled against those who broke the artistic code by acknowledging that they worked for a living. Oliver Goldsmith, whose career was quintessentially that of a Grub Street journalist, churning out histories, poems, reviews, short stories, children's tales, novels, plays, and essays, could nevertheless write that 'the author who draws his quill merely to take a purse, no more deserves success than he who presents a pistol'.[44] The number of limners and hacks who endorsed this particular sort of double-think was legion.

Not every cultural producer, it is true, was so discreet. Hogarth was shamelessly commercial: willing to advertise, to contribute to an exhibition of

signpainters in defiance of those who severed art from commerce. He showed no ambivalence about offering art to a public which was socially diverse as well as divisible into 'men of penetration' and 'the ordinary reader'.[45] Similarly Dr. Johnson was prepared to acknowledge and even to glory in the fact that he wrote to maintain a household, fill his cup, and keep the bailiffs from his door. And, in a fit of pique because he was socially neglected, the bookseller's son from Lichfield could embarrass Reynolds by asking him in genteel company, 'How much do you think you and I could get in a week, if we were to *work as hard* as we could?'[46] Yet, as this anecdote demonstrates, no matter what the attitude or response (and both Hogarth and Johnson were self-consciously breaking what they knew to be prevailing norms or rules), artists, authors, and performers had to confront their peculiar social position, one in which they were supposed to embody the values of politeness and gentility and yet were palpably dependent for their livelihood on the workings of the cultural marketplace.

It would be easy if we were to conclude on the basis of this cursory examination of cultural production and consumption in the eighteenth century that the ambivalent and ambiguous position of the artist was a consequence of powerful tensions within a society and culture which was nascently commercial but incompletely capitalist, and which was still dominated by a leisured class of landed proprietors concerned to fabricate a culture in its own image. But I don't find this a satisfactory solution, because neither the ambiguous status of the artist nor the tension between art and commerce can be confined to eighteenth-century England. Moreover, I am not at all sure that the leisured class of landed proprietors succeeded in creating a culture in their own image, which is not to say that they did not try. Rather, what I would choose to emphasise about the eighteenth century is the cultural vitality of a period when the boundaries and definitions of both audiences and their taste were subject to redefinition and debate. These changes were troublesome to many who found them aesthetically unpleasing and morally offensive, but they also provided the environment in which experiment and innovation, though they were not actively encouraged by the cultural establishment, were able to flourish and develop.

1. For a discussion of this term see Lawrence E. Klein, 'Shaftesbury and the Progress of Politeness', *Eighteenth-Century Studies* 18, no. 2 (1984–85): 186–214; Klein, 'Liberty, Manners and Politeness in Early 18th-Century England', *The Historical Journal* 32 (1989): 583–605.
2. See especially J. H. Plumb, *Georgian Delights* (London: Weidenfeld and Nicholson, 1980); Neil McKendrick, John Brewer, and J. H. Plumb, *The Birth of a Consumer Society: The Commercialization of Eighteenth-Century England* (London: Europa, 1982); Peter Borsay, *The English Urban Renaissance: Culture and Society in the Provincial Town, 1660–1770* (Oxford: Clarendon Press, 1989); Paul Langford,

A Polite and Commercial People: England, 1727–1783 (Oxford: Clarendon Press, 1989), 59–121.

3. Most explicitly by J. H. Plumb in 'The Acceptance of Modernity', McKendrick, Brewer and Plumb, 316–34.

4. Iain Pears, *The Discovery of Painting: The Growth of Interest in the Arts in England, 1680–1768* (New Haven and London: Yale University Press, 1988), 52–54; Alvin B. Kernan, *Printing Technology, Letters, and Samuel Johnson* (Princeton: Princeton University Press, 1987), 59; *New Grove Dictionary of Music and Musicians* (1980), 11:142–217.

5. For a recent summary and analysis of these developments see Pears, esp. chap. 3.

6. *The Correspondence of Horace Walpole* (New Haven: Yale University Press, 1937–82), 23:211.

7. On prints see especially Ronald Paulson, *Hogarth, His Life, Art, and Times,* 2 vols. (New Haven and London: Yale University Press, 1971); Richard T. Godfrey, *Printmaking in Britain: A General History from Its Beginnings to the Present Day* (Oxford: Phaidon Press, 1978); Louise Lippincott, *Selling Art in Georgian London: The Rise of Arthur Pond* (New Haven and London: Yale University Press, 1983); Sven H. A. Bruntjen, *John Boydell, 1719–1804: A Study of Art Patronage and Publishing in Georgian London* (New York: Garland Publishing, 1985).

8. *New Grove Dictionary of Music and Musicians,* 11:142–217, esp. 158, 169, 177–81, 191–93, 202–4; Cyril Ehrlich, *The Music Profession in Britain since the Eighteenth Century: A Social History* (Oxford: Clarendon Press, 1985), 17; Karl Geiringer, *Haydn: A Creative Life in Music,* 2nd ed. (London: Allen and Unwin, 1964), 88–89, 102–3, 107–21.

9. These developments can be followed in Emmett L. Avery and Arthur H. Scouten, *The London Stage, 1660–1800,* 5 parts (Carbondale: Southern Illinois University Press, 1960–68); Sybil Rosenfeld, *The Theatre of the London Fairs in the Eighteenth Century* (Cambridge: Cambridge University Press, 1960); Borsay, esp. 117–21, 144–49, 218–20, and App. 3.

10. C. J. Mitchell, 'The Spread and Fluctuation of Eighteenth-Century Printing', *Studies on Voltaire and the Eighteenth Century* 230 (1985): 305–21.

11. See, amongst many others, *The Spectator* 5 (6 March 1711); 13 (15 March); 14 (16 March); 22 (26 March); 29 (3 April); 39 (14 April); 40 (16 April); 83 (5 June); 226 (19 November); 445 (31 July 1712); 555 (6 December).

12. *The Universal Magazine* 37 (1765).

13. The phrase is, of course, that of Benedict R. O'G. Anderson, in *Imagined Communities: Reflections on the Origin and Spread of Nationalism* (London: Verso, 1983).

14. For these series see Lippincott, 128–48; Bruntjen, 40–46.

15. Recent literature on rates of economic growth has revised growth rates downward, see N. F. R. Crafts, 'English Economic Growth in the Eighteenth Century: A Re–examination of Deane and Cole's Estimates', *Economic History Review,* 2nd. ser., 29, no. 2 (1976): 226–35; C. K. Harley, 'British Industrialization before 1841: Evidence of Slower Growth during the Industrial Revolution', *Journal of Economic History* 42, no. 2 (1982): 267–89; Peter H. Lindert, 'Remodelling British Economic History: A Review Article', *Journal of Economic History* 43 (1983): 986–92.

16. William Weber, 'The Eighteenth-Century Origins of the Musical Canon', *Journal of the Royal Musical Association* 114 (1989): 12–13; John Summerson, *Architecture in Britain, 1530–1830* (London: Penguin Books, 1963), 189–90, 206; Linda Colley, 'The English Rococo: Historical Background' in *Rococo: Art and*

Design in Hogarth's England (London: Trefoil Books, Victoria and Albert Museum, 1984), 11–12.

17. Simon Schaffer, 'The Consuming Flame: Electrical Showmen and Tory Mystics in the World of Goods', in John Brewer and Roy Porter, eds., *Consumption and the World of Goods* (London: Routledge, 1993).

18. E. P. Thompson 'Eighteenth-Century English Society: Class Struggle without Class?', *Social History* 3, no. 2 (1978): 133–65; J. M. Golby and A. W. Purdue, *The Civilisation of the Crowd: Popular Culture in England, 1750–1900* (London: Batsford Academic and Educational, 1984).

19. Pat Rogers, *Literature and Popular Culture in Eighteenth-Century England* (Sussex: Harvester Press, 1985); Ronald Paulson, *Popular and Polite Art in the Age of Hogarth and Fielding* (Notre Dame: University of Notre Dame Press, 1979); Ronald Paulson, *Breaking and Remaking: Aesthetic Practice in England, 1700–1820* (New Brunswick: Rutgers University Press, 1989).

20. Gerald Newman, *The Rise of English Nationalism: A Cultural History, 1720–1830* (New York: St. Martin's Press, 1987), 1–60, esp. 50–51.

21. For an important general discussion of this topic see Peter Stallybrass and Allon White, *The Politics and Poetics of Transgression* (Ithaca: Cornell University Press, 1986), esp. chap. 2.

22. Alexander Pope, *The Dunciad in Four Books* (1742), bk. 1, lines 222–23, *The Twickenham Edition of the Poems of Alexander Pope,* 3rd ed., ed. James Sutherland (London: Methuen, 1963), 5:286.

23. David Garrick, 'The Farmer's Return from London', *Poetical Works* (London: George Kearsley, 1785), 1:187.

24. For an extremely important discussion of this topic see John Barrell, *The Political Theory of Painting from Reynolds to Hazlitt: 'The Body of the Public'* (New Haven: Yale University Press, 1986).

25. Edward Edwards, *Anecdotes of Painters Who Have Resided or Been Born in England; with Critical Remarks on Their Productions* (London, 1808), xxvi.

26. Sir Joshua Reynolds, *Discourses on Art,* ed. Robert R. Wark (New Haven and London: Yale University Press, 1975), 90.

27. Quoted in Barrell, 90.

28. See, for instance, Shaftesbury's remarks on this subject: 'And without a public voice, knowingly guided and directed, there is nothing which can raise a true ambition in the artist; nothing which can exalt the genius of the workman, or make him emulous of fame, and of the approbation of his country, and of posterity....When the free spirit of a nation turns itself this way, judgements are formed; critics arise; the public eye and ear improve; a right taste prevails, and in a manner forces its way'—Shaftesbury, *Second Characters, or, the Language of Forms,* ed. Benjamin Rand (Cambridge: Cambridge University Press, 1914), 22–23.

29. *Boswell's London Journal, 1762–1763,* ed. Frederick A. Pottle (New York and London: McGraw Hill, 1950), 236–37.

30. Ronald Paulson, *Hogarth: His Life, Art, and Times,* 1:347–50; Brian Allen, *Francis Hayman* (New Haven and London: Yale University Press, 1987), 62–70, 107–9; *Rococo: Art and Design in Hogarth's England,* 74–98; T. J. Edelstein and Brian Allen, *Vauxhall Gardens* (New Haven: Yale Center for British Art, 1983).

31. *The Scots Magazine* (August 1739): 363.

32. Arthur Machen, ed., *The Memoirs of Jacques Casanova de Seingalt* (New York: G. P. Putnam, [1959]), 5:219.

33. Quoted in Terry Castle, 'Eros and Liberty at the English Masquerade, 1710–1790', *Eighteenth-Century Studies* 17, no. 2 (1983–84): 162.

34. Rogers, 209.

35. Barrell, esp. Introduction and chap. 1.

36. Gainsborough to Mr. [Prince] Hoare, undated, *The Letters of Thomas Gainsborough,* ed. Mary Woodall (Bradford, England: The Country Press, 1963), 95.

37. Marcia Pointon, 'Portrait Painting as a Business Enterprise in London in the 1780s', *Art History* 7, no. 2 (1984): 189.

38. For this topic see David Alexander and Richard T. Godfrey, *Painters and Engraving: The Reproductive Print from Hogarth to Wilkie* (New Haven: Yale Center for British Art, 1980).

39. Bruntjen, 69–157.

40. Lippincott, passim.

41. William T. Whitley, *Artists and Their Friends in England, 1700–1799* (London: The Medici Society, 1928), 1:49.

42. George Vertue, 'Notebooks', vol. 1, *Walpole Society* 18 (1929–30): 2.

43. Kathy MacDermott, 'Literature and the Grub Street Myth', in Peter Humm, Paul Stigant, and Peter Widdowson, eds., *Popular Fictions: Essays in Literature and History* (London: Methuen, 1986), 21–24. For a modern example of this sort of thinking see Nicholas Penny's disparagement of printsellers Macklin and Boydell as 'the equivalent of today's Cinema or Television producers'. (Nicholas Penny, 'An Ambitious Man. The Career and Achievement of Sir Joshua Reynolds', in Nicholas Penny, ed., *Reynolds* (New York: Abrams, 1986), 35.

44. Oliver Goldsmith, 'An Inquiry into the Present State of Polite Learning', *The Miscellanous Works of Oliver Goldsmith* (London, 1821), 1:248. This remark can be compared to that of John Gross in his *The Rise and Fall of the Man of Letters* (London: Weidenfeld and Nicholson, 1973), 26: 'Journalism is a career; literature is, or ought to be, a vocation'.

45. Ronald Paulson has developed these themes in his biography of Hogarth, in *Popular and Polite Art in the Age of Hogarth and Fielding,* and in *Emblem and Expression: Meaning in English Art of the Eighteenth Century* (Cambridge: Harvard University Press, 1975).

46. James Boswell, *Life of Johnson,* ed. R. W. Chapman (Oxford: Oxford University Press, 1953), 174.

Hogarth and the Distribution of Visual Images

Ronald Paulson

Hogarth's Models for Consumer and Product

The relationship of consumer and product developed by Hogarth over the forty years of his career was based on a series of overlapping models, which I shall designate: the Veil of Allegory, Subscription, the Theatre, Beauty (the Labyrinth and the Chase), Framed Print and Folio, Property, and Public Exhibition.

There are two privileged texts for a discussion of Hogarth's idea of an audience, the consumers of his product, which he called the 'modern moral subject'. One is the programmatic subscription tickets with which he announced each new series of prints; the other is the notes he wrote toward his *Analysis of Beauty* and an introduction to the bound folios of his prints late in his life. But in order to place his overt intentions within a context of actuality, we can begin by sketching in the audience he did in fact reach with his first and paradigmatic series, *A Harlot's Progress* (1732).

This audience originated with a few men—probably prurient, perhaps the swindlers Sir Archibald Grant and James Thomson or the eccentric Duke of Montagu—who (as George Vertue tells us) came to Hogarth's studio-shop, saw his painting of a harlot in her shabby garret, and asked for 'more'.[1] But the audience of the finished series of six engravings certainly included the pious readers of Bunyan (and his secularised equivalent, Defoe), who saw a simple morality play of Protestant choice, crime, and punishment. It included as well the more sophisticated readers of Butler, Swift, Pope, and Gay. The latter would have recognised the exploitation of the Harlot and the unpunished evil of her models, corrupters, and exploiters. It would have included those who took pleasure in the sheer play of fancy, the witty juxtapositions within each plate and between plates; those 'coffee house politicians' who recognised the contemporary portraits and followed the careers of Charteris, Needham, Gonson, and the rest in the newspapers; and those who detected the social and gender recoding of politics in the story of the Harlot.

The Veil of Allegory

The official model Hogarth offered in his first subscription ticket, *Boys Peeping at Nature* (1731, fig. 2), was based on the bipartite audiences of Renaissance allegory: a young satyr and a putto are struggling to reveal and conceal the lower, private parts of a female figure of Nature. Lifting her skirt is an allusion

Antiquam exquirite Matrem.

necefse est
Indiciis monstrare recentibus abdita rerum,
dabiturque Licentia Sumpta pudenter. Hor:

Rec.d of mr. Lambert

half a Guinea being yr first Payment
for Six Prints of a Harlot's Progress
which J Promise to Deliver when Finish'd
on Receiving one half Guinea more
W. Hogarth

fig. 2
William Hogarth
Boys Peeping at Nature, 1730–31
Engraving, 3½ x 4¾ in. (8.9 x 12.1 cm.)
The Royal Collection © Her Majesty The Queen

to (1) the female personification of naked Truth (*nuda veritas*) and, at the same time, (2) the veil of allegory by which the poet traditionally protected the Truth he was conveying. Hogarth associates his plates with the double meaning—a 'plain literal sense' and a 'hidden Meaning'—of epic allegory. Addison's *Spectator* (No. 315) on allegory, emphasising the 'ordinary Reader', indicated the breadth of Hogarth's projected audience: 'The Story should be such as an ordinary Reader may acquiesce in, whatever Natural, Moral or Political Truth may be discovered in it by Men of greater Penetration'. There will be a plain (a low) story of a prostitute, her crime and punishment, and then, for the 'Men of greater Penetration', something closer to naked Truth.[2]

The latter refers, when we explore the *Harlot's Progress,* to the Renaissance concept of *difficultas:* 'You must read, you must persevere, you must sit up nights, you must inquire, and exert the utmost power of your mind', as Boccaccio put it; and, closer to Hogarth's own time, the Earl of Roscommon: 'For if your Author be profoundly good,/ 'Twill cost you dear before he's understood'.[3] In Hogarth's (and *The Spectator's*) terms these viewers are the 'men of greater penetration', as opposed to the 'ordinary reader'. *Difficultas* includes also the playful readers Hogarth will sum up in *The Analysis of Beauty* as engaged in 'the pleasure of pursuit': for example, the reader who remembered the passage at the very beginning of Locke's *Essay Concerning Human Understanding,* in the dedicatory letter to the Earl of Pembroke: 'But there being nothing more to be desired for Truth, than a fair unprejudiced hearing, no body is more likely to procure me that, than your Lordship, who are allowed to have got *so intimate an Acquaintance with her, in her more retired recesses*' (italics added). 'Recesses' referred in both poetic and midwifery contexts to the womb.[4]

In this model imagination is required on the part of the audience to infer the 'recesses' of nature (the Harlot's story) that are concealed under the veil. But the most playful aspect of the imagination projected in Hogarth's image is that in fact—as anyone knew who was familiar with images of Diana of the Ephesians—it is not a full body but a herm, only a column tapering downward from the head and breasts, and there is nothing to see beneath but smooth stone.

The statue of Diana of the Ephesians is usually seen in the context of art, in Gérard de Lairesse's *Art of Painting* (and the question of how many breasts she should be represented with) and in Rubens's painting *Nature Adorned by the Graces.*[5] But it also has a biblical context, recalling the story in Acts 19.24–41 of the 'Diana'—Artemis, the Asian mother-goddess (thus, for Hogarth, 'ancient mother'), whom St. Paul vanquishes in the name of the Christian god. Implicit in this figure of Diana Multimammia is the pantheist and materialistic 'Nature' of the Deists. Seen in this context (and the allusion in Plate 2 to the deist Thomas Woolston), the veil of allegory summons up

John Toland's 'exoteric and esoteric distinction' (or the third Earl of Shaftesbury's 'defensive raillery', Anthony Collins's 'irony', or the more precise and blunt term, 'theological lying').[6] Shaftesbury's words come very close: ''Tis real Humanity and Kindness to hide strong Truths from tender eye'.[7]

Censorship then is also implicit in Diana's veil. Not only the political but also the religious dimension is being hidden from 'tender eyes'. In Collins's words the freethinker will 'sacrifice the privilege of irony' only when there is freedom of expression, or in Toland's: 'considering how dangerous it is made to tell the truth, 'tis difficult to know when any man declares his real opinion'.[8] Whether Hogarth picked up all of this by listening to coffee-house conversations or by reading the Deist tracts, he clearly *knew* the assertions and counter-assertions. In the *Harlot* he can be seen demystifying the Scriptures, rejecting or reinterpreting the Virgin Birth, the Annunciation, and the Visitation in ways that removed their supernatural implications. It is well to remember, however, that for Hogarth, as for a Deist like Toland, the starting point was antipopery, the real enemy with its tradition, priesthood, and mysteries—as opposed to Protestantism, the Bible, and reason. And so in a sense all he is doing is rooting out the residue of papist superstition in England, whether it be in Old Master paintings or in the clergy or their mystification of the Bible.

The result is paradoxical: on the one hand, he emphasises the esoteric reading, the 'reader of greater penetration'; on the other, this reading is populist rather than sophisticated, dissenter rather than Church of England, and subculture rather than culture. Hogarth's model is on the one hand contractive but on the other radically expansive. In *Industry and Idleness* (1748) the 'ordinary' and the 'reader of greater penetration' become, by implication, (1) the master who buys and hangs the prints on his wall for the edification (and coercion) of his apprentices, i.e., primarily the *Industrious* Apprentice, and (2) the apprentices, by which Hogarth—and any working apprentice—would mean the *Idle* Apprentice. But this does not eliminate the reader of greater penetration, who now has the aesthetic pleasure of detachment, seeing *both* of these readings from a safe distance, rather like the man of wisdom who stands on 'the vantage ground of truth (a hill not to be commanded, and where the air is always clear and serene) and [sees] the errors and wanderings, and mists, and tempests, in the vale below'.[9] Also, of course, rather like the 'detachment' that defines for Shaftesbury the aesthetic experience.

Subscription

Emblematised by the subscription ticket, the procedure of subscription employed by Hogarth to vend his *Harlot's Progress* addressed a small group of elite purchasers and readers in the subscribers, clearly the privileged readers,

who paid half a guinea, took home the subscription ticket, perhaps puzzled out its meaning, flattered themselves that they were 'readers of greater penetration', and when the engravings were finished returned to Hogarth's shop with the ticket and another half-guinea to claim them. The ordinary readers were left to buy the authorised set of cheap copies made by Giles King (when they did not stoop to buying piracies) or peruse the sets in coffee houses and other places of public access.

But Hogarth very soon saw the limitation of this plan, and in the *Rake's Progress* he extended the audience to include those who purchased the prints after the subscription—and to those who even bought at other printshops (where the prints were sold on consignment). He tacitly acknowledged the existence of the more general public—not just the 1,500 people who subscribed to the *Harlot's Progress* but the thousands more who bought the prints over the next thirty years of his life and for many years thereafter.

The Theatre

The metaphor of a theatre audience describes this more generous sense of audience. The *Boys Peeping at Nature* print had in fact focused on the artist imitating Nature rather than the audience—an adjunct to the subject of social imitation in Plate 2—and only secondarily on the audiences implied by the metaphor of the veil. In his next subscription ticket, called *A Pleased or Laughing Audience* (1733, fig. 3), Hogarth turned to the theatre, representing an audience divided into social and intellectual segments by pit, box, and (by implication) gallery, reminding us that as early as his *Beggar's Opera* paintings he had represented both actors and audience as interdependent entities, and that his work from the beginning depended on the ancient metaphor of life as theatre (*Theatrum mundi*).[10]

Once again he thematised his model in the print series he was announcing, *A Rake's Progress;* this time he followed with a separate print called *Southwark Fair,* where the theatrical metaphor is materialised in role-playing and heroic posturing. Finally, the *Rake's Progress* itself, in the context of both subscription ticket and pendant, becomes a story of a young bourgeois who tries on various roles, running from 'rake' to Paris, Nero, and (in the final plate) a sentimental version of Christ.

If Hogarth pictured the theatre as the metaphor for his multiple audiences, Henry Fielding—as was repeatedly the case in their relationship—then formulated and verbalised it in *Tom Jones* (1748–49), in 'A Comparison between the World and the Stage' (VII.i.), which adds to the pit, boxes, and galleries the privileged area 'behind the scenes'. Fielding placed his emphasis, like Hogarth's in the subscription ticket, on the theatre audience. But in the *Rake's Progress* Hogarth emphasises the stage itself, and in his so-called *Autobiographical Notes* he says he sees his characters as 'actors who were by

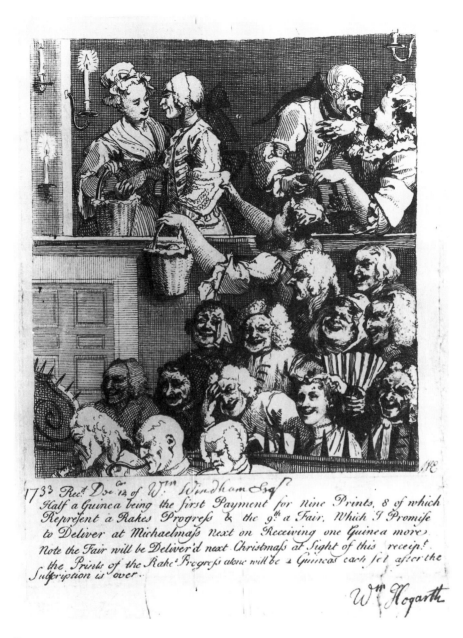

fig. 3
William Hogarth
The Laughing Audience, 1733
Engraving, first state, 7 x 6¼ in. (17.8 x 15.9 cm.)
Cambridge, Fitzwilliam Museum

Mean of certain Actions and express[ions] to Exhibit a dumb shew' and constructs his compositions as if in a theatre.[11]

At the crucial moment of each of the drafts of his life, he describes the mnemonic technique he developed in his youth to meet the circumstances of a precarious existence. These pages begin in a rejected passage for the *Analysis* (pp. 184–85) and continue in the *Autobiographical Notes,* where they appear as the climactic and emphatic element in a biographical sequence that is repeated, more or less, eight times. This sequence (pp. 201–13, italics added) begins with the fact of his apprenticeship:

'As the chief part of my time was lost (till I was three and Twenty)', employed merely copying designs for plate, a 'business too limited in every re[s]pect', therefore, 'Drawing object[s] something like *nature* instead of *the monsters of Heraldry* became necessary to attain which the common methods were much too tedious for one who loved *his pleasure* and that *came so late* to it'. Again, 'He never accustomd himself to *coppy* but took the *short way* of *geting objects by heart* so that werever he was [he] cau[gh]t some thing and thus united his *studies* with his *pleasure*[.] by this means he was apt [to] *catch momentary actions and expressions*. He repeats the words 'studies' and 'pleasures' over and over. Thus he 'hit upon a Method more suitable to my disposition which was to make my *studies* and my *Pleasures* go hand in hand.'

Hogarth's mnemonic technique combined these by sending him out—'strolling'—around the London streets and 'catching' what he sees. He demonstrates that 'by this Idle way of proceeding I grew so profane as to admire *Nature* beyond *Pictures* and I confess sometimes objected to the devinity of even Raphael Urbin Corregio and Michael Angelo for which I have been severely treated'. Other artists (by which he probably means his colleagues of the 1730s–40s) could not understand his method, and so his exaltation of nature was taken as such a '*Blasphemous* expression that I fear I fear [*sic*] *Persecution*'—and 'I have suffer'd a kind of *Persecution.* nevertheless from the *bigots*'. He defines those 'bigots': 'my notions of Painting differs from those Bigots who have taken theirs from books, or upon trust'; and he refers to 'the old *religion* of pictures'. This story, with the vocabulary of specifically religious persecution, announces that he was denying the almost universally-held doctrine of art, embodied in the writings of both Shaftesbury and Jonathan Richardson, summed up at the beginning of the tradition in Alberti's criticism of the ancient painter Demetrius, 'who failed to obtain the highest praise, because he paid much more attention to making paintings which were true to nature than to making them beautiful'.[12] But he was also contesting the conception of Nature as the general, summed up at the other end of the tradition by his eventual antagonist, Joshua Reynolds, in his seventh *Discourse* (1776): 'The terms beauty, or nature, which are general ideas, are but different modes of expressing the same thing…. Deformity is not nature, but an accidental

deviation from her accustomed practise. This general idea therefore ought to be called Nature, and nothing else, correctly speaking, has a right to that name.'[13]

For Hogarth 'nature' (actually 'truth', as in *Boys Peeping*) includes everything observed with his senses, however flawed—and not from a distance (seen with the detachment Shaftesbury required of the aesthetic experience) but close-up, as an active participation in the artist's 'pleasures'. But as he realises, and expresses in his subscription ticket for *A Harlot's Progress,* this direct contact is no more than a peep or glance at what is hidden under Nature's skirt, a voyeuristic 'pleasure'.

What exactly *was* Hogarth's mnemonic technique? John Nichols's story of the artist's making thumbnail sketches during his rambles ties in with his claim that the method involved 'retaining *in my mind lineally* such objects as fitted my purpose best'.[14] Some sort of a linear code, which at one point he associates with an alphabet, could refer to notation that catches a particular nose or other physical feature (as in a story told of Leonardo). But if we are to accept his words, his point is precisely that he memorises *en passant* without making a drawing of any sort on the spot; he makes a literally mental note, which he can transcribe in his studio or perhaps summon up much later— part of a visual repertoire—when it is needed for a particular composition. Referring to his theory, 'an arch Brother of the pencil gave it this turn That the only way to learn *to draw well was never to draw at all*' (p. 185). It is evident that Hogarth used only the most rudimentary sketches prior to applying paint to the canvas.

In one draft he extends the discussion of his mnemonics to the 'theatre of memory': 'my Picture was my Stage and men and women my actors who were by Mean of certain Actions and express[ions] to Exhibit a dumb shew'. This suggests that he carried the image of a stage around in his mind, recalling the story of Simonides and the visualised room used by orators as an *aide mémoire*.[15] Hogarth's scenes, invariably constructed as a single-point perspective box, essentially a proscenium-arch stage, filled with furniture and emblems, can be seen to serve as the traditional memory structure *turned away from* the orator toward his audience, seen from the spectator's point of view. As a rhetorical construct this is the *modus operandi* of Hogarth's prints. But it is also possible to see the room from the artist's point of view as a basic structure to be 'furnished' in his memory before setting it down on paper. With this architectural model Hogarth could walk the streets of London mentally filling a stage set: with the composition given, always the same, he could arrange/ dispose the figures as he experienced them, later putting them in their proper places on his canvas. Robert Boyle had formulated the idea of a 'conclave mnemonicum', a 'certain Room, Artificially furnish'd with Pictures or other Images of things', the most ordinary and everyday objects, seen as visual aids.[16]

But the archetypal room, of course, reaches from Plato's cave up to Newton's 'dark Chamber' and Locke's 'dark room' of the mind.[17]

In art-historical terms what Hogarth depicts in almost all of his pictures is the closed single-point perspective box of Renaissance art in its final emblematic *reductio ad absurdum*. That, like the prison cell with which it has much in common, it confines and contracts, that at the same time the humans cannot always be quite contained by their closed boxes, is his point.

The theatre audience, as both Hogarth and Fielding realised, represented a microcosm of London society, in terms of whose responses they attempted to structure their products. But it was a model that complicated the simple allegorical distinction between 'ordinary' reader and 'reader of greater penetration' into the dichotomy of study and pleasure with (as in his *Beggar's Opera* paintings) the motto emblazoned over the stage: *Utile et dulce*. In *Tom Jones* Fielding admits the virtual impossibility of communication with such a diverse audience—which, as *Tom Jones* proceeds, he turns from the audience in a theatre into the jury in a courtroom. But while *Tom Jones* is a plea for the defence, Fielding's next novel *Amelia* (1751) is a charge for the prosecution. Hogarth implicitly makes the same shift in the works that follow *The Analysis of Beauty*, which is itself largely about judgement, true and erroneous, based on experience and on hearsay. The relationship between spectacle and audience is much the same as in the theatre, but the seriousness and actuality of the magistrate's court adds a grim dimension that is as evident in Hogarth's works of the 1750s as in *Amelia*.

Perhaps it is significant that in Hogarth's next subscription ticket after *The Laughing Audience*, called *Characters and Caricaturas* (1743, fig. 4) (which responded to Fielding's preface to *Joseph Andrews* before he had formulated his theatre audience in *Tom Jones*), Hogarth made a more realistic distinction between the great mass of varying 'characters' and the stereotyped faces of caricatures with, situated at the point of demarcation, laughing into each other's faces, the likenesses of himself and Fielding (whom he acknowledged in words beneath the design).

Beauty (the Labyrinth and the Chase)

This multitudinous complex of 'character' was formulated by Hogarth in his principle of 'Variety' in *The Analysis of Beauty* (1753). In the first draft of the preface, he introduces a parody of one of his most pervasive topoi, Shaftesbury's proposed model for modern history painting, Hercules at the Crossroads.[18] The 'natural philosophers', Shaftesbury and Francis Hutcheson, attempting to follow the straight road of beauty = virtue, find themselves instead in the 'labyrinth' of variety that is not confined to the limitations of 'harmony and order':

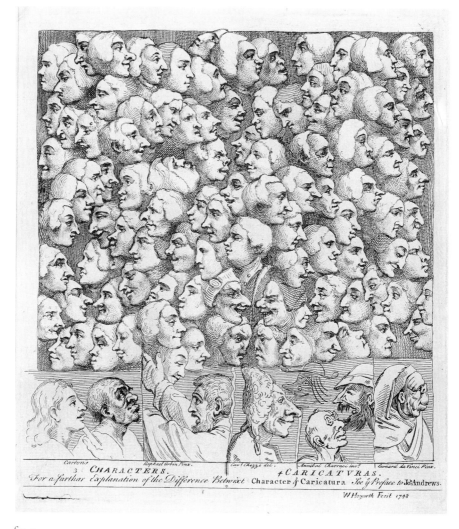

fig. 4
William Hogarth
Characters and Caricaturas, 1743
Engraving, 7 11/16 x 8 1/8 in. (19.5 x 20.6 cm.)
London, British Museum

Thus wandering a while in the maze of uncertainty, without gaining ground; they then to extricate themselves out of these difficultys; suddenly ascend the mound of moral Beauty, contiguous with the open field of Divinity, where ranging at large, they seem to lose all remembrance of their first pursuit (p. 190).

Hogarth is contrasting the broad road of moral order leading up to the Palace of Wisdom in the Choice of Hercules with the labyrinthine paths 'of sportiveness, and Fancy…which differ so greatly from her other beauties, of order, and usefulness', what he will call 'the pleasure of pursuit', an important aspect of Beauty in the *Analysis*. In the published treatise the long and elaborately developed metaphor of the road is reduced to the bald statement that the 'ingenious gentlemen who have lately published treatises' upon beauty, unable to discover the principle of the Line of Beauty, 'have been bewilder'd in their accounts of [beauty], and obliged so suddenly to turn into the broad, and more beaten path of moral beauty' (pp. 3–4).

'To see objects truly' is the reiterated aim of the treatise. Hogarth keeps repeating that painters who did not know about the Line of Beauty had no grace in their pictures 'more than what the *life chanced* to bring before' them (p. 10). He means that this line is *in nature,* by which he means 'chance' as well as 'life', and any painter who can closely follow nature or observation rather than the formulae, taste, and custom of other painters, will produce 'Beauty'. But along with 'nature' and the common man, there is an element of the secret, mysterious, and hieroglyphic. These truths are 'mysterious to the vulgar' or 'secret from those who were not of their particular sects', words which suggest the 'readers of greater penetration' of the veil of allegory and the esoteric and exoteric readings of the Deists.

In the manuscript draft of his preface Hogarth showed the Serpentine Line and the labyrinthine way complicating—indeed replacing—the simply binary highways of the Choice of Hercules—or even, it is possible, suggesting Vice's path of dalliance and pleasure. In this sense the *Analysis* retrospectively explains the strategy he had employed in *Industry and Idleness* and the six popular prints of 1751.[19] The opposition between the classical beauty of Goodchild's face and the plebeian plainness (or grotesqueness) of Idle's was in effect dissolved. These prints were made as another stage in his attempt to collapse—through irony, undifferentiation, and esoteric-exoteric readings—the categories of beautiful-ugly and sublime-grotesque, as well as virtue and vice: examples that were then followed by the precepts of the *Analysis*.

The labyrinth is a version, on the ground, of the principle of 'Intricacy', which is at the heart of Hogarth's epistemology of beauty in *The Analysis*. The 'intricacy in form' of Beauty, Hogarth tells us, 'leads the eye a wanton kind of chace'. The 'pleasure of pursuit' and of 'the chase' combine Locke's hunting metaphor of the *Essay*—the mind's 'searches after truth are a sort of hawking

and hunting, wherein the very pursuit makes a great part of the pleasure'—with the sexual: '*Eloquence,* like the fair Sex, has too prevailing Beauties in it, to suffer it self ever to be spoken against. And 'tis in vain to find fault with those Arts of deceiving, wherein Men find pleasure to be Deceived'. Pleasure comes from Beauty's deceit—a beauty Hogarth has unsurprisingly connected with eloquence and rhetoric.[20]

Strolling about London—that active series of moments involving a voyeuristic peeping at Nature—becomes the 'pleasure of pursuit', and Hogarth asks his reader to duplicate his own process in conceiving/composing the scene in the reading of it. Thus to problem-solving and pursuit (or the metaphor of the chase) he adds wantonness, pleasure, and deceit.

Truth was traditionally defined either in terms of the hazards of the climb or the pleasure of the prospect from the top of the hill, specifically of the labyrinth through which one has struggled to reach the top. The labyrinth itself was an ambiguous topos: after all, Truth is naked, whereas masked she becomes Falsehood.[21] But if Truth edifies, it is precisely the masked and deceitful Truth that gives pleasure: 'A mixture of a lie doth ever add pleasure', as Francis Bacon wrote, and the reference is to the process of masking, lying, and idleness that Hogarth mixes with his 'studies'.[22]

He is writing against the grain of most literary and art theory, in part because he is formulating it as aesthetics (that new-fledged philosophy), which amounts to simply the pleasure component of *utile et dulce:* Hogarth is of Satan's crew. The lines from *Paradise Lost* on his title page (Eve's temptation by the serpent[ine line]) could be augmented by reference to the fallen angels, at this point still 'beautiful', who find 'no end, in wand'ring mazes lost' (of false philosophy) and enjoy 'ignoble ease, and peaceful sloth':

> …for who would lose,
> Though full of pain, this intellectual being,
> Those thoughts that wander through Eternity.[23]

In the *Analysis,* where he formulates and urges the 'pleasure' of the labyrinthine 'chase', the question is whether he distinguishes this pleasure from—or confuses it with—the detached prospect from the top of the hill. The first deals with the spectator sharing in the *making* of the picture, closely implicated with the artist and the object; the other is the safe detachment of the Shaftesburean aesthetician: in *Industry and Idleness* Hogarth shows both at work, and it is difficult to say which he privileges.

Framed Print and Folio

Hogarth initially advertised his prints as fit for framing as 'furniture'. There is no evidence that he framed the prints in his shop, but surviving prints (some

of them in their original frames) suggest that the sheets were cut to the plate mark and framed without borders. (The prints reproduced in *Harlot's Progress* 3 are simply tacked to a wall, 'framed' by narrow borders.) They may have been arranged on a wall in whatever spaces the purchaser had available, purely as decoration, perhaps in some instances not even hung consecutively. But Hogarth must have visualised the series in an order as he engraved the plates, and at least his 'readers of greater penetration' must have sought to follow this order: I presume either a horizontal row, 1 to 6, or 1 to 3 over 4 to 6 (not 1, 3, 5 over 2, 4, 6).

Beginning in 1737 the advertisements announced that the prints could also be had bound in folios (the new print with all Hogarth's previous work).[24] He had the prints bound personally, and, once bound, their order could not be altered, although blank pages were left for tipping in subsequent Hogarth prints. Hogarth (occasionally in consultation with the purchaser) established the order, which began with his self-portrait and proceeded chronologically (eventually ending with his *Tailpiece*).

The folio meant that he was adding to the iconic or admonitory exhibition on a wall the closer 'reading' of a book, where the prints will also follow in sequence from his earlier series. The folio sacrificed the visual impact and the juxtapositions possible on a wall but substituted the possibility of a closer, focused perusal, a more intimate contact, which approximates the reading of a novel (the existence of which was to some extent prefigured by Hogarth's folios). The prints were framed not by the lines of a wooden frame but by the whiteness of surrounding margins, like the blankness of the uninscribed world around and outside the 'room' of the print or the column of type of the book. (The larger Boydell and Heath folios of the 1790s and after, with wider margins, simulated the exhibition experience of a gallery.)

In the folio Hogarth's audience is almost totally democratised. From this point onward he balanced and tested the concept of a published book, which requires not the seeing of changing scenes but the turning and reading of pages—close contact and time for study—against not only the stage but the exhibition, gallery, and salon, whose function was summed up by Reynolds's belief that a picture had to be taken in at a single glance. These were two different forms of public space which fought for preeminence in his own career and in the development of English art in his time, eventuating in what he opposed most, the Royal Academy, an institution characterised by hierarchy, models of foreign art, and rules.

Hogarth's folio also presupposes a social scale descending from the painting to the print: the most graphic object, by virtue of its relatively unmediated colours, forms, and textures, is the painting. This is the elite product, ordinarily intended for a single connoisseur. The painting prepares for, is followed in time by, an engraved copy with more clearly denotative (or legible) structures,

which include a title and often verses that assist the translation of the images into words. The engraving is then prefaced by an etched, not engraved (more personal, less official), subscription ticket with a programmatic design and inscriptions that explain Hogarth's artistic (not his political or moral) intentions in the print itself. And from the 1740s on, publication is followed by a written commentary explaining the print's meaning, at first for French readers and later for English as well, intended as a preface to the folios.

The Hogarth folio and Hogarth 'collection' are implied as part of the totality that is the Hogarthian work of art, and they project an owner and reader who knows *all* of Hogarth's works and can distinguish the variations and modifications. This reader will recognise the meaning when Hogarth replaces his face in a self-portrait with that of his enemy or adds on the wall of Bedlam an image of Britannia. Both states will coexist in the folio—*Rake* 8a and 8b, both versions of *Hogarth Painting the Comic Muse,* and *Gulielmus Hogarth* as well as *The Bruiser*—registering a change either in the times or in the artist's attitude toward the times.[25] The whole sequence, as for example the one involving *Paul before Felix,* with the different ways of telling the story played against the different styles of representation from Rembrandt to Raphael to Hogarth, has to do with knowing and represents an empirical exploration.[26]

The model Hogarth creates is, on the one hand, a visual object constructed so as to project a verbal text (the reverse of an illustration for *Paradise Lost*), which is materialised in various kinds of commentary, becoming ever more verbal as it moves out from the original visual image. At every stage he attempts to close or enclose the visual image with conceptual 'meaning', though this 'meaning' itself may exfoliate so luxuriantly and ambiguously that the end, complicating and cancelling itself, is more aesthetic than moral. And in fact the moral discourse of the commentary (e.g., Rouquet's) is supplemented in the 1750s by a consciously aesthetic one in *The Analysis of Beauty* and *The Bench.*

For, on the other hand, the principle of the Hogarth folio is a process that is both additive and revisionary. Even though he makes a final attempt at closure by designating a print his *Tailpiece*—and then dying—he *knew* he had left the folio open to the collector's efforts to secure earlier, rare, supposititious prints and rare states.

Property

The Hogarth folio also embodies a sense of its audience as possessor-owner, literally as consumer. As opposed to the pater familias (or master) who hangs Hogarth's prints on his wall in order to instruct his charges, the 'collector' now replaces the various readers, high, middle, and low.

But an engraving carried with it a different sense of 'property' than a painting. 'Property' applied to an engraving meant the right of the engraver, as

opposed to the dealer, to his work; the extension was easily made to the original work of art, whose ownership (to follow Locke's concept of 'property')[27] derives from the artist's labour, as opposed to the antique sculptures and Old Master paintings and copies gathered (sold, bought) by the collector or dealer. The latter were unrelated to a living transaction between a painter and a patron or a purchaser; rather, they were objects that had been removed from the context of their making to the collector's gallery by way of the dealer's (or before that the copyist's) shop.

The symbolic political act of Hogarth's professional career was the Engraver's Act (in his time known as Hogarth's Act), which guaranteed the possession of his own works, as opposed to their possession by a printseller or even a purchaser. Instead they could be disseminated to a wide audience, while at the same time remaining his own both in the sense that he derived profit from his own labour, and in the sense that he could establish their own context and therefore their meaning.

In Hogarth's terms this is to say that the deepest meanings of the work of art lie *beyond* the private delectation of the aesthete or the privileged possession of the collector: they are accessible rather to the public—those people who can see the painting exhibited in public or reproduced in an engraving—a public defined only by an inquiring mind, that is by (to use Hogarth's words in the *Analysis,* which echo Locke's in his *Essay*) the 'pursuit [that] makes a great part of the pleasure' of the possessing.

As was his custom, he thematised, or made a plot of, the patron and the old relationship he was trying to replace. The patron remains within his 'modern moral subjects', as, along with the printseller ethos, a villain: in the patronly-aristocratic assumptions embodied in the Old Master paintings on the walls that dominate the contemporary figures and in the imitative gestures with which they respond, botching their lives.

For Hogarth, then, property meant legal ownership and financial profit, but also, and more important, the determination (or retention) of its meaning. The latter he sought to accomplish by creating his own context for his product. This context he created by engraving his paintings, selling the engravings himself, providing explanations, and arranging them according to his own plan in folio collections, and with the paintings themselves by establishing their setting vis-à-vis a public audience, not a private collector.

Public Exhibition

Although Hogarth was not above cultivating patrons, and his claims against them were to some extent built on his inability to attract or hold them, his most publicised gesture was to seek and find (and, it is important to add, share with his fellow English artists) public places of exhibition for his paintings. Where there was a patron—a public organisation, as with the Benchers of

Lincoln's Inn who commissioned *Paul before Felix*—Hogarth still supposed a more general and extensive print audience: perhaps because he had a message he felt would be lost on the Benchers. For the patron in this case is alienated if not eliminated, and once again absorbed into the scene as a villain (Felix the magistrate, Tertullus the lawyer), while the print audience associates itself with the accused criminal (condemned victim) St. Paul. When, a few years later, the actual engravings were published, they became part of a series that began with a Rembrandt forgery, followed by a Rembrandt parody, and included different versions, stylistically and compositionally, of the painting, capped by the third and final employment of the *Boys Peeping at Nature* subscription ticket declaring that these spectators were being instructed in aesthetic as well as moral affairs, on the way to their indoctrination by *The Analysis of Beauty* in the next year.

He sought as much control as possible over the paintings, contriving to have them placed on permanent exhibition in, for example, the setting of a hospital for the poor, a hospital for foundlings (where Christ or the Good Samaritan would be seen as a symbol of the marginal; where the figures of British soldiers or of Moses are obviously, by the context, designated foundlings). He made his painting of *Paul before Felix* so large that it could not fit into the chapel intended as its location by the Benchers of Lincoln's Inn; it had to hang in the great hall, above the chair where the Lord Chancellor sat and where the Benchers ate, thus applying to this captive audience its moral concerning corrupt judges and lawyers (as in the other theatrical motto, complementing *Utile et dulce: veluti in speculum*).[28]

This policy helps to explain his disagreement with the artists' exhibition of 1761–62, where the other artists were trying less to instruct or move the spectators than to sell their paintings (or others like them). These artists wanted spectatorship limited because the 'mob' was entering to see their paintings without any potential as patrons or purchasers; whereas Hogarth insisted that they be admitted. The next year he contributed to a parody exhibition, showing works by humble craftsmen, as if attempting to reverse the whole course of the Renaissance from Alberti to Reynolds, but also correcting the imbalance of decorum between consumer and product.

If we return to the question of Hogarth's audience, we can now see that the one figure always excluded from the transaction has been the patron (by which we mean connoisseur or 'Man of Taste'). Prior to the *Harlot's Progress*, Hogarth suggests, the patron's ideology (and that of the printseller/patron) had to be shared, ostensibly at least, and reflected by the painter as by the patron's clients. With the addition of a general body of consumers, however, the possibility arises that they will bring another ideology to bear, which will involve interpretations of a wider or different, heterodox or even possibly subversive sort. Hogarth has opened the door to this audience, with whom the patron is

bound to feel uncomfortable. Hogarth accepts and exploits this opportunity, coming as he does from what he regards as a subordinate ideology (dissenter, apprentice, Deist) and a marginal occupation (engraver, painter of drolls). Given the fact that he sometimes places his paintings in public buildings, the same set of factors are brought to bear on these original, non-duplicable objects as on the exactly repeatable engravings—and, among other things, the distinction between object of beauty (pleasure) and an object of utility is narrowed (for example, between the painting and the print of *The March to Finchley*).

The widespread audience for prints made possible a variety of readings and interpretations in a way that a painting with its circumscribed audience did not—until Hogarth introduced public exhibition spaces where the painting became part of almost as general a range of response. He nevertheless contrived to involve both the aristocratic and bourgeois segments of his audience, even while denying their values. The first he retained to some extent because, while he ostentatiously rejects the assumptions of the aristocratic patron, this same person is allowed access through the back door: first as a putative ideal 'reader of greater penetration' and second insofar as the very basic conservative assumptions of the aristocratic do coincide with those of the subculture as against the middle class. The latter (the apprentice's master) is involved by a kind of double-think that allows him to read the prints as sheer crime-punishment, journalism, and humour, while watching with admiration Hogarth's *laissez-faire* mode of production. And it is quite possible that many tradesmen (if nothing else, as ex-apprentices) did in fact share Hogarth's particular brand of progressive-subversive ideology.

Hogarth's prints address (if they do not embody) a dominant ideology by complementing and compromising it with subordinate (residual or emergent, repressed or marginal) ideologies. These coexist with, and to some extent challenge (resist, contest, even modify or displace), the dominant ideology, which is itself trying in various ways to absorb or destroy them. And this agon—manifest in the form of Hogarth's audiences—creates the deep structure of the prints.

I would not want to claim that Hogarth's product does not to some degree represent the dominant ideology. Hogarth ostensibly shares, or at least invokes, the Latitudinarian ideology of toleration, charity, and works. On the other hand, his work cannot be fitted into the Althusserian category of a work 'held within ideology, but [which] also manages to distance itself from it, to the point where it permits us to "feel" and "perceive" the ideology from which it springs'.[29] That description might fit Defoe or Richardson, the experiental lives of whose characters overflow the bounds of the ideology they carry and inhabit. Hogarth's subject itself is ideology—as Blake's will be, and to some extent Fielding's was also. He is constantly commenting on the dominant or

hegemonic ideology of his time, or what he took it to be. 'Dominant' would be the word he wishes to stress, his example/analogue being the Old Testament Commandments, a set of rigid and over-formalised rules exploited by both clergy and government, by both artists and theorists of art. His ideology passes for Latitudinarian when in fact it is freethinking, sceptical, and in some respects deist.

Hogarth dramatises—and then formulates in *The Analysis of Beauty*—what has been called a 'creative consumption'.[30] His prints pose this double sense of the cultural object: one sense determined by the producer (by which we mean the patron or 'system') and the other refashioned by the standpoint and agency of the consumer. A story of crime and punishment (or reward vs. punishment) that upholds the message being inculcated in the popular audience also permits the designated consumers to appropriate it, in some cases quite actively, for their own purposes and/or pleasure.

Hogarth leaves the material open to appropriation either for purposes (e.g., of subversion) or for mere pleasure; but in either case for an end counter to the bourgeois piety and moral instruction that go with the form of a moral 'progress'. He articulates the first, 'studies' or 'purposes', most forcibly in the double texts of *Industry and Idleness* and the popular prints of 1751; the second, 'pleasure', in his discussion of variety and intricacy in *The Analysis of Beauty*. And this is the situation Hogarth encourages, indeed creates, especially in his prints—in effect by offering them in a folio to be perused (like *Pamela* or *Clarissa,* or Pamela's or Clarissa's letters) in the privacy of one's closet. The success of Hogarth's prints depended upon their power to address and intersect with deeply felt everyday needs and anxieties of the private, pleasure-loving, idle, and un-official reader.

1. George Vertue, 'Notebooks,' vol. 3, *Walpole Society* 22 (1933–34): 58.

2. See Michael Murrin, *The Veil of Allegory: Some Notes toward a Theory of Allegorical Rhetoric in the English Renaissance* (Chicago: University of Chicago Press, 1969).

3. Earl of Roscommon, 'Essay on Translated Verse' (1684) in J. E. Springarn, *Critical Essays of the Seventeenth Century* (Bloomington and London: Indiana University Press, 1957), 2:302.

4. William Walker has drawn attention to this image of Truth as a woman; for 'recesses', cf. Abraham Cowley, 'Ode to the Royal Society', where philosophy is a male and nature female, and the former presses his sight into her 'privatest recess'. And 'recess' was also a term for womb in Restoration and eighteenth-century midwife books. See *An Essay Concerning Human Understanding,* ed. Peter H. Nidditch (1975; reprinted Oxford: Oxford University Press, 1979), 3, italics added; also 48, 285; Walker, 'Locke Minding Women: Literary History, Gender, and the *Essay*', *Eighteenth Century Studies* 23 (1990): 261–62; Robert Erickson, '"The Books of Generation": Some Observations on the Style of the British Midwife Books, 1671–1764', in Paul-Gabriel Bouce, ed., *Sexuality in Eighteenth-Century Britain* (Totowa, New Jersey: Manchester University Press, Barnes & Noble Books, 1982),

81, 84; and John Steadman, *The Hill and the Labyrinth* (Berkeley: University of California Press, 1984), 137–41.

5. For explication see Ronald Paulson, *Hogarth's Graphic Works,* rev. ed. (London: Print Room, 1989), no. 120.

6. John Toland, 'Clidophorus; or of the Exoteric and Esoteric Philosophy', in *Tetradymus* (1720); Earl of Shaftesbury, *An Essay on the Freedom of Wit and Humour* (1709). For the last term I am indebted to David Berman, 'Deism, Immortality, and the Art of Theological Lying', in J. A. Leo Lemay, ed., *Deism, Masonry, and the Enlightenment: Essays Honoring Alfred Owen Aldridge* (Newark: University of Delaware Press, 1987), 61–78.

7. Shaftesbury in Berman, 63. But cf. the Puritan's world of *seeing,* which meant to see not only literally but to sense the unseen reality within natural objects as well. Like the Puritan's the *Harlot's* world, with its innumerable things scattered about, may seem intended for a reader who sees not only literally but senses the unseen reality, however witty and apparently unspiritual. 'In a world charged with meaning by the creator', writes a recent scholar, 'the elect are distinguished by their accurate sense of vision, and this in turn involves not only seeing but interpreting correctly'—Davis J. Alpaugh, 'Emblem and Interpretation in *The Pilgrim's Progress*', *ELH* 33 (1966): 300. There was clearly an 'elect' among Hogarth's readers.

8. Anthony Collins, *A Discourse Concerning Ridicule and Irony in Writing* (1729), 24; Toland, *Tetradymus,* 95; cited in Berman, 62. On Hogarth and the Deists see Ronald Paulson, *Hogarth,* vol. 1, *The 'Modern Moral Subject'* (New Brunswick: Rutgers University Press, 1991), chap. 9.

9. Francis Bacon, *Selected Writings,* ed. Hugh G. Dick (New York: Modern Library, 1955), 7–8.

10. See Ronald Paulson, 'Life as Journey and as Theater: Two Eighteenth-Century Narrative Structures', *NLH* 8 (1976): 43–58; in *Popular and Polite Art in the Age of Hogarth and Fielding* (Notre Dame: University of Notre Dame Press, 1979), 115–33.

11. William Hogarth, *The Analysis of Beauty,* ed. Joseph Burke (Oxford: Clarendon Press, 1955), 209. This text includes Hogarth's *Autobiographical Notes.*

12. 'Della Pittura' in *Leone Battista Albertis kleinere kunsttheoretische Schriften,* ed. Jantischek, 151; as cited in Anthony Blunt, *Artistic Theory in Italy, 1450–1600* (Oxford: Clarendon Press, 1964), 15.

13. Joshua Reynolds, *Discourses,* ed. Robert R. Wark (New Haven and London: Yale University Press, 1975), 124.

14. John Nichols's story, *The Genuine Works of William Hogarth,* 3 vols. (London, 1808–17).

15. See Frances A. Yates, *The Art of Memory* (Chicago: University of Chicago Press, 1966).

16. Robert Boyle, *Occasional Reflections on Several Subjects* (London, 1665), xxi.

17. Isaac Newton, *Opticks* (1690), I.i., Prop. II; John Locke, *An Essay Concerning Human Understanding* (1690), II.xi.17, ed. Alexander Campbell Fraser (New York: Dover Publications, 1959), 1:212.

18. As in *Benefit Ticket for Spiller, The Lottery, Harlot* 1, *Rake* 2, *March to Finchley,* etc.

19. See Paulson, *Hogarth's Graphic Works,* nos. 168–79, 185–90.

20. The 'chase' metaphor is from 'To the Reader' of *An Essay Concerning Human Understanding,* 7, 508. On Renaissance representations of rhetoric or eloquence as female, see Steadman, *The Hill and the Labyrinth.*

21. See, for example, John Donne, 'Third Satire', *Poetical Works,* ed. Herbert J. C. Grierson (Oxford: Clarendon Press, 1971), 139; Steadman, *The Hill and the Labyrinth,* 3–8.

22. Bacon, *Selected Writings,* 7–8.

23. John Milton, *Complete Poetry and Major Prose,* ed. Merritt Y. Hughes (New York: Odyssey Press, 1957), 245, 235, 237.

24. *The Craftsman,* 12 March 1736/7.

25. Paulson, *Hogarth's Graphic Works,* nos. 181, 215.

26. Ibid., nos. 191–92.

27. John Locke, *Second Treatise of Government* (1704), chap. 5; see Ronald Paulson, *Breaking and Remaking: Aesthetic Practice in England, 1700–1820* (New Brunswick: Rutgers University Press, 1989), chap. 6.

28. This motto was added in the final version of the *Beggar's Opera* paintings (in the Yale Center for British Art and the Tate Gallery).

29. Terry Eagleton, *Marxism and Literary Criticism* (Berkeley: University of California Press, 1976), 18.

30. This is a 'creative consumption' that could 'be posed as a way of explaining how people actually express their resistance, symbolically or otherwise, to everyday domination, by redefining the meanings of mass-produced objects and discourses in ways that go against the "dominant" messages in the text'. Andrew Ross, *No Respect: Intellectuals and Popular Culture* (New York: Routledge, 1989), 53.

'An Exquisite Practise':
The Institution of Drawing as a Polite Art in Britain

Ann Bermingham
For Peter Bicknell

The phrase, 'An Exquisite Practise', comes from the title of a seventeenth-century drawing manual by Henry Peacham. It is in the context of 'practise', broadly inflected to include both its social as well as artistic aspects, that I wish to situate the institution of drawing as a polite art in Britain. I will be arguing that this process depended on the formation of the figure of the amateur who, in addition to confirming his status as a gentleman through drawing, also embodied key ideals having to do with the making and function of art. Because they were widely shared, these ideals not only created a public for art but were internalised by professional artists in their struggle for social recognition and respectability.[1] Moreover, I wish to explore the political implications of amateur drawing's popular dissemination of the tools of visual representation by seeing this process in relation to the larger organisation of perception which characterised the formation of bourgeois culture in the eighteenth century and which sustained it in the nineteenth. I believe the institution of amateur drawing has importance for the study of 'a modern art world'; for if modernism, as both a stylistic and historical term that binds what otherwise would be disparate social phenomena, figures a shift in the relations and functions of power, then its particular techniques of signification must be examined in light of the way they both changed and unified the representational field.

Like linear perspective and the oil painting, the amateur is an invention of the Renaissance. In his *The Book of the Courtier* Castiglione recommended that courtiers have 'cunning in drawing, and the knowledge in the verie arte of painting'.[2] Translated into the English by Sir Thomas Hoby in 1561, *The Book of the Courtier* was widely read and helped to shape courtly life under Elizabeth and the Stuarts. In the sixteenth century drawing was the practice of artisans not gentlemen. For this reason the courtier, Count Lewies, must justify his recommendation. 'And wonder ye not', he tells his audience,

> if I wish this feate in him, which now adayes perhapps is counted an handicraft and full litle to become a gentleman, so I remember I have reade that the men of olde time, and especially in all Greece, would have gentlemens children in the scholes apply [study] painting, as a matter both honest [honourable] and necessarie. And this was received in the first degree of liberal artes, afterwards openly enacted not to bee taught to servants and bondsmen.[3]

The ancients' appreciation of drawing and painting as liberal arts was, alone, not enough to elevate their status in the sixteenth century. In order to remove the stigma against them it was necessary to separate drawing and painting from any taint of handicraft. Thus, in contrasting painting with sculpture, the Count notes, 'painting appeareth and carving is'. Because, presumably, they do not depend on the physical work of carving and casting, the Count is able to declare painting and drawing to be the more 'noble' arts.

The Count's defence of drawing and painting comes after a discussion of music. Whereas music 'makes sweete the minds of men', drawing and painting are associated with the accumulation of knowledge. The Count declares the natural world to be a picture painted by the hand of God and that men who are capable of imitating it are worthy of praise, for such skill demonstrates their 'knowledge of many thinges'. He goes on to note that there are many 'Commodities, and especially in warre, to draw…Countries, Platformes, Rivers, Bridges, Castls, Holdes, Fortresses, and such other matters, the which though a man were able to keep in minde…yet he cannot shew them to others'. The Count's association of drawing with knowledge of nature and the waging of war recalls Leonardo's notebooks in which his careful delineations of the natural world coexist with drawings of grisly war machines. In this context of knowledge and domination, drawing may be associated with that other Renaissance art form, cartography, for, like the map, drawing imposed on nature an economy of information retention, circulation, and control.[4] In the Count's address drawing is implicitly associated with power and privilege, with nascent imperialism and the ancient art of making war, and, finally, with the modern impulse to abstract the natural world in order to better comprehend it through graphic signs.

A final thing to note is that unlike the courtly, performing arts of music, dancing and, to some extent, poetry, drawing was a singular pastime. Drawing was not an act of self-presentation, a means through which one could insinuate oneself into the rituals of court, but rather an act of insulation, a seeming retreat from the social realm into the private world of the self. Like the courtly art of diplomacy, it trained the courtier to observe discreetly and fostered an inwardness and a self-sufficiency that, in their most extreme form, rendered relations with others superfluous. In discussing the subjectivity of the courtier as it emerges in Renaissance prose and poetry, Stephen Greenblatt has remarked, 'The single self, the affirmation of wholeness or stoic apathy or quiet mind, is a rhetorical construct designed to enhance the speaker's power, allay his fear, disguise his need'.[5] As a social practice drawing signaled the subject's interiority and singularity. Like lyric poetry, drawing gave the private self a public face.

In poetry the single self in addition to being noble was indisputably male.

'The man's singleness', Greenblatt notes, 'is played off against the woman's doubleness—the fear that she embodies a destructive mutability, that she wears a mask, that she must not under any circumstances be trusted, that she inevitably repays love with betrayal'.[6] Drawing too produced a rhetoric of masculine singularity. Drawing, the Count tells his listeners, enables one to develop a true sense of beauty, in particular of feminine beauty, and for this reason it is to be especially valued. To illustrate his point the Count reminds his audience of the story of Apelles and Campaspe, the mistress of Alexander. Alexander, the Count says, believing that the painter Apelles received greater pleasure than he himself did in *looking* at Campaspe, 'determined to bestow her upon him, that [he] (in his mind) could know her more perfectly'.[7] As the story of Apelles and Alexander illustrates, the aesthetic detachment the practices of drawing and painting necessitate enables the masculine bearer of the gaze to desire a woman as an object of vision while, at the same time, in so desiring to maintain an emotional separation from her. The exchange of Campaspe between the conqueror and the artist represents a tribute on Alexander's part to a superior form of domination. Just as drawing is allied to the development of modern warfare and its 'commodities', so too, Castiglione suggests, it was at the service of another kind of warfare. As the objects of vision and the enemies of its operations, women, objectified now as 'beauty', become the site upon which a certain masculine terror of difference could be restaged and mastered as the gentlemanly art of drawing.

This is not to say that women are entirely excluded by Castiglione from the practice of drawing. In Book 3 Count Julian, in describing the female counterpart to the courtier, remarks, 'I will that this woman have a sight in letters, in musicke, in drawing, or painting, and skill in dauncing, and in devising sports and pastimes, accompanying with that discrete sober moode [modesty] and with the giving of a good opinion of herself'.[8] The admission of drawing into the sphere of sexual difference signaled by Count Julian's concern with discreet and sober feminine modesty turns the conversation among the courtiers to philosophical questions having to do with women's essence, their fitness to rule, and their behaviour in love. An explanation as to how drawing helps to form the gentlewoman is never forthcoming; instead drawing simply serves as one of the signs of gentility and proper feminine modesty. What the text is anxious to describe instead is the way these signs of femininity operate within the larger frame of masculine power and self-identification. Count Julian's defence of women as able and virtuous becomes an exemplary exercise of proper masculine courtly respect for a particular ideal of the feminine. From these passages one must conclude that as a signifying practice drawing has two registers, masculinity and femininity. Rather than function as a sign of selfhood, drawing for women—by signifying a masculine ideal of the

feminine—becomes instead an expression of women's lack of self. Put another way, when practised by women, drawing facilitates their conformity to a representation of the feminine which signifies male desire.

I have dwelled on Castiglione's discussion of drawing in order to isolate certain themes that I believe have relevance for the institution of drawing in the eighteenth century. They may be summarised as: first, an elevation of drawing to the status of a liberal art based on its removal from the sphere of manual labour and its attachment to intellectual pursuits through the illusionistic reduction of matter to visual signs; and secondly, the ability of drawing as a practice to produce and reinforce sexual difference in the terms of a certain courtly image of masculine essence which depended on an enactment of interiority and on the emotional detachment from the object of vision. Rather than functioning as a superficial personal embellishment, drawing emerges in Castiglione's account as a way to negotiate the politically sensitive and hazardous social and sexual spaces of the court.[9]

In 1631 Henry Peacham, a teacher of Latin and Greek, included in his etiquette book *The Complete Gentleman* a drawing manual entitled *The Gentleman's Exercise* (figs. 5, 6). Peacham's inclusion of this separate volume devoted to the visual arts suggests that by the early seventeenth century an understanding of art and the ability to draw and paint were popular signs of a gentleman. In his introduction to the second edition of *The Gentleman's Exercise* (1634), Peacham notes that the directions for drawing contained in his manual are:

> mine owne, not borrowed out of the shops, but the very same Nature acquainted me withall from a child, and such as in practise I have ever found most true. I may perhaps be snarled at by some few obscure Artizans, that affect their base private gaine before a generall commodity: but if any thing herein (Reader) shall content thee, I care not what the other say....[10]

In declaring his technique to derive from a natural quality of mind and not from the technical recipes that might be found in shops or acquired from the trade secrets of artisans, Peacham proposed to teach drawing in a way that differed from that used by men in commercial and professional occupations.

Given this, the subtitle of *The Gentleman's Exercise* is somewhat puzzling. It describes drawing as *'An Exquisite practise, as well for drawing all manner of Beasts in their true Portraitures: as also the making of all kinds of colours, to be used in Limning, Painting, Tricking, and Blazon of Coates...As also Serving for the necessary use and Generall benefit of divers Trades-men and Artificers, as namely Painters, Joyners, Free-Masons, Cutters, and Carvers, etc. for the farther gracing, beautifying, and garnishing of all their absolute and worthy pieces, either for Borders, Architects, or Columnes, etc.'* The social gap evident in the title of

THE
GENTLEMANS
EXERCISE.

OR,

An exquisite practise, as well for draw-
ing all manner of Beasts in their true Por-
traitures: as also the making of all kinds of colours,
*to be vsed in Limming, Painting, Tricking, and
Blazon of Coates, and Armes, with divers other most
delightfull and pleasurable obseruations, for all
young Gentlemen and others.*

As also

Serving for the necessary use and generall
benefit of diuers Tradef-men and Artificers, as
*namely Painters, Ioyners, Free-Masons, Cutters and
Carvers, &c. for the farther gracing, beautifying, and
garnishing of all their absolute and worthy pieces, ei-
ther for Borders, Architects, or Columnes, &c.*

By HENRY PEACHAM Master of Artes.

LONDON,
Printed for *I. M.* and are to bee sold by *Francis Constable*
at the signe of the Crane in *Pauls* Church-yard.
1 6 3 4.

fig. 5
Henry Peacham
Title page from *The Gentleman's Exercise,* 2nd edition
London, 1634

The Gentleman's Exercise, where the 'Exquisite practise' is addressed to both gentlemen and to 'divers Trades-men and Artificers', is striking and is not entirely bridged by the text. The book includes chapters on the history of drawing and painting which remark the high esteem in which they had been held by kings and men of learning from antiquity to the present day, as well as chapters on emblematic representations of traditional subjects like the nine muses or the months of the year. These chapters, all of which, by gesturing toward the classical past, underscore drawing and painting's claims to being liberal arts worthy of a gentleman, are cheek by jowl with other chapters which contain technical recipes for mixing colour and varnish meant to assist the professional artist and decorator.

Falling between these two socially determined extremes of fine art and specialised technique are the chapters that deal with drawing itself, which contain simple procedures for rendering objects, portraits, drapery, heraldic designs, and landscape as well as instructions on perspective and shading. They provide education in a subject whose basic procedures appear to fall outside the social distinctions drawn elsewhere between liberal art and technical skill. The actual techniques of drawing, as distinct from drawing's literary pretensions or industrial usefulness, become in Peacham's book transcendent 'universal' forms of knowledge.

In learning to draw, Peacham recommended beginning with geometric shapes—the square, the circle, the pyramid, the oval—'so that you may reduce many thousand bodies to these few general figures'.[11] His technique embodied a kind of abstract notational shorthand that reduced complex natural forms to generic geometric figures (fig. 6). His system presents us with a metaphysics of the visual, for it proposes that underlying the shifting and deceptive appearances of the surface there is a bedrock of unchanging ideal forms. Drawing meant that mentally one had to reduce the natural object to a geometric shape and then in sketching reconstruct the object in a more ideal form. Thus, in drawing, one exercised an intellectual mastery and scopic control—not of the rules of art, for there are virtually none in Peacham's manual—but of natural appearances. The emotionally detached, alienated vision implicit in Castiglione's account of drawing here finds its technology. However, for the reader of Peacham's manual, abstraction was not simply a means of distancing oneself from the object of vision but of intellectually reducing it to something easily grasped by the mind.

As John Barrell has reminded us, the ability to derive general ideas and principles from particular examples was taken as a sign not only of reason but of class and gender as well. For the ability to reason abstractly was believed in the seventeenth and eighteenth centuries to be limited to those who were financially secure enough to maintain a selfless detachment from the object of vision,[12] and this was an ability generally denied to the vulgar and to women.

Which Diameter with the croſſe line, are not onely
your directors, for the equall placing of the greater
and leſſer beames, on the ſide as you may perceive :
but alſo for the Drawing of the Noſe, Mouth and
Eyes, even in the midſt of the Face.

 I will give you another example of a Goblet or
cup. Firſt, I make a half or ſemicircle for the Bowle,
downe the midſt of which (as low as I would have
the foote to come) I draw my Diameter or ſtraight
line, which being done, the worſt is paſt : you muſt
now marke : I am not tyed to make my Bowle as
round as the circle, but long or what faſhion I liſt,
no other uſe hath the Circle there then to guide mee
even on either ſide, whether I make it broad or nar-
row, long or ſhort, emboſſe it, or howſoever, the o-
ther part of the line cauſeth mee to make the foote
even as you ſee.

<div align="right">Which</div>

fig. 6
Henry Peacham
Page from *The Gentleman's Exercise,* 2nd edition
London, 1634

While supporting this idea of reason, Peacham's manual also presupposes that the ability to reason abstractly was not necessarily a condition of birth. While in his introduction he assures the reader that the technique was his 'owne, not borrowed out of the shops, but the very same Nature acquainted me withall from a child', the rationale of the manual implies that if one did not have the good fortune to be born to this natural and superior way of seeing, one could acquire it at the cost of a book. Peacham's text responds to the reality of a multi-classed society rather than to the hermetic courtly world of Castiglione. This paradox as to whether the ability to draw like a gentleman was innate or learned, and by extension whether *being* a gentleman was a consequence of birth or education, is unconsciously posed but not resolved by the text. What is clear, however, is that, by allying the practice of drawing to codes of gentility, Peacham like Castiglione made it irredeemably amateur. Becoming a gentleman meant becoming an amateur, and amateurism became the sign of the gentleman.

The eighteenth-century gentleman owed his existence to the formation of a nation state from a capitalist commercial economy which eroded the feudal foundations of power and instituted in their place a comprehensive yet highly individuated social sphere of 'polite society'. Comprised of coffee houses, newspapers, journals, novels, and lending libraries, polite society was situated between the state and civil society. Habermas has termed it the 'bourgeois public sphere' and has characterised it as a body of genteel, informed public opinion which legitimated its natural rights to social and political power through a shared discourse of universal reason.[13] Through the development of a print culture the bourgeoisie created and consolidated their social position. Men like Addison and Steele directed their writings at a public who lived in cities and towns and who derived their fortunes from them. The publication and success of Richardson's *Pamela* in 1740 is usually taken to be the sign of the collective formation of an urbane public that delighted in literary forms of psychological narrative and domestic drama and which mediated their own life experiences through them. In Habermas's phrase it was a public 'passionately concerned with itself'.[14] Its members sought the enlightenment of their social and private lives in the representations they created and consumed in novels, plays, and leisure activities like drawing. I wish to argue that it was largely within this public sphere of books and writing, rather than through the activities of professional artists, that drawing came to be institutionalised as a practice of middle-class life.

Like Peacham, John Locke also associated drawing with universal reason. Locke is important to the institution of amateur drawing for two reasons: first, for his notion that ideas are pictures; and secondly, for his equation of drawing

with writing. In the well known passage from Book II of his *Essay Concerning Human Understanding* (1690), Locke compared the human mind to 'a white paper void of all characters without any ideas' on which fancy paints her 'vast store'.[15] Further on, he likens the understanding to a camera obscura which 'let in external visible resemblances, or ideas of things without', declaring that 'would the pictures coming into such a dark room but stay there and lie so orderly as to be found upon occasion, it would very much resemble the understanding of a man in reference to all objects of sight and the ideas of them'.[16] Locke's visual analogies and metaphors are important, for not only do they associate knowledge with the mind's ability to picture but, like Peacham's system of abstraction, they link the thought process—that is, recording of images/ideas in the mind and the mind's reflection on them—with the artistic processes and instruments of drawing.

Even more significant, however, is his observation in Book III that pictures are clearer in their meaning than words and his proposal

> that words standing for things which are known and distinguished by their outward shapes should be expressed by little draughts and prints made of them. A vocabulary made after this fashion would perhaps, with more ease and in less time, teach the true signification of many terms…and settle truer ideas in men's minds of several things…than all the large and laborious comments of learned critics.[17]

Developing this idea further, Locke recommended in his *Thoughts on Education* (1693) that, after learning to read English, the child should be taught writing and then 'exercise his hand further' in drawing:

> a thing very useful to a gentleman on several occasions, but especially if he travel, as that which helps a man often to express, in a few lines well put together, what a whole sheet of paper in writing would not be able to represent and make intelligible. How many buildings may a man see, how many machines and habits meet with, the ideas where of would be easily retained and communicated by a little skill in drawing; which being committed to words, are in danger to be lost, or at best but ill retained in the most exact descriptions.[18]

In Locke's eyes drawing's capacity to exceed the descriptive power of writing made it an ideal form of writing, a kind of figurative shorthand able to amplify, clarify, and express all that writing could not.[19]

In evaluating drawing in this way, he echoes the thoughts of Castiglione who recommended drawing as a means to communicate ideas visually. One finds similar opinions expressed in eighteenth-century amateur drawing manuals. *The Draughtsmen's Assistant* (1795) claimed, 'Drawing is a kind of universal language that speaks to the Eye, and conveys Ideas understood by every

Nation and people on the Globe'.[20] It is worth noting that drawing and visual images had not always been thought of in this way. In 1685 William Aglionby in his three dialogues on painting declared, 'Pictures have that singular Privilige that, though they seem Legible Books, yet they are Perfeck Hiero-glyphicks to the Vulgar, and are all alike to them'.[21] For Aglionby, anxious to elevate the visual arts, decoding pictures was deemed a skill possessed only by the learned. However, from Locke onwards drawing was largely seen to erase the cultural differences language and writing imposed. In their place it prom-ised a kind of visual esperanto which could transcend nationality and unite all men of reason. As a universal and essentialist kind of writing, the practice of drawing was able to lay claims to the social space mapped out earlier in the eighteenth century by writing, and in doing so it subscribed to the optimism of bourgeois culture which sought to project itself and its institutions as 'uni-versal' and 'natural'.

The kinds of reforms that Locke desired to see introduced into education were those that would train the young man in the ways of reason and would adjust him to the modern demands of a growing commercial society. In Locke's opinion drawing could maintain a public role only as long as it func-tioned as a form of writing subordinate to the task of describing the natural world. 'I do not mean', he cautions, 'that I would have your son be a perfect painter; to be that to any tolerable degree, will require more time than a young gentleman can spare from his other improvements of greater moment'.[22] Thus if one spent too much time acquiring the knack of drawing or pursued it exclusively, it would cease to be a useful skill and become merely a useless art. The danger of drawing practised as an art was that it would enervate young men, making them indifferent to public life. Drawing's utility therefore depended on its ability to supplement writing. As a supplement to writing amateur drawing participated in a commercial system of value; placed at the service of commerce, it became a practical skill suitable to the businessman or soldier and basic to the exchange and circulation of knowledge and informa-tion. In this capacity as an efficient, visual form of writing universally under-stood, drawing was introduced in the early 1700s into the curricula of the government and privately-run naval and military academies.[23]

In the eighteenth century drawing's public utilitarian function came to be complemented by a private moral one. In his *Essays on the Pleasures of the Imagination* Addison designated the acquisition of knowledge of the fine arts as one of the leisure activities worthy of a gentleman. The point of the essays was to draw attention to those pleasures that were becoming to a gentleman who, thanks to his commercial and manufacturing activities, had the money and leisure time to pursue them. Pleasuring the imagination was, Addison realised, the most efficient way to police it. 'There are, indeed', he wrote, but very few who know how to be idle and innocent, or have a relish of any

pleasures that are not criminal; every diversion they take is at the expense of some virtue or another, and their very first step out of business is into vice or folly'.[24] In its Addisonian capacity as an improving leisure activity, drawing promised its practitioners not only the development of reason but of moral sensibility. Throughout the eighteenth century drawing is often described as a mode of moral self-improvement. William Gilpin, for instance, in a dialogue on the *Education of Young Gentlemen,* recommended drawing as a way to contain and redirect young men's high spirits.[25] Clearly drawing was seen to have a civilising effect that would ultimately benefit society at large by preventing young men from squandering their fortunes and their health in less wholesome activities.

Thus by the end of the first quarter of the eighteenth century, the practice of amateur drawing as a sign of gentility was no longer fixed and restricted to courtly life. Because it required no special equipment other than the implements of writing and because, like writing, it was a graphic transcription of the natural world, drawing, more so than painting or music, was more immediately responsive to the utilitarian demands of an expanding commercial economy. The popularisation of drawing as a social practice represents a fundamental reorganisation of the subject, for it constructs one whose social mobility was the precondition for a society where, as Jonathan Crary has noted, 'sign value took precedence over use value',[26] and where images and spectacles continually threatened to supplant literacy as the common glue holding together a diverse social fabric.

Drawing entered the new public sphere of writing and commerce through the amateur drawing manual. The middle-class character of the drawing manual almost goes without saying. With their modest prices and promises of being able to take the place of a costly drawing master, they were intended for an audience that valued economy as much as it valued knowledge. Many of these drawing books were published in 'numbers' or 'series' and issued in monthly or yearly instalments which sold at modest prices, thus placing them within the financial range of even some of the lower classes. The large number of these books published in the eighteenth century indicates an extensive market for them. Within this market drawing manuals entertained two rather contradictory ideas: first, that drawing was a useful and universal form of knowledge and second, that this knowledge was somehow privileged. Manuals sold knowledge of drawing by suggesting that what they were selling was privilege, that is, a kind of knowledge that had been restricted in its circulation, one—as so many drawing manuals like to claim—that was 'heretofore unavailable in books' or available, that is, only to a select few—the very rich, the very fashionable, the already very knowledgeable. Manuals defined their pedagogical role in terms of democratic dissemination and social and economic self-improvement. In so doing drawing manuals differed in a subtle but significant

way from the Lockeian perspective with regard to drawing's utility. Drawing was useful, they argued, not just because it was a universal kind of writing and therefore enabled one to amass ideas and communicate them to the world, but because it was a form of knowledge that carried with it an aura of social privilege. Thus amateur manuals bridge the public sphere of writing and commerce and the private sphere of individual moral and social self-improvement. In this respect drawing manuals reflect the larger commercial invasion and restructuring of leisure and private life as 'markets'.

In both creating and responding to an increasingly diversified audience, drawing manuals at the end of the eighteenth century began to specialise their subject. There were manuals devoted to landscape, to drawing the human figure, to drawing animals, to perspective and flower painting, and which rank subject matter not according to academic hierarchy but rather in terms of characteristics like 'difficulty', 'novelty', and 'picturesqueness'. Abandoning the standard techniques of drawing, authors of drawing manuals now began to experiment with new, individualised methods of teaching. As this suggests, manuals addressed a public that increasingly saw itself not so much in terms of static social roles (as it had in Peacham's day) but in terms of a fluid commercial society of individuals whose private lives were structured by uniquely personalised domestic interests and gender relations. Drawing was no longer posited as simply a universal system of abstract reasoning but increasingly as a variety of systems of classification which, in celebrating the individuality of the subject and subject matter, divided and fragmented the representational field. By the end of the eighteenth century amateur drawing had become a lucrative trade. Men like Rudolph Ackermann made their fortunes in publishing manuals and prints and supplying paper, paint, and 'all necessary and sundry articles' to amateurs eager to ply their skill. Moreover, as a print from the early nineteenth century showing the interior of Ackermann's Repository of the Arts suggests, the public for amateur drawing was becoming female, a result in part of the growing tendency to associate drawing with the private sphere of morally improving, leisure activities (fig. 7).

The drawing manual not only taught the amateur how to draw but presumably also how to distinguish good drawing from bad and in a larger sense how to appreciate the artistry of others. Thus, in addition to serving the needs of booksellers, art suppliers, and drawing masters, amateur drawing also can be said to have served the needs of professional artists who, in working for an open market of dealers and annual exhibitions, now depended on an educated art public. In many cases the link between the professional artist and the amateur market was direct; artists like Paul Sandby, Alexander Cozens, Thomas Malton, and later David Cox, John Sell Cotman, and John Varley, for instance, produced drawings to be copied by amateurs and often supplemented their meagre incomes with lessons in drawing. The symbiotic relationship that

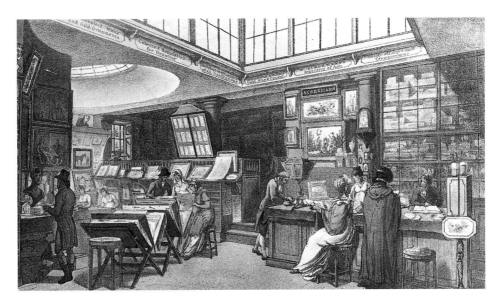

fig. 7
Anonymous
Ackermann's Repository of the Arts, 101 Strand, 1809
Etching and aquatint with transparent watercolour
5¼ x 8⅞ in. (13.3 x 22.5 cm.)

grew among professional artists, tradesmen, and amateurs may explain why, unlike many literary figures who directly attributed the decline in literature to the growing mass audience and the popular writing it consumed, professional artists for the most part did not seem particularly threatened by the amateur practice of art or the industry which propagated it.

Thus, by the beginning of the nineteenth century one finds in Britain a loosely structured, widely disseminated amateur art culture that had tangible ties to both the professional world of artists and the commercial world of tradesmen. As he emerges in the texts and practices of drawing, the amateur gentleman with his education, income, confidence, and disinterested love of beauty matched by the talent and means to indulge it was not only a familiar figure in the eighteenth century but, more significantly, a model for professional artists to emulate. The institution of the visual arts as modes of politeness in eighteenth-century Britain was mediated largely through this figure of the amateur draughtsman and resulted in a modern conception of professional artistic practice characterised by masculine privilege and by the effacement of labour and economic conditions necessary to the production of art. Apropos the development of this image of the artist, it is worth noting that one of the most important functions of the Royal Academy was a social one, that is, it provided artists with an elegant and urbane setting—not unlike a gentleman's club—in which they could entertain patrons and repay in kind the hospitality of the gentry and nobility who supported the arts.[27] It is in the attitudes developed around amateur drawing in the eighteenth century that one can trace the formation of this process of professionalisation conceived as gentrification and, I would like to suggest, that it is in the life and career of Sir Joshua Reynolds that one sees the results of these attitudes epitomised.

Reynolds's character and career may be read as an example of the formulation of the term 'artist' according to the terms that had already been established for 'amateur'. Reynolds is a key figure in what we might call the gentrification of artists and the practice of art in Georgian England.[28] His years in Rome and enthusiasm for the antique entitled him to become a member of the Society of Dilettanti, and his elevation to the Presidency of the Royal Academy, followed by his knighthood and the bestowal of the title of Doctor of Civil Law from Oxford University, represented the acme of all that professional artists, to say nothing of gentlemen, could aspire to. The example of his life as much as his art was an inspiration for generations of artists that followed him. He combined in his person and his art erudition, reason, decorum, detachment, urbanity, and *sprezzatura*—attributes associated with the ideal of the gentleman amateur as far back as Castiglione. Unlike James Barry, who found himself bitterly alienated by the disparity between his high artistic ideals and the taste of contemporary society for fashionable portraits and who expressed his rage in what were perceived to be boorish attacks on the

reputations of his colleagues, Reynolds appears to have been at home with a genre and a public that valued gentility and wit and with whom he could take his gentlemanly ease.

Given the masculine and public nature of amateur drawing in the eighteenth century, the relationship of women to this practice was necessarily ambiguous. Most often drawing for women was placed at the service of domestic amusement and decoration. For instance, manuals addressed to women like *The Whole Art of Painting in Water-Colours, on Glass, China, Velvet, etc.* (London, 1782) explain how to manage a number of non-traditional painting surfaces most likely encountered in domestic decoration. Drawing was believed to be an improving activity for women as well, particularly useful in disciplining the feminine mind. One thinks of Eleanor Dashwood's drawing habits in *Sense and Sensibility* as an indication of her serious nature or, on the other hand, of Emma Woodhouse's unfinished sketches as an index of her overactive imagination. As the examples of Jane Austen's heroines suggest, feminine modes of representation were deemed best when, as she said about her own work, they were narrowly focused on simple, concrete, familiar things and worked in miniature on a tiny bit of ivory.

For the most part drawing for women was viewed as an 'accomplishment', that is, as something that made a woman desirable because it fulfilled a certain cultural ideal of the feminine. Unlike music and dancing, drawing was a sedentary occupation and not an occasion for ostentatious display. By and large it was performed privately; its triumphs were tucked away in folios while its disasters could be quietly disposed of in the waste basket. While it is dangerous to generalise, it can be noted that often in the discourse on drawing women emerge as copyists. Two drawings by Paul Sandby illustrate this. In the one a young woman copies in watercolour a drawing which is pinned vertically on a board in front of her (fig. 8), and in the other Lady Frances Scott traces a landscape with the help of a camera obscura (fig. 9). Such procedures and visual aids were no doubt deemed necessary for women who by nature were believed to lack the masculine ability to abstract. The prevalence of this view may account for why, by the end of the first quarter of the nineteenth century, manuals proposing to teach women to draw were often little more than colouring books, combining instructions for mixing various pigments with outline drawings to be painted in. Like the artisan who in the industrial setting of the nineteenth century was increasingly relegated to executing the designs of the professional artist or designer, women were perceived as vehicles for the maintenance and transmission of culture in the form of decorating, colouring, tracing, and copying the work of others but were not thought of as creators of culture.

The growth in the number of women amateurs and of a market that supplied them with manuals to follow, prints and papier-mâché objects to

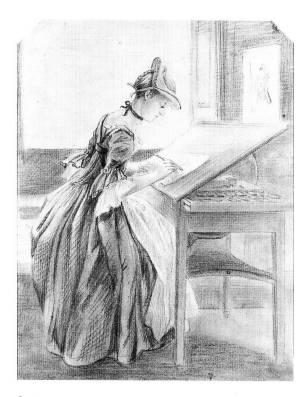

fig. 8
Paul Sandby
A Lady Copying at a Drawing Table, c. 1760–70
Pencil, red and black chalk and stump, 7¾ x 6 in. (19.6 x 15.3 cm.)
Yale Center for British Art, Paul Mellon Collection

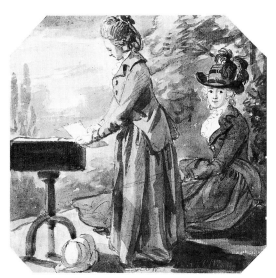

fig. 9
Paul Sandby
Lady Frances Scott and Lady Elliott, c. 1780
Watercolour over pencil, 5 x 5⅟₁₆ in. (12.7 x 13 cm.)
Yale Center for British Art, Paul Mellon Collection

paint, and drawings to trace and copy helped, no doubt, to cast a negative connotation on the notion of artistic amateurism. Just as men deserted flower painting in the early nineteenth century when it became associated with femininity,[29] so too by the middle of the nineteenth century amateur drawing was increasingly resigned to women. Yet insofar as we can identify the visuality of nineteenth-century culture as 'modern', the role of women as reproducers and disseminators of visual signs is significant.[30] The entrance of women into the sphere of art and amateur drawing in large numbers signals an important shift in the visual culture of the early nineteenth century from the use of images to create a class ideology to their use in sustaining it.

Contributing to the gradual femininisation of amateur practice was the success of Reynolds and the Royal Academy to professionalise the practice of art; eventually such a process not only tended to discount amateur practice but also threatened the political consensus of the bourgeois public sphere that it represented. As if in anticipation of this ideological difficulty, John Gwynn, in arguing for the institution of a public academy in Britain to rival the Royal Academy of France, noted in 1755:

> Drawing is mechanical, and may therefore be taught, in some Measure, to any Person of Moderate Talents, who applies sufficiently to the Practise of it: but Design is the Child of Genius, and cannot be wholly infused: The Principles of it must exist in the Soul, and can be called forth only by Education, and improved by Practise.[31]

Gwynn's argument preserved drawing's universality but only by reducing drawing to a simple mechanical skill. To Gwynn's mind, genius differentiates the professional artist from the amateur, and the professional artist becomes the superior representative of the public sphere, one able to speak for it more eloquently. While dismissing amateur practice, professional artists nevertheless continued to model themselves after the gentleman amateur. While it is often a matter of discussion among art historians as to why England did not develop an avant-garde culture in the nineteenth century, the history of amateur art practice suggests that the identification of the professional artist with the bourgeois gentleman was too complete and the cultural fabric that it created too socially stable to permit the kind of radical anti-bourgeois alienation of artists that one finds in France at mid-century.

In conclusion, I would suggest that as a process of social formation, the eighteenth-century origin of British modernism is of interest to us who, in the late twentieth century, have witnessed the conclusion of the economic and social revolutions that accompanied the emergence of bourgeois culture and at a time when advertising, the media, and the self-help book have replaced drawing and the novel as forms of popular self-discovery. In such a climate the drawing manual and the attitudes and practices that surrounded amateur

drawing take on a new and timely interest, for they suggest a history for our own addiction to images and to technologies of subjectivity. In decrying his century's craze for popular novels and manuals, Matthew Arnold sniffed, 'culture works differently'.[32] What Arnold meant by 'culture' was obviously something different from what he saw around him; yet, as is clear to us today, what he saw around him was culture—and more different than he knew.

My study of amateur drawing is indebted to Peter Bicknell, whose knowledge of amateur drawing manuals is extensive and whose willingness to share it has been unfailingly generous.

1. An important study of the social role of painting is Iain Pears, *The Discovery of Painting: The Growth of Interest in the Arts in England, 1680–1768* (New Haven and London: Yale University Press, 1988). Pears's account of the growing professionalism of the artist in the seventeenth and eighteenth centuries coincides at many points with my own. On the topic of the developing art market in London in the first half of the eighteenth century, see Louise Lippincott, *Selling Art in Georgian London: The Rise of Arthur Pond* (New Haven and London: Yale University Press, 1983). Pioneering studies of the practice of amateur drawing in Britain include: Peter Bicknell and Jane Munro, *Gilpin to Ruskin: Drawing Masters and Their Manuals, 1800–1860* (Cambridge: Fitzwilliam Museum, 1988); Michael Clark, *The Tempting Prospect: A Social History of English Watercolours* (London: British Museum Publications, 1981); Joan Friedman, 'Every Lady Her Own Drawing Master', *Apollo* (April 1977): 262–67; Francina Irwin, 'Lady Amateurs and Their Masters in Scott's Edinburgh', *Connoisseur* (December 1974): 230–37; John Krill, *English Artists Paper: Renaissance to Regency* (London: Trefoil, 1987); Kim Sloan, 'Drawing—A "Polite Recreation" in Eighteenth-Century England', *Studies in Eighteenth Century Culture* 2 (1982): 217–39; Ian Fleming-Williams in Martin Hardie's *Water-colour Painting in Britain* (London: B. T. Batsford, 1968), 3:212–81; Iolo Williams, *Early English Watercolours* (London: Connoisseur, 1952), as well as several booksellers' catalogues published by Ken Spelman of Micklegate, York.
2. Baldassare Castiglione, *The Book of the Courtier,* trans. Sir Thomas Hoby (London: Dent; New York: Dutton, 1974), 77.
3. Ibid.
4. In this context one might note that Paul Sandby's mapping of Britain following the Jacobite revolt of 1745 is a later but no less natural confluence of war, cartography, and the development of drawing. On maps see J. B. Harley, 'Maps, Knowledge, Power', in Denis Cosgrove and Stephen Daniels, eds., *The Iconography of Landscape: Essays on the Symbolic Representation, Design and Use of Past Environments* (Cambridge: Cambridge University Press, 1988), 277–312.
5. Stephen Greenblatt, *Renaissance Self-Fashioning: From More to Shakespeare* (Chicago: University of Chicago Press, 1980), 147.
6. Ibid., 149.
7. Castiglione, 82.
8. Ibid., 195.

9. This Renaissance formation of the individual subject (who, as Luce Irigaray claims, has always been appropriated by the 'masculine') was inscribed in the techniques of drawing; in particular one thinks of innovation of linear perspective, which in orienting the picture around an ideal and individual vantage point suggests in Svetlana Alper's terms 'a commanding attitude toward the possession of the world'. See 'Art History and Its Exclusions: The Case of Dutch Painting', in Norma Broude and Mary D. Garrard, eds., *Feminism and Art History: Questioning the Litany* (New York: Harper and Row, 1982), 201–20.

10. Henry Peacham, *The Gentleman's Exercise,* 2nd ed. (London, 1634), n.p.

11. Ibid., 17. For forms of mixed or uncertain shape 'where your circle or square will do you no good', Peacham recommended, 'having the general notion or shape of the thing in your mind you mean to draw…draw it with your lead or coal after your own fashion…the next day, peruse it well, bethinke your selfe where you have erred, and mend it according to that Idea you carry in your mind'. Later teachers such as William Salmon would recommend that the draughtsman compare his final drawing to a good print in order to judge his skill at forming general ideas and representing them. See William Salmon, *Polygraphice: or the Art of Drawing, Engraving, Etching, Limning, Painting, Washing, Varnishing, Colouring and Dying* (London, 1672), p. 10.

12. See John Barrell, *English Literature in History, 1730–80: An Equal, Wide Survey* (London: Hutchinson, 1983), 38, and *The Political Theory of Painting from Reynolds to Hazlitt: 'The Body of the Public'* (New Haven and London: Yale University Press, 1986). See also Raymond Williams, *Culture and Society, 1780–1950* (Harmondsworth: Penguin Books, 1961), 52–56.

13. Jürgen Habermas, *The Structural Transformation of the Public Sphere: An Inquiry into a Category of Bourgeois Society,* trans. Thomas Burger with the assistance of Frederick Lawrence (Cambridge: MIT Press, 1989), 27–43.

14. Ibid., 42.

15. John Locke, *An Essay Concerning Human Understanding,* ed. John W. Yolton (London: J. M. Dent and Sons, 1961), II.i.2, 33.

16. Ibid., II.xi.17, 76.

17. Ibid., III.xi.25, 265–66.

18. John Locke, *Some Thoughts Concerning Education,* ed. Peter Gay, Classics in Education Series (New York: Columbia University, 1964), 118.

19. Joseph Priestly and Charles Davy believed that drawing preceded alphabetic writing and that the earliest form of writing was hieroglyphics—Roy Harris, *The Origins of Writing* (London: Duckworth, 1986). The persistence of Locke's idea that drawing was a universal form of writing accounts for the fact that in the following century both Diderot and Rousseau included drawing in their model curricula. Moreover, the *Encyclopédie* (1751–65) of Diderot and D'Alembert takes for granted Locke's notions about the efficacy of illustrating ideas with pictures. The *Encyclopédie* contained over three thousand illustrations of various industries. The illustrations, perhaps even more so than the text, are an important record of eighteenth-century technology, a technology that was already in the process of being transformed by the industrial revolution. For the importance of Locke's ideas for Diderot see Robert L. Cru, *Diderot as a Disciple of English Thought* (New York: AMS, 1966), 269.

20. Carrington Bowles, *The Draughtsmen's Assistant* (London, 1795), 1.

21. William Aglionby, *Painting Illustrated in three Diallogues; containing some choise Observations upon the Art; together with the Lives of the most eminent Painters from Cimabue to the Time of Raphael and Michael Angelo* (London, 1685), and quoted by Pears, *The Discovery of Painting*, n.p.

22. Locke, *Some Thoughts Concerning Education*, 118.

23. As Kim Sloan has described it, the curriculum in the military academies emphasised perspective and topography. Bernard Lens's *A New and Complete Drawing Book* (1751), used by trade and naval students at Christ's Hospital, included landscapes obviously intended as models of military draughtsmanship. In his introduction Lens echoed both Peacham and Locke's idea that drawing is a skill useful to men of all walks of life. 'There is scarce any Art or Profession which receives not some Assistance from Drawing', he wrote, 'without her Help, no Designs or Models can be well executed; to her the Mathematician, Architect and Navigator is continually indebted; no station of life is exempted from the Practise of it, from the General at the Head of an Army, to the Mechanic, who subsists by his handicraft'—Bernard Lens, *A New and Complete Drawing Book* (London, 1751), 1.

24. Joseph Addison, *The Works of Addison*, ed. Richard Hurd (New York, 1856), selections from *The Spectator*, no. 411 (June 21, 1712), 6:325.

25. William Gilpin, *Dialogues on Various Subjects* (London, 1807), 385.

26. Jonathan Crary, 'Spectacle, Attention, Counter-Memory', *October* 50 (Fall 1989): 99.

27. Hardie, *Water-colour Painting in Britain*, 3:249. Iain Pears has observed that the formation of the Academy paralleled the formation of other professional organisations for middle-class occupations such as medicine, law, and education (Pears, 109–11).

28. On Reynolds's income, style of life, and polite pretensions see Marcia Pointon, 'Portrait Painting as a Business Enterprise in London in the 1780s', *Art History* 7, no. 2 (1984): 178–205. See too Pears (109) who sees Reynolds's achievement of distinction as a gentleman and a painter to be the exception for artists rather than the rule.

29. See Rozsika Parker and Griselda Pollock, *Old Mistresses: Women, Art, and Ideology* (New York: Pantheon Books, 1981), 50–58.

30. As reproducers of signs that were the signs of signs, women amateurs hastened and helped conclude the erosion of semiotic exclusiveness that had characterised the use of the sign before the Renaissance and which had been destabilised by the emergence of a social class that demanded a more flexible system of signification organised around appearances in order to establish its cultural hegemony. See Jean Baudrillard, *La société de consommation: ses mythes, ses structures* (Paris, 1970), 60, as discussed by Crary, 'Spectacle, Attention, Counter-Memory,' 98)

31. John Gwynn, *An Essay on Design: Including Proposals for Erecting a Public Academy To be Supported by Voluntary Subscription…for Educating the British Youth in Drawing and the several ARTS depending thereon* (London, 1755).

32. Matthew Arnold, *Culture and Anarchy*, ed. Ian Gregor (Indianapolis, 1971), 56. Quoted in Leo Lowenthal, *Literature, Popular Culture, and Society* (Palo Alto, California: Pacific Books, 1968), 97.

Doubting Visionaries:
Thomson, Barry, and the Future of the Arts

Marilyn Butler

My subject today is a topic very significant in the English arts, in literature as in painting, in the four decades preceding the French Revolution. The topic is the promise or threat of human progress and its implications for art. The social optimism generated in the late eighteenth-century by the Enlightenment and revived in the early twentieth by the Russian Revolution has had to take some hard knocks since the Second World War, not least in the bicentennial year of the Fall of the Bastille, when the concept of revolution seemed to undo itself in Tiananmen and Wenceslas squares. But 'progress', in the sense in which it appears in the late eighteenth-century creative works, could hardly be the same concept as the totalised and systematised 'progressivism' underlying the state tyrannies of Stalin and Mao.

On the contrary, progress figures in eighteenth-century arts as anything but a powerful and monstrous reality. When artists enlist in its cause, they do so anxiously, even guiltily, with many a lingering look behind. It is interesting to compare two characteristically troubled glimpses of futurity in two different art forms: James Thomson's Spenserian poem, *The Castle of Indolence* (1748), and James Barry's series of six paintings, *The Progress of Human Knowledge,* in the Great Room of the Society of Arts in the Adelphi, London. Barry may have known Thomson's poem, since he did know of Thomson. The possibility that one of my artists influenced the other does not directly concern me: I wish to explore what each makes of a similar topic, the transition from an aristocratic to a commercial or bourgeois society.

The two cantos of Thomson's poem, each about eighty stanzas long, straddle an imaginary revolution which takes place in a stylised but recognisable eighteenth-century Britain. Most of the poem's leading protagonists are poets, but the arts in general play a large part in its imaging of the pre-revolutionary world. Thomson gives most attention to the visual arts—to landscape painting, landscape gardening, architecture, interior decoration, and what can only be called lifestyle. The poem imagines what happens after the violent destruction of an aristocratic order, in which the possession of lovely things has been the outward sign of inherited wealth and of personal distinction; what kind of world it will be when (in Canto II) it is ruled by a seemingly philistine and iconoclastic middle-class order, for whom art means those 'arts' which are useful, technological, and wealth-creating. The first and second of Barry's paintings also portray a primitive 'Before', the third, fourth and fifth an advanced

order, 'After' a crucial transformation in human affairs. Barry doesn't bring to the surface the same anxious forebodings as Thomson does, but his series is not free of them. This is the type of insight I hope to explore by reading the two works together.

Another reason for comparing Thomson and Barry is that they are similarly and perhaps representatively placed within English culture. Thomson is a Scots immigrant, Barry an Irish one; both got crucial support and patronage from compatriots in London, Thomson from a group or clique of London-Scots writers and from his generous and foresighted Scottish publisher, Andrew Millar; Barry from his fellow Irishman, Burke. In the works we are now concerned with, each aligns himself strongly and publicly with the 'commercial interest'. Thomson's revolutionary hero in Canto II is a newcomer riding in from the West called the Knight of Arts and Industry; Barry at his own expense spends six years adorning the council chamber of that informal research institute and ginger-group for the agrarian and industrial revolution, the Society of Arts, Manufactures and Commerce. Though the Society was not founded until 1754, six years after Thomson's death in the same year as *Castle of Indolence,* Thomson especially in his last decade was a promoter of the same 'interest'. This readily appears in the lyric he and his Scots friend David Mallet composed for the finale of the masque *Alfred* in 1740. 'Rule, Britannia!', as it became known, filled the role of a national anthem throughout the remainder of the century, not for the nation as centred in London and expressed institutionally as the state, but for that interestingly different possibility, the so-called 'patriot nation'. Thomson seems to have thought of the nation primarily in terms of provincial opinion in the fastest-developing regions, which were those with outlets through Bristol, Liverpool, and Glasgow to the Americas. Hence the strongly angled view in the song of what being British in practice amounts to:

> To thee belongs the rural reign;
> Thy cities shall with commerce shine;
> All thine shall be the subject main,
> And every shore it circles thine.

The verses call for economic, not military, expansionism: it is not people Thomson proposes to rule but trade routes. The thumbnail sketch of British life given in 'Rule, Britannia!' evokes the provinces and their growing commercial centres; it makes no reference to the king and to parliament, the twin pillars of the state's authority, nor indeed to London, where both are located.

Finally, I am using Thomson because John Barrell has recently made much of him, in *English Literature and Its Background* (1983) and in *Poetry, Language and Politics* (1988). As the best-known British critic working in this period with both literary and artistic materials, Barrell has had influence on how

eighteenth-century culture is currently perceived. Plainly he and I agree in finding Thomson a crucial, perhaps the crucial, writer for the transitional period following the Augustans; but I believe we do not agree why or how, and we are not using the same poems. Barrell concentrates on *The Seasons,* Thomson's first English poem, which was substantially written between 1725 and 1730, and for which Thomson sought aristocratic patrons in the then conventional manner. I am equally or more interested in his work after 1735, when his income came essentially from the sale of his work to his publisher or to the commercial theatre, and when the ideological alignment of the poetry seems more decisively with the commercial interest.

In estimating Barrell's contribution, we have to locate his work in the British-Marxist tradition of the literary critic Raymond Williams. This is a tradition historical in that it seeks to explore past culture, but rather paradoxically committed at the same time to the method of close critical reading developed by F. R. Leavis, William Empson, and others in pre-war Cambridge. I call this paradoxical because in practice it can rely too much on the close examination of a few carefully selected passages, to the exclusion of matters other historicists might want to devote time to, such as authors' social relations, their literary relations with others using the same discourse, and the material circumstances of literary production, distribution, and reception. In Barrell's analysis the eighteenth-century topographical or landscape poet stands on rising ground surveying the view. His strategic position is too easily equated with that of the landscape painters and much too easily subsumed in that of the landed proprietor: poet and painter seem committed, unvaryingly, to a similar trope of dominance, and it is a trope expressing not their own social position but that of their patron(s). In order to sustain Barrell's interpretation, we would surely have to reconcile it with the facts of Thomson's career and with Thomson's own analysis of his cultural position in the strangest and profoundest of his poems, *The Castle of Indolence.*

In a brief opening Advertisement, Thomson warns us that this 'Allegorical Poem' is 'writ in the Manner of Spenser', so that it uses 'obsolete Words, and a Simplicity of Diction in some of the Lines which borders on the Ludicrous'. A self-consciously homely, unpolished idiom will separate the narration from its topic—high art. Thomson slily justifies this technique by citing a sophisticated precedent. At the court of Louis XIV, he says, poets in political opposition invoked the style of Marot, a writer of the early sixteenth-century court of Francis I. Sometimes, then, a real challenge to the status quo might appear cloaked in a traditional disguise; regression could signal aggression. The French analogy works because the English governing elite readily look 'Frenchified' to the eye of an English provincial.

The text of *The Castle of Indolence* opens with an imaginative representation of courtly art. The castle of the poem's title is a treasure house of works

produced in the past and almost always in another country. It is the home of a Wizard who is also an eighteenth-century man of taste, and he has chosen or modelled his surroundings on one of those mysterious seventeenth-century countrysides which Spenser sometimes describes and Poussin, Claude, or Salvator Rosa paint:

> Full in the Passage of the Vale, above,
> A sable, silent, solemn Forest stood;
> Where nought but shadowy Forms were seen to move,
> As *Idless* fancy'd in her dreaming Mood:
> And up the Hills, on either Side, a Wood
> Of blackening Pines, ay waving to and fro,
> Sent forth a sleepy Horror through the Blood;
> And where this Valley winded out, below,
> The murmuring Main was heard, and scarcely heard, to flow. (I.v.)

'A pleasing Land of Drowsy-hed it was', the next stanza opens; a landscape of romance, indicating the sphere of Imagination, which is both the poem's terrain and the target of its critique. A little less sceptically observed, it will also be the setting of Ann Radcliffe's work and much of Keats's, two of the most strikingly pictorial of Romantic artists.

Once inside we are more firmly sealed in a region of man-made enchantment, governed as the Wizard explains by the pleasure principle. It seems that it is only human society in its advanced, fallen state that is consumed with 'savage thirst of Gain' (I.xi.5). The Wizard makes the case for aestheticism seductively, in the languages of idealism and of ethics. In his castle candour and good nature replace competitive strife, and the heart 'Is sooth'd and sweeten'd by the social Sense' (I.xv.8). As the tradition of Roman republicanism attests, 'The Best of Men have ever lov'd Repose' (I.xvii.1); or, in the modernised and naturalised version of virtuous retirement popularised in the previous century by Izaak Walton, have practised sober contemplation while waiting for the trout to bite (I.xviii.5–9). It is important that the company the Wizard keeps is the best company, the very circles Pope was proud to be invited into and to serve with his pen.

Nothing of outer reality can apparently be seen from the castle walls or from its windows, if there are any. In the Wizard's wily seduction, even quotidian life comes across quaint and picturesque, as though he has learnt about it in pleasant old books, such as Chaucer's fabliaux:

> 'No Cocks, with me, to rustic Labour call,
> From Village on to Village sounding clear;
> To tardy Swain no shrill-voic'd Matrons squall;
> No Dogs, no Babes, no Wives to stun your Ear;
> No Hammers thump; no horrid Blacksmith sear,

No noisy Tradesman your sweet Slumbers start
With Sounds that are a Misery to hear:
But all is calm as would delight the Heart
Of *Sybarite* of old, all Nature, and all Art'. (I.xiv)

The world is what is enacted in the tapestries round the walls. History
and geography come in tales of Arcadia, Sicily, Chaldea, or of fairy-lighted
Baghdad.

But the reader is allowed to feel that these people are defined by everything
they have excluded. Their gentlemanly clubbability is something short of
the Wizard's pretended social sense, and his own tones tend to betray their
limitations:

'The Best of Men have ever lov'd Repose:
They hate to mingle in the filthy Fray'. (I.xvii.1–2)

The modern 'Stoic' lives easily on his estate and among his books, keeping
company only with a few friends among his social equals. Even the Toryism
of the post-revolution generation, the reign of William and Mary, seems to be
dwindling here into the sybaritism of a booming economy, a strange confusion
between good living and the Good Life. The Wizard, an excellent host, pre-
sents even physical effort as another form of looking after oneself:

'But if a little Exercise you chuse,
Some Zest for Ease, 'tis not forbidden here'. (I.xviii.1–2)

With such a tour guide it is not hard to feel the attractions of the well-heeled
private life.

Whimsically, Thomson introduces his own circle of friends, the Castle
guests or prisoners, including his patron George Lyttelton. Rather as though
a camera is being handed round, Lyttelton is allowed to take Thomson in
return, and he opens companionably with a reference to the poet's weight
problem—'"a Bard here dwelt, more fat than Bard beseems"'(I.lxviii.1). The
coterie-talk becomes startlingly recontextualised by the narrative that sur-
rounds it and by a short passage in which Thomson breaks into the first per-
son. Suddenly it is 'I', the immigrant poet, speaking, and he, aware of his own
alienation, is capable of seeing the castle not as the setting of real art but as the
place that kills it:

Ye Gods of Quiet, and of Sleep profound!
Whose soft Dominion o'er this Castle sways,
And all the widely-silent Places round,
Forgive me, if my trembling Pen displays
What never yet was sung in mortal Lays.
But how shall I attempt such arduous String?

I who have spent my Nights, and nightly Days,
In this Soul-deadening Place, loose-loitering? (I.xxxi.1–8)

The traditional academic view of *The Castle of Indolence* seems to be that Thomson was in love with indolence and with the sensuousness offered by its version of art. But this passage implies an acute element of artistic disgust, even artistic self-hatred. It is confirmed by the wrong course suddenly taken by the castle tour, where, as though a door is opened, we suddenly find ourselves in the dungeons. The prisoners there are the rejects of the world of creativity, arts, and letters, sick from failure or from the occupational diseases of success. It is at this dreamlike turn of events that the portrait of aristocratic culture breaks off and with it the first Canto.

In a similarly general vein Canto II represents the destruction of all that, regime, arts, and all. It is the first of a series of literary apocalypses to appear in English in the three quarters of a century before the death of Byron. These are figurings of revolution, visions of a violent future, which do not claim to be reportage and do not literally or passively reflect specific events in America or France. Some others use a great house to symbolise the present order, aristocracy perhaps rather than the state: Horace Walpole's *Castle of Otranto* (1765), for example, set in a Gothic fortress challenged by its dispossessed old owner, and Godwin's underrated early novel *Imogen* (1784), a romance allegory set in Roman Britain, but featuring a splendidly-filled Palladian mansion of more recent times. Imaging revolution is not necessarily to wish for its political realisation. Yet, on the whole the genre feels like a political intervention, because it represents the seemingly stable culture of (by inference) the present day as subject to imminent change or as nearing collapse. This is surely the impact of *The Castle of Indolence,* with its strange power to prefigure the next violent century.

Canto II sets off on a whole new narrative by introducing its hero, the saviour who is to overthrow the Wizard. In one of those schematic histories of the period that tells the history of society from its origins, we learn of the birth of the child who is to grow into the 'Knight of Arts and Industry' in a primal state of Nature, a 'youthly Morning, void of Care' (II.viii.1). He matures into a Noble Savage, who in addition to the kind of knightly exercises practised by Spenser's characters puts in an apprenticeship with the spade, plough, and 'strong mechanic Tool' (II.xii.4–6). He is also trained to use the artist's pencil and sculptor's chisel. The Wizard's version of history could sound as if it was haunted by the rise of the bourgeoisie; he repeatedly warned his guests against a fall from civility into a mundane and mediocre practicality. The Knight's story allows Thomson to present the same imminent takeover as the story of progress:

Now to perform he ardent did devise;
To-wit, a barbarous World to civilize.
Earth was till Then a boundless Forest wild;
Nought to be seen but savage Wood, and skies:
No Cities nourish'd Arts, no Culture smil'd,
No Government, no Laws, no gentle Manners mild. (II.xiv.4–9)

Canto II is a tale of Everyman, seen as Selfmademan: human social evolution encapsulated as a single life story. The Knight comes out of the East and passes through ancient Egypt, Greece, and Rome before finding his natural home—Britain—which he reaches in time to approve the natives' sturdy resistance to the Roman invasion. He is coterminous with historical Britain, unlike the Wizard, who has no roots in the past. Yet the Knight's long residence in the island achieves little, and almost nothing in the Fine Arts, until 'A matchless Form of glorious Government' (II.xxiv.2) emerges in late seventeenth-century England, after which, old now, he contentedly goes into retirement 'in *Deva's* Vale'. And then, in or only shortly after the present day, the crisis of the Wizard's rule draws him out of retirement.

Like the Wizard, the Knight needs to be located with the group or class whose interests he champions: what matters, then, is his simplicity and marginality, signified by his being a Celt and probably by the direction he comes from, the commercial, industrialising *English* North-West. The poem makes it seem significant that in Welsh culture the Dee or Dyfrdwy is associated with the Welsh Homer, the sixth-century bard Taliesin; for the Knight brings an aide with him, 'a little Druid Wight' called Philomelus. The name of this personage and his 'Russet brown' attire link him allegorically with the Nightingale, though his 'wither'd Aspect', or smallness, hints at Alexander Pope (II.xxxiii).

Once the Wizard is snared in the Knight's net, a coup d'état which takes only two lines to relate, Philomelus embarks on the real central event of Canto II, which is appropriately enough an event in discourse—his attempt to debrief the intelligentsia now forcibly liberated from the Wizard's castle. Where the Wizard could hold them willing captives with a philosophy of art which linked sensuous pleasure with social superiority, the Druid has an uphill task to convert them to the austerity of bourgeois poetics. Accompanying himself on his '*British* Harp', he speaks to an audience now mysteriously swelled to ten thousand people from the world outside. He does not talk about art but 'arts', agriculture, 'the thriving Mart', war, the management of states (II.lx). His views reflect Thomson's, rather than Pope's; they belong to a Deist who subscribes to the life-principle or 'Supreme Perfection', which Philomelus equates with energy, even with the Sun. The models he wants artists to follow are not the Wizard's named heroes like Scipio but the world's workers:

'Better the toiling Swain; oh happier far!
Perhaps the happiest of the Sons of Men!
Who vigorous plies the Plough, the Team, or Car;
Who houghs the Field, or ditches in the Glen,
Delves in his Garden, or secures his pen'. (II.lv.1–5)

In what is in effect a lecture, the dwarf makes productivity his priority, since art is paid for with society's surplus wealth. Had arts not made us opulent,

'Great HOMER's Song had never fir'd the Breast
To Thirst of Glory, and heroic Deeds;
Sweet MARO's Muse, sunk in inglorious Rest,
Had silent slept amid the *Mincian* reeds…
Our MILTON's *Eden* had lain wrapt in Weeds,
Our SHAKESPEAR stroll'd and laugh'd with *Warwick* swains…

'Dumb too had been the sage Historic Muse,
And perish'd all the sons of antient fame;
Those starry Lights of Virtue, that diffuse
Through the dark Depth of Time their vivid Flame,
Had all been lost with Such as have no Name.
Who then had scorn'd his Ease for others' Good?
Who then had toil'd rapacious Men to tame?
Who in the Public Breach devoted stood,
And for his Country's Cause been prodigal of Blood? (II.lii—liii)

Belying the sweetness of his name, Philomelus uses a vocabulary which derives from war, from power relations, and from the marketplace. Again, nothing that he says sounds much like Pope; some lines anticipate Gray, whose 'Elegy in a Country Churchyard', that bleak and alienated poem, was to appear two years later. Philomelus, like Gray's ruminative onlooker, brings a message that at best art must take its chance in a brave new bourgeois world. He pointedly refrains from offering the life of a full-time writer as an option open to his ten thousand.

Philomelus does manage to rouse a few of 'the better sort' among his hearers, among them 'Thomson' himself, who now for the first time acknowledges his own presence in the liberated crowd:

Even so we glad forsook these sinful Bowers,
Even such enraptur'd Life, such Energy was ours. (II.lxv.8–9)

Most of the literati roundly reject the speech, accusing Knight and Druid of barbarism, hate, and envy: 'Is Happiness a Crime?' (II.lxvi.8) At this the Knight turns nasty and, waving a wand, replaces their illusory palace of art with a baleful marshland, where suicides hang on the blackened trees. The

great majority of the 'ungodly Fry'—a puritannical expression for the men of letters of the old regime with some disquieting seventeenth-century associations—are driven off into the 'sadden'd Country', out of a reformed society which has no place for them:

> Even so through *Brentford* town, a Town of Mud,
> An Herd of bristly Swine is prick'd along. (II.lxxxi.1–2)

The conclusion of the second Canto, the inauguration of the post-revolutionary world, is as dystopic for most artists as the scenes in the dungeons at the close of the first. It is made emphatic by the twist it gives to the myth of Circe. Here it is not the aristocratic Wizard or Comus-figure who turns his dupes into swine but their bourgeois professed rescuer.

We have seen in allegory an English cultural revolution, and it leads to a shakeup among writers and intellectuals severe enough to anticipate Mao rather than Thatcher. It is in the light of this troubling dénouement that I turn to James Barry's representation of a cultural new wave for the Society of Arts.

Barry painted his series, *The Progress of Human Knowledge*, without a fee between 1777 and 1783, the years of the triumph of the American Revolution, with which he strongly sympathised. The first three paintings show the cycle of progress in the Ancient World. Two pictures, filling the space on either side of the door in the west wall, represent first the dawn of knowledge, in which Orpheus, the first instructor, teaches the inhabitants of a savage countryside; second, a cultivated but still agrarian scene, a harvest home in which villagers give thanks to Ceres, Bacchus, and Pan. The large picture on the north wall, entitled *Crowning the Victors at Olympia*, shows Periclean Athens in its glory. Most of the intellectual celebrities are there—Herodotus and Hippocrates, Socrates and Aristophanes—for the amiable purpose of seeing others' merit rewarded. The most celebrated of republics supplies a precedent for and mirrors the doings of the English room below, where premiums are handed out to modern competitors in all the arts.

The sequel, Barry's modern series of three, takes over in recent times. The two smaller paintings on either side of the east door are *Commerce, or the Triumph of the Thames*, an allegorical celebration of the navigators from Drake to Cook who have given Britain a worldwide trade, and *The Distribution of Premiums by the Society of Arts* (fig. 10) a fascinating group portrait which serves yet more complexly than the Athenian scene as a version of activities in the hall below. The *Distribution* is a work which avoids conventional ordering or hierarchy. The figures crowd together, on a level and informally grouped. Arthur Young, Elizabeth Montagu, Samuel Johnson, William Hunter as leaders of thought mix with and appear to dominate the merely rich and fashionable. Elizabeth Montagu stands in the foreground more prominent than two

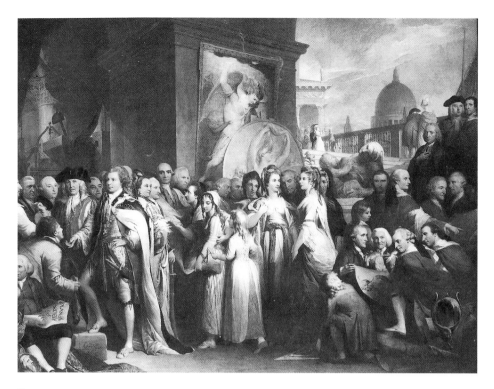

fig. 10
James Barry
The Distribution of the Premiums in the Society of Arts, c. 1777–84
Oil on canvas, 142 x 182 in. (360.7 x 462.3 cm.)
London, The Royal Society for the encouragement of Arts, Manufactures & Commerce

duchesses, between whom Johnson's massive head appears. He is pointing out Montagu to the titled women, as a model to follow.

Finally, the forty-two-foot finale to the series represents the last of all distributions of awards, *Elysium*. On the face of it Judgement Day will be the ultimate republican gathering, for which invitations will go out to the wise, good, and enlightened of every phase of western civilisation. Shaftesbury is in, behind Columbus, along with Locke, Zeno, Aristotle, and Plato. Behind Sappho sits Alcaeus talking to Ossian. To Homer's right is Fénelon, with Virgil leaning on his shoulder. In 1798 Barry added the Jewish intellectual Moses Mendelssohn to a group of English eighteenth-century writers including Dryden, Pope, Gray—and James Thomson. At bottom right those rejected from Elysium are hurtling into Tartarus. A warrior, a glutton, an ambitious man, a Knight of the Garter, a despotic king, a Pope, a covenanter represent the traditional institutions of power and are cast down. Barry's heaven has a lot to do with politics, and his politics are influenced by the American model. So at first sight he is less uneasy than Thomson at the likely course of Progress; less impressed by the worst scenario, that of Puritan iconoclasm.

Also at first sight the last painting alone shows dispossession, violence, loss, and punishment, and indeed revolution in the accepted modern understanding. The suffering is someone else's, and Barry seems to take an unabashed pleasure in contemplating what is to befall the sectors of society he disapproves of. Retribution awaits them, if not here then in the hereafter. He seems to have brought the story of the world to a satisfying millenarian conclusion.

Looked at more closely, the series looks back on revolution not forward to it, and this makes the mood much less complacent. Orpheus the theologian, himself an improver, is superseded by the superior 'arts' of late agrarianism, which in turn give place to the intellectual zenith achievable only in a city-state such as Athens. Everything from here on is revolutionary. The fourth and fifth paintings, like the third, are striking for what they do not represent, the traditional topoi with which artists flatteringly render the old hierarchies of the state and its military and clerical orders. The history of the world has long since become republican, Barry seems to say in a celebratory mode, even if some constitutional arrangements and much artistic convention have not acknowledged it. Eighteenth-century attenders of meetings looked up to see a mirror of themselves which idealised without mystifying them in myth; which portrayed them as a modern committee, not as archaic leaders and rulers. Barry's brave new world stands for civility and egalitarianism, a perspective that levels while it elevates. And thus it is fictional, utopian, an example of that favourite narrative kind of the 1780s and 1790s, 'Things As They Are Not'.

Barry's visionary republicanism is in all senses visionary. It converts the Great Room, though surely not intentionally, into an inverted Castle of Indolence. For, once a room looks and feels like a sanctuary walled with art,

framing particular messages to its onlookers, it puts the question posed by all sanctuaries, what is on the outside? So Barry's sequence representing the world: progress to a state where artists and men and women of vision get their rewards ceases to seem confident. Though much less alienated than Thomson's from progress as a concept, it is equally uncertain that it can be achieved. The artists and thinkers on these walls are individual competitors for 'premiums', meaning that they are paid (when they are paid) by an impersonal wealthy corporation, not an individual patron. The striking stress laid in three of the paintings on judgement, evaluation, the difficult mechanisms of discrimination, tells its own tale, and it is not reassuring. These artists are equal but not privileged citizens of the republic: in a system devoted to wealth-getting, they are by-products and indeed have to be generally represented as bystanders, at least until translated to a better place. The only painting of Barry's six which allows an artist to dominate his world is the first, in which Orpheus, the poet and musician, presides over what might be one of the mysterious landscapes of Poussin. It is the kind of painting which hangs in the Wizard's castle, and very appropriately so, since the primitive paradise in which Barry places Orpheus reveals itself full of menace, a degenerate Eden where marauding beasts wait in the shadows to spring on the children at play.

Like Thomson, then, Barry seems to concede with mixed emotions the passing of a state of society in which art might be graceful, charming, and within its limited locale significant. On the face of it, the prospect of commercial hegemony disturbs Barry far less than Thomson. But *The Progress of Human Knowledge* does portray artists competing for scarce resources, citizens of a wider republic of 'arts' where the value-system will not self-evidently rate beauty above utility. Barry's representation of Progress, again like Thomson's, turns anxiously back to one issue: where does art belong in the Republic to which Progressivism is delivering us? Sometimes its paymasters or arbiters remain out of sight, like the ultimate judge in Elysium. When they are present in the form of an Athenian or a gentlemanly English jury, the unease implicit in Barry's progress towards enlightened individualism or capitalist competitiveness becomes more insistent. The creative act that can make the space of this room so different from the space of the world that surrounds it cannot really de-regulate its conventional groupings, let alone influence the actions and decisions made there. Barry has not been able to envisage a present or a future in which he can be confident of being paid.

The Representation of the Human Body:
Art and Medicine in the Work of Charles Bell

Ludmilla Jordanova

The generation of a richer historical perspective on British art in the eighteenth and nineteenth centuries is an important project. It will involve paying greater attention to the complexity of the social settings in which artistic activities take place, and exploring the relationships between art and other domains. The intertwinings between literature, philosophy, political theory, and art are already being investigated.[1] Here I shall examine some of the links between art and medicine. Yet 'links' does not capture adequately their kinship, which at the most obvious level derives from their shared concern with the representation of the human body. The profound affinities between art and medicine are historically revealing since they carry the specificities of time and place. It is immediately apparent, however, how inadequate conventional vocabularies are for dealing with phenomena such as these. Above all, it is our assumptions about disciplines that are unhelpful. To a degree all disciplinary boundaries are arbitrary, especially when they are applied to past societies that mapped knowledge differently and possessed few institutional means of embodying intellectual divisions. The intellectual value of such distinctions was by no means obvious. At the same time, boundaries were being drawn in the eighteenth and nineteenth centuries, even if they were fragile and unstable. They enabled practitioners to explore their identities, to probe the coherence of their own enterprises; in this respect art and medicine were engaged in similar quests. That the term 'art' was and is a loose term, containing ambiguous elements, perhaps makes its boundaries—such as they were—all the more fascinating. Hence the importance of undertaking a search for the historically specific forms of kinship between art and other areas of social and cultural life. Nowhere is such kinship more significant than in the representation of the human body.

It is in this context that I discuss Charles Bell (1774–1842)—artist, anatomist, surgeon, and natural theologian—hinting at some of the social and cultural questions raised by the striking range of his interests and activities. There are genuinely revealing connections here that can contribute to the production of a fuller historical account of British culture. This essay mentions some of the ways in which it is possible to use an individual as a case study to facilitate our appreciation of early-nineteenth-century Britain. Such a biographical focus has distinct advantages because it makes it easier to trace intricate ideological, professional, aesthetic, and political threads, to understand their

inter-relationships, and to recognise their historically specific character. In particular, it helps us to see how religious concerns continued to be a central issue in representing the body, as we know from the fierce mid-nineteenth-century debates around Darwinian evolutionary ideas.[2]

Sir Charles Bell has often been mentioned as someone who influenced artists—Haydon, Wilkie, the Pre-Raphaelites, and the Landseer brothers.[3] Indeed, influence is often seen as an attractive way of linking two apparently distinct areas, such as art and medicine. Superficially, this sounds all the more plausible when there is shared subject matter, such as the representation of the human body. But the use of 'influence' raises more questions than it answers, and it inevitably simplifies the processes whereby ideas pass between people. It also tends to neglect the means by which the parties involved find each other—if artists read and were influenced by Bell, for example, how did they come across him, why him rather than other writers in the area, which aspects of him touched their projects, and why and in what ways did they transform his work in the process? It is possible to recast influence in terms of social networks—did artists read Bell because they moved in overlapping circles, had mutual friends and patrons, belonged to the same organisations, or had shared religious, class, or political affiliations? This formulation has a certain appeal, because it seems to root an abstract relationship (influence) in a material one (social networks); it appeals to common sense. I shall return later to the question of networks, but for the moment it may be noted that the quality and content of the constituent relationships within networks are always significant.

Bell has been remembered as a medical innovator because he made an important discovery about the nervous system.[4] As a result, only a tiny proportion of his writings is ever read, even by specialists. It is as a scientist, that is, as someone who has added to the sum of natural knowledge and contributed to the modern scientific world, that Bell has been recognised. The stress on scientific originality is, of course, historiographically problematic, just as that on its artistic counterpart can be. It selects historical actors by present-day criteria; it is deeply Whiggish in separating out the work of an individual into different categories, which are basically evaluative ones—in this case Bell's important scientific work (correct by our standards) and the rest (historically interesting perhaps but of no enduring value). In Bell's case the result is that we have lost a sense of what was sacred to him, and I use a religious term deliberately. This loss occurs because an emphasis on innovation obscures cultural spaces that have ceased to exist and that consequently have been devalued.

In what follows I stress not novelty and innovation but aspects of Bell's concerns that seem distant from our own preoccupations. My reason for doing so is the conviction that it is important to search for the underlying unity, not just in Bell's preoccupations but in his contacts with others. I take it as a basic

premise that what brings people, groups, and ideas together is likely to be not just contingent affinities but areas that touch them deeply, that mediate their most delicate and intimate interests. By putting it in this way I am not alluding to *personal* idiosyncrasies, but to patterns, whether political, social, metaphysical, or theological, that shape mental worlds and social behaviour. In setting aside the image of Bell as medical pioneer, I am not falling into the opposite trap of treating him as a hopeless reactionary. He was indeed conservative, but to assert this is not to diminish him; it is to evoke a quality that pervades his life and work and so holds out the possibility of understanding him better. His form of conservatism was quite historically specific. It seems that neither art historians nor medical historians have known quite what to do with Charles Bell, or indeed with other figures like him. In proposing ways of examining him, I am therefore speaking about Bell both as an unusually rich case study for social and cultural history and as an example for historiographical debate.

Charles Bell was born in 1774 to a Scottish Episcopalian minister and his wife, who came from a distinguished church family. His oldest brother John, to whom he was apprenticed, was a surgeon and anatomist in Edinburgh, and they collaborated on a number of publications. He had another brother, George, to whom he was especially close and who became an eminent Scottish lawyer. Indeed, Charles and George married sisters whose brothers were medical men closely associated with Charles. John and Charles shared an interest in dissection and in producing illustrated works on anatomy and surgery. Charles even more than John sketched from his preparations, painted, and used his own drawings in his publications. He also prepared dissections for display either by preserving them or by casting them in wax. In addition to illustrating his own books, Charles was a collector of anatomical specimens, a museum keeper, and a writer on anatomy and painting.[5] Although sometimes described as a physician, Bell was in fact a surgeon. This is not a trivial distinction. As a surgeon who was active in teaching and in hospital work and as an anatomist, his skills were manual ones. And, as a museum owner, he was interested in making objects ready for visual display. His craft skills were those primarily associated with touching and looking. Intensely interested in medical as in artistic education, Bell stressed the importance of teachers actually demonstrating bodies to students, working with them as they dissected. Visual skills were central to medical practice in this period, and Bell valued them all the more because of his preoccupation with natural theology. God's design was visible in nature. As a surgeon, anatomist, and experimenter, he needed a blend of visual and manual abilities. Bell possessed a great deal of technical knowledge, and I include here the part of his work that is best described as craft skills. His technical competence was both medical and artistic, and it was mobilised in the service of general, non-specialised discourses. Indeed, the

claims he made about the visual arts were underpinned by his detailed natural knowledge. This distinctive blend of the practical and the intellectual, the technical and the general, the medical and the visual holds the key to Bell's oeuvre.

His formative years were spent in Edinburgh, where he became friends with a number of important intellectual figures, many of whom, like him, moved to London in search of fame and fortune, such as Brougham the statesman, Horner the political economist, and Jeffrey the critic. Although Edinburgh medical society was relatively small at the time, it was certainly not a homogeneous or cohesive group; Bell was involved with factions and held strong opinions on medical ethics and the organisation of the profession.[6] He was an ambitious man who valued his contacts with those among his medical peers he thought could advance his career. But just as important were his contacts with non-medical people, such as Henry Brougham, who helped him considerably in practical ways and with whom he edited an edition of Paley's *Natural Theology* (1836). Most of Bell's working life was in fact spent in London, where he was involved in a great many enterprises and activities including the early times of University College, the foundation of Middlesex Hospital Medical School, and his own school and museum in Windmill Street. To his fraught relationship with the Royal Academy we shall turn shortly.

The span of Bell's work is notable, not just for its intellectual range, which included military medicine, surgery, anatomy, natural theology, comparative anatomy, and physiology, but for the variety of formats he used and the diverse levels at which he wrote, from short popular works to learned articles, from medical atlases to surgical textbooks, from polemical pamphlets to what would now be called 'monographs'. In relation to art, however, it is *The Anatomy of Expression* that is generally referred to. First published in 1806, it went through numerous nineteenth-century editions, many of them expressly produced for the art student. Illustrated largely by his own drawings, it is an interesting, although by no means a unique, publication.[7] The *Anatomy* attempts to conceptualise the general importance of expression in human beings; it discusses particular expressions and their physiological basis; it examines critically artistic education and analyses its main shortcomings to demonstrate the positive role that medicine or, to be more specific, anatomy, can play in it. It also possesses two less obvious but highly significant features: its use of a natural theological framework and its sustained deployment of the concept of language, not just as a metaphor but as a description of expression and its representation. These two features are closely linked, and I shall explore them in greater depth.

The general importance of natural theology in British society during the early nineteenth century needs to be underlined. As an enterprise natural

theology was neither straightforward nor unproblematic. Nonetheless, there seems to have been a certain consensus around what we could call the Paley approach to natural theology, to which many prominent people in early-nineteenth-century Britain felt able to subscribe. This style was to receive something like official recognition in the Bridgewater Treatises, to which Charles Bell contributed the volume on *The Hand* (first edition 1833).[8] If we want to acquire a firmer grasp of the historically specific project of Bell and others in relation to the representation of the human body, an understanding of natural theology, and of Bell's treatise in particular, and a sense of the political concerns that lay behind it, are essential.

A clue to these may be found in the preface to his treatise where Bell refers to a matter of intense interest to himself and his contemporaries: the differences between French and British approaches to the study of life (ironically, he says 'English'; as a Scot he associated himself with the latter). The French approach to biology was, for Bell, as for many of his peers, synonymous with materialism, that is, with the denial of the soul: 'French philosophers and physiologists…represented life as the mere physical result of certain combinations and actions of parts by them termed Organisation'.[9] Bell was using recognised shorthand here. He was able to conjure up a whole gamut of 'French' qualities, by referring to their predilection for 'organisation'. These include anarchic revolutionary activities and a general Godlessness. Bell's conservative reaction to French traditions, whether medical or political, led him to emphasise the moral dimensions of his work. Thus, in addressing new students and staff at University College, London, in 1828, Bell continually referred to the medical teachers not as mere instruments for the acquisition of knowledge but as moral mentors.[10] Here is Bell's deepest commitment coming through, a commitment that produced a particular view of the representation of the human body. It is found consistently in his publications, and it served as a powerful conceptual link between his medical, artistic, theological, and political concerns.

The subject of Bell's treatise, the hand, was specifically mentioned in the Earl of Bridgewater's will, so it is reasonable to assume that Bell received fairly precise instructions about his remit.[11] Nonetheless, he turned the subject to his own particular interests. Bell discoursed at length on the comparative anatomy of the hand and of analogous organs, offering a detailed exposition of bones, musculature, and of animal behaviour. He also discussed the senses, especially the sense of touch, what was called the muscular sense, and sensibility. The senses form part of the nervous system, which was understood by Bell not just as a physical structure but as the key to human capabilities, that is, to man's unique intellectual and emotional faculties. There was no consensus on the interpretation of the human nervous system in this period—it was the subject of highly polarised and politicised debate—but whatever position one

espoused on this question, the *precise* ways in which the nervous system was understood were central. Bell's intense interest in nervous phenomena has the most general significance. His position could be characterised as physiological dynamism: he stressed the dynamics of living systems. As a devout Christian he was committed to the idea that the body was animated by the mind/soul and believed that bodily activity could only be properly understood in terms of God's creative powers. Here, for example, is Bell on aging:

> The poet's picture of the last stage of man's life is not a true one. If man totters under the burthen of years, the simile of a ruin is inapplicable. The material of his frame is not different, and not older, than that of a child—it is ever decaying, ever renewing, whilst the office of digestion and assimilation goes on at all. The difference of the activity with which this change in the material of the body is wrought, compared with that of the child, may be as a week to a day; but here is not the cause of the grey hairs, the faded cheek, and the feeble step. This is the stamp which the Creator has intended should be deciphered and interpreted.[12]

This conveys both Bell's general orientation to the human body—his physiological dynamism—and something of his natural theology. There are three elements here that I wish to draw attention to. First, there is the energy behind the word 'stamp'—God imposes himself forcefully upon the world. Second, what he imposes is a form of language, to be deciphered. Third, merely reading God's marks is not sufficient; they have to be interpreted. Here is the hub—art and medicine unite as disciplines for reading, interpreting, and representing God's language as it has been stamped upon human beings. Naturally, God made his mark on animals too, but he reserved special languages for the human race, as in the case of expression.

The hand is of interest to Bell as an instrument. It is the instrument of human will; and as such it is a paradigm of the relationship between mind and body, a relationship that can never be fully understood by human beings. Thus we could say that the hand is God's instrument as well as man's. It should come as no surprise to discover that Bell discusses the hand as an instrument of expression, nor that the authorities invoked are 'the great painters…since by the position of the hands, in conformity with the figure, they have shown how to express every sentiment'.[13] He names here Guido, Raphael, and Leonardo. The status Bell gives to art should be noted: it is, by implication, a source of knowledge of nature, a text to be read as precisely as the book of nature. This deeper union between art and medicine is theological, and the hand of the artist is implicitly analogous to the hand of God.

The Hand contained a number of 'additional illustrations' at the end of the volume, the last three of which are of special interest: (1) Comparison of the Eye with the Hand, (2) The Motion of the Eye considered in regard to the

effect of shade and colour in painting, and (3) Expression in the Eye. In the first of these, Bell argues that there is 'a strict analogy between' the eye and the hand, and discusses the eye—'our finest organ of sense'—at length, to deny the validity of the eye-camera analogy[14]. For him the eye is active in general visual judgements and in coordinating, purposefully, with that other instrument, the hand. The second 'additional illustration' introduced a new topic for Bell—visual pleasure. His discussion of the uses of colour to produce pleasing effects is once again theologically directed: 'The yellow, pale green, or isabella colours, illuminate in the highest degree, and are the most agreeable to the sense [i.e. of vision]; and we cannot but observe, when we look out on the face of nature, whether to the country, the sea, or the sky, that these are the prevailing colours'.[15] Again, art, medicine, nature, and a universal humanity are cemented together through the argument from design.

The third 'additional illustration' is also illuminating—it concerns the position of the eyes in prayer. God's stamp is found by Bell in what he sees as a universal occurrence, that the eyes are raised heavenwards in reverence and awe, and once again he invokes the authority of 'the great painters' to support his contention that the eyes are indeed raised in this way and that the whole of the rest of the body adapts accordingly. Such paintings 'speak to all mankind'. Hence it is 'the very constitution of the body and mind' that is at issue; this is the shared domain of art and medicine.[16] Bell closed the book with an appendix on the classification of animals. Significantly enough, it starts with the *top* of the animal kingdom, with the order of mammals, Bimana, which possesses only one species—man. By virtue of his hands, man stands alone—hands that are central to surgery, anatomy, and dissection, as they are to drawing, painting, etching, and sculpting.

The two key themes in Bell's *The Anatomy of Expression*—natural theology and language—are closely linked; one can infer the existence of God not just from the design of the physical world but also from the existence of natural languages created by him. Human expression is one such language. Expression is, for him, a dynamic entity; and the dynamism of expression, like that of all organic phenomena, ultimately emanates from God. In the case of human beings the soul animates the body, but, as we have seen, Bell also construes the body as active, as perpetually in motion. Putting Bell's concerns in this way enables us to bring into sharper focus important issues in the confluences between art and medicine in early- and mid-nineteenth-century Britain, conventionally discussed via physiognomy.[17]

Physiognomy and phrenology, fields in which medicine and the visual representation of the body were intertwined, have been understood as theoretical systems that sanctioned direct links between traits and their meaning, enabling gestures, expressions, or physical characteristics to be decoded by beholders. Some practitioners of these disciplines assumed that artists should use them,

deliberately, to make their productions legible. In fact, the situation was considerably more complex than this. Phrenology differed from physiognomy, not least in its emphasis on the physical causes of the variety of head shapes. It presupposed a theory of cerebral localisation, had nothing to say about expression, and was rooted in the assumption that use increases the size of an organ. Physiognomy and pathognomy, although they had numerous intellectual roots, did not necessarily entail any of these commitments. Indeed, phrenology was often associated with materialism; hence physiognomy and phrenology had different political valences. Not surprisingly, Bell, like his friend Francis Jeffrey, editor of *The Edinburgh Review*, was hostile to phrenology and certainly did *not* conceive of his own enterprise in terms of the simple legibility of the human body.[18] Nor did he think there was a mechanical relationship between physical traits and their meaning. Nonetheless he ardently supported the general contention that medicine had a major contribution to make to artistic techniques.

Bell made some quite specific assumptions about the nature of the fine arts in his own day. For example, he simply took for granted that the living human figure was its central concern; he exhibited relatively little interest in landscape painting. By implication he gave primacy to history painting and further assumed that this should become more 'natural', by which he meant strictly lifelike—accurately depicting the body in movement, as understood with the assistance of the medical sciences. There is a fundamental distinction to be made between the approach he advocated and a combination of excessive respect for the antique and excessive reliance on the study of the human figure in the artifical situation of the studio.[19] The former approach rests on understanding and portraying natural motion that derives ultimately from the Creator, the latter on copying static artefacts—an artificial and mechanical procedure akin to simplistic methods for making the body legible. There is indeed a world of difference between a deciphering method, where a handbook, for example, could be used as an index and guide, and Bell's ideas, which entailed getting *inside* nature, especially human nature, recognising the uniqueness of the human figure—a uniqueness that is theologically sanctioned—and endowing the representation of the human body with devotional significance. The implications of his approach are that art is properly a religiously-inspired endeavour, and that it can only be fully developed with the help of medicine.

Although we know that some artists were indebted to Bell's work, reactions to him certainly varied. It is therefore appropriate to ask whether there were any connections between the content of Bell's ideas and the context in which they were received by artists that might help to account for the mixed responses he received. In practice Bell's relations with the artistic community were strained, especially with the part of it represented in the Royal Academy.

Bell arrived in London late in 1804. He had already written *The Anatomy of Expression,* although it was not published until 1806. It has been claimed that Benjamin West assisted him in finding a publisher. Bell only returned to Edinburgh in 1836. In the thirty-two years he spent in London, he clearly enjoyed the extensive *informal* contacts with artists, if his letters to his brother George are anything to go by.[20] During that period the Professorship of Anatomy became vacant twice, in 1808 and in 1824, the year the second edition of *The Anatomy of Expression* was published. Although he expressed a wish to be appointed and did a certain amount of lobbying to achieve this end, on neither occasion was he successful. The Presidents at the time of the two appointments were Benjamin West (1808) and Thomas Lawrence (1824). The latter made it clear in his personal correspondence that Bell was an unacceptable candidate: he thought Bell unsuitable socially and politically—his technical competence was not called into question.[21]

Given Bell's passion for and extensive involvement with the visual arts, his failure to gain the Academy post is significant. In fact, there was ambivalence on both sides. As Charles confided to his brother early in 1807, 'Horner the wise says I must take care not to appear to the public too much to be occupied on the arts'—a theme he took up in his letter to Thomas Lawrence.[22] Although the letter is undated, it must have been written in 1824, since it refers to the new edition of *The Anatomy of Expression,* a copy of which Bell sent to the President of the Royal Academy. 'You must know', Bell remarked, 'that it can do no service to any medical man to be thought much conversant with [the Arts] but would on the contrary do him great harm…it would be a sacrifice of money as well as time for any man in practice in London to connect his name with your particular studies'.[23] Lawrence had been involved in behind-the-scenes politicking when the post became vacant in 1808; he was completely opposed to Bell's election.

A curious situation therefore existed. Bell consorted with and taught artists. His great passion for both medicine and art led to successful publications. His whole intellectual framework encouraged him to think of these two fields as possessing a profound kinship. Yet he was never accepted into the Academy, and he apparently harboured deep reservations about the relationships between the two professions. Although a number of explanations spring to mind, it would be premature to fix on any one now. But it may be fruitful to point to some of the issues raised by the evidence.

It is, of course, possible to explain antipathies and uncertainties such as these in terms of personal qualities and the formation of networks, but this is perhaps somewhat limited. Clearly Lawrence, and doubtless other luminaries of the Royal Academy, were hostile to Bell. But there were others who supported him. Indeed, the Duke of Bedford, Landseer's patron, wrote to Lawrence warmly recommending Bell.[24] So, does it come down to the relative

strength of factions? An alternative approach is to search for conflicts of interest at professional and ideological levels. It seems reasonable to assume, for example, that Academicians preferred Professors of Anatomy, who were not after all drawn from their own ranks, to 'know their place' and to desist from making critical pronouncements on art and artistic education. There is certainly evidence to suggest that the Academy in this period did 'police' the publicly expressed views of its members.[25] Bell was indeed sharply critical of the teaching methods employed in the Academy and often castigated painters for their ignorance of anatomy. He also had very decided opinions on how such ignorance should be remedied.

On the side of Bell and the medical men, it is possible they feared that the hard masculine images of scientific and medical pursuits many of them were actively fostering would be jeopardised by an intimate association with the arts. The culture of medicine at this time stressed its progressive, humanitarian qualities; the aura practitioners were working hard to create was in manifest tension with the cultivation of visual pleasure, aristocratic patronage, and the world of luxuries. Socially, the medical self-image was educated middle-class, although on an individual basis titles and wealth were warmly welcomed as rewards for merit and industry. Yet medical practitioners were equally concerned to establish themselves as learned and cultured men, participants in polite culture, in order to create a profession high in public esteem and respect, as far removed as possible from any association with quackery, manual work, trades, and butchery. The strong currents of agitation for professional reform, especially in the 1820s and 1830s, made medical practitioners anxious both to gain general approval, to display their beneficence, and to assert their special scientific expertise.[26] While it is, of course, difficult to extrapolate from Bell's case to the profession as a whole, he certainly represented the new, and more self-consciously scientific, style and was at the forefront of institutional developments designed to improve medical education, the status of practitioners, and medical care. It is also possible that, in writing to Lawrence, Bell was playing games with him. It may have been an affectation on his part to imply that an estrangement existed between the professions of art and medicine in which he himself did not genuinely believe.

It is essential to consider the further possibility that some Academicians disliked the *content* of Bell's work. Bell generally illustrated his publications himself, and it is easy to imagine conflicts arising around his *artistic* competence, conflicts that became more urgent as he criticised existing art practices. Furthermore, in presenting the need for a theologically sanctioned union of art and medicine, Bell gave the latter the upper hand. He could assign a dominant role to medicine precisely because he did not employ the mechanical model mentioned above. Within this model medical men provided easy-to-use handbooks of anatomical and physiological signs for artists to use in their own

ways. Bell expected something more—that anatomy would teach art the language of expression and thereby provide artists with new interpretative skills. Indeed, his continual stress on the dynamism of organisms, and especially of human beings, gives additional emphasis to the need for a sophisticated interpretative framework derived from the natural and medical sciences. Without such a framework art would not be able to represent the human body adequately and thereby do justice to nature and to God's craftsmanship. On this reading the tensions pertain to ideological power.

All these matters require further investigation. They do suggest, however, that it may be unhelpful to think simply in terms of 'influences' between distinct fields, that invoking 'networks', while it can lead to useful insights, only deals with a limited range of historical issues, and that the representation of the human body was as complex a problem for natural scientists and medical practitioners as it was for artists. For a short while the existence of powerful traditions of natural theology brought art and medicine together around the body and its representation. It is perhaps significant that this historical moment was also a critical one for both the medical and the artistic enterprises. Not so much professionalisation as profession*alism* was a major issue.[27] These are questions of identity, of the self-image of occupations, of problematic boundaries between fields, of how elites form, acquire, and retain power.

Bell's letters reveal how conscious he was of his contacts, of his public image, and of the role of aristocratic support. In his natural theological conciliation between art and medicine, Bell was attempting to create, albeit unsuccessfully, an area of consensus and of stable moral values. There can be no doubt that he failed to win over the hearts and minds of the institutional base of the art establishment. In seeking to explain why this was so, we will be drawn into much broader and more complex areas than the rather bland phrase 'art and medicine' hints at.

An examination of Bell's approach to the representation of the human body has produced a mixed picture. On the one hand, he was deeply committed to a profound union of artistic and medical-cum-scientific representations, a union that was theologically sanctioned at a conceptual level, personally sanctioned at a practical level by his possession of skills in both fields, and socially sanctioned by his publications and his lectures for and contacts with artists. Yet, on the other hand, his failure to gain official recognition from the Academy suggests, at the very least, the existence of tensions that need to be thoroughly explored, not just in the service of understanding better the manner in which a particular individual was inserted in the medical and artistic communities, but to see if there are more general patterns at work.

We know that Bell was intensely status conscious. To some degree this was inevitable. He was after all a foreigner in London, who needed to build up links if he was to succeed in private practice, which was a competitive and

overcrowded field. The need for patronage was very real in both art and medicine, although in quite different ways.[28] Bell did indeed make connections and develop a practice, but he also rooted himself in London through a variety of institutions, including his own school and museum, his briefly-held post at University College, London, his membership of and active participation in the College of Surgeons, and his central role in the establishment of a medical school at the Middlesex Hospital. Although it would be wrong to exaggerate the security of the medical profession in Bell's time, nonetheless he was able to form alliances and to build up power bases in a variety of ways. While the need for patronage was great, successful medical men like Bell could spread the risks that are inevitably entailed in patronage situations.

Patronage is a highly complex yet largely unexplored issue in the history of medicine; it involved an amalgam of clients (patients), colleagues, and lay persons, who wielded considerable power in the administration of hospitals, for example.[29] The situation of artists was rather different in that they had fewer institutions available to them as insurance policies. Furthermore, by the 1830s the discourse of the humanitarian medical practitioner was already well developed, and it had a distinctly romantic tinge to it; from the beginning of the century the image of doctors as heroes, who were also essential to the *material* well-being of society, was being conjured into existence and actively moulded for professional ends. Systematic comparisons between art and other occupations will uncover the rhetoric, the self-image, the risks, and the rewards involved at a specific historical juncture.

We also need to be alive to the existence of ambivalences about the value and status of domains such as art and medicine. These were partly rooted in the social differences between the two communities, one manifestation of which was distinct kinds of patronage. In other words, we need to move towards a more structural analysis of the communities associated with art and with medicine, indeed with any field that bears upon art. It goes without saying that this involves printers, engravers, teachers, critics, and so on as well as painters themselves and, by the same token, extends to scientists and medical men who saw themselves as assisting in some way with the education of artists and the practice of art.

There can be little doubt that Bell had a conservative vision of the world; his natural theology stabilised and unified art and medicine, partly by stressing their overriding moral dimensions. Yet the precise historical situation in which he found himself did not sustain his vision at a material level. It was one in which there was enormous instability in all senses, an instability that was experienced directly in the persistent economic, moral, political, and institutional vulnerability that was the lot of many medical practitioners. One expression of this was the yearning for a stable order, for the aesthetic nurturance that we find in natural theology.[30]

A study of Sir Charles Bell does more than add to our knowledge of the complexity of the art world in nineteenth-century Britain. It prompts us to reflect on the position of art relative to other domains and to recognise the variety of historical dimensions involved. It is necessary to understand ideas, networks, professions, and institutions, and to see how metaphysics as well as interests, skills as well as theories, content as well as coteries contributed to the cluster of issues mediated by the representation of the human body in Bell's time.

I am grateful to the Royal Academy for permission to quote from their collection of Thomas Lawrence's letters.

1. For example, Ralph Cohen, ed., *Studies in Eighteenth-Century British Art and Aesthetics* (Berkeley: University of California Press, 1985); Jean H. Hagstrum, *The Sister Arts: The Tradition of Literary Pictorialism and English Poetry from Dryden to Gray* (Chicago: University of Chicago Press, 1958); John Barrell, *The Political Theory of Painting from Reynolds to Hazlitt: 'The Body of the Public'* (New Haven and London: Yale University Press, 1986); John Barrell, ed., *Painting and the Politics of Culture: New Essays on British Art, 1700–1850* (Oxford: Clarendon Press, 1992).
2. Charles C. Gillispie, *Genesis and Geology: A Study in the Relations of Scientific Thought, Natural Theology, and Social Opinion in Great Britain, 1790–1850* (New York: Harper, 1959); James R. Moore, ed., *History, Humanity and Evolution* (New York and Cambridge: Cambridge University Press, 1989); William Irvine, *Apes, Angels and Victorians: The Story of Darwin, Huxley, and Evolution* (New York: McGraw-Hill, 1955); Tess Coslett, ed., *Science and Religion in the Nineteenth Century* (Cambridge: Cambridge University Press, 1984); James R. Moore, *The Post-Darwinian Controversies: A Study of the Protestant Struggle to Come to Terms with Darwin in Great Britain and America, 1870–1900* (Cambridge: Cambridge University Press, 1979).
3. Lindsay Errington, *Tribute to Wilkie* (Edinburgh: National Galleries of Scotland, 1985), 27–32 and 49–51; Frederick Cummings, 'Charles Bell and *The Anatomy of Expression*', *Art Bulletin* 46 (1946): 191–203; Tom Taylor, ed., *The Autobiography and Memoirs of Benjamin Robert Haydon* (London: Peter Davies, 1926), 1:32–33, 136; Richard Ormond, *Sir Edwin Landseer* (London: Tate Gallery, 1982), esp. 4; Julie Codell, 'Expression over Beauty: Facial Expression, Body Language, and Circumstantiality in the Paintings of the Pre-Raphaelite Brotherhood', *Victorian Studies* 29 (1986): 255–90.
4. 'Bell introduced new methods of determining the functional anatomy of the nervous system'—this opening sentence of the entry in the *Dictionary of Scientific Biography* conveys something of the traditional historiography on Bell (1970, 1:583–84). The standard literature in the field tends to concentrate on the priority dispute between Bell and Magendie over the discovery of the distinction between sensory and motor spinal nerve roots. See, for example, Paul Cranefield, ed., *The Way In and the Way Out: François Magendie, Charles Bell and the Roots of the Spinal Nerves* (Mt. Kisco, New York: Futura, 1974).

5. Brief biographical accounts of Bell may be found in the *Dictionary of National Biography* and in the *Dictionary of Scientific Biography;* for a more detailed study see Gordon Gordon-Taylor and E. W. Walls, *Sir Charles Bell, His Life and Times* (Edinburgh and London: E. and F. Livingstone, 1958).

6. See, for example, Bell's pamphlet, *Letter to the Members of Parliament for the City of Edinburgh on the Two Bills Now before Parliament for the Improvement of the Medical Profession* (Edinburgh, 1841); an anonymous pamphlet attributed to him, *A Letter to the Governors of the Middlesex Hospital, From the Junior Surgeon* (London, 1824), also expresses strong views about medical politics and professional ethics. On Edinburgh medicine in this period see Lisa M. Rosner, *Medical Education in the Age of Improvement: Edinburgh Students and Apprentices, 1760–1826* (Edinburgh: Edinburgh University Press, 1991).

7. *Essays on the Anatomy of Expression in Painting* (London, 1806); *Essays on the Anatomy and Philosophy of Expression,* 2nd ed. (London, 1824); numerous later editions appeared as *The Anatomy and Philosophy of Expression as Connected with the Fine Arts.* For the more general context of Bell's work see Mary Cowling, *The Artist as Anthropologist: The Representation of Type and Character in Victorian Art* (Cambridge: Cambridge University Press, 1989).

8. The Bridgewater Treatises are discussed at length in Gillispie; see also Jonathan Topham, 'Science and Popular Education in the 1830s: The Role of the Bridgewater Treatises', *British Journal for the History of Science* 25 (1992): 397–430; M. L. Clarke, *Paley: Evidence for the Man* (London: SPCK, 1974); Richard Yeo, 'William Whewell, Natural Theology and the Philosophy of Science in Mid-Nineteenth-Century Britain', *Annals of Science* 36 (1979): 493–516; John Hedley Brooke, *Science and Religion: Some Historical Perspectives* (Cambridge: Cambridge University Press, 1991). Bell's treatise, the fourth in the series, was *The Hand, Its Mechanism and Vital Endowments, as Evincing Design* (London, 1833); it went through numerous nineteenth-century editions. On his treatise see Ludmilla Jordanova, 'The Hand', *Visual Anthropology Review* 8 (1992): 2–7.

9. Charles Bell, *The Hand,* 4th ed. (London, 1837), ix–x (all subsequent citations of this work are to this edition). Karl Figlio has explored the significance of 'organisation' in the period in 'The Metaphor of Organisation: A Historiographical Perspective on the Bio-Medical Sciences of the Early Nineteenth Century', *History of Science* 14 (1976): 17–53. Topham (see note 8) discusses Bell's identification of organisation with Frenchness and with dangerous ideas, 416–19. Adrian Desmond, *The Politics of Evolution: Morphology, Medicine, and Reform in Radical London* (Chicago: University of Chicago Press, 1989) explores the broad historical context of these debates.

10. Gordon-Taylor and Walls, 246–50.

11. Details of the will of the Earl of Bridgewater, who died in 1829, are given at the front of each treatise.

12. Bell, *The Hand,* 183.

13. Ibid., 259.

14. Ibid., 329–49; these 'additional illustrations' did not appear in all editions of the work.

15. Ibid., 360; see also Gillian Beer, '"The Face of Nature": Anthropomorphic Elements in the Language of *The Origin of Species*', in L. J. Jordanova, ed., *Languages of Nature: Critical Essays in Science and Literature* (London: Free Association Books, 1986), 207–43.

16. Bell, *The Hand,* 361–62. In Bell's formulation universality is stressed, and accordingly the link between science and natural law, God, and art makes painting into a form of natural knowledge that apprehends the universals of nature.

17. On physiognomy see Graeme Tytler, *Physiognomy in the European Novel: Faces and Fortunes* (Princeton: Princeton University Press, 1982); Cowling, *The Artist as Anthropologist;* Ludmilla Jordanova, 'The Art and Science of Seeing in Medicine: Physiognomy, 1780–1820' in W. F. Bynum and Roy Porter, eds., *Medicine and the Five Senses* (Cambridge: Cambridge University Press, 1993), 122–33; Barbara Stafford, *Body Criticism: Imaging the Unseen in Enlightenment Art and Medicine* (Cambridge: MIT Press, 1991), 84–129.

18. Roger Cooter, *The Cultural Meaning of Popular Science: Phrenology and the Organization of Consent in Nineteenth-Century Britain* (Cambridge: Cambridge University Press, 1984), 27–28, 309. Although it relates to an earlier period, Norman Bryson in *Word and Image: French Painting of the Ancien Régime* (Cambridge: Cambridge University Press, 1981) tackles the question of legibility and physiognomy in a stimulating manner.

19. Valuable insights into approaches to artistic instruction on the representation of the human body may be found in Ann Chumbley and Ian Warrell, *Turner and the Human Figure: Studies of Contemporary Life* (London: Tate Gallery, 1989), 12–16; this section deals with Royal Academy Schools. It would be rewarding to compare Bell's ideas with those of William Hunter; see Martin Kemp, ed., *Dr. William Hunter at the Royal Academy of Arts* (Glasgow: University of Glasgow Press, 1975). Bell discussed the role of anatomy in the education of artists in *The Anatomy and Philosophy of Expression as Connected with the Fine Arts,* 7th rev. ed. (London, 1886), essays 9 and 10.

20. *Letters of Sir Charles Bell, Selected from His Correspondence with His Brother George Joseph Bell* (London, 1870). This edition was prepared by Charles's widow; the extent to which the letters have been expurgated is unclear. I know of no major collections of Bell's private papers.

21. The following letters in the Lawrence papers at the Royal Academy relate to Bell directly, LAW/1/202, LAW/4/310, LAW/5/291; also relevant is LAW/1/199 about the 1808 vacancy for a Professor of Anatomy.

22. *Letters of Sir Charles Bell,* 91.

23. LAW/4/310 (Bell to Lawrence).

24. LAW/5/291 (Duke of Bedford to Lawrence).

25. See, for example, Sidney C. Hutchison, *The History of the Royal Academy, 1768–1968* (London: Chapman and Hall, 1968), chaps. 7–9.

26. Ivan Waddington, *The Medical Profession in the Industrial Revolution* (Dublin: Gill and Macmillan, 1984), esp. pt. 2; Catherine Crawford, 'Professional Reform and the Science of Forensic Medicine in England, 1800–1830', in Roger French and Andrew Wear, eds., *British Medicine in an Age of Reform* (London: Routledge, 1991), 203–30. For a general treatment of the period see Asa Briggs, *The Age of Improvement, 1783–1867* (London: Longmans, Green, 1959).

27. On nineteenth-century professions see W. J. Reader, *Professional Men: The Rise of the Professional Classes in Nineteenth-Century England* (London: Weidenfeld and Nicolson, 1966); M. Jeanne Peterson, *The Medical Profession in Mid-Victorian London* (Berkeley: University of California Press, 1978); Waddington, esp. part 1; Irvine Loudon, *Medical Care and the General Practitioner, 1750–1850* (Oxford: Clarendon Press, 1986).

28. Iain Pears in *The Discovery of Painting: The Growth of Interest in the Arts in England, 1680–1768* (New Haven and London: Yale University Press, 1988) has suggested that there were some significant social affinities between art and medicine in his period (110–11, 250). However, by Bell's time the differences between the key institutions of the two professions and between their self-justifying discourses is striking.

29. Patronage remains an underdeveloped field in the history of medicine despite the fact that numerous nineteenth-century novels explored its impact on practitioners and communities alike. While *Middlemarch* (1871–72) remains the best-known example, lesser writers, such as Francis Brett Young (1884–1954), active in a somewhat later period, can help sensitise historians to the social complexities at the core of medical patronage. In addition to the works cited in note 27, see N. Jewson, 'Medical Knowledge and the Patronage System in Eighteenth-Century England', *Sociology* (1974): 369–85; John Woodward, *To Do the Sick No Harm: A Study of the British Voluntary Hospital System to 1875* (London: Routledge and Kegan Paul, 1974); Michael Bevan, 'The Social Context of Medical Practice: Gynaecology in Glasgow, 1850–1914' (Ph. D. thesis, University of Essex, 1992).

30. I have tried to explore the aesthetic side of natural theology in 'Nature's Powers: A Reading of Lamarck's Distinction between Creation and Production' in James R. Moore, ed., *History, Humanity, and Evolution: Essays for John C. Greene* (New York and Cambridge: Cambridge University Press, 1989), 72–98; 81–87 deal with Paley and the natural theological enterprise.

Art Exhibitions as Leisure-Class Rituals in Early Nineteenth-Century London

Andrew Hemingway

Art history is beset by the phenomenon of reification—that species of miscognition in which relations between persons appear to take the form of a natural or essential property of things. The fetishisation of those relics of earlier cultures which we describe as art contributes to a basic confusion of categories. The paintings and sculptures which our culture (literally) enshrines in the museum are widely assumed to be the art of the past. But this cannot be the case. For the art of the past was also a particular type of experience—a function of social relations then prevailing, an effect of discourse, and a range of complex learnt pleasures. The material objects denoted as art were originally given their status as such within that nexus. Art objects are the material residue of a variety of social exchanges. The fact that the same objects continue to have art functions in our own society is another matter—those functions are different, if genealogically related. Thus, in relation to the theme of this essay, I want to begin by asserting that the experience denoted by the term 'art' in the early nineteenth century was different in important respects from the experience we associate with that term today.

To illustrate something of what I mean, in that period 'art' still had strong connotations of crafts and useful skills, and the radical autonomy of the aesthetic was not yet envisaged—art was not as sharply separated from things of use as it was to become.[1] There was as yet scarcely a discourse of art history, and the interpretation of pictures, insofar as we can judge it from contemporary criticism, was thought mainly within terms drawn from academic theory and, to a lesser extent, from association aesthetics. The experience of the original audience was also framed within institutions and social spaces unlike those which frame the experience of the contemporary scholar or gallery-goer.

Modern scholars encounter early-nineteenth-century paintings in ensembles which are very different from those in which they were first presented. Most commonly they see them in public or commercial galleries and to a lesser extent in sale rooms or private collections. In the round of exhibition displays history is represented in periods or phases, themes are isolated, genres are discreetly separated from one another, artists are separated from their contemporaries. Much art of the past, even when it survives, is never displayed. However, criticism of museums and exhibitions is not my purpose here, I simply wish to point to the distance which separates us from the early-nineteenth-century art experience.

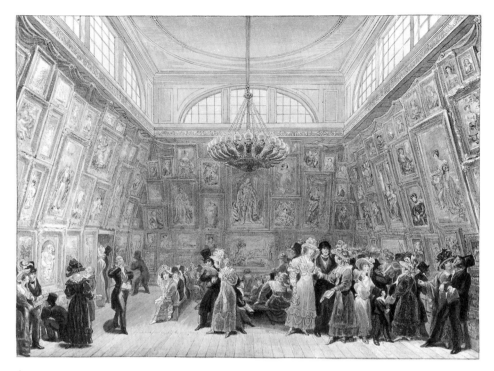

fig. 11
George Scharf I, *The Royal Academy Exhibition, 1828*
Watercolour, 7 ⅜ x 10 ³⁄₁₆ in. (18.8 x 25.9 cm.)
Museum of London

The scholar's gaze is extended and reflective—or so we hope. To confirm their credentials, scholars must discover what the casual eye fails to notice. To tease out (or should we say construct?) the subtleties of meaning demands a complex and discriminating study of contemporary texts and of other images which may function as sources or offer comparative evidence. The individual work of art (or at least the *important* work of art) focuses the profound concerns of an historical moment. Yet the scholar's discriminating gaze is not only differentiated from that of most modern gallery-goers, it is probably very unlike the distracted glances of the majority of the original exhibition audience.

Scholarship seeks to place the art of the past within an historical narrative—a narrative which takes a number of forms. British art history has tended to be dominated by the monograph, a form in which meaning (at least in the crudest variants of the type) is produced as an effect of the artist's personality or intentions. More sophisticated monographs displace the artist's personality and intentions in varying degrees but continue to index works to the agency of their producers. Most period studies have been orientated to artists and their works. The artist's audience are usually unspoken partners in the exchange which produces meaning. Yet the narratives within which that first audience placed its artistic experience are necessarily very different ones from ours. After all, it is likely that most of those who visited exhibitions approached the display with an attitude neither reflective nor profound. The nature of the experience of the exhibition visitor or the purchaser of pictures is something about which we can only speculate, but speculate about it we must, if we are concerned with the effects of pictures on their original users. It is some of the evidence about the social ritual of the exhibition space, and the way this mediated the effects of pictures, that I wish to consider in this essay.

In the absence of a public gallery devoted to modern British art, the exhibition was the place in which art was given its most public definition in the early nineteenth century (fig. 11). In attempting to evoke the experience which occurred there, I have no resources but the representations of exhibitions in the contemporary press. These representations are necessarily interested views. The periodical press was a textual space in which several types of discourse came together: political commentary, reports of accidents and bankruptcies, fashionable news, and reviews of the theatre, literature, and the arts.[2] Although the text of the periodicals is frequently somewhat heterogeneous, these different discourses inform one another in varying degrees. Art criticism was framed by political statements and frequently functioned as a mode of cultural critique. But then art and politics are unlikely to have been discrete aspects of experience for the exhibition visitors. I am not suggesting that the reviews give us any direct access to the experience of the exhibitions, but they are an effect of that experience and the most extensive contemporary account of it to

survive. In any case, we may assume that the experience of the exhibition was partly defined by criticism—that if criticism was an effect, it in turn was effective.[3]

I want to begin by situating the exhibition experience in the continuum of the city of London. To evoke that London, then the most modern metropolis of the world (a kind of early-nineteenth-century Tokyo), I shall draw on Southey's *Letters from England,* published under a pseudonym in 1807. The prospect of Southey's London, seen from St. Paul's, although it had nothing individually sublime about it, was sublime from scale alone. 'In every direction the lines of houses ran out as far as the eye could follow them'. The 'streets immediately within view' were 'blackened with moving swarms of men, and lines of carriages'. At ground level, they had the 'most monotonous appearance imaginable', stretching in strict parallels, the regularity of which was reinforced by the uniform brick walls, windows and doors of the houses. The extent of London made it unknowable, 'an endless labyrinth of streets'. And in the heart of that labyrinth, as at Cheapside, the crowd was remarkable both for its numbers and the determined and regular way individuals moved about their business. 'Nobody was loitering to look at the beautiful things in the shop windows', windows which were notable for their large plate-glass frontage. Displays were ever changing, as the 'ingenuity of trade and the ingenuity of fashion are ever producing something new'. Posters and advertisements abounded, and pedestrians had handbills constantly thrust upon them. The signs of commerce and luxury were everywhere.[4] In this startlingly modern urban environment, art exhibitions, whatever the ambitions of some artists to distance art from trade, were seen almost inevitably as one of a species of entertainments—as shows.

Visitors to any of the city's major exhibitions went to those parts where crowds were less thick than in the City of London itself and where trade was less in evidence. They went to Somerset House on the Strand, to the British Institution at 52 Pall Mall, to the Society of British Artists in Suffolk Street (off Pall Mall), or the Water-Colour Societies' exhibitions, which moved around various venues on or off Pall Mall, in Piccadilly and Old Bond Street. The major exhibitions thus took place among or near the capital's major public buildings in the City of Westminster.

It seems clear that the social rituals of these different exhibition spaces were qualitatively distinct. To begin with, while it was a common criticism at the time that the Royal Academy was not a properly public institution, it was housed from 1780 in the major public building of George III's reign (Somerset House), along with other academic bodies and government offices. The situation of the Academy inevitably linked it with the authority of the state,[5] but, run by mere artists, its status was somewhat ambiguous despite its Royal Charter. The British Institution situated near the royal palaces also offered

opulent surroundings and explicitly excluded artists from its management. With royal patronage and a substantial number of the nobility in its directorate, it could hardly fail to become 'the favourite morning lounge of our fashionable amateurs', as *The Morning Post* put it in 1806.[6] The Institution came to represent a critique of the limitations of the Academy; and, although many academicians exhibited there, it was seen by some as an assertion of patronal authority. For liberal critics it could also serve as a symbol of the shortcomings of government policy on the arts.

The Water-Colour Societies and Society of British Artists inevitably attempted to dignify their wares through lavish decor, private views, and dinners. But it was impossible for them to compete in social tone with the Academy and the Institution. Not only were they run by artists, they were artists who were by definition not academicians and who operated them like a stock company. Landscape and genre painters tended to dominate in their management. Water-colour was widely described as a 'humble' branch of art (despite the claims made for it in some periodicals), and it was indissolubly linked with the practice of amateurs, some of whom were also active in the Society of British Artists. The Society of Painters in Water-Colours even acknowledged its commercial function by listing the prices of works in its catalogue.

As one would expect, it was the shows at the Academy and the British Institution which received most attention in the press and which were taken as most symptomatic of the condition of British art. It is on these I shall concentrate here. In the early nineteenth century the number of visitors to Academy exhibitions was already very large. To judge from the Academy's accounts, admissions rose somewhat unevenly from 54,853 in 1805 to between a high of 91,827 and a low of 70,036 in the 1820s (figures from 1822 and 1824 respectively).[7] A further indication of the scale of the occasion and the social complexity of the crowd is that a regular entry under exhibition expenses was for the attendance of Bow Street constables to 'Keep the Peace' as the 1820 accounts put it. By comparison, the attendance at the British Institution seems to have been far less. The exhibition itself was smaller, partly because it excluded the portraits which frequently made up almost a half of the Academy's display and sometimes more. The Institution had a smaller exhibition space, and up until 1830 its shows fluctuated between a quarter and rather less than a half the size of the Academy's.[8] More than 10,000 tickets were sold for its first exhibition in 1806, and the figure fluctuated a little above this for the next two decades.[9]

Contemporary accounts suggest that attendance at both occasions was socially mixed. In 1806 *The Edinburgh Review* referred to the 'motley multitude' which flocked to exhibitions.[10] Ten years later the conservative *New Monthly Magazine* compared visitors to the British Institution's 'Old Masters' exhibitions with those of the spring show as follows:

We have been on every visit delighted with the respectful and attentive demeanour of the company of the British Institution; when the same rooms were filled with portraits, gewgaws, and indifferent battle pieces, they were the morning lounge of military fops from St. James Street, and the idle gaping of *all classes,* but the persons who now visit them are of a more refined cast, and seem in some degree to partake of the superiority of the pictures they behold.[11]

Of course the term 'all classes' should not be taken literally, but it does indicate that aristocracy, gentry, and different ranks of the bourgeoisie came together in the crowds. This was one of the implications of the status of exhibitions as urban entertainments—they could not depend on an exclusive audience alone if they were to be profitable.

One consistent feature of reviews in newspapers and magazines across the political spectrum is comments on the fashionable presence at exhibitions. Whether or not this presence was viewed with approval depended on the political stance of the periodical concerned. Conservative periodicals, those which were most satisfied with the contemporary social order, tended to represent exhibitions and their audiences most favourably. To give some instances, in 1806 the *Oracle* newspaper observed of the Academy show:

The EXHIBITION ROOMS were crowded during the whole of yesterday. About three o'clock the blaze of beauty was at its meridian, and admirable as are the exertions of our most esteemed Artists, the promenading groupes of Fair Originals seemed to afford certain Connoisseurs more pleasure in the examination, than all the glowing effects of the pencil.[12]

Such statements appeared frequently in *The Morning Post,* a consistently conservative paper directed at an aristocratic readership. In 1807 it commented on the 'great number of fashionable visitors' at the British Institution and continued:

he must be an enthusiastic admirer of Painting, who will not allow his attention to be occasionally diverted from the beauties of the art on the walls, to the natural animated beauties who honour the Gallery with their presence. It has been often observed, that female charms are never seen to more advantage than in the Exhibition at Somerset House: the remark may be justly extended to the British Gallery....[13]

Such comments not only neatly illustrate assumptions about the gender of the newspaper reader, they also suggest that for this interpellated reader, part of the pleasure of the exhibition experience may have been of the same sort as that provided by any other fashionable occasion.

Periodicals which were critical of the social and political establishment generally found both the display of wares and the rituals of the audience in front

of them less pleasing. Indeed the two were seen as mutually expressive—as Hazlitt observed caustically of the Academy exhibitions in 1814: 'Is it at all wonderful, that for such a succession of connoisseurs such a collection of works of art should be provided…'.[14]

Hazlitt's comment appeared in *The Champion,* a prominent Sunday paper with liberal leanings, and within the liberal press generally the fashionable presence was much criticised as an improper distraction from the serious contemplation real art demanded. In 1816 *The Champion* described the Academy as 'one of the gay spring-amusements of the metropolis', which was 'at present' only 'a little eclipsed by the Bazaars'.[15] Elsewhere it referred to it as a 'gaudy chaos'.[16]

Complaints that the exhibition ambience encouraged mediocrity, flashy meretricious effects, and banal subjects were frequent. Here is Hazlitt again, writing this time in the liberal Sunday paper, *The Examiner:*

> The artists have not time to finish their pictures, or if they have, the effect would be lost in the superficial glare of that hot room, where nothing but rouged cheeks, naked shoulders, and Ackermann's dresses for May, can catch the eye in the crowd and bustle and rapid succession of meretricious attractions, as they do in another hot room of the same equivocal description.[17]

Hazlitt is comparing the exhibition room to a brothel, and this of course reveals that there was a distinctly gendered element to the critique of fashion. The ideal spectator was the intellectual male.

Even some publications which were essentially conservative in their overall position, such as Ackermann's *Repository of Arts* and *The New Monthly Magazine,* were critical of the exhibition experience. For instance, in 1818 *The New Monthly Magazine* acknowledged there were works of merit at the Academy but claimed that 'by far the greater number are imbecile and unworthy productions, and ought to have been rejected'. After making similar comments in a review of 1827, the magazine observed that all the exhibition bodies seemed to select works 'almost as much with a view to the mere attraction and gratification of the vulgar gaze and curiosity, as to the merit of the work exhibited, and the encouragement of the best energies of the rising artist',[18]—a statement which, consonant with the magazine's conservative politics, attributes the deficiencies of the display not to the fashionable presence, but to that of those lowest in the social hierarchy of visitors.

Even when the audience was described as attentive, the quality of its attention was often found lacking. In some instances the naïvety of the audience is contrasted with the profound responses of the critic. Thus, in 1810 *The Morning Herald* observed:

In walking round the…Exhibition at Somerset Place, there is no circumstance more amusing, to an *intelligent individual,* than that affectation of criticism, which prevails in all comers and quarters, among the more shallow part of the visitors. The old and the young, the grave and the gay, of both sexes, are all furnished with tablets, and *affecting* to write annotations and criticisms upon subjects of which they have no knowledge themselves, and of course utterly incapable of communicating it to others.[19]

The figure of the ignorant visitor became a stereotype of criticism and one necessary to license its functions. Such visitors always flocked to the most popular works. In 1821 *The London Magazine,* probably the most intellectual general magazine of the period, described 'the exquisites of criticism' surrounding Martin's *Belshazzar's Feast* at the British Institution 'three deep'—it was necessary to wait an hour to see the picture. The comments of these 'fancied connoisseurs' balanced 'dogmatism' with 'emptiness and folly'. The year before, the same critic had evoked 'a parcel of chuckleheaded Papas, doting Mammas, and chalk-and-charcoal-faced misses' 'riding upon one another's backs' to see Wilkie's *Reading of the Will,* not to study the expressions of the faces but to wonder at the 'brass clasps of the strong box'. The business of the professional commentator on the arts, as defined in *The London Magazine,* was with art which was 'neglected and misunderstood' because of the intellectual limitations of the public. The 'obvious and the palpable' he implied was lacking in value.[20]

In this period comments on the deficiencies of the growing public for art and literature were made by commentators from across the political spectrum of those who represented the propertied classes—from conservatives such as Payne Knight and Coleridge to the Benthamite Radicals, the avant-garde of bourgeois ideology. Although their solutions to what they perceived as the problem differed, they were agreed that its cause lay largely in the commercialisation of literature and art.[21]

The aspect of the exhibition display in which this commercialisation was most clearly signified was the predominance of portraits at the Academy. In 1820 John Scott, writing in *The London Magazine,* described the impact of the exhibition room as follows:

we must confess, that, on getting to the top of the Academy stair, and coming full in the way of that flood of brilliancy which streams from the frames and colours of so many whole lengths…it seemed as if we were committing an unjustifiable intrusion on a number of ladies and gentlemen, whose gowns and coats, wigs, ringlets, and rosy cheeks, concern themselves very much, but have very little relation to Fine Art.[22]

It should be noted that, whatever the intellectual grounds of Scott's critique here, it can also be read as manifesting an effect of exclusion. The portraits of

fashionables which lined the best places on the Academy's walls interpellated an ideal spectator—a select group among those assembled in front of it. Those who did not belong to the same class as that ideal spectator would presumably have been made to feel the inferiority of their rank. For liberal critics such paintings were not representations of individuals; rather they were 'portraits of velvet robes, satin gowns, dandy coats and gaudy regimentals'—that is, they were representations of the display of rank through dress and thus displays of rank in their own right with no redeeming aesthetic aspect.[23]

The predominance of portraits for many critics signified the limitations of patronage—that the wealthiest section of the audience was not interested in the higher functions of art. In 1821 *The Champion* complained: 'The purse of patronage is open only for the transcript of an unmeaning face, and the chronicle of modes and fashions—the patient presentation of the capricious skill of tailors and dress-makers'.[24]

For a liberal paper like *The Champion* portraits of the upper ranks of society had no value in themselves. For the conservative *New Monthly Magazine* the problem was not the images of such persons but of 'multitudes of men, women, and children' who were given a 'momentary notoriety to which they [were] not entitled by birth or attainments' through the 'prostitution of the pencil'. Images of the warrior who had served his country were legitimate but not those of the 'shopkeeper' or the 'fop'.[25]

In 1817 a review in *The Champion* asserted:

The walls of Somerset House are now deplorably stocked with insulted canvass:—It is in this precious temple of art that painters hang out the banners of Mammon;—and it is here that the creatures of high-life crowd to gaze at flashes of red and yellow, and to compliment each other on their own gaudy countenances.

The exhibition proved that art had become but 'a dashing and heartless appeal from the hands of painting-tradesmen to the affectations and whimsicalities of fashionable men and women'.[26]

Somerset House is like a market or a shop, and it is a fitting setting for the creatures a commercial society produces, and who throng to disport themselves there. But if fashion was generally represented as an effect of commercial societies in contemporary political discourse, the connection was not an unbreakable one. For the radical bourgeoisie, fashion was produced by the idleness of aristocratic society, and those who led industrious lives were less likely to succumb to its lure. However, for critics who took such a position there remained the problem that the outlook generated by commercial societies was inherently materialistic—that they generated a preoccupation with gain above all qualitative values. Exhibitions could thus signify the commercial character of British society in another way than through the image of a corrupt landed

elite. They could signify it through the dominance of mundane subjects and what was perceived as the absence of imaginative power. This response is exemplified by the effect of the Academy's display of portraits as reported by the Benthamite *London Magazine* in 1828: 'The loyal and domestic character of the English nation eminently stares one in the face on the walls of Somerset House;—the sense of property and self-respect is everywhere inculcated...'.[27] The 'routine' art of the Academy 'smacks somewhat of the city; is steeped a little in the mud of the Thames'.

The variety of the responses I have been describing can certainly be attributed partly to the interests of the critics. But the critics addressed an ideal reader who they presumed would recognise the experiences they described; they presumed that the exhibition would signify the same ideas for a section of the audience. The images of the exhibitions offered depended mainly on the political complexion of the journal concerned. They ranged from accounts of them as gracious scenes of high life in a setting dignified by distinguished images of the great and good, to scathing descriptions of art arrayed like goods in a shop, and of a social ritual before it, which, rather than being centred on reflection and contemplation, was primarily preoccupied with personal display and status differentiation.

One of the main concerns of the modern sociology of taste from Thorstein Veblen onwards has been the functions of art and cultural acquirements in defining social class and legitimating status hierarchies.[28] In the early nineteenth century these functions were no mystery of ideology. Commentators such as Humphry Repton and Martin Archer Shee observed that paintings were primarily viewed as 'furniture' and 'ornaments' used to 'distinguish the taste, the wealth, and dignity of their possessors'.[29] In 1824 the Benthamite *Westminster Review* described the elite of rank and wealth as a small class who regarded themselves as 'Somebodys' and the rest of society as 'Nobodys'. The 'Somebodys' had assumed the privilege:

> of having a circle and taste exclusively their own; of keeping at a distance any Nobody who dares approach; and at the expense of the excluded class, indulging in all the pleasure of arrogance and malignity; trampling with as much contempt on the necks, as it were, of their pursuits, opinions, and wishes, as the sovereign of Ashantee does on the nape of his sable attendants.[30]

The *Westminster* was here commenting primarily on the functions of the literary culture inculcated in public schools and universities, but the argument also applied to the visual arts. Some of the evidence I have discussed suggests that art exhibitions were a place in which this phenomenon of exclusion was made palpable and manifest. We may imagine them as social spaces in which personal encounters were governed by that subtle but rigid pattern of conventions

distinguishing rank which the novels of Jane Austen evoke—where some were acknowledged and others were not, where some were ignored and others did the ignoring, where some looked and others averted their eyes, where some were embarrassed. The hostility of critics of the liberal press to the fashionable presence may be understood as representing their objections to this use of art's public space.

I do not claim that paintings functioned only as a mode of status differentiation. Neither am I suggesting that we should base our account of the meanings of art works solely on what was said about them in exhibition reviews. However, I am suggesting that we should take the evidence of the reviews seriously when we try to assess the effects and functions of early nineteenth-century art. This evidence suggests that the impact of paintings on the cognitive faculties of the original exhibition audience was in most instances a small one—that the aesthetic judgement of that audience was not sophisticated and that it did not look for subtle or difficult meanings in works. I would suggest that this has important implications for how we construe the ideological effects of paintings. While it does not mean that we should cease to treat some paintings as important symbols of contemporary ideological contradictions, it does indicate that we should not confuse their status as such with their original effects. Those who study the early nineteenth century know that it was not Constable's *Landscape, Noon* which exhibition visitors crowded round in 1821–22;, it was pictures which have received nothing like the same degree of art historical attention, such as Martin's *Belshazzar's Feast*, and Wilkie's *Chelsea Pensioners Reading the Waterloo Dispatch*. While we may continue to treat Constable's picture as a profound cultural symbol, the fact is that, on the evidence available, it was not one for most of his contemporaries.

An important and related point is that exhibitions as ensembles signified more powerfully than the individual works on display, and those individual works which did stand out were framed by an ensemble which determined their effect. Generally speaking, it was not single art objects which focused conflicting political interests, but rather the institution of art as a public symbol of the social and political order. It was the social functions of art, in this sense, which brought into play the antagonism between the manners and values of the 'aristocracy' and the 'middling classes'.

In relation to the theme of this conference, what we may discover from the critical responses to the exhibition phenomenon is the emergence both of a new type of bourgeois public for art, which treated it primarily as a source of simple pleasures, and of a fraction of the intelligentsia, critics, who insisted that art should be the source of a profound moral and intellectual experience—an experience which the conditions of commercial society prevented artists from producing and the audience from having.

This essay is based largely on materials and arguments drawn from my book *Landscape Imagery and Urban Culture in Early Nineteenth-Century Britain* (Cambridge: Cambridge University Press, 1992).

1. For the changing meanings of 'art' see Raymond Williams, *Keywords: A Vocabulary of Culture and Society* (London: Fontana Paperbacks, 1983).
2. On the periodical press in this period see Stephen E. Koss, *The Rise and Fall of the Political Press in Britain,* vol. 1 (London: Hamish Hamilton, 1981–84); John Olin Hayden, *The Romantic Reviewers, 1802–24* (London: Routledge and Kegan Paul, 1969); Alvin Sullivan, ed., *British Literary Magazines: The Romantic Age, 1789–1836* (Westport, Connecticut: Greenwood Press, 1983).
3. The status of the art critic, like that of other journalists, was not a high one. Within the periodical press itself there were frequent complaints as to the partiality and ignorance of critics. A representative example is a spoof letter in the first number of *The Weekly Literary Register* ('Original Communications', 6 July 1822), written by a fictitious would-be contributor, Horace Handy, who offered to write on a range of subjects: 'But, supposing your arrangements are so made as not to allow me scope as a general contributor, may I request one subject entirely to myself? I mean the Fine Arts….My own utter ignorance of any thing connected with the art will not, I presume, incapacitate me in your estimation. That such is not the result to individuals similarly circumstanced, I am well aware.'
4. Robert Southey, *Letters from England,* ed. Jack Simmons (London: The Cresset Press, 1951), 153, 70, 49–50, 78, 51.
5. For a contemporary perception of Somerset House as a public building, see Victoire, Comte de Soligny (P. G. Patmore), *Letters on England* (London, 1823), 1:23: 'This is the only public building in London which can be said to have any pretensions to the character of grandeur and magnificence…'.
6. 'British Gallery', *The Morning Post,* 7 April 1807. On the British Institution see Peter Fullerton, 'Patronage and Pedagogy: The British Institution in the Early Nineteenth Century', *Art History* 5, no. 1 (March 1982).
7. These estimates are based on receipts of £2,742.13.0d., £4,591.7.0d., and £3,501.16.0d. respectively. I am grateful to the Royal Academy of Arts, London, for allowing me access to the account books of 1769–1819 and 1819–49.
8. For example, the respective numbers of exhibits at the British Institution and the Academy in selected years were as follows: 1806: 257, 938; 1810: 318, 905; 1815: 235, 908; 1820: 323, 1,072; 1825: 415, 1,072; 1829: 541, 1,223.
9. This estimate is based on figures for exhibition receipts in the Institution's Minute Books in the library of the Victoria and Albert Museum.
10. Review of *An Analytical Inquiry into the Principles of Taste,* by Richard Payne Knight, *The Edinburgh Review* 7 (June 1806): 302.
11. 'Review and Register', *The New Monthly Magazine* 6, no. 1 (August 1816) (my emphasis). The 'battle pieces' referred to here were probably the sketches for paintings of the Battle of Waterloo, which had been shown at the spring exhibition that year. The 'military fops from St. James Street' may have attended partly because officers of the guard at St. James's were admitted to the exhibition free since the brigade on duty provided 'centinels' outside the exhibition room.
12. 'Royal Academy', *The Daily Advertiser, Oracle, and True Briton,* 7 May 1806.
13. 'British Gallery', *The Morning Post,* 23 May 1807.
14. 'Fine Arts. Whether They Are Promoted by Academies and Public Institutions', *The Champion,* 28 August 1814, 11 September 1814, 2 October 1814. Reprinted in

P. P. Howe, ed., *The Complete Works of William Hazlitt* (London and Toronto: J. M. Dent and Sons, 1930–34), 18:46.

15. 'The Exhibition at the Royal Academy', *The Champion,* no. 175 (12 May 1816). At this time *The Champion* was edited by John Scott and pursued rather idiosyncratic liberal politics. It was fiercely critical of the Academy, which it represented as a corrupt institution, symptomatic of a larger condition of corruption in the upper ranks of English society. On Scott see Josephine Bauer, *The London Magazine, 1820–29* (Copenhagen: Rosenkilde and Bagger, 1953).

16. 'Royal Academy, No. V', *The Champion,* no. 441 (16 June 1821). For other statements on the 'chaos' of the display and the predominance of portraits, see 'National Gallery of Arts', *The Literary Chronicle,* 15 July 1820. The exhibitions were also likened to a 'kaleidescope'—see 'Exhibition of the Royal Academy', *Repository of Arts, Literature, Fashion, and Manufactures, &c.,* 2nd ser., 13 (June 1822).

17. 'The Catalogue Raisonné of the British Institution', *The Examiner,* no. 462 (3 November 1816). Reprinted in Howe, ed., 18:106. Cf. Preface to *Annals of the Fine Arts* 3 (1818): 5; 'Exhibition of Pictures', *The Parthenon, A Magazine of Art and Literature,* no. 1 (11 June 1825): 8–9. Both these latter publications represented what may be regarded as the beginnings of the specialist art press.

18. 'Exhibition at Somerset House', *The New Monthly Magazine,* no. 53 (1 June 1818); 'British Institution', *The New Monthly Magazine,* April 1827. For comments in the *Repository of Arts* on exhibition displays, see 'Exhibition of the Royal Academy', 2nd ser., 1 (1 June 1816); 'Exhibition at the Leicester Gallery', 2nd ser., 7 (1 April 1819).

19. 'Royal Academy', *The Morning Herald,* 2 May 1810. The pretensions of criticism are set out particularly clearly in a review of the Royal Academy in the *Oracle* of 2 May 1807: 'A just critique may be considered as a glass, without which the higher beauties of painting are not perceivable; for it is ridiculous to imagine, that uninformed minds can discover, by what is titled natural taste, "abnormis sapiens", the great points of art, any more than they can by the same natural taste, understand a passage of HOMER.'

20. 'The British Institution', *The London Magazine,* 1st ser., 3 (April 1821); 'On the Exhibition at Somerset House', 1st ser., 3 (June 1820); 'Exhibition at the Royal Academy', 1st ser., 4 (July 1821). The author of these criticisms was in fact T. G. Wainewright, later to gain notoriety as a multiple murderer. For Wainewright see Jonathan Curling, *Janus Weathercock: The Life of Thomas Griffiths Wainewright, 1793–1837* (London: Thomas Nelson and Sons, 1938); W. C. Hazlitt, ed., *Essays and Criticisms of Thomas Griffiths Wainewright* (London, 1880). For *The London Magazine* see Bauer, 1953.

21. Samuel Taylor Coleridge, *Biographia Literaria,* Everyman, ed. George Watson, (London and New York: J. M. Dent and Sons, 1956), 21, 28, 33–34; John Stuart Mill, 'On the Present State of Literature' (1827–28) in Edward Alexander, ed., *J. S. Mill: Literary Essays* (Indianapolis: Bobbs-Merrill, 1967).

22. 'The Exhibition at the Royal Academy', *The London Magazine,* 1st ser., 1 (June 1820).

23. 'Royal Academy, No. V', *The Champion,* no. 441 (16 June 1821). This review was probably written by John Thelwall.

24. 'Royal Academy', *The Champion,* no. 436 (12 May 1821). Cf. 'Fine Arts', *The Literary Chronicle,* no. 208 (10 May 1823). Such statements may be contrasted with *The Morning Post*'s comment on the portraits at the 1815 Academy show (24 April 1815): 'We witness with feelings of reverence, admiration, and national pride, the most perfect resemblances that art can produce, of many of the

illustrious and distinguished characters, to whose firmness, talents, and valour, our country is mainly indebted for the preeminent advantages she enjoys.'

25. 'Exhibition of the Royal Academy', *The New Monthly Magazine,* no. 29 (1 June 1816).

26. 'Royal Academy', *The Champion,* no. 227 (11 May 1817).

27. 'The Exhibition of the Royal Academy', *The London Magazine,* 3rd ser., 1 (June 1828). To explain such comments, it is important to note that Philosophic Radicalism is not synonymous with the doctrine of 'economic man' associated with Ricardian political economy; it centred around deep concern with individual rights and human happiness, whatever criticisms one may make of its programmes to realise these ends. On Benthamism and the arts see George L. Nesbitt, *Benthamite Reviewing: The First Twelve Years of the Westminster Review, 1824–1836* (New York: Columbia University Press, 1934), and my article, 'Genius, Gender and Progress: Benthamism and the Arts in the 1820s', *Art History* 16, no. 4 (December 1993).

28. Thorstein Veblen, *The Theory of the Leisure Class* (London: Allen and Unwin, 1970), 98. This subject has been explored at considerable length by Pierre Bourdieu. See particularly his *Distinction: A Social Critique of the Judgement of Taste* (London and New York: Routledge and Kegan Paul, 1984).

29. Humphry Repton, 'Sketches and Hints on Landscape Gardening' (1795) in J. C. Loudon, ed., *The Landscape Gardening and Landscape Architecture of the Late Humphry Repton, Esq.* (London, 1840), 95.

30. Review of *Tales of a Traveller,* By Geoffrey Crayon, Gent., *The Westminster Review* 2, no. 4 (October 1824): 335.

The British School and the British School

John Gage

The transformation of the notion of an artistic 'school' from meaning the followers of a particular artist or studio in early seventeenth-century Italy to connoting something like a national style, around 1800, would be an enlightening subject for study, and one of the landmarks would probably be Gavin Hamilton's *Schola Italica Picturae* of 1773, a collection of magnificent engraved plates which was given some sort of coherence by confining itself to the painters of the High Renaissance and the classical revival in early-seventeenth-century Rome. But the British situation at the time of Hamilton's publication was, of course, a very different one; and it is noticeable that throughout the eighteenth century there was a reluctance among British commentators to identify a 'British School' of painting in concrete terms. Bainbrigge Buckridge's *Essay towards an English School of Painters* of 1706 was no more than a series of brief lives, appended to those of foreign masters collected by Roger de Piles; and it is remarkable that de Piles, as late as the close of the seventeenth century, although he was able to identify fairly easily the characteristics of the German and Flemish 'goût', could find none for the French, since, as he said, the painters of France had been too diverse and too dependent on their training in the various centres of Italy.[1] Buckridge felt no comparable qualms, but his own use of 'school' is no less problematic, since most of his 'English' artists were foreigners, or had at least been trained outside this country, and their styles have little in common.

Dr. Johnson, reviewing the efforts of the Society of Arts to promote British painting by competitions in the late 1750s, was still very tentative, speaking of the 'honest emulation' which would 'give beginning to an English School';[2] and, most surprisingly of all, the founding President of the Royal Academy, in the eulogy of Gainsborough which occupied so much of his fourteenth *Discourse* in 1788, could still speculate that: 'If ever this nation should produce genius sufficient to acquire to us the honourable distinction of an English School, [Gainsborough would be] among the very first of that rising name'.[3]

So when, in 1802, an exhibiting society appeared in London under the bald title *The British School,* it should arouse rather more interest among historians of British art than it has so far enjoyed; I want in this essay to arouse this interest by giving a brief account of the institution as well as to assess how far it can be said to have circumscribed a national school of artists.

The British School was, not surprisingly, noticed by Whitley in the first volume of *Art in England;* but until very recently, and very typically for British

art-institutions, it has not been the subject of any substantial analysis.[4] It was a society founded for the sale and exhibition of works of painting, sculpture, drawing, and engraving by three men; the young technologist George Field, who claimed to have been the prime mover; the Anglo-Irish landscape painter William Ashford, who seems to have provided some contacts, expertise, and, most important, funds; and the marine painter John Thomas Serres, whose chief role was probably to make contact with artists and patrons including, since he had a court appointment, the Prince of Wales, who became Patron of the School. The School was to be sustained by up to fifty 'Proprietaries' or shareholders, about whom we have virtually no information; an indefinite number of Life Patrons, among whom were several members of the Royal Academy and many prominent collectors who were later to form the British Institution of 1805; and an equally indefinite number of Annual Subscribers, including many Academicians and other artists who exhibited at the School.[5]

The first exhibition opened with a fashionable flourish in October 1802 in a gallery on Berners Street in the artists' quarter off Oxford Street, near what is now Tottenham Court Road. It appears to have been a great success; so much so that, early the following year, a series of premiums was offered for paintings, from £60 for the best historical picture to £40 for the best landscape or marine and £25 for the best '*fancy head* or Portrait of a public Character'. Exhibits could be shown for at least three months but not longer than a year. The second exhibition, for which the Victoria and Albert Museum seems to hold the only surviving catalogue of the more than three hundred and fifty works shown, opened in May 1803; but by the end of that year Serres was going through one of his periodic financial crises and was forced to resign his directorship, although not without leaving a burden of debts for his fellow directors to clear. Field and Ashford tried to carry the School alone, but they were not able to sustain the expense of the exhibitions beyond the spring of 1804, by which time the number of exhibited works had risen to above five hundred.

So much for the truncated history of the enterprise, but what was the character of the works it showed? As both George Field in his *Prospectus* and John Serres in the speech with which he opened the first exhibition stressed, *The British School* was to be distinguished from the Academy, which at that time was the only other exhibiting society in the country, by its emphasis on sales: '...as the Royal Academy provides for the honor of the Artist, so it is hoped that this Institution will complete a desideratum, by contributing to his emolument, and extending his reputation'.[6] The emphases suggest that the Academy was seen as not having served artists as well as it should; that it was regarded rather as a sort of parade-ground on which the patron-classes could admire each other—at the Exhibition, the Annual Banquet, and so on—and that other, more intrinsic functions like teaching were being neglected, as indeed they were. The School was nonetheless well supported by members of

the older institution, although the point about emolument was reinforced by the fact that many of the works exhibited in Berners Street had already been seen on the walls of Somerset House. John Downman R.A., for example, a Life-Subscriber to the School, showed seventeen works during the course of the second exhibition, fifteen of which had been shown at the Royal Academy as long ago as 1782 and as recently as 1802 (e. g. fig. 12). The character of the *British School* exhibitions was indeed very much that of the Academy Summer Exhibitions, with the exceptions that the School was not concerned with architecture, that few portraits were admitted, and that, on the other hand, there was a great emphasis on engraving, which was seen to be particularly highly developed in eighteenth-century Britain, and which was, of course, especially helpful to the European reputation of British painters (fig. 13).[7] It would thus be very difficult to characterise the modern British art exhibited at the School in any way that would suggest that it was peculiarly representative of British style.

But *The British School,* again anticipating the British Institution, and unlike the Academy, showed a certain interest in exhibiting British 'Old Masters', and we know both from Field's *Prospectus* and from Serres's *Discourse* that this was a very central part of the School's programme. Field identified the foundation and progress of the Academy as 'dignifying the Arts in this country, and establishing its Professors as those of a specific School';[8] and Serres expanded on this point in a more theoretical vein:

> For the information of the younger admirers of the Fine Arts, permit me to remark, that in the different countries in which they flourished each possessed a different manner or style, and were particularly distinguished by the appellation of the different Schools; namely, the Roman, Florentine, Bolognese, Venetian, Dutch, Flemish and French. *Neglected* England was not, at that *time,* considered worthy of being classed among them, although, in the minds of *no* mean judges, equally *deserving,* particularly with the latter [i.e. the French].

After mentioning the names of a few of the leading artists in each School, and very few of the French ('a mediocrity of merit'), Serres argued that *originality* was the ruling characteristic of the British; and he concluded by noting that examples of works by Reynolds ('the Prince of Painters') and the 'sublime' Wilson were before his audience and might be joined in their minds by Hogarth, Kneller, Lely, Thornhill, Scott, Gainsborough, Brooking, Taverner, (Ebenezer) Tull, Mortimer, Hamilton, and Wheatley, as well as by Serres's own father Dominic, who, like Samuel Scott and Charles Brooking, had been a marine specialist.[9]

Running through both the *Prospectus* and the *Discourse* is a sense that British artists are to measure themselves chiefly against the French; and we

fig. 12

John Downman, *Edwin and Emma,* 1780, oil on canvas, 17¼ x 23¼ in. (43.8 x 59 cm.)
Sold at Christie's, 21 March 1975 (126)

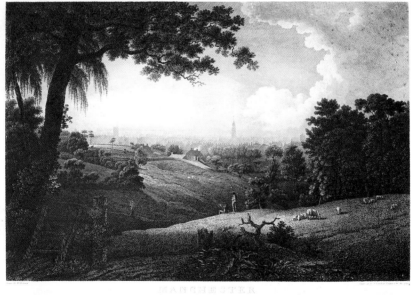

fig. 13

John Landseer after W. M. Craig, *Manchester from Mount Pleasant,* 1802
Etching and engraving, 12 x 16 in. (30.5 x 40.7 cm.), Manchester Central Library

are reminded that in the autumn of 1802 many were returning with their first impressions of Continental modern art in a France made accessible again by the Peace of Amiens and were busily turning this experience to the task of defining the characteristics of the French and English Schools.

Serres's list of British 'Old Masters' was not an entirely predictable one, and it is not easy to support it with evidence from the *British School* exhibitions themselves because of the incomplete documentation provided by the single surviving catalogue and the reviews. Hogarth was represented by one work in the 1803 exhibition, the Earl of Iveagh's *Taste in High Life* (1742) (fig. 14); and among other genre artists were Edward Penny R.A., whose *City Shower,* also exhibited in 1803, had first been seen at the Society of Artists in 1764 (fig. 15), and Francis Wheatley R.A., who had died only the year before the opening of the School (fig. 16). Theatrical genre was represented by William Hamilton R.A., who had also died in 1801.[10] Given the importance of genre in the spectrum of eighteenth-century British painting, and its prominence among the deceased as well as the living artists shown at *The British School,* it is somewhat surprising that the Directors offered no prize in this category of painting. This is perhaps a further sign of the influence of Reynolds and his condemnation of the vulgarity of low-life subjects in *Discourse* III (1770), although he had of course revised his opinion of Hogarth somewhat by 1788 and was a particular admirer of Gainsborough's sentimental genre.

It would be unrealistic to suggest that the presentation of the historical 'British School' could have been entirely coherent or representative; nor are we at present fully informed about which works by deceased artists were seen at the School's exhibitions. The early history of many of these works is unknown, and many others have proved impossible to identify by their titles alone. Some, if not all, were clearly loans from private collectors: it is, for example, quite likely that some of the five Gainsboroughs shown in 1803 with all too general titles were loaned from the collection of the dealer Noel Desenfans, an Annual Subscriber, whose former Gallery was now the home of the School; or of the Third Earl of Egremont, who was a Life Subscriber and two of whose Gainsborough landscapes now at Petworth may have been owned by him as early as this date; or of J. W. Steers, another Annual Subscriber and also a considerable collector of Gainsborough, who in the late 1790s was hoping to exchange one of his cattle subjects (a type recorded at *The British School*) with Sir George Beaumont, a Life Subscriber.[11] Steers and Egremont were mentioned by Serres in his *Discourse* as among the most prominent sponsors of modern art.[12] Another 'Old Master', Richard Wilson, whom Field saw as among those who would 'bear immortal testimony of British merit in the Polite Arts', was also perhaps introduced into the School's exhibitions by Life Subscribers such as the Duke of Northumberland or Dr. John Wolcot, a critic and collector who had been the painter's special friend. It may have been

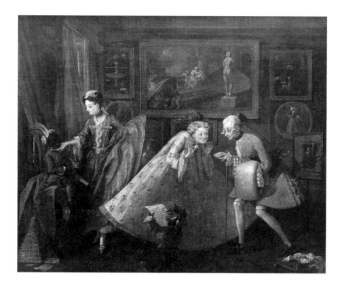

fig. 14
William Hogarth
Taste in High Life, 1742
Oil on canvas, 24¼ x 29¼ in.
(61.6 x 74.3 cm.)
Private collection

fig. 15
Edward Penny, *A City Shower,* 1764
Oil on canvas, 29¼ x 24¼ in. (74.3 x 61.6 cm.)
Museum of London

fig. 16
Francis Wheatley, *Returning from Market,* 1786
Oil on canvas, 29½ x 24½ in. (74.9 x 62.2 cm.)
Leeds City Art Galleries

Northumberland's version of Wilson's *Syon House* (his own seat) which was No. 463 in the 1803 exhibition and Wolcot's *Kew Gardens: The Pagoda and Bridge,* now at the Yale Center for British Art (fig. 17), which was No. 103.[13]

We do by chance have some information about the way in which the 'loan' element in the *British School* exhibitions functioned. John Bannister, the art student turned comic actor, who is one of the more familiar minor patrons and collectors of the period, and who was an Annual Subscriber to the School, had acquired Reynolds's late *Madonna col Bambino* at one of the President's posthumous sales in 1796. He had paid £68.5s for it, but sent it to the School in 1803 priced at 250 guineas. Egremont offered him 200 guineas for it but on the advice of Sir William Beechey R.A., also a Life Subscriber, agreed to meet Bannister's price, as he wrote to Serres: 'The more I look at Sir Joshua's Madonna, the more I am convinced that it is one of the finest pictures that ever were painted, in any age, and well worth the price Mr Bannister first put upon it'.[14]

Although the picture is now a wreck and can only be appreciated in J. R. Smith's fine mezzotint (fig. 18), which was also on show at *The British School* in 1803, this pastiche of Corregiosity became one of the best-known of Reynolds's 'historical' subjects, since Egremont and his heir lent it to the British Institution once every ten years from the time of the Reynolds Retrospective in 1813 until 1843. One of the President's rare landscapes was also exhibited at the School in 1803, and, given John Downman's close association with the institution, it is very possible that this was the 'picture' he had cut out of a Reynolds portrait in 1796 and which Farington noted 'is an excellent specimen of Sir Joshua's landscape painting'.[15]

But perhaps the most interesting of the 'Old Master' paintings to be shown at *The British School* was a group of four works by John Hamilton Mortimer, including three of his most important historical or poetic subjects: *Sir Artegal* (fig. 19), one of the versions of *The Death of Orpheus,* with a landscape by Thomas Jones, and, most extraordinary of all, *Sextus Applying to Erictho to Know the Fate of the Battle of Pharsalia,* now known only in the engraving by Robert Dunkarton. We saw that Serres regarded originality as the chief characteristic of the British School of painting, and Field, too, in his *Prospectus* had argued that '…indeed it would be a reproach to a people, whose characteristic is originality, if in these Arts alone they were deficient of that peculiar excellence which distinguishes'.[16]

Mortimer had, of course, made a profession of originality, and these paintings were, not least in their clear debt to Salvator Rosa, among the most original of his productions. Only the *Sextus* has a provenance reaching back beyond 1803, and even it disappears after a Christie's sale of 1791 and the *British School* exhibition. But *The Death of Orpheus* and *Sir Artegal and Talus the Iron Man* both appear for the first time in the collections of Life Subscribers to the

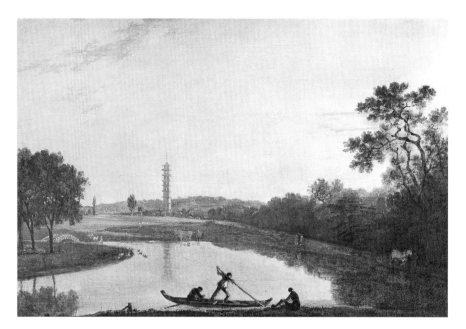

fig. 17
Richard Wilson, *Kew Gardens: The Pagoda and Bridge,* 1762
Oil on canvas, 18¾ x 28¾ in. (47.6 x 73 cm.)
Yale Center for British Art, Paul Mellon Collection

fig. 18
John Raphael Smith after Sir Joshua Reynolds
Madonna col Bambino, 1791
Mezzotint, proof before letters
20⅜ x 14⁵⁄₁₆ in. (51.7 x 36.4 cm.)
Cambridge, Fitzwilliam Museum

School, respectively J.W. Steers, whom we have encountered in connection with Gainsborough, and Sir Thomas Bernard, who went on to become the leading figure in the forming of the British Institution two years later. We may suppose that Steers and Bernard either lent their Mortimers like Bannister (or Richard Payne Knight, who lent, but did not propose to sell, one of his favourite Westalls) or, like Egremont, acquired them from the *British School* exhibition.[17]

Allowing for a degree of randomness in the choice of deceased masters to represent the developing British School of painting, and for the incompleteness of our knowledge of what stood for that 'School' in the *British School* exhibitions, we can at least see that the Directors did not expect to present a homogeneous style; indeed, their emphasis on 'originality' led them into an extreme manifestation of that *Stilpluralismus* which marks so much of the art of the Romantic period. In this it may be distinguished from the notions of Englishness developing among the artists returning from France, who, if we are to judge from the conversations recorded by Farington, were generally concerned to set British painterly preoccupations against French emphasis on drawing. On 29 September 1802, for example, Farington recorded the report of the Anglo-French artist Masquerier that:

> the best pupils of David held the English School in contempt, supposing it to possess nothing but *colouring* and *effect,* which they hold to be very inferior requisites of the Art. They think the picture of Cardinal Bentivoglio by Vandyke to be very inferior to a Portrait of General Murat in the French Exhibition painted by Gerard, which they say is much better drawn & finished in every part.[18]

Carle Vernet's drawing was admired by the English,[19] and so was David's drawn study for the *Sabines,* which was contrasted with the hardness of the painting.[20] And when one English visitor, Alderman Combe, observed on September 3 that 'whatever might be thought of the modern French Exhibition, it was very superior to what was seen in England', John Opie R.A. 'roundly asserted the contrary'.[21]

What seems clear is that *The British School* was an enterprise spurred equally by professional self-consciousness, commerce, and patriotism: as Field put it euphorically in his *Prospectus*:

> Peace is again shining, with benign influence, in every quarter of the Globe, with Plenty in her train: the Arts, pursued by the rage of War, have taken refuge, and found succour alone in this United Kingdom, which now stands the first in the world for Riches, Arts and Commerce. This is the auspicious crisis for the British Artist to distinguish himself: already the first in his Age, it may be our own fault if he is not among the first in all Ages; but to attain such ends, he requires the fostering hand of

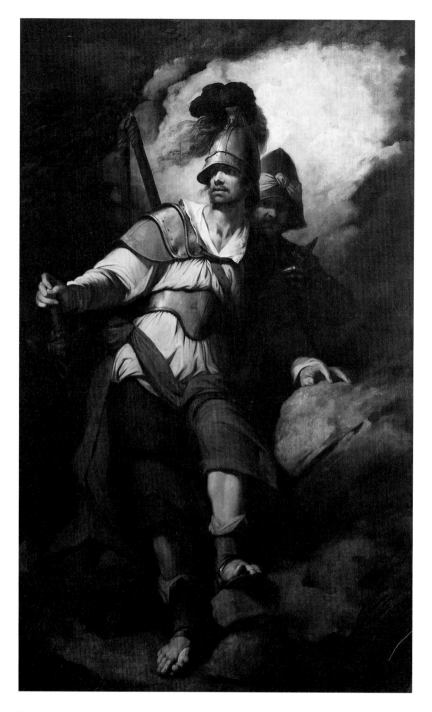

fig. 19
John Hamilton Mortimer
Sir Artegal the Knight of Justice with Talus the Iron Man, 1778
Oil on canvas, 93 x 57 in. (236 x 145 cm.)
London, Tate Gallery

Patronage, an intercourse with his Contemporaries and their works, publicity for his own, and celebrity for the School to which he belongs.[22]

The emphasis on patronage is important and is one of the many ways in which the School was the ancestor of the British Institution, which launched a very similar programme in 1805.[23] But by that date, perhaps because of the notorious misfortunes of Serres and the fate of the School, the patrons of the new institution, many of whom had, as we saw, been Subscribers to the earlier society, decided to do without the advice and the self-help of artists and take matters entirely into their own hands.

1. Roger de Piles, *L'Ideé du Peintre Parfait* (1699), cited here from the reprint in André Félibien. *Oeuvres* (1725), 6:102ff. (facsimile with a Preface by Anthony Blunt, 1967).
2. *The Idler,* no. 45 (February 1759), cited by John Sunderland in 'Samuel Johnson and History Painting', *Journal of the Royal Society of Arts* 134 (1986): 835; Morris R. Brownell, *Samuel Johnson's Attitude to the Arts* (Oxford: Clarendon Press, 1989), 47–48.
3. Sir Joshua Reynolds, *Discourses on Art,* ed. Robert R. Wark (New Haven and London: Yale University Press, 1975), 248.
4. William T. Whitley, *Art in England, 1800–1820* (1928; reprinted New York: Hacker Art Books, 1973), 1:45–48; John Gage, *George Field and His Circle: From Romanticism to the Pre-Raphaelite Brotherhood* (Cambridge: Fitzwilliam Museum, 1989), 9–10.
5. *Abstract of the Plan and Conditions of the British School* (1803), 18 (copies at the Courtauld Institute and the Yale Center for British Art).
6. George Field, *Prospectus and Catalogue of the British School...,* 2nd ed. (London, 1803), 14 (copy at the Courtauld Institute); see also John Thomas Serres, 'Discourse Delivered on the Opening of the Institution', ibid., 30.
7. On the role of engraving at the School, see John Gage, 'An Early Exhibition and the Politics of British Printmaking, 1800–1812', *Print Quarterly* 6 (1989), esp. 126–28.
8. Field, *Prospectus,* 11. See Reynolds, *Discourse* IX (1780), 169: 'It will be no small addition to the glory which this nation has already acquired from having given birth to eminent men in every part of science, if it should be enabled to produce, in consequence of this institution, a School of English Artists'.
9. Serres, 'Discourse', 31–32. 'Hamilton' is probably William Hamilton R.A., who had died in 1801 but several of whose works were shown at both the 1802 and the 1803 exhibitions. Ebenezer Tull, 'the English Ruysdael' (1733–c.1762), was a close imitator of Gainsborough's landscapes.
10. A stray proof sheet of the catalogue, now among the Field mss. at Messrs. Winsor and Newton, and probably from the first catalogue of 1802, shows that Hamilton's *Mrs. Wells in 'The Merry Wives'* (also R.A. 1789, no. 81) and *Kemble in 'Richard III'* (also R.A. 1788, no. 22)) were included.
11. The Desenfans Gainsborough is now at Minneapolis—John T. Hayes, *The Landscape Paintings of Thomas Gainsborough: A Critical Text and Catalogue Raisonné*, 2 vols. (London: Sotheby Publications, 1982), no. 33. There are two landscapes with similar subjects at Petworth (Hayes nos. 115, 178). For Steers and

Beaumont, see the entry for 23 April 1797 in *The Diary of Joseph Farington,* ed. Kenneth Garlick and Angus Macintyre (New Haven and London: Yale University Press, 1979), 3:826 (see Hayes nos. 75, 124).

12. Serres, 'Discourse', 35.

13. For the Northumberland painting, see W. G. Constable, *Richard Wilson* (Cambridge: Harvard University Press, 1953), 185; and for the Kew, David H. Solkin, *Richard Wilson: The Landscape of Reaction* (London: Tate Gallery, 1982), no. 98.

14. John Adolphus, *Memoirs of John Bannister, Comedian* (London, 1839), 2:197–99. The history of the painting, still at Petworth in a ruined condition, according to C. H. Collins-Baker—*Catalogue of the Petworth Collection of Pictures…,* (London: The Medici Society, 1920), no. 334—omits this episode and identifies the Egremont canvas with that in the sale of another Life Subscriber to *The British School,* Caleb Whitefoord, in 1810, where it was bought by the dealer Spackman for a mere nine guineas and allegedly sold to the Third Earl. The price suggests that this must have been a copy of Bannister's picture; another copy, by William Collins, was sold at the Collins sale in 1847.

15. *Diary of Joseph Farington,* 2:557 (26 May 1796).

16. Field, *Prospectus,* 11–12.

17. For the Mortimers, see John Sunderland, *John Hamilton Mortimer: His Life and Works, Walpole Society* 52 (1986), nos. 35, 51, 136. The Steers connection with no. 35, *The Death of Orpheus,* makes it likely that it was this version, rather than that now at the Yale Center for British Art (no. 35a) which was the work shown at *The British School.*

18. *Diary of Joseph Farington,* 5:1825 (29 September 1802).

19. Ibid., 5:1882 (28 September 1802).

20. Ibid., 5:1840 (8 September 1802).

21. Ibid., 5:1825 (3 September 1802).

22. Gage, *George Field,* 9.

23. Peter Fullerton, 'Patronage and Pedagogy: The British Institution in the Early Nineteenth Century', *Art History* 5, no. 1 (March 1982): 59–72.

In Search of the 'True Briton':
Reynolds, Hogarth, and the British School

Martin Postle

> We shall speak first of Hogarth, both as he is the first name in the order
> of time that we have to boast of, and as he is the greatest comic painter of
> any age or country…. Criticism has not done him justice, though public
> opinion has.[1]

Today it is quite natural to begin an account of British art with Hogarth. And
yet when William Hazlitt wrote his essay, 'The Progress of Art in Britain' for
the *Encyclopaedia Britannica* of 1817, he was being deliberately contentious.
Although beloved by the public, in the opinion of writers on art Hogarth was
a prodigy who had little long-term influence on British art. According to
them, the founder of the British School was Sir Joshua Reynolds, first Presi-
dent of the Royal Academy and author of the *Discourses on Art*. This essay
explores the ways in which the posthumous reputations of Reynolds and
Hogarth were shaped by a variety of interests during the period 1792 (the year
of Reynolds's death) and 1830 (the year of William Hazlitt's death). On a
broader level the intention is to show how, during the post-Revolutionary
period, successive self-appointed arbiters of taste sought to condition the para-
meters of British high visual culture according to their own political—as well
as artistic—interests.

William Hogarth died on 25 October 1764. *The St. James's Chronicle* report-
ed: 'Last night died, suddenly, after being very chearful [*sic*] at Supper, at his
House in Leicester Fields, the celebrated William Hogarth Esq.'. The state-
ment was repeated by several other newspapers, although no obituary was
forthcoming.[2] Twenty seven years later, on 23 February 1792, Sir Joshua
Reynolds died. He had been seriously ill for several years and had spent his
final months in considerable physical pain.[3] In the week following his death a
number of reports appeared in the newspapers observing how he had 'surveyed
death with the fortitude of a philosopher and the piety of a christian'.[4] Only
two days after his death Reynolds's close friend Edmund Burke wrote that his
'illness was long, but borne with a mild and cheerful fortitude, without the
least mixture of any thing irritable or querulous'.[5] Burke's comments may have
been influenced by a rumour, then circulating, that Reynolds had in fact been
severely depressed towards the end of his life.[6] Of minor importance in its
own right, Burke's desire to promote Reynolds's personal stoicism in the face
of death—and in the face of contrary opinion—signalled the beginning of a
protracted campaign on behalf of those to whom the apotheosis of Reynolds

fig. 20
Sir Joshua Reynolds, *Count Ugolino and His Children in the Dungeon,* 1773
Oil on canvas, 49¼ x 69⅞ in. (125 x 176 cm.), Private collection

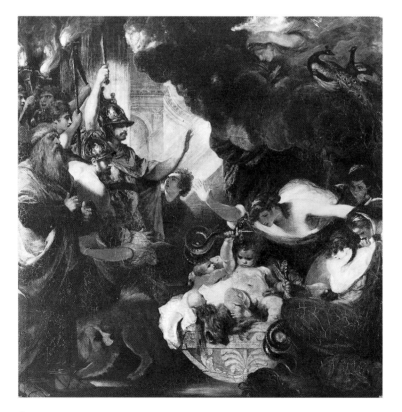

fig. 21
Sir Joshua Reynolds, *The Infant Hercules Strangling the Serpents,* 1788
Oil on canvas, 119¼ x 116⅞ in. (303 x 297 cm.)
St. Petersburg, The State Hermitage Museum

was essential to the retrospective formulation of the history of the British School.

Reynolds's principal activity as a painter had been portraiture. During the 1790s, however, its importance within his oeuvre was eclipsed by the promotion of his subject paintings, which were in turn used as the platform on which to ground Reynolds's posthumous reputation. While the mass of portraits which had guaranteed Reynolds's livelihood were virtually ignored, pictures such as *Ugolino and His Children in the Dungeon* (fig. 20) and *The Infant Hercules Strangling the Serpents* (fig. 21) were continually used as testimony of Reynolds's commitment to High Art. Published checklists of Reynolds's oeuvre invariably began with subject pictures, while the portraits included were either clearly allegorical or those such as *Lord Heathfield* (National Gallery) which had achieved the status of 'confined' history paintings.[7] The above scale of values was reflected by the prices fetched for Reynolds's works in the auction houses, where the sums bid for subject paintings far exceeded portraits. In 1796 a full-length portrait of *Mrs. Carnac* was sold at Greenwood's for seventy guineas, while a much smaller portrait of Miss Morris fetched 150 guineas. The difference in price may be accounted for by the fact that Miss Morris's portrait had been exhibited in 1769 as a subject picture entitled *Hope Nursing Love.*[8]

Although there was, in general, a tacit agreement over the ordering of Reynolds's oeuvre, views differed widely on his personality and opinions—especially in view of the changes which had taken place in France since his death. Here, the political affiliations of the various protagonists, rather than their artistic preferences, were of paramount importance—as one can see by comparing the attitudes of the radical Irish artist, James Barry, and the conservative English Shakespearean scholar, Edmond Malone. James Barry had, during the 1770s and 1780s, continually baited Reynolds in the Academy and through the press over the President's perceived lack of commitment to the establishment of history painting in England. During the 1790s, however, he emerged perversely as one of his principal apologists. As he told the assembled students of the Royal Academy shortly after Reynolds's death:

> nothing can exceed the brilliancy of light, the force and vigorous effect of his picture of the Infant Hercules strangling the serpents; it possesses all that we look for, and are accustomed to admire in Rembrandt, united to beautiful forms, and to an elevation of mind, to which Rembrandt had no pretentions....[9]

As the decade moved on and Barry's own feud with the Royal Academy intensified, so his remarks about Reynolds became increasingly wedded to his own views. A vigorous supporter of the French Revolution, Barry—an Irish Catholic—emphasised Reynolds's own allegiance to the traditions of French

art, even linking his name with that of Jacques-Louis David 'and his noble fellow-labourers in that glorious undertaking'.[10] As Barry's rage against the Royal Academy intensified, so his adherence to the memory of Reynolds grew. 'Alas! poor Sir Joshua? how many melancholy consequences have taken place since your removal?', he asked rhetorically, in reference to the current regime at the Royal Academy; while, in the context of his argument to secure the Duke of Orleans's collection for the Academy, he stated nostalgically 'Poor Sir Joshua, God be with him; were he living he could find a remedy'.[11]

Edmond Malone, unlike Barry, had always maintained a deep respect for Reynolds. A close friend, he had been also an executor of the artist's will. In 1797 Malone published *The Literary Works of Sir Joshua Reynolds*. Principally intended as a compendium of Reynolds's writings, the book also contained a lengthy character appraisal in order to show 'something of the man as well as the painter'.[12] Reynolds's pictures were not discussed other than the provision of a list of the subject paintings, their owners, and the prices paid for them.[13] Malone, like Reynolds, was a friend of Edmund Burke, and like Burke had taken up a more conservative position with regard to the French Revolution. (He described France as 'that OPPROBRIOUS DEN OF SHAME, which it is hoped no polished Englishman will ever visit'.)[14] Interestingly, one of Malone's aims was to demonstrate that Burke's views—as set out in his *Reflections on the Revolution in France*—had been anticipated by Reynolds, stating that 'long before that book was written [Reynolds] frequently avowed his contempt of those 'Adam-wits' who set at nought the accumulated wisdom of ages, and on all occasions are desirous of beginning the world anew'.[15] Some years later William Blake wrote in his copy of Malone's *Literary Works,* 'this book was Written to serve political purposes'.[16]

Both Barry and Malone shaped Reynolds's reputation to their own ends, although there was substance in each viewpoint. Given Reynolds's deep respect for tradition, and for Edmund Burke, there is little doubt that he would have distanced himself from the new French artistic and political regime. And yet, Barry was correct to stress Reynolds's affinity to contemporary European art and his belief in a supranational artistic community. Only a few years earlier— in 1790—Reynolds had resigned as President of the Royal Academy, at least in part over the refusal of the Council to elect the Italian architect, Joseph Bonomi, as Professor of Perspective. Indeed, the notes Reynolds made at the time revealed his anxiety that Academicians had based their judgement on racial grounds. 'I reminded the Academicians', wrote Reynolds, 'that...our neighbours, the French, behaved with more liberality and good sense'.[17]

The promotion of Reynolds's image as the quintessential patriot was consolidated in the early nineteenth century through the efforts of Sir George Beaumont. Despite Beaumont's seminal role in the creation of the National Gallery, and his newly-found reputation as 'one of the most enlightened

British patrons', he was until the late 1790s a tangential figure on the British cultural scene.[18] As a member of Parliament he was a fellow-traveller, while as a patron of the arts he was—despite his enthusiasm—skittish. Nonetheless, by 1800 Beaumont was, alongside Sir John Leicester, Sir John Angerstein, and Charles Long, among the most influential arbiters of British artistic taste.

In celebration of Beaumont's plans for a series of retrospective exhibitions of the work of British artists, in 1801 William Sotheby (1757–1833) published *A Poetical Epistle to Sir George Beaumont, Bart., on the Encouragement of the British School of Painting*. The tenor of the poem was fiercely jingoistic:

> Ah, woe for Britain! if her youthful train
> Desert their country for the bank of Seine!
> Ah, woe for Britain! if insidious Gaul
> Th'attracted artist to her trophies call.[19]

Like Malone, Sotheby also made play of the link between the contribution of art and the national economy:

> Beaumont! (the Arts thus speak), oh urge thy ain:
> Trade, freedom, virtue, vindicate our claim.[20]

In the pantheon of past British artists cited by Sotheby, Reynolds received the greatest attention. ('Hail! guide and glory of the British School / Whose magic line gave life to every rule'.[21]) Several stanzas were devoted to the history paintings, *Macbeth* and *The Infant Hercules*. Hogarth's entire achievement was summarised in two lines:

> Satire and sense, on Hogarth's tomb reclin'd,
> Shall point the ethic painter of mankind.[22]

Beaumont, who had known Reynolds in old age, combined a reverence for the memory of the artist with a belief in the institutional promotion of high art, binding the two together with an appeal to patriotic fervour and commercial enterprise. Indeed, these elements explain to a high degree the reasons why Reynolds's subject pictures were regarded as a viable nexus for the British School. They also explain why these pictures also became a target for those who resented the patrician, proprietorial stance of Beaumont's self-appointed 'Committee of Taste'.

In 1805 under the aegis of Beaumont and his associates, the British Institution was founded in order to promote the cause of an indigenous school of art. Although relations between the British Institution and the Royal Academy were cool, both organisations were agreed that Reynolds was central to any concept of a British School—as lectures given at the Academy by J. M. W. Turner reveal. Of all Reynolds's apologists none spoke more passionately or sincerely than Turner, whose lecture notes bristle with patriotic praise for the

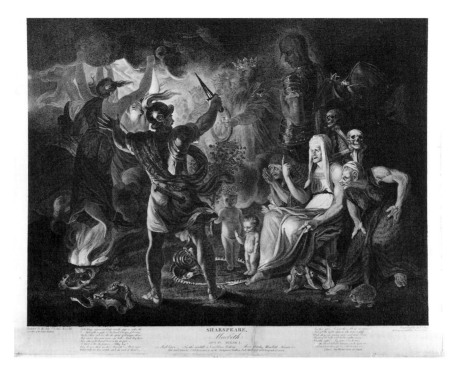

fig. 22
Robert Thew after Sir Joshua Reynolds, *Macbeth and the Witches,* 1802
Stipple engraving, 24¾ x 19⅜ in. (63 x 49.2 cm.), London, British Museum

fig. 23
Leonardo da Vinci after Vitruvius
The Proportions of the Human Figure, 1492 (detail)
Pen and ink, 13½ x 9⅝ in. (34.3 x 24.5 cm.)
Venice, Accademia Galleries

man he termed the 'greatest ornament of the British School'.[23] Turner's determination to demonstrate Reynolds's intellectual affiliation to the Old Masters emerges in his comparison between the 'half-extinguished light in the Resurrection, by Rembrant [*sic*]' and the 'agonised and Livid tone of Ugolino'.[24] Similarly he notes in Reynolds's conception of Macbeth 'the very geometric problem mentioned by Vitruvius…that a figure whose Arms are raised to their utmost Elevation and the legs extended, the whole would produce a circle'[25] (figs. 22, 23).

Another Royal Academician who upheld Reynolds's reputation as a history painter was John Opie—although the contrast between his private views and public statements is intriguing. In 1798 Opie wrote the entry on Reynolds for a new edition of the Reverend Matthew Pilkington's *Gentleman's and Connoisseur's Dictionary*. Although quite complimentary, the essay contained a surprising attack on Reynolds's failure to provide a proper lead to English history painters, rejecting the two standard excuses for Reynolds's relative inattention to the genre:

> First 'that he adopted his style to the taste of his age'. But ought not a great man, placed at the head of his art, to endeavour to lead and improve the taste of the public, instead of being led and corrupted by it? Secondly, 'that a man does not always do what he would, but what he can'. This, whatever truth there may be in it, certainly comes with an ill grace from the mouth of ONE who constantly and confidently maintained in his own writings, 'that by exertion alone every excellence of whatever kind, even taste, and genius itself, might be acquired'.[26]

Opie presumably allowed himself licence to write so freely about Reynolds's shortcomings because the dictionary entry was penned anonymously.[27] In any case, he was far more positive about Reynolds in the series of lectures he delivered as Professor of Painting at the Royal Academy in 1807. In his second lecture he selected Reynolds's *Death of Cardinal Beaufort* (fig. 24) as a valid alternative to works of art which had only a transient, populist appeal. In praising the 'varied beauties' of the picture, Opie explained that its lack of popularity was due not to any intrinsic flaws but to the increasingly debased taste of the public. 'It is no wonder', he opined, 'that this work of our great painter has been condemned without mercy, by a set of cold-hearted, facsimile connoisseurs who are alike ignorant of the true and extensive powers of art'.[28] It was the growing awareness among artists and connoisseurs—highlighted by Opie—of a new public, uninterested in the elusive qualities of British history painting, which provided the fulcrum for future debates on the merits of Reynolds and Hogarth and their relative positions within the canon of British art.

fig. 24
Sir Joshua Reynolds, *The Death of Cardinal Beaufort,* 1789
Oil on canvas, 84⅞ x 62¼ in. (218 x 158 cm.)
Petworth, National Trust (Egremont Collection)

From the late 1790s to the end of the first decade of the nineteenth century, the commonly accepted platform for a British School of art had been built jointly on Reynolds and the Royal Academy. In the introduction to his *Dictionary of Painters, Sculptors, and Engravers* of 1810, John Gould gave a comparative analysis of the 'English School' with those of Rome, Venice, and France. 'The English School', maintained Gould, was 'connected with the Royal Academy, in London, instituted in 1766 [*sic*]'.[29] As a corollary he affirmed that the 'English School of painting must acknowledge Sir Joshua Reynolds as its great founder, under Royal auspices, in the establishment of the Academy'.[30] Although Hogarth's name appeared in the body of Gould's dictionary, he did not feature in the introductory essay on the establishment of the English School. No mention either was made of George Romney—who had consistently snubbed the Royal Academy—nor of George Stubbs or Joseph Wright, neither of whom held the Academy in very high esteem.

By 1810 William Hogarth had been dead for nearly fifty years. As a consequence there was nobody still alive who could write about him from personal experience. Indeed the standard entry in successive editions of Pilkington's *Dictionary* (and in that of John Gould) was taken from Horace Walpole's *Anecdotes of Painting in England* of 1780.[31] Since that time there had been little attempt to re-evaluate Hogarth's reputation, which was that of a comic-print maker who was regarded with affection, if not overwhelming respect. Indeed, more recent writers, including the Shakespearean scholar George Steevens, John Nichols, and John and Samuel Ireland, had all endorsed Walpole's opinion. Even Georg Christian Lichtenberg, stated Nichols, 'although a German, looked at him completely through the medium of wit'.[32] Hogarth's reputation had been shaped by individuals whose interest lay primarily in print dealing and collecting. Hitherto no separate evaluation of his paintings had been made.

Reynolds was regarded as a moral paradigm by virtue of his character. Hogarth's merits were allied to his 'modern moral subjects'. And despite the general appeal of Hogarth's pictorial narratives to the strictures of the Protestant work ethic, his direct characterisation of the subversiveness of the mob, the venality of politicians, and the lax morality of the aristocracy and gentry must have been unsettling for a society which sought to promote its cultural and moral superiority. And while Hogarth's 'modern moral subjects' supposedly improved the mind, John Thomas Smith at least (Keeper of Prints and Drawings at the British Museum) did not believe that 'the man who was so accustomed to visit, so fond of delineating, and who gave up so much of his time to the vices of the most abandoned classes', was in truth a 'moral teacher of mankind'. 'My father', Smith added darkly, 'knew Hogarth well, and I have often heard him declare, that he revelled in the company of the drunken and profligate'.[33] There was, in addition, concern over Hogarth's lack of education.

It was evidenced most bizarrely in the Reverend Edmund Ferrer's *Clavis Hogarthiana* of 1817, a book which strung together miscellaneous snippets from Horace's *Ars Poetica* and other classical texts to illustrate Hogarth's modern moral subjects and which was subtitled 'illustrations from Hogarth: i.e. Hogarth illustrated from passages in authors he never read, and could not understand'. Whereas today Hogarth's deep affinity with the classical tradition is accepted, most early-nineteenth-century commentators would have agreed with Reynolds's statement in the fourteenth *Discourse* that 'our late excellent Hogarth, who, with all his extraordinary talents, was not blessed with a knowledge of his own deficiency; or of the bounds which were set to the extent of his powers'.[34]

In 1811 Charles Lamb published an article entitled 'On the Genius and Character of Hogarth' in the radical periodical *The Reflector*.[35] The article was a watershed in the critical evaluation not only of Hogarth's reputation but that of Reynolds. One of the aims of *The Reflector*, according to editor Leigh Hunt, was to promote 'an uncommon ardour for the British School of Painting'. The ostensible aim of Lamb's essay was to elevate Hogarth beyond the status of a 'mere comic painter'—at the expense of Reynolds. 'It is the fashion', he noted, 'with those who cry up the great Historical School in this country, at the head of which Sir Joshua Reynolds is placed, to exclude Hogarth from that school as an artist of an inferior and vulgar class'.[36] And while Lamb stated that he had 'the highest respect for the talents and virtues of Reynolds', he was aggrieved that 'his reputation should overshadow and stifle the merits of such a man as Hogarth'.[37] Not content with defending Hogarth, Lamb took the unusual step of pitting one of Hogarth's modern moral subjects—*A Rake's Progress*—against two of Reynolds's history paintings, as he compared Hogarth's characterisation of Tom Rakewell (fig. 25) with that of Ugolino and Cardinal Beaufort. 'I would like to ask the most enthusiastic admirer of Reynolds', he wrote:

> whether in the countenances of his *Staring* and *Grinning Despair*, whether he has given for us the faces of Ugolino and the dying Beaufort, there be any thing comparable to the expression which Hogarth has put into the face of his broken-down rake in the last plate but one of the *Rake's Progress*.... When we compare the expression in subjects which so fairly admit of comparison, and find the superiority so clearly to remain with Hogarth, shall the mere contemptible difference of the scene of it being laid in the one case in our Fleet or King's Bench prison, and in the other in the State Prison of Pisa, or the bedroom of a Cardinal...so weigh down the real points of the comparison, as to induce us to rank the artist who had chosen the one scene or subject...in a class from which we exclude the better genius...with something like disgrace?[38]

fig. 25
William Hogarth, *The Rake in Prison* (*A Rake's Progress* 7), c. 1733
Oil on canvas, 24½ x 29½ in. (62.2 x 74.9 cm.)
London, by courtesy of the Trustees of Sir John Soane's Museum

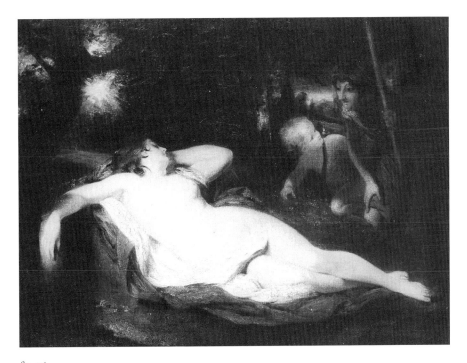

fig. 26
Sir Joshua Reynolds, *Cymon and Iphigenia,* 1789, oil on canvas, 56⅜ x 67¾ in. (143.2 x 172.1 cm.)
The Royal Collection © Her Majesty The Queen

Lamb was making two distinct points. First, he claimed that—contrary to current opinion—Reynolds's subject pictures were inferior to those of Hogarth. Secondly, he believed that the prevailing canon in British high art was far too slavishly in favour of existing hierarchy of genres and paid scant attention to indigenous responses to art, which valued the real above the ideal. Lamb concluded by affirming that far from fostering vulgarity Hogarth, alongside his literary contemporaries Fielding and Smollett, 'prevent that disgust at common life…which an unrestricted passion for ideal forms and beauties is in danger of producing'.[39]

Lamb was acutely aware that in promoting Hogarth above Reynolds he was not simply questioning the relative merits of two British artists or the prevailing artistic hierarchy. He was also implicitly challenging what he perceived to be the deep-seated prejudices within the political and artistic status quo. And the parliamentary reform which both Lamb and Hunt sought was reflected in the stranglehold which they felt the Tory-based establishment had on the visual arts. Indeed, Lamb's comparison between Hogarth's mundane London gaol and Reynolds's medieval Pisan prison was shortly to achieve an added poignancy as Leigh and Robert Hunt were incarcerated for libelling the same Prince Regent who had in the 1780s dispensed his patronage upon Reynolds.

In 1813, two years after Lamb's essay appeared in *The Reflector,* Reynolds's *Ugolino* and *Death of Cardinal Beaufort* were open to common inspection at a major retrospective exhibition of over two hundred of Reynolds's paintings. The exhibition, sponsored by the British Institution, was held in the British Gallery in Pall Mall (formerly the premises of Boydell's Shakespeare Gallery) and was accompanied by candle-lit private tours and a banquet attended by the Prince Regent. More significantly it was, as Joseph Farington stated, the first real test of Reynolds's reputation since his death, since when 'almost a new generation had risen up, whose taste had been formed upon works that had been exhibited to the public since his time'.[40] The Tory press warmly endorsed the exhibition, *The Morning Post* stating that the 'dictionary of praise would be exhausted before we could express the pleasure we experienced in viewing this noble collection', and *The Observer* concluding that it would 'for ever set at rest the question which by some has been so strangely raised as to the competency of Sir Joshua Reynolds to the attainment of excellence in the highest department of art'.[41] The exhibition also spawned a poem by the staunchly conservative Academician, Martin Archer Shee. Published in 1814, *The Commemoration of Reynolds* celebrated the high moral tone of Reynolds's art. Of *Cymon and Iphigenia* (fig. 26), which Reynolds's niece presented the same year to the Prince Regent, Shee wrote:

Distaining all the coarse allures of sense
A polished archness sports without offence,

Aspires to touch with chaster hand the heart,
And hits the mark—but not with poisoned dart.[42]

'No opportunity', continued Shee in an accompanying footnote, 'should be lost, to guard the honourable purity of the British School from this foreign pollution: to hold up to contempt and detestation, an offence which degrades the noblest of Arts to an immoral engine of the most pernicious influence, and sinks the painter and his patron, to the same level of vulgar depravity'.[43] Shee was surely unaware that Reynolds had used as his model for Iphigenia the body of an ageing prostitute.[44]

In 1814 a second retrospective was held by the British Institution of works by Gainsborough, Hogarth, Wilson, and Zoffany (although Richard Payne Knight questioned the inclusion of Zoffany, as he was not a 'British painter'[45]). Hogarth was represented by the series paintings, *A Rake's Progress*, *Marriage à la Mode*, and the *Election* series, plus twelve other works. Since Hogarth's work had so scrupulously characterised the appearance and habits of his contemporaries, it was perhaps inevitable that early-nineteenth-century viewers thought his pictures looked dated, John Nichols remarking several years later that the 'preposterous and tasteless costume of the period, both in dress and furniture, which from our not being accustomed to it in real life, gives to his figures a grotesque and antiquated air'.[46] In common with others he felt that the contemporary Scots painter David Wilkie was far more natural in his characterisations. William Hazlitt—who was to emerge as Hogarth's principal apologist—considered that (with the exception of *Marriage à la Mode*) 'Mr Wilkie's pictures are in general much better painted than Hogarth's'.[47]

The previous year Hazlitt had reviewed Hogarth's paintings at the British Institution in *The Morning Chronicle*. Although an admirer of Hogarth's graphic work, Hazlitt was critical of the quality of his paintings and virtually oblivious to his originality as a colourist—as indeed most of the artist's contemporaries had been.[48] Like many commentators Hazlitt judged Hogarth's free handling of pigment in the light of Wilkie's polished performances, as well as their seventeenth-century Dutch precedents. The *Election* series of 1754—which he believed to be a comparatively early work—was, he said 'very little above the standard of common sign painting'. *Marriage à la Mode* of 1743 (which he thought was later), however, 'in richness, harmony, and clearness of tone, and in truth, accuracy, and freedom of pencilling, would stand a comparison with the best productions of the Dutch School'.[49] Unlike Lamb, Hazlitt did not seek to elevate the supposed vulgar aspects of Hogarth to the status of high art. As he noted elsewhere, he would rather 'have never seen the prints of Hogarth than have never seen those of Raphael'.[50] It was presumably for this reason that he defended Hogarth's widely ridiculed history painting *Sigismunda*, which he asserted was 'delicate in the execution, and refined in the

expression, at once beautiful and impassioned, and though not in the first, probably in the second class of pictures of this description'.[51]

Hazlitt was an enigmatic blend of radical and conservative. Born in 1778, he was steeped in the traditions and mores of the eighteenth century. In 1796 he proclaimed his three favourite writers to be Burke, Junius, and Rousseau, while on a visit to the Louvre in 1802 he complained to his father of being 'condemned to the purgatory of the modern French gallery while queuing to inspect Napoleon's assemblage of looted old-masters'.[52] As the son of a minister from a large and comparatively well educated family, Hazlitt's background was in some ways quite similar to Reynolds's own. Indeed, his brother John, who was a miniaturist, had studied in Reynolds's studio, while Hazlitt himself had entertained genuine ambitions of becoming a portraitist. Although initially on the fringes of Sir George Beaumont's circle, by 1808 Hazlitt migrated to the more avant-garde company of Charles Lamb and the brothers Robert and Leigh Hunt. Resolutely bourgeois, they regarded their frequent literary gatherings as free-spirited and egalitarian and, as Hazlitt later recalled, 'abhorred insipidity, affectation, and fine gentlemen'.[53] By 1812 Hazlitt saw his future as lying in journalism rather than painting, securing a post on the Whig newspaper, *The Morning Chronicle*. From the outset his pieces—including an assault on Thomas Lawrence—were outspoken, and his contract was shortly terminated. It was as correspondent of the radical newspaper, *The Champion*—to which he transferred in the summer of 1814—that Hazlitt began to question the pre-eminence of Reynolds.

Although Hazlitt clearly admired Hogarth more than Reynolds, as a journalist it was to be expected that he devoted far more time to pulling Reynolds from his pedestal than promoting Hogarth. In any case, Hazlitt's argument was not simply with Reynolds but with the control over British art-patronage exercised by the Royal Academy and the British Institution. The polarity he exploited between Hogarth and Reynolds was, in a sense, a projection of his own position as an outsider. Hogarth the innovative prodigy was set up against Reynolds the supreme Academician, in the same way that Hazlit, the self-confessed lay-art critic set himself up against the established cognoscenti, working via instinct rather than a prescribed agenda.

In 1814 Hazlitt wrote an essay on the 'Character of Reynolds' for *The Champion*. Rather than attacking Reynolds's reputation directly, Hazlitt chose instead to damn him with faint praise. Although he self-deprecatingly stated that 'from the great and substantial merits of the late President we have as little the inclination as the power to detract', he added bluntly that 'we certainly think that they have been some-times overrated from the partiality of friends and the influence of fashion'.[54] Hazlitt's *modus operandi* differed from that of previous critics. Previously, even when dissatisfaction with Reynolds's subject pictures had surfaced, it had been expressed in formal terms. As narrative had

mattered little to Reynolds except as the *lingua franca* of high art, it was of little concern to those who evaluated his work. Hazlitt, however, had little interest in formal arguments. In judging Reynolds's subject pictures, he stated that he would not 'attempt to judge them by scientific or technical rules, but make observations on the character and feeling displayed in them'.[55] For Hazlitt the power of the work of art depended on the way in which it conveyed its message directly to the viewer via the visual senses, not upon coded references to the Old-Master tradition which were intelligible only to an initiated elite. Hazlitt subjected Reynolds's subject pictures to the same reading as Hogarth's works. Hence, even though Reynolds had artfully based the attitude of his model for Count Ugolino upon a figure by Michelangelo, to Hazlitt he looked like 'a common mendicant at the corner of a street, waiting patiently for some charitable donation'.[56]

A month before Hazlitt first aired his views on Reynolds in *The Champion*, an anonymous review of James Northcote's recently published *Memoirs of Sir Joshua Reynolds* appeared in *The Edinburgh Review*. The author was Richard Payne Knight, then still regarded (before his misjudgement over the Elgin Marbles) as the doyen of the British art establishment.[57] An imaginative and pioneering scholar, Knight was in many ways far less traditional in his views and tastes than Hazlitt. In his review of Northcote's biography—which like most book reviews was really a platform to expound his own views—Knight professed his profound admiration for Reynolds, even asserting that he found in the artist's history paintings a lack of affectation not present in Michelangelo. By way of contrast Knight roundly condemned Hogarth's 'abortive attempts at heroic composition, into which his preposterous vanity led him …'.[58] Knight's stance was consciously autocratic. He firmly believed in the educative value of high art and believed that public money spent on the efforts of contemporary practitioners was of far greater value than ephemera such as firework displays which merely 'attract the stupid gaze of a dissolute populace'.[59]

Hazlitt's essays, written in the immediate aftermath of the Napoleonic Wars, were especially unpopular with the Tory Party. As the Tory-backed *Quarterly Review* remarked of him in 1817:

> If the creature [Hazlitt] in his endeavours to crawl into the light, must make his way over the tombs of illustrious men, disfiguring the records of their greatness with the slime and filth which marks his track, it is right to point him out that he may be flung back to the situation in which nature designed that he should grovel.[60]

Hazlitt's opinions on Reynolds were only a microcosm of his general questioning of the creation and manipulation of national heroes by the status quo, in order to further their own political and cultural goals.

Despite Hazlitt's attempts to force a re-evaluation of the accepted view of Reynolds's art, the artist's popularity among collectors remained undiminished. In 1821 the sale at Christie's of the largest existing collection of Reynolds's work—that belonging to the artist's niece Mary Palmer, Marchioness of Thomond—was greeted with enthusiasm. Benjamin Robert Haydon, who was present, noted how Reynolds's own paintings fetched larger prices than Old Masters in his collection ascribed to Teniers, Titian, and Correggio. Reynolds's sketchbooks—which are only now receiving critical attention— were the object of fierce bidding between William Herschel and Royal Academicians John Soane and J. M.W. Turner. The attention paid by Academicians to Reynolds's work was reflected once more by an address given by Sir Thomas Lawrence in 1823 at the Royal Academy on the occasion of the annual distribution of student prizes. Lawrence recalled past history painters including Barry, Fuseli, and Opie, concluding that even the lately deceased Benjamin West 'would still have yielded the chief honours of the English School to our beloved Sir Joshua'.[61] He proceeded to discuss Reynolds's achievement, reinforcing the prevalent view that works such as *Mrs. Siddons as the Tragic Muse* and *Lord Heathfield* ought to be considered as a species of history painting rather than just portraits. It was perhaps with Hazlitt's incursions in mind that Lawrence concluded by stating that 'there can be no new PRINCIPLES in art; and the verdict of ages (unshaken, during the most daring excitement of the human mind), is now not to be disturbed'.[62]

Lawrence's address to the Royal Academy was published in 1824. The same year a small octavo volume was published, entitled *Sketches of the Principal Picture-Galleries in England*. Among the pictures discussed were Reynolds's *Lord Heathfield* and *Mrs. Siddons*. Of the former painting (then in the collection of Sir John Angerstein) the author stated that it was 'well composed, richly coloured, with considerable character, and a look of nature', although the version of *Mrs. Siddons* in the Dulwich Picture Gallery (fig. 27) 'appears to us to resemble neither Mrs. Siddons, nor the Tragic Muse. It is in a bastard style of art'.[63] Hogarth's *Marriage à la Mode* was, by way of contrast, warmly and extensively praised. 'The modern moral subjects' were 'in the strictest sense, historical pictures' which, he affirmed 'will be found to have a higher claim to the title of Epic Pictures, than many which have of late arrogated that denomination to themselves'.[64] Published anonymously, *Sketches of the Principal Picture-Galleries in England* was, in fact, a compilation of articles by Hazlitt which had appeared in periodicals during the early 1820s. At the same time Hazlitt's book was published, a second anonymous guide entitled *British Galleries of Art* appeared. It was also highly uncomplimentary about Reynolds's subject pictures. Nor was it a coincidence that the author, Peter Patmore, was a friend of Hazlitt. A professional journalist, Patmore was keenly aware of the need to entertain as well as inform the viewer. The hallmark of both Hazlitt's

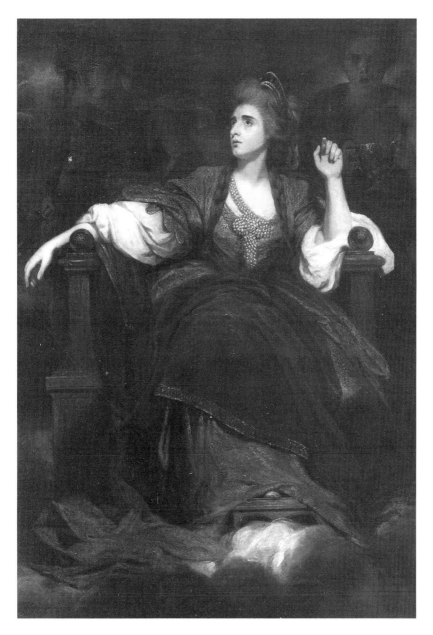

fig. 27
Sir Joshua Reynolds, *Mrs. Siddons as the Tragic Muse,* 1789
Oil on canvas, 94⅛ x 58⅛ in. (239.7 x 147.6 cm.), London, Dulwich Picture Gallery

and Patmore's gallery guides was their airy, irreverent approach. As Patmore stated in his introduction, 'in choosing the subjects for these papers, I must not forget that they are intended to be popular and amusing, rather than didactic'.[65]

Even among professed didacts there were signs by the mid-1820s that Reynolds's reputation was no longer completely intact. In 1826 William Carey published *Some Memoirs of the Patronage and Progress of the Fine Arts in England and Ireland*. Carey traced what he saw as the 'anti-British' prejudice during the late eighteenth and early nineteenth centuries among connoisseurs who were unwilling to purchase the works of native artists. Although Reynolds had made a good living from portraiture, his subject pictures, stated Carey, 'were executed for commercial men in this country and for foreigners'. With unintentional ambiguity he added that 'if Reynolds had been necessitated to struggle for a living by history painting, he must have hazarded starvation'.[66] Although an admirer of Reynolds, Carey could not conceal the fact that the apotheosis of Reynolds had undermined the wider interests of the British School. 'It is a memorable satire upon the affected taste of some of his contemporaries', he stated,

> that those chief panegyricists of Reynolds looked with indifference or contempt upon the fine moral and dramatic compositions painted by Hogarth, not withstanding their practical excellence…. [T]he grand landscapes of Wilson, and the rural scenery and rustic groups of Gainsborough, were equally overlooked and neglected by the arbiters of taste, who were the eulogists of Reynolds.[67]

Aside from the tarnishing of Reynolds's professional laurels, the mid-1820s witnessed new revelations about Reynolds's personal life. The prime mover was again Hazlitt, although in his present venture he had co-opted James Northcote. Today Northcote is best remembered as Reynolds's pupil and biographer, although before his biography of Reynolds appeared in 1813 he was known principally as a portrait and history painter in his own right. A tireless gossip, Northcote relished the association which he had had with Reynolds, especially by the mid-1820s when he was almost the only living artist who could provide firsthand information on Reynolds, stretching back almost to the foundation of the Royal Academy. And yet, although he admired Reynolds he also bore him a number of grudges which he willingly shared with anyone prepared to listen. In 1826 Hazlitt began to publish his conversations with Northcote (then aged eighty) in *The New Monthly Magazine* under the title 'Boswell Redivivus'.[68] 'All you have to do', maintained Hazlitt, 'is to sit and listen…it is like hearing one of Titian's faces speak'.[69] And yet, although Hazlitt ostensibly acted as Northcote's amanuensis, he was in fact the puppet-master, adding or omitting details according to their newsworthiness. Through

Hazlitt's conversations with Northcote various details about Reynolds's domestic arrangements emerged, including revelations about his less than generous treatment of his sister Fanny—and his long-suffering pupil, James Northcote. The cumulative effect of the 'conversations'—although they touched on many other subjects aside from Reynolds—was to de-mythologise the first President of the Royal Academy to the point that his life and art were a source of entertainment as well as instruction.

During the course of their twentieth 'conversation', published in 1829, Northcote and Hazlitt discussed the newly published first volume of Allan Cunningham's *Lives of the Most Eminent British Painters*. Neither of them professed to like it—ironically because of Cunningham's consciously populist stance.[70] In addition, while Hazlitt had often assumed the role of the layman in relation to established connoisseurs and artists, Cunningham freely admitted that he had no special knowledge of his subject but had read up all the available published information in order to transform it into a lively and unbiased narrative. The text was lively, but it was hardly unbiased, as Reynolds's art and character were severely reprimanded, while Hogarth received almost undiluted adulation. Cunningham's friend George Darley informed him that 'the painters & picture lovers are mortally offended with your Memoir …'.[71]

Allan Cunningham (1784–1842), although Scots by birth, had worked for many years in London as a critic and poet. Like Hazlitt he had received some artistic training (he continued to work in the studio of the sculptor Francis Chantrey until the latter's death in 1841). The crucial difference between the two men was that, while Hazlitt maintained a deep respect for high art and retained an appreciation of the purpose of allegory, Cunningham openly derided art which did not have its roots in the 'real world'. Perversely, Cunningham felt that Reynolds, as a portrait painter—and therefore at base a tradesman—had betrayed his roots by courting wealthy patrons. And when Reynolds raised his fees, his privileged patrons were, stated Cunningham, 'glad of the increased price, for it excluded the poor from indulging in the luxury of vanity'.[72] Cunningham's championing of Hogarth—as well as his downgrading of Reynolds's achievement—was, as William Vaughan has observed, just one aspect of the growth of a protestant entrepreneurial ethic in English art.[73] Indeed Cunningham, who was a fervent admirer of his fellow Scot David Wilkie, ironically celebrated in his life of James Barry—who had been such a vigorous opponent of the established hierarchy—the demise of high art in England and the failure of the British Institution to establish a school of contemporary history painting. Barry's heroic struggle against the Academy failed to impress Cunningham because his chosen art form was perceived as elitist and exclusive. Cunningham was equally unimpressed by Reynolds's portraits. 'The painter', he stated, 'who wishes for lasting fame must not lavish his fine colours and his choice postures on the rich and titled alone; he must seek to

associate his labours with the genius of his country'.[74] 'Fame', Cunningham insisted in his life of Hogarth, was not conferred by the dictates of patrons and connoisseurs, but was 'the free gift of the people'.[75]

When asked by Northcote where Cunningham had derived his outspoken opinions, Hazlitt told him he thought it may have been Charles Lamb.[76] Hartley Coleridge, who knew both Hazlitt and Cunningham, made extensive annotations to his copy of Cunningham's life of Reynolds. Although the notes were later published, the following annotation was omitted: 'What could have inspired him [Cunningham] with so strong a feeling towards Sir Joshua I cannot tell. Hazlitt hated Reynolds because he was a gentleman—and Hazlitt evidently exercised a considerable influence over Allan's mind'.[77] Hazlitt, however, had always managed to control his prejudices, and his evident dislike for Reynolds did not allow him to place a disproportionate emphasis on the achievement of Hogarth or even to install him as people's champion. In September 1829 in an essay in *The Atlas,* Hazlitt stated that Cunningham was wrong to follow Lamb's lead in searching for an alternative to the Catholic traditions of high art in Hogarth's secular modern moral subjects. 'We hate', he affirmed, 'all exclusive theories and systems; insomuch as if the Catholic spirit of criticism were banished from the world, it would find refuge in our breast …'.[78] Moreover, Hazlitt continued, any 'attempt to prove that Hogarth was something more than he was, shows that his bigoted admirers are not satisfied with what he actually was …'.[79] And yet, in his campaign to undermine Reynolds's posthumous position as the artistic hero of patriots during the Age of Revolution, Hazlitt created the climate for Hogarth to assume the same mantle in the Age of Reform.

1. William Hazlitt ,'On the Progress of Art in Britain', in P. P. Howe, ed., *The Complete Works of William Hazlitt* (London and Toronto: J. M. Dent and Sons, 1930–34), 18:434. Unless otherwise indicated, all quotations from Hazlitt are taken from the above edition, hereafter cited as *Works.*

2. The notice in *The St. James's Chronicle* also appeared in *The General Advertiser* (29 October) and *Lloyd's Evening Post & British Chronicle* (26–29 October). In 1781 John Nichols stated, 'going to bed he [Hogarth] was seized with a vomiting, upon which he rung his bell with such violence that he broke it, and was found in such a condition that he expired two hours afterwards'. John Nichols, *Biographical Anecdotes of William Hogarth; and a Catalogue of His Works Chronologically Arranged; with Occasional Remarks* (London, 1781), 56.

3. Ernest Irons has stated that the 'last illness of Sir Joshua Reynolds was caused by a malignant tumour of the liver, primarily in the left eye'. Ernest E. Irons, M.D., *The Last Illness of Sir Joshua Reynolds* (Reprinted from the Bulletin of the Society of Medical History of Chicago, May 1939), 18. Irons, who was a medical doctor, sought to defend Reynolds's physicians against Edmond Malone's assertion that he would have lived longer had they taken better care of him.

4. *The Diary,* 17 February 1792.

5. *The Morning Herald,* 25 February 1792.

6. *The Diary* reported on 25 February 1792 that Reynolds had 'by no means supported his illness with that composed philosophy that was naturally to be expected from such an enlarged and cultivated mind'. The report was repeated in *The Morning Herald* (27 February 1792). The same day, however, *The Diary* retracted its earlier comment about Reynolds, stating that it had been 'led aside by the erroneous rumour that had prevailed among those who had not the happiness of a familiar intercourse with him'.

7. The first such list was published in April 1792 in *The Gentleman's Magazine,* 381. See also Samuel Felton, *Testimonies to the Genius and Memory of Sir Joshua Reynolds* (London, 1792), 20–30; Edmond Malone, *The Literary Works of Sir Joshua Reynolds* (London, 1797), 1:lxii–lxx; James Dallaway, *Anecdotes of the Arts in England* (London, 1800), 521–22.

8. *A Catalogue of Portraits, Fancy Pictures, Studies, and Sketches, of the Late Sir Joshua Reynolds…Sold by Auction, by Mr. Greenwood…at the Great-Room, Savile Row,* 16 April 1796, lots 47 and 64.

9. Edward Fryer, ed., *The Works of James Barry* (London, 1809), 1:553–54, note. See also William L. Pressly, *The Life and Art of James Barry* (New Haven and London: Yale University Press, 1981), 136ff.

10 Fryer, ed., 2:518.

11. James Barry, 'An Appendix to the Letter to the Dilettanti Society', 17 March 1798, in Fryer, ed., 2:607–17.

12. Malone, 1:iii.

13. Ibid., 1: lxii–lxx.

14. Ibid., 1:lxxii.

15. Ibid., 1:civ.

16. See William Blake's annotated copy in the British Library of the second edition (1798) of Malone's *Literary Works,* 1:cv. Blake's annotation is set next to a footnote on the health of Britain's trade figures.

17. Reynolds's ms. notes (Royal Academy of Arts) were first published in C. R. Leslie and Tom Taylor, *The Life and Times of Sir Joshua Reynolds with Notices of Some of Their Contemporaries* (London, 1865), 2:559.

18. See Felicity Owen and David Blayney Brown, *Collector of Genius: A Life of Sir George Beaumont* (New Haven and London: Yale University Press, 1988), 232.

19. William Sotheby, *A Poetical Epistle to Sir George Beamont, Bart.* (London, 1801), 24.

20. Ibid., 28.

21. Ibid., 20.

22. Ibid., 18.

23. J. M. W. Turner, ms. lecture notes, Department of Manuscripts, British Museum, Add. ms. 46151 BB f. 50a. I am grateful to Richard Spencer for allowing me to use his transcription of these manuscripts.

24. Ibid., N f.7.

25. Ibid., S f.10a.

26. The Reverend Matthew Pilkington, *The Gentleman's and Connoisseur's Dictionary of Painters. A new ed. to which is added, A Supplement containing anecdotes of the latest and most celebrated artists, including several by Lord Orford…* (London, 1798), 2:819–20.

27. See Ada Earland, *John Opie and His Circle* (London: Hutchinson and Co., 1911), 214. Sir Francis Bourgeois told Thomas Holcroft that he believed the entry's author to be either John Wolcot or John Opie. See Thomas Holcroft, *Memoirs of the Late Thomas Holcroft* (1816), 3:7.

28. John Opie, 'On Invention', second lecture delivered at the Royal Academy, 23 February 1807, in *Lectures on Painting. Delivered at the Royal Academy of Arts* (1809), 76.

29. John Gould, *A Dictionary of Painters, Sculptors, Architects, and Engravers, Containing Biographical Sketches of the Most Celebrated Artists, from the Earliest Ages to the Present Time…* (London, 1810), xxiv–xxv.

30. Ibid.

31. Horace Walpole, *Anecdotes of Painting in England* (London, 1780), 4:68–80.

32. John Nichols, *The Works of William Hogarth from the Original Plates Restored by James Heath to Which Are Prefixed a Biographical Essay on the Genius and Productions of Hogarth…* (London, 1822), viii.

33. J. T. Smith, *Nollekens and His Times* (London, 1828), 170.

34. Joshua Reynolds, *Discourses on Art,* ed. Robert R. Wark (New Haven and London: Yale University Press, 1975), 254.

35. 'On the Genius and Character of Hogarth with Some Remarks on a Passage in the Writings of the Late Mr. Barry', *The Reflector,* no. 3 (1811) in *The Collected Essays of Charles Lamb,* 2 vols., introduction by Robert Lynd and notes by William MacDonald (London and Toronto: J. M. Dent and Sons, 1929).

36. Ibid., 2:243.

37. Ibid., 2:245.

38. Ibid., 2:245–46.

39. Ibid., 2:255.

40. Joseph Farington, *Memoirs of the Life of Sir Joshua Reynolds; with Some Observations on His Talents and Character* (London, 1819), 3.

41. *The Morning Post,* 13 May 1813; *The Observer,* 16 May 1813. Quoted in Farington, 247–48 and 251–52.

42. Martin Archer Shee, *The Commemoration of Reynolds, in Two Parts* (London, 1814), pt. 2, 67–68.

43 Ibid., 71.

44. William Hazlitt ,'Real Conversations, Nos. II & III', *The London Weekly Review,* March 14 and April 11, 1829, in *Works,* 11:237.

45. Kathryn Cave, ed., *The Diary of Joseph Farington* (New Haven and London: Yale University Press, 1984), 13:4495–96.

46. Nichols, 1822, viii.

47. William Hazlitt, *The Champion,* 5 March, 1815, in *Works,* 18:99 n. 1.

48. For contemporary attitudes towards Hogarth as a colourist see David Bindman, *Hogarth* (London: Thames and Hudson, 1981), 162–65.

49. *Works,* 18:23.

50. Ibid., 6:148.

51. Ibid.

52. P. P. Howe, *The Life of William Hazlitt* (Harmondsworth: Penguin Books, 1949), 84.

53. Ibid., 131.

54. *Works,* 18:51.

55. Ibid., 18:53.

56. Ibid., 18:58.

57. For Knight's authorship of the *Edinburgh Review* article see Michael Clarke and Nicholas Penny, eds., *The Arrogant Connoisseur: Richard Payne Knight, 1751–1824* (Manchester: Manchester University Press, 1982), 119.

58. *The Edinburgh Review,* September 1814, 255.

59. Ibid., 288.

60. The remarks were made in the context of a review of Hazlitt's *Round Table.* See *The Quarterly Review* 17 (April–July 1817): 159.

61. Sir Thomas Lawrence, *Address to the Students of the Royal Academy, Delivered before the General Assembly at the Annual Distribution of Prizes, 10 December 1823* (London, 1824), 12.

62. Ibid., 19.

63. *Works,* 10:26.

64. William Hazlitt, *Sketches of the Principal Picture-Galleries in England. With a Criticism on 'Marriage à la Mode'* (London, 1824), 188–89.

65. P. G. Patmore, *British Galleries of Art* (London, 1824), 147.

66. William Paulet Carey, *Some Memoirs of the Patronage and Progress of the Fine Arts in England and Ireland* (London, 1826), 35–36.

67. Ibid.

68. Hazlitt probably wrote the bulk of his 'conversations' with Northcote in 1826, the first six being published between August 1826 and March 1827. He had, however, already published several essays relating to Northcote, such as 'On Patronage and Puffing' in *Table Talk* (1821–22), cited in *Works,* 8:289–302, and 'On the Old Age of Artists', in *The Plain Speaker* (1826), cited in *Works,* 12,:88–96.

69. Howe, *The Life of William Hazlitt,* 384.

70. See *Works,* 11:302.

71. Claude Colleer Abbott, *The Life and Letters of George Darley, Poet and Critic* (London: Oxford University Press, 1928), 138–39.

72. Allan Cunningham, *The Lives of the Most Eminent British Painters,* rev. ed. (1879), 1:230.

73. William Vaughan, 'When Was the English School?', *Probleme und Methoden der Klassifizierung,* 3. XXV. International Conference, Vienna, 4–10 September 1983, 109.

74. Cunningham, 1:254.

75. Ibid., 1:230.

76. *Works,* 11:303.

77. Hartley Coleridge, ms. note in Allan Cunningham, *Lives of the Most Eminent British Painters* (London, 1829), 1:318–19. (Coleridge's annotated copy is in the British Library.)

78. *Works,* 11:302.

79. Ibid.

William Hazlitt, Prince Hoare, and the Institutionalisation of the British Art World

Peter Funnell

It is quite wrong to suppose, Hazlitt writes, 'that the temples of the muses may be raised and supported by voluntary contribution; that we can enshrine the soul of art in a stately pile of royal patronage, inspire corporate bodies with taste, and carve out the direction to fame in letters of stone on the front of public buildings'.[1] Hazlitt's well-known statement appeared originally in a piece entitled 'Fine Arts. Whether They are Promoted by Academies and Public Institutions', printed in three parts between August and October 1814 in John Scott's *The Champion*.[2] It is worth remembering that the article was written at an early point in Hazlitt's career as a journalist and art critic and that he was writing as something of an outsider to the art world. We should also remind ourselves that it was written as newspaper criticism, responsive to the specific circumstances of the time and, to use John Barrell's word, to particular 'provocations'.[3] The provocation for the piece on Institutions, and Hazlitt's starting point for the article, was the preface to the British Institution catalogue of the 1814 exhibition of works by Hogarth, Wilson, Gainsborough, and Zoffany, a preface which raises the hope that if Britain could produce artists like these 'at a time when art received little comparative support' then 'we shall see productions of still higher attainment, under more encouraging circumstances'.[4] In challenging this assumption, Hazlitt ranges widely, reviewing the whole history of painting in support of his counter-arguments and engaging in a long-standing debate as to the nature of progress and decline in the arts. But the urgency of his piece, as suggested by the passage with which I began, derives from his dismay at what he saw as the creeping institutionalisation of the contemporary British art world. The immediate objects of his attack are obvious. The stately pile of royal patronage is, of course, the Royal Academy; the reference to the muses being 'raised and supported by voluntary contributions', the British Institution itself.

As work of the last decade or so has shown, a significant—perhaps dominant—feature of the art world of Hazlitt's time was the rise of art institutions.[5] Over the decades following its establishment in 1805, the British Institution was imitated by similar bodies in many of the urban centres, bodies adopting its institutional structure and intended to encourage the fine arts through the provision of models for aspiring artists, prize competitions, and annual exhibitions of contemporary works. And for all the societies of art which came into being, there was a mass of schemes and proposals advocating further reforms

and measures, either to existing institutions or suggesting some broader pro-
gramme of intervention. Of the rapidly increasing literature on the fine arts
of the period, a large proportion is directed to these ends and, specifically, to
the end of promoting a British school of history painting. Again, anyone who
has ever glanced at the books, pamphlets, and articles which constitute this
often highly repetitive literature will immediately appreciate the tone, and the
specific reference, of Hazlitt's remarks. The passage, with its high-flown talk of
inspiring corporate bodies with taste and carving out the direction to fame in
letters of stone on the front of public buildings, nicely parodies the language,
and the arguments, of writers such as Martin Archer Shee, William Paulet
Carey, and the figure I wish to use as a representative of this literature in this
essay, Prince Hoare. Elsewhere in his article Hazlitt directly challenges the
beliefs on which these writers advanced their schemes. Attainment of excel-
lence in painting has nothing to do with 'mere artificial props' or the sort of
'factitious patronage' which they propose. It will not be achieved under the
auspices of 'patrons and vice patrons, presidents and select committees', and
their 'prizes of the first, second, and third class' will only have the effect of
'beating up for raw dependents'. If anything, 'a period of dearth of factitious
patronage', Hazlitt writes, 'would be most favorable to the full development of
the greatest talents'.[6] And, to return to the beginning of his piece, the example
of the art of Hogarth and Wilson serves to show the truth of his arguments.
For these were artists, Hazlitt claims, who excelled even though working in
'obscurity and poverty'.[7]

I should say at this point that it is not my primary intention in this essay
to provide a context for Hazlitt's writings. Nor will I produce startling new
evidence of a direct engagement between Hazlitt and Hoare.[8] Rather I want to
use the viewpoints of the two men to represent two more widely held bodies
of belief, and to expose what I consider to be crucial issues in British artistic
debate of the first decade or so of the nineteenth century. Their opinions, I
shall suggest, reveal fundamentally opposing conceptions of the nature of
painting, its function in society, and the history of the art. Hoare articulates
the case for history painting in its most pure and elevated form—an art neces-
sarily occupying a place in the public sphere—while Hazlitt questions the
assumptions behind these arguments and, writing from what I see as a funda-
mentally colourist position, conceives of painting as an essentially private art
form. Clearly, the tracks of these polarities extend far back into the eighteenth
century. It will also be apparent that I am treading on ground which has been
charted by John Barrell in *The Political Theory of Painting* and that many of my
comments will parallel Barrell quite closely.[9] My concern, however, is to exam-
ine these issues with reference to the particular circumstances of the early
1800s and especially the rise of art institutions and the prevalence of writings
urging the encouragement of history painting.

It is a generalisation, but it does seem to me that to write upon art at this period was either to participate in these calls for more extended patronage, often strident in tone, or to react against them. In this sense, I believe that Hazlitt's writings on art of 1814–15 have to be seen as reactive and, as such, can be associated with those of the connoisseur Richard Payne Knight. In articles of 1810 and 1814 in *The Edinburgh Review,* Knight had vigorously rejected what he calls the 'clamours of misguided and disappointed genius'[10] for greater funding and undermines the theoretical basis of history painting by advancing a theory of the art which emphasises a close imitation of nature through colouring and execution and which directly challenges conventional hierarchies of school and genre. While this is not the place to establish this connection between Hazlitt and Knight fully, there are clear similarities in their points of view, similarities in fact remarked upon at the time by Henry Crabb Robinson.[11] Paradoxically, in view of his own doubts regarding schemes for patronage, Knight was himself one of that group of connoisseurs who established and governed the British Institution and soon became immersed in the controversies which it provoked. Presenting itself as a possible solution to the neglect of history painting, the Institution instead became the focus for renewed protest, and in turn, I think, Knight's views became more extreme in the manner I have mentioned. The Institution also came to be regarded as a powerbase for connoisseurs like Knight, operating in direct rivalry to the Royal Academy, and stirring up old antagonisms between artists and connoisseurs. These reached a climax in 1815 with the publication of the first *Catalogue Raisoné* [*sic*] roundly attacking the Institution and its Directors. The impassioned response which Hazlitt wrote, partly in their defence, has often seemed to contradict the line he had taken on art institutions in his *Champion* piece. I will briefly return to that essay at the end and, while perhaps not solving its contradictions, will at least use it to position Hazlitt within art world politics of these years.

But let me now turn more fully to the views and activities of the other key player in this essay, Prince Hoare. Whereas Hazlitt, as I have mentioned, must be seen as occupying a place on the periphery of the art world, Hoare's central position is clear. He was of the Academy, occupying the post of Secretary for Foreign Correspondence, and the publication by which he is best known, a periodical he established in 1807 called *The Artist,* was clearly a strategic move designed to mitigate the power of the connoisseurs. Thus Hoare held to a strict editorial policy of publishing writings by practising artists only. But the work by Hoare to which I will pay most attention is a book called *Epochs of the Arts,* published in an edition of five hundred in 1813.[12] In the *Epochs* Hoare details a comprehensive and, indeed, utopian plan of reforms by which British art may be improved, reforms in which bodies like the British Institution play a role but a comparatively minor one. 'A thousand galleries', Hoare writes,

might be added to those which already exist, without any real effect.[13] And like other protagonists of what may be called the patronage lobby of the period—Haydon and Shee for example—Hoare identifies the chief flaw in such bodies as consisting in their merely perpetuating established forms of patronage. They are governed by individual collectors and connoisseurs—in other words those who had so signally failed British painting in the past—and through their chief means of encouragement, the exhibition of works for sale, were simply providing alternative market outlets. The great cry of those whose views I am using Hoare to represent was not so much for more money, for an increase in individual patronage. It was for the task of encouraging painting to be removed from the caprice and unpredictability of the market and to be placed under the regulatory control of government. 'It is manifest to all who have reflected much on the subject', Hoare writes, 'that in order to raise [the arts] to excellence…some enlarged and predominant direction of their powers to *public purposes* must be sought at the hands of the state. From the *state,* it must be repeated, from the state alone, it can be sought'.[14]

There are, clearly, theoretical underpinnings as to the nature of this art, directed to 'public purpose' and which the 'state alone' can support. Hoare writes in the full spirit of the tradition which Barrell has described, insisting repeatedly that the 'arts of design', a designation he is keen to use, should be directed to the highest moral purposes, offering matter for virtuous instruction. The artists who produce these works will, of course, be men of the most expanded moral and intellectual cultivation, and their paintings will demonstrate the purist principles of form and line. Indeed Hoare is so clear upon this that he dismisses possible objections as to the durability of paintings hung in public places, 'since the moral uses of the art', he says, will remain 'long after the passing charms of colour are extinguished'.[15] Like Carey, Shee, and others Hoare does envision a type of large scale, public painting which, on purely economic grounds and in terms of where such works would be seen, must be reliant on government funding. The palaces of the monarchy, the halls of Westminster, government offices, and so on would all be thus adorned but so would churches and cathedrals and, indeed, the palaces of commerce and manufacture. Existing institutions like the British Institution and the Academy would, properly reformed, continue to play a role in the promotion of art and the education of artists. Indeed, education on a broader scale, serving 'to raise the public mind to a just conception of the art',[16] is advocated. Few aspects of national life, and the nation's institutions, are neglected in Hoare's lengthy proposals in his book. But above all, as he repeatedly insists, the government must be involved. 'Some constant and connecting measure must be found', he writes, to bring all these activities together and this can only come from the state.[17] Yet Hoare is equally keen to emphasise the reciprocal benefits that must accrue to the state from this involvement; and, as the title of his

book suggests, he offers an historical analysis giving illustrations of those 'epochs' when this reciprocity between state and art was most pronounced. Reviewing the history of art from Periclean Athens to Louis XIV, Hoare cites examples when the art has been truly 'epochal', when state and art have worked in unison. But he also traces a parallel history rejecting works from this description, such as Rubens's Whitehall ceiling, which, he feels, fail to express 'the essential principle of the state'.[18]

Although characteristic of much writing of its time, Hoare's *Epochs of the Arts* is nevertheless remarkable for its scope. And, as we shall see, the programme which it details is such as would have fulfilled Hazlitt's worst nightmares. But before returning to Hazlitt, I would like to look briefly at one other aspect of Hoare's activities in the early 1800s—the self-assigned duties into which he threw himself in taking up the previously honorary post of Secretary for Foreign Correspondence at the Academy. Hoare immediately set to work sending off letters to the Academies of Europe and, between 1802 and 1809, published those replies which he got back in the form of four volumes under the title of *Academic Correspondence or Academic Annals*.[19] These lengthy communications—from Madrid, Milan, Vienna, St. Petersburg—incorporating details of their academies' respective constitutions and regulations, testify to Hoare's absolute faith in the need for properly organised academic training. But Hoare's activities as Secretary for Foreign Correspondence reveal wider ambitions. He was, if you like, trying to create a map of the international art world, moving Britain from the periphery and placing it firmly at the centre: making London, as a contemporary account put it, 'the central point of information' as regards these matters of 'intellectual cultivation'.[20] At the same time Hoare was also trying to reform English art, pulling it into the continental mainstream, since, as he writes, 'an enlarged communication of sentiments and ideas, [will] prevent the growth of contracted habits in art, or what is commonly called *manner,* which, whether national or individual, will… necessarily detract something from the perfection of talent'.[21]

The almost obsessive fascination with institutional protocol which Hoare's volumes of *Academic Correspondence* reveal—and which is confirmed by references to him in Farington's *Diary* and the Royal Academy Council Minutes—epitomises one aspect of the academic system which Hazlitt famously deplored. It was that corrupt atmosphere, as he writes in his essay 'Of Corporate Bodies', which made the Academician neglect anything to do with art itself but filled his mind with 'rules of the academy, charters, inaugural speeches, resolutions passed or rescinded, cards of invitation to a council-meeting, or the annual dinner, prize-medals, and the King's diploma, constituting him [and I shall come back to this] a gentleman and esquire'.[22] But there are, of course, broader arguments contained in Hazlitt's attacks on academies, arguments which apply equally to all art institutions, and which

stand in stark contrast to the cosmopolitan and centralising spirit of Hoare's activities as Secretary for Foreign Correspondence. The principal aspect of academic procedure which Hazlitt identifies is the imitation of past models and the belief that art would progress, through a process of successive imitation, towards some ultimate perfection. For Hazlitt 'this theory of progressive perfectibility',[23] the idea that 'art may go on in an infinite series of imitation or improvement, has not a single fact or argument to support it'.[24] And like many critics of academies, and the academic system, Hazlitt turns to the example of history to provide his strongest argument. 'The arts', he writes, 'have in general risen rapidly from their first obscure dawn to their meridian height and greatest lustre and have no sooner reached this proud eminence than they have as rapidly hastened to decay and desolation'.[25] Hazlitt is adopting a position here which is common in the eighteenth century—a belief in the sudden rise, yet immediate decline in the arts, or indeed, civilisations, a belief which Wittkower has called the 'theory of cultural despair'.[26] And it is a phenomenon which Hazlitt traces in the history of painting, in particular Italian painting. 'After its long and painful struggles in the time of the earlier artists', he writes, painting 'burst out with a light almost too dazzling to behold, in the works of Titian, Michelangelo, Raphael and Correggio'.[27] But immediately after this point, with one or two brief recoveries, we notice its gradual decline until the final period of decay which Hazlitt finds in 'the works of Carlo Maratti, of Raphael Mengs, or of any of the effeminate school of critics and copyists who have attempted to blend the borrowed beauties of others in a perfect whole'.[28] It is a version of the history of Italian painting familiar in the period, and there is almost a consensus regarding what Hazlitt sees as the sameness and mediocrity of Mengs and Batoni in particular. Moreover, as Hazlitt makes clear, this process of decay is one coincident with the rise of academies and the procedure of imitating or blending 'borrowed beauties'. It is an extraordinary paradox that when circumstances seem most propitious, when artists have centuries of tradition to draw upon, instead we see a gradual falling off.

This argument from history, exposing this paradox, provides one of the strongest cards in the pack for those who opposed academies. It is also an argument which Hazlitt could have found, and I believe must have read, in Knight's writings between 1805 and 1814. Knight too deplores the 'corporate spirit' of academies, their tendency to promulgate what he calls a sort of 'central style', passed from one academy to another like a 'contagion' and, using language similar to Hazlitt's, the 'insipidity' and 'tame uniformity' which characterises eighteenth-century Italian painting.[29] And the history of the art which he describes also traces a process of immediate advance followed by steady decline. 'The art burst at once into being', Knight writes of Giorgione, Titian, and Correggio, 'and started immediately to a degree of perfection

which it has never since approached'.[30] Instead it decayed 'till it reached the ultimate extreme of vapid, feeble and opake monotony, in Placido Costanza and Pompeo Batoni'.[31] The art only flourished, Knight asserts, among those who 'lived remote from the scene of imitation, and had no such models perpetually before them, as Velasquez in Spain, Rubens in Flanders, Rembrandt in Holland, and', he adds provocatively, 'Reynolds in England'.[32]

The implications which Hazlitt draws from all this for modern British painting are exceedingly pessimistic. Questioning the advances made in British art since the foundation of the Academy, he asks, 'What greater names has the English school to boast than those of Hogarth, Reynolds and Wilson, who owed nothing to it?'[33] And when one reads Hazlitt's exhibition reviews of 1814, the clear impression is that modern British painting, in particular history painting, is already declining according to the familiar pattern—succumbing, to use Knight's word, to the academic 'contagion'. This analysis is quite the reverse, clearly, of what Hoare had in mind when publishing his *Academic Correspondence,* publications which, we remember, he hoped would prevent 'contracted habits of art, or what is commonly called manner…whether national or individual'. Hoare has no doubts as to the possibility of progress in painting, of the need for British art to embed itself in mainstream traditions, and had indeed trained as a young artist himself in Rome in the studio of Mengs.[34] Nevertheless Hazlitt could appeal to the broad consensus of English opinion on the state of arts in Italy. 'There is not a single name', he writes of Italian painting of the previous century, 'to redeem its faded glory from utter oblivion'. 'Yet', he goes on, 'this has not been owing to any want of Dilettanti and Della Cruscan Societies,—of academies of Florence, of Bologna, of Parma, and Pisa,—of honorary members and [tantalisingly] Foreign Correspondents—of pupils and teachers, professors and patrons, and the whole busy tribe of critics and connoisseurs'.[35]

This clearly moves us beyond academies. It is the whole busy tribe who constitute a modern art world that Hazlitt is condemning, a tribe who contribute nothing to greatness in painting. And once again Hazlitt, and Knight too, turn to an historical example—that of Correggio—to support their arguments. Drawing on Vasari, Correggio is their prime example of an individual excelling in the art though removed, in Knight's phrase, 'from the scene of imitation' and, as Hazlitt claims, 'the most melancholy instance on record of the want of a proper encouragement of the arts'. 'But a golden shower of patronage', he goes on, 'dropping prize medals and epic mottoes, would not produce another Correggio!'[36] And elsewhere in his *Champion* article Hazlitt presents Correggio as an isolated figure, indigent, and 'of no school', forced to construct for himself 'an image of truth and beauty from the contemplation of nature'. 'We can conceive the work growing under his hands by slow and patient touches', he writes, 'approaching nearer to perfection, softened into

finer grace, gaining strength from delicacy, and at last reflecting the pure image of nature on the canvass. Such is always the true progress of art; such are the necessary means by which the greatest works of every kind have been produced'.[37] This treatment of Correggio is the best, though not the only, example of the way Hazlitt's discussion, in Barrell's words, is 'conducted in terms of a transaction between individual genius and a variously aspected nature, a transaction unmediated by the circumstances of history, and virtually unmediated by patronage'.[38]

Now while Hazlitt advances his belief in 'individual genius', in a creative process removed from any 'circumstances of history' across the arts—poetry for example—I believe we can be more specific as to what it is he thinks constitutes genius in painting. Once again, his account of Correggio is very reminiscent of how Knight conceives of painterly creativity. Knight reduces all to this sort of transaction. Thus, writing of those painters whose art 'burst forth' to excellence in Italy, Giorgione, Titian, and, again, Correggio, he speaks of how they had 'no models for imitation, but those of nature, nor any other objects of professional study than the composition of materials, and the use of their implements'.[39] The aspect of Hazlitt's description of Correggio, which this extremely reductive account makes me think of, is his emphasis upon, as he says, the way the painting grows 'under his hands by slow and patient touches'. In the context of early-nineteenth-century writings on painting, that phrase nicely intensifies the polemical force of Hazlitt's passage. The whole programme of history painting rests upon a distinction between the art's intellectual and its 'mechanical' aspects—something which has important ramifications for the social standing of the painter. There is, as Andrew Hemingway has pointed out, an element of self-interest in the perpetuation of the orthodoxies of history painting in these calls from the patronage lobby for state funding—not just in terms of money but in those of social status.[40] And it is precisely this self-conception among contemporary artists which Hazlitt is keen to puncture when he ends his passage in 'Of Corporate Bodies', condemning the whole academic system, by mocking how the academician styles himself 'gentleman and esquire'. One of the objects of Hoare's periodical *The Artist,* on the other hand, is clearly to secure this image of the painter—they can write also—and the ideal of the painter as a highly cultivated intellectual is, as I have said, advanced throughout his writings. It is no surprise, then, that when he comes to consider Correggio in the *Epochs,* he writes that this archetype of the unlearned artist is, in fact, 'no longer denied to have possessed the means of erudition'.[41] And indeed, Hoare can say this with some justice—he presumably has in mind Mengs's *Life* of Correggio.

But then, of course, these totally opposed versions of art history are determined by more immediate considerations and prejudices. Hoare's 'epochal' history of art is one which insists on the greatest possible degree of external

intervention, while Hazlitt registers greatness in painting in terms of the absence of such forces. As I noted earlier, Hazlitt argues strenuously in his *Champion* article that only if there is a positive 'dearth of factitious patronage' will art in Britain attain excellence. Indeed, he says that the only true form of patronage will be that between the private collector and the painter—returning, in other words, to that very system of patronage by individuals which Hoare and others wished to replace. 'Titian was patronised by Charles V', Hazlitt writes, 'Count Castiglione was the friend of Raphael. These were true patrons and true critics', men of an age when 'only those minds of superior refinement would be led to notice works of art'.[42] And Hazlitt pictures a contemporary art world which is fixed and static and contains at most a tiny community of 'superior refinement'—'there are not fifty persons to be found who can really distinguish 'a Guido from a Daub'.[43] An extensive system of art education, Hoare had argued, is required 'to raise the public mind to a just conception of the art'—a just conception as regards its true principles, but also principles to be understood by an expanded, if still, I think, very circumscribed, public. Hazlitt, in a familiar and problematic passage, denies this possibility.

> The diffusion of taste is not…the same thing as the improvement of taste; but it is only the former of these objects that is promoted by public institutions and artificial means…the principle of universal suffrage, however applicable to matters of government, which concern the common feelings and common interests of society, is by no means applicable to matters of taste.[44]

There is, it seems, a genius in the patron as there is in the artist—a small elite, as Barrell has said, of true taste. But here again, I think we can be more precise as to the nature of this elite and, in doing so, locate Hazlitt more clearly within the warring factions of the London art world. Hazlitt conceives of this refinement in the patron, it seems to me, as being the product of acquired taste and not just of innate sensibility. And it's just this sort of taste, gained through long study of paintings and drawings, which is associated in the period with the figure of the connoisseur. It is the connoisseur who looks long and closely at a painting, and what he is looking at are not the gigantic forms of instructive outline but the minute qualities of colouring and execution. The connoisseur, to borrow a phrase of Wind's, has a tendency to turn all art 'into intimate chamber art'[45] or, to put it another way, into a 'private' art form. The contemporary images we are presented with of connoisseurs peering myopically at pictures—Haydon's disgusted accounts, for example—suggest this identification. Indeed, the writings of contemporary connoisseurs themselves—Knight certainly, but also fellow Directors of the British Institution like Abraham Hume—confirm this preoccupation with the finely coloured

detail. And it is precisely this preoccupation with 'mechanical excellences' which the writers of the explosive *Catalogue Raisoné* of 1815 identify and which, they assert, disqualifies the Directors from the position they hold. For it is a preoccupation which leads to their 'dismissing or rather missing all consideration of the subject matter or the sense it is intended to display in the contemplation of a picture'.[46]

Now I wouldn't claim that Hazlitt, in his art criticism, misses all consideration of subject matter. But he does emphasise fine execution in his praise of Old Masters and points to the lack of it in so much modern painting. He writes, for instance, that Van Dyck's *Charles I on Horseback* is worth all the productions of the Academy, containing as it does 'more sense of what it is in objects that give pleasure to the eye, with more power to communicate this pleasure to the world'.[47] These tendencies suggest further links between Knight's writings and Hazlitt's work of 1814–15, and it is significant that in his reply to the *Catalogue Raisoné* Knight is the one Director of the British Institution whom he specifically defends.[48] More significantly, Hazlitt's impassioned reply does show that he was willing to position himself alongside the connoisseurs and against what he saw as the self-interested pretensions of modern artists. If he had little time for the purposes of the Institution, then he clearly saw a worse enemy in the Academy faction. This at least goes some way to explaining some of the contradictions—a sense of a larger community of taste, of the possibility of historical continuity—which his reply contains to the views he had expressed in *The Champion.*

But then, are not these arguments against institutions liable, anyway, to be subject to contradiction? Just as Hoare can hardly have expected his ambitious schemes to receive funding—and only in 1810 an appeal to government for a modest £5,000 had been turned down flatly[49]—so Hazlitt's objections to the whole apparatus of a modern art world were surely unrealistic. His was a difficult position to maintain at a time when the art world was growing ever more complex and, moreover, when he himself had become a part of the world. Condemning the 'whole busy tribe of critics' in *The Champion,* he must have done so with a consciousness that he had joined their ranks not six months earlier.

1. P. P. Howe, ed., *The Complete Works of William Hazlitt* (London and Toronto: J. M. Dent and Sons, 1930–34), 18:38, hereafter cited as *Works.*
2. Published on 28 August, 11 September, 2 October.
3. John Barrell, *The Political Theory of Painting from Reynolds to Hazlitt: 'The Body of the Public'* (New Haven and London: Yale University Press, 1986), 316.
4. *Catalogue of Pictures by the Late William Hogarth, Richard Wilson, Thomas Gainsborough, and J. Zoffani* (London, 1814), preface and quoted in *Works,* 18:37.
5. On the British Institution for Promoting the Fine Arts, see Peter Fullerton, 'Patronage and Pedagogy: The British Institution in the Early Nineteenth Century',

Art History 5, no. 1 (March 1982): 59–72, and for provincial developments Trevor Fawcett, *The Rise of English Provincial Art, Artists, Patrons and Institutions Outside London, 1800–1830* (Oxford: Clarendon Press, 1974).

6. *Works,* 18:38–45, quoted variously.

7. Ibid., 18:37.

8. Hoare is only mentioned once by name in Hazlitt's writings when Hazlitt discusses his character with Northcote, commenting perceptively that 'Mr. H__ was too fastidious, and spoiled what he did from a wish to have it perfect. He dreaded that a shadow of objection should be brought against any thing he advanced, so that his opinions at last amounted to a kind of genteel truisms'. *Works,* 11:270.

9. See Barrell, especially chap. 5.

10. Richard Payne Knight, review of *The Works of James Barry* by Edward Fryer, in *The Edinburgh Review* (August 1810): 310. Knight's other major piece for the *Edinburgh* was a review of James Northcote's *Life of Reynolds* (September 1814): 263–92.

11. The most explicit connections can be found in Hazlitt's articles on Reynolds's *Discourses,* published shortly after Knight's review of Northcote. Here he refers to an 'eminent critic' who, in the context, can only be Knight (*Works,* 18:84).

12. John Murray Ltd. Archives, Ledger A62, November 11, 1814, recording payment to the printer Moyes.

13. Prince Hoare, *Epochs of the Arts, Including Hints on the Use and Progress of Painting and Sculpture in Great Britain* (London, 1813), 281.

14. Ibid., 279.

15. Ibid., 275.

16. Ibid., 70.

17. Ibid., 280.

18. Ibid., 321.

19. Hoare published the first two volumes, *Extracts from a Correspondence with the Academies of Vienna & St. Petersburg* (London, 1802) and *Academic Correspondence* (London, 1804) at his own expense; those of 1805 and 1809, when Hoare had persuaded the Academy to sanction his publications officially, are entitled *Academic Annals.* For a further account of these activities see Peter Funnell, 'The London Art World and Its Institutions', in Celina Fox, ed., *London–World City, 1800–1840* (New Haven and London: Yale University Press, 1992).

20. Prince Hoare, *The Cabinet; or a Monthly Report of Polite Literature* (July 1807), 1:293.

21. Hoare, *Extracts,* v.

22. *Works,* 8:270.

23. Ibid., 18:38.

24. Ibid., 18:48.

25. Ibid., 18:39.

26. Rudolf Wittkower, 'Imitation, Eclecticism and Genius', in E. R. Wassermann, ed., *Aspects of the Eighteenth Century* (Baltimore: Johns Hopkins Press, 1965), 152.

27. *Works,* 17:39.

28. Ibid., 17:41.

29. Knight, 1814, see especially 279 ff.

30. Knight, 1810, 314.

31. Ibid., 315.

32. Ibid.

33. *Works,* 18:40.

34. See Hoare, *The Cabinet,* 289.

35. *Works,* 18:39.

36. Ibid., 18:45.

37. Ibid., 18:42.

38. Barrell, 319.

39. Knight, 1810, 314.

40. See Andrew Hemingway, 'Academic Forms versus Association Aesthetics: The Ideological Forms of a Conflict of Interest in the Early Nineteenth Century', *Ideas and Production,* no. 5 (1986).

41. Hoare, *Epochs,* 192.

42. *Works,* 18:45.

43. Ibid., 18:47.

44. Ibid., 18:46.

45. Edgar Wind, *Art and Anarchy* (London: Faber and Faber, 1963), 50.

46. *A Catalogue Raisoné* [sic] *of the Pictures now Exhibiting at the British Institution* (London, 1815), 24.

47. *Works,* 4: 150.

48. Hazlitt is prepared to exculpate Knight for his mistaken views on the Elgin Marbles: the *Catalogue Raisoné* 'talks big about the Elgin Marbles, because Mr Payne Knight has made a slip on that subject' (ibid., 143).

49. The British Institution applied to the government for this sum in response to plans outlined in Martin Archer Shee's *A Letter to the President and Directors of the British Institution* (London, 1809). Farington reports that the request had been turned down on 26 June 1810. Kathryn Cave, ed., *The Diary of Joseph Farington* (New Haven and London: Yale University Press, 1982), 10:3676.

Ramsgate Sands, Modern Life, and the Shoring-Up of Narrative

Caroline Arscott

This essay starts from the assumption that the mechanisms of narrative in mid-nineteenth-century British painting were neither fixed nor unproblematic. Modernist art history has focused on the disruption and refusal of verisimilitude in late nineteenth-century painting: on those moments where paint marks function more as statements of their own materiality than as references to elements of a visualised scene. These transgressive gestures, identified as anti-narrative, have been picked out and strung together to form an unfolding drama. It has been necessary, in order to preserve the integrity of this drama, to imagine a neat opposition between realism and modernism. Narrative is seen to be dislodged at the moment that realism is questioned. As a result art history has been blind to unevenness, hesitation, and compromise in narrative painting when it adheres to realist modes.

Realist modes rest upon assumptions about the representability of the world. So long as the conventions of the proper limits of the representable are conformed to, and so long as the rules of subordination and organisation of elements within a work are observed, then representation is able to affirm the knowableness of natural and social phenomena. However, the limits and rules of representation are under constant revision, and so the link between narrative and verisimilitude is repeatedly disrupted. As a consequence the security of knowledge is threatened. This essay discusses changes that occurred in the field of visual representation—more particularly in the realm of fine art—in Britain in the period from the mid-1840s to the late 1850s. These were changes that threatened the security of knowledge. Of course the knowledge that came under threat was not knowledge in the abstract but the ruling classes' knowledge: the ideological certitudes produced and purveyed by, and on behalf of, the bourgeoisie for the consumption of society in general. The central tenet of this ideology was the legitimacy of the middle class to rule. The bourgeoisie had to represent to itself and others its own position in the world. It had to achieve simultaneously self-definition, in contradistinction to other class positions, and the presentation of a homogenised picture of the world in its own image. These dual tasks of representation were in tension with one another, and narrative in Victorian painting is produced from the balancing of these functions. Where the balance is disturbed narrative itself is eroded.

In the western European tradition narrative has been associated with the grand subjects of scripture and history and with the modest domestic subjects

of private existence. It is equally a function of high art and of the lower categories of painting. The presence of human figures promises their participation in a narrative except in the case of the immaterial figures of allegory or, in some cases, the personal presence of portrait sitters. In portraiture the narrative has been subsumed into the figure. The face of a sitter for an Academy portrait would, in the mid-nineteenth century, offer a summation of the individual's public career and private virtues, but the act of summation is final and there is little space for speculation on future actions: the portrait offers the past and the present, but the present is asserted with such certainty that there is no invitation to future projection.

Narrative painting stands halfway between the non-narrative modes of allegory and portraiture. Laura Mulvey has drawn attention to the discussion of narrative structure by Terence Turner and Gerald Prince where narrative is said to consist of three phases:

> A minimal story consists of three conjoined events. The first and third are stative, the second is active. Furthermore, the third is the inverse of the first. Finally the three events are conjoined by three conjunctive features, in such a way that (a) the first event precedes the second in time and the second precedes the third, and (b) the second event causes the third.[1]

In narrative painting we are given that crucial second phase of narrative, upon which the resolution depends. The situation is assumed to stand between the past and a future; although a resolution will follow as a consequence of the second phase, that resolution was not always inevitable. Narrative has a certain openness attached to the causal nature of the active phase. Unlike portraiture it has a future, one that is to some extent uncertain.

Genre painting is a narrative form which presents figures whose status hovers between being 'real' and indeterminate. If the figures lose that sense of indeterminacy and are conceived of as entirely actual, then the picture threatens to move from genre into the non-narrative mode of portraiture. Conversely if the figures in portrait painting fail to assert their personal right to the picture space in a certain way, then the image ceases to function effectively as a portrait and moves towards genre.

These points refer to picturemaking conventions and to the way such conventions govern the viewer's expectations. Criticism offers useful indications of the confirmation or thwarting of these expectations as conventions shift. The Italian organ-player in Thomas Webster's *Sickness and Health* (fig. 28), exhibited at the Royal Academy in 1843, was referred to as 'a perfect specimen of his class' in *The Art Union,* meaning that the figure corresponded to a recognisable type.[2] The participants in the narratives of genre had to be generic rather than individual. Individuation was welcomed insofar as the separate figures were clearly distinguished from one another as physical or character types, but that

fig. 28
Thomas Webster, *Sickness and Health,* 1843 (detail)
Oil on panel, 20 x 32 in. (50.7 x 81 cm.)
London, Victoria & Albert Museum, Sheepshanks Gift, 1857

process of individuation was not meant to go so far that particular people were shown. Where the figures appeared too individual there was felt to be a failure of narrative. So in a picture, now lost, of Chelsea pensioners by A. Morton, shown at the Royal Academy in 1845, the figures were criticised for being too much just portraits; here *The Art Union* complained of 'portraiture without expression; composition without a story'.3 The very frequent complaints of narrative figures looking like models posing in hired costumes should be considered in this context.4 The figures are not sufficiently typical, they have too much of the portrait in them. Genre pictures based on literature, or set in the domestic byways of history, might appear to be unproblematically narrative in that they are linked to specific stories, but the narrative is eroded if the predominant impression is of a stagey arrangement of artist's model, tights, and velvet cloak. As a result the figures cease to fill their proper role in the picture; the properties take over.

An equivalent problem emerges in portraiture. Here the conventions are threatened when the subject does not have sufficient social status. High birth or exceptional personal attainment of a sitter makes possible the supposedly exact delineation of his or her features, dress, and surrounding properties. In this case there is no problem of the usurpation of the viewer's attention from the person depicted. Their rank will lend ideality to their features. The exact transcription of the face of someone of doubtful rank is another matter entirely. The face, not ideal, becomes another material item in a composition where the costume, furniture, and accessories jostle for attention. And so we hear of a portrait of a shopkeeper's widow, described as a picture of 'ten thousand pounds worth of diamonds and her face'.5 The rules of portraiture are challenged when the sitters are wealthy but, in an Academy context, fail to convince the viewer that they are sufficiently refined. The many instances of this kind of disturbance have to be seen in the light of a widening of the scope of portraiture outside the realm of academy practice, in daguerrotypes, in reportage, and in police records. If a situation occurs in the mid-nineteenth century, where incursions are being made upon genre by portraiture, resulting in perceived denarrativisation, then equally there is a disturbance in the regime of portraiture.

This essay considers the way that one particular genre painting from the 1850s deals with the problem of protecting genre from the incursions of portraiture and manages to maintain the balance between the representation of authentic-seeming specifics and ideologically convincing generalities. *Life at the Seaside,* by W. P. Frith was exhibited at the Royal Academy in 1854 (fig. 29). It is a fairly large oil painting, 30 x 60 inches, with a multitude of small figures. It is possible to count nearly seventy figures, arranged horizontally in a seaside setting. Together they form a crowd, and for contemporary viewers it was an unequivocally metropolitan crowd. The figures indicated as middle-

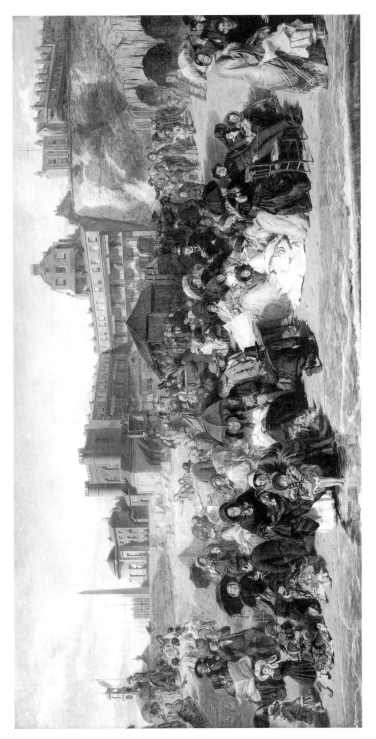

fig. 29

William Powell Frith, *Ramsgate Sands: 'Life at the Seaside'*, 1854

Oil on canvas, 30 ¼ x 61 in. (76.8 x 154.9 cm.)

The Royal Collection © Her Majesty The Queen

class are construed as visitors to the seaside, so despite its Ramsgate setting this is a picture of city life. Viewers recognised this, and reviews frequently attached the term 'cockney' to the scene—often softening the negative connotations of the term for Londoners (not necessarily proletarian, as today, but distinctly undignified) with the suggestion that this was a paradisal version of the cockney. Both *The Art Journal* and *The Athenaeum* introduced the idea of 'cockaigne'—an imaginary world of luxury and idleness which could be punned as the land of the cockneys.[6]

The figures are packed close to one another. So we are shown a gathering where there are no guarantees of exclusivity. Close crowding would not be a problem in the controlled environment of a private party, or an assembly where an entry fee or introduction system could be relied upon to exclude undesirables, but here the setting is not only public but entirely uncontrolled. We are shown middle-class family groups at leisure—open to inspection and vulnerable to damaging contact with people who do not belong to their social milieu.

Moreover this situation is compounded by the fact that this beach was known to adjoin the bathing area. The bathing machines in the background allude to this. Questions are raised concerning the display of the body. Nude male, and partly draped female, bathing is conceived of as taking place in the sea to the right of the picture space. It is possible to see Frith's painting as an elaborate commentary on bathing—on the demure aversion or lowering of women's eyes and the surreptitious male voyeurism permissible at the margins of the picture. In this context the veiling of forms and the inward turning of figure groups functions as a protective strategy, warding off the manifold dangers of improper glances. This commentary is in itself an interesting subject to investigate but is mentioned here in passing and in relation to the picture's preservation of private domestic space within the public crowd and the preservation of paradigmatic bourgeois identity in a situation which offers threats to social boundaries.

The central group of the picture consists of a middle-class family and a wandering entertainer. The father reads his newspaper, the mother half glances up from her crochet work, two of the young ladies stare in fascination at the little white mice displayed by the kneeling entertainer, their attention drawn from the books they were reading. *The Art Journal* noticed this group in the following terms:

> That family in the centre are remarkable for their exclusiveness; at Peckham, their garden wall is higher than that of anybody else; and here they turn their backs upon everybody, living as it were within a ring-fence. The papa wears his slippers and reads *The Times*. The mama, who is yet pretty, shades her complexion with what the boatmen call a 'main topgallant stu'n-sail' of blue silk to her bonnet. The young ladies read Bulwer

and Disraeli, and keep worrying their matter of fact father for the newspaper to look over the list of marriages.[7]

This links turned backs and lowered bonnet hoods with high walls and exclusive private dwellings. The same review, in no doubt as to the resort's identity as Ramsgate, says: 'If we look up we can catch a glimpse of the crescents rejoicing in the names of Nelson and Wellington'.

The last few houses of Wellington Crescent can be seen in the top right-hand corner of Frith's painting, and Ramsgate had another cliff-top crescent on the West Cliff called Nelson Crescent. There is a deliberate play within this review on the ironic contrast between Peckham and the noble titles of these crescents. Their names refer to a period of British military heroics and to a particular phase in the history of Ramsgate when the town was at the height of its reputation as a fashionable aristocratic watering place, had royal associations, and played a role as embarkation point for troops leaving to take part in the peninsular war.[8] The early years of the nineteenth century saw the building of these fashionable properties. Wellington Crescent was built in 1819–22, East Cliff House beside it c. 1823, and Albion Place, a house which can be seen in the centre of Frith's painting, was commenced in 1789. There were barracks and officers' quarters on the West Cliff to the other side of the harbour until the troops were withdrawn in 1819, and the high concentration of officers made the town socially attractive. Charlotte, Princess of Wales, had stayed in Ramsgate in 1803 and 1804, and George IV had used Ramsgate as a departure point, an event commemorated by the obelisk of 1821–22, plainly visible in the painting behind the harbour wall. His parting address was delivered from the balcony of the Pier House, also visible in the picture, in September 1821, and on that occasion he announced that Ramsgate should be known as 'the Royal Harbour of Ramsgate'.[9]

Since that era the grandeur of the resort had turned to a moderate gentility. Ramsgate came about midway in the league table of resorts that all commentators drew up when dealing with seaside resorts.[10] Among the Kent resorts it fell between Margate, which had the reputation of low visitors, and Herne Bay or Broadstairs, which were comparatively exclusive. It still had a cachet attached to its exalted past. There were slight connections with the current monarch. The Duchess of Kent had brought the child Princess Victoria to Ramsgate several times in the 1820s and once again in 1835. In 1838 there was a rumour that Queen Victoria was going to build a summer palace on the West Cliff, though in fact Queen Victoria and Prince Albert chose the more remote Isle of Wight for holidays. The guidebooks of the 1840s and 1850s informed visitors that a portrait of Queen Victoria by Fowler could be seen at the Town Hall. The harbour establishment functioned as a sort of substitute military installation and, with its uniformed officers, was considered to raise the tone. Financially it served as a prop to the continuing improvements to the resort, in

promenades, lighting, sewerage, and other amenities which were vital to attract speculative investment, which in turn attracted a higher class of holiday makers.[11] Kent Terrace, shown in front of Albion Terrace, was built in the latter part of the 1830s as a speculative venture for seasonal letting.

Life at the Seaside, then, provokes the ironic juxtaposition in a review of an anonymous Peckham street with the grandeur of Nelson Crescent. It does so by including in the picture all the signs of Ramsgate's past—pier, obelisk, harbour buildings, and crescents. But instead of leaving these monuments to the gaze of a select group of visitors, well distanced from a pair of picturesque locals, as do the engravings reprinted from issue to issue of the local guidebook (fig. 30), it packs the picture space with people.[12] The fear raised is that the middle class will be unfitting successors to the nobility of the Napoleonic era. In that case the juxtaposition would work in terms of bathos rather than gentle irony. But the picture successfully wards off this fear by disposing the figures into self-contained groups and providing a compendium of comic types at the edges of the composition.

The specific signs of Ramsgate might be thought of as working against the general impression of seasideness in the picture. All the familiar types from accounts of seaside life are present. The man with his telescope, the bathing attendant with reluctant child, the black-faced minstrels, the bothersome hawkers, the pretty, marriageable young ladies, the self-conscious young man dressed in quasi-naval fashion, and the enervated lounging dandy—these were all standard elements in the accounts of seaside life familiar to readers of fiction, of serious magazine articles, or of the seasonally recurring jokes and cartoons of *Punch*.[13]

These were not necessarily comforting self-images for a bourgeois audience to contemplate. The over-dressed young men were absurd (in Frith's picture one is given donkey's ears by a trick of perspective), the oglers could be considered brutal, the flustered couple besieged by donkey men lacked dignity and perhaps betrayed lower-middle-class origins despite the similarity of their costumes to those of the serene and elegant figures in the foreground. The picture acknowledges the possibility that London's seaside resorts might attract a socially diverse public, but the construction of the picture gives the impression that the danger of undesirable contact between different elements of that public is minimal.

The very fact that these figures were familiar types permitted narrative readings of the separate incidents. Topographical or portrait accuracy of the place Ramsgate gave way to the genre readings allowed when figures were patently types. One review commented that the painting was like a kaleidoscope: '…this composition which at each turn of the kaleidoscope presents a new picture'.[14] The kaleidoscope, apparently suggested by the child's telescope in the picture, indicates the distribution of bright patches of colour, and a

Obelisk, &c.--Ramsgate.

fig. 30
'Obelisk, &c.—Ramsgate'
Frontispiece to *New Ramsgate, Margate and Broadstairs Guide,* 1850 (?)
London, by permission of The British Library [10359 a.10]

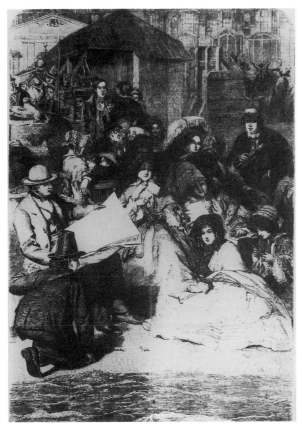

fig. 31
'Ramsgate Sands, No. 2'
from *Illustrated Times*
12 February 1859

manner of viewing that pauses at one pattern and then shifts to a completely new configuration as the viewer's eye travels across the canvas. We have a montage of separate elements, each taking on for a moment a separate identity. Indeed when the picture was engraved for the Art Union of London, it was said to create special problems for the engraver. The problem was to bring the subject together, but one part of the appeal of the picture for its public was that its component parts did not impinge on one another. It is significant that when *The Illustrated Times* reproduced the painting in 1859, on the occasion of the Art Union issue of Sharpe's engraving, it broke with the normal procedure of reproducing pictures in their entirety and chose to serialise the picture.[15] The work is treated as a source to be mined rather than a framed and unified composition. A series of extracts from the picture appeared, each accompanied by commentary on the 'characters' shown (fig. 31).

How can narrative theory help us to deal with the phenomena we have observed—on the one hand, the failure to cohere in genre pictures, where the elements do not appear sufficiently *typical,* the portrait-like 'compositions without a story', and, on the other hand, the kaleidoscopic disintegration of *Ramsgate Sands,* which tells many stories? Barthes in his 'Introduction to the Structural Analysis of Narratives' of 1966, followed Propp in referring to one kind of narrative unit as a function.[16] According to Barthes, functions are arranged sequentially and refer in a chronological or logical way to other equivalent functions on the same level. Some functions are key moments of initiation or resolution of uncertainty; other functions act as chronological fillers. Where the movement between one key moment and another is extended, by the multiplication of filler functions, by the elaboration of more and more apparently irrelevant detail, then it is possible for the properly narrative suspense in waiting for a resolution to give way to pleasure in the materiality of the text itself. Barthes characterises the horizontal relation of functions as metonymic and identifies another vertical axis which consists of indices. These refer to signifieds on a different level such as character or mood. This axis is metaphoric rather than metonymic.

One way of differentiating between narrative texts, visual as well as literary, may be to examine the way that different axes of the text are emphasised. I would suggest that we can see an emphasis on the metaphoric axis in works that function unproblematically as sentimental genre, works such as the painting *In Sickness and Health* by Webster, referred to earlier. Problems enter narrative painting when the other, metonymic, axis is emphasised. The extreme case of denarrativisation occurs when the work seems to consist of nothing but filler functions—where the elaboration of detail overtakes the establishment of hinges of narrative. Within a Lacanian frame of reference the metonymic and metaphoric relationships between elements can be seen to offer, respectively, an untrammelled chain of substitution and a secure fixing of meaning.

Metonymy makes possible a rush of desire, whereas metaphor does not permit this. Instead it fixes meaning by effecting a crossover from the sequence of signifiers to signifieds.[17] One might argue that *Ramsgate Sands,* for all its elaboration of detail, escapes an effect of denarrativisation. We are given the illusion of the pleasures associated with metonymy—the endless movement along a chain of signifiers is mimicked by the way the picture breaks into myriad coloured patches—but the dangers and displeasure associated with that metonymic movement of desire are fended off by the assertion of incident at every juncture. The picture plays with metonymy, but in the last instance the conjunction of signifier and signified is secured. The metonymic features of the work are important for its attempt to communicate the excitement of modernity: the scale and variety of the modern metropolitan crowd, the movement and pace of the modern world. They are also crucial to its claim to tell the truth not just about the specific locality Ramsgate but about the contemporary world. The implication, however, is an uncomfortable one. It seems that the social world, like the pictorial field, is infinitely divided. We see shades of social difference but never really encounter social distinction. Frith's picture does not allow this impression to persist. By moving back from the uncertainty of the metonymic to the firmer ground of fixed meaning, the picture secures the normative bourgeois family's right to occupy this social and historical space.

This essay is based on material drawn from my Ph.D. thesis, *Modern Life Subjects in British Painting, 1840–60,* Leeds University, 1988. I would like to thank Griselda Pollock for help and support in working on this topic and would also like to acknowledge the valuable input from other members of the Fine Art Department at Leeds, particularly Fred Orton.

1. Gerald Prince, *A Grammar of Stories* (The Hague: Mouton, 1973), cited in Laura Mulvey, 'Myth, Narrative and Historical Experience', in *Visual and Other Pleasures* (Houndmills, Basingstoke: Macmillan, 1989), 170.
2. *The Art Union* (1843): 164.
3. *The Art Union* (1845): 191.
4. For example, *Punch* 23 (July–December 1852): 17, and Charles Dickens, 'An Idea of Mine', *Household Words,* 13 March 1858.
5. *The Art Union,* (1845).
6. *The Art Journal* (March 1859): 95; *The Athenaeum* (6 May 1854): 560; and *The Athenaeum* (5 March 1859): 325–26.
7. *The Art Journal* (June 1854): 161.
8. See R. S. Holmes, "Continuity and Change in a Mid-Victorian Resort: Ramsgate, 1851–1871" (Ph.D. thesis, University of Kent, 1977).
9. Speech described in *New Ramsgate and Broadstairs Visitors' Guide…with New Illustrations* (Ramsgate, [1855?]), 8.

10. For example, A. B. Granville, *The Spas of England,* 2 vols. (London, 1841; Somerset: Adams & Dart, 1971) and *The Illustrated Times,* 'By the Seaside' series, 1856–57.

11. For the financial link between the harbour and the town see the terms of the Ramsgate Improvement Act of 1838.

12. The view in fig. 30, from a guidebook of c. 1855, also appears in *The Picturesque Pocket Companion to Margate, Ramsgate etc.* (1831), opp. p. 153, in *New Margate, Ramsgate and Broadstairs Guide…* (Margate, [1850?]), opp. p. 24, and in *New Ramsgate, Margate and Broadstairs Guide…* (Ramsgate, [1850?]), opp. p. 8.

13. 'The Seaside Resorts of the Londoners', *Chambers's Edinburgh Journal* (12 November 1853): 305–9, and Charles Dickens, *Sketches by Boz* (1836–37). See also many examples in *Punch,* e.g. *Punch* 23 (July–December 1853): 121.

14. *The Art Journal* (June 1854): 161.

15. *The Illustrated Times* (5 February 1859): 89; (12 February 1859): 104; (19 March 1859): 184; and (3 September 1859): 152.

16. V. Y. Propp, *Morphology of the Folktale,* trans. Laurence Scott (Austin and London: University of Texas Press, 1979); Roland Barthes, 'Introduction to the Structural Analysis of Narratives,' in *Image, Music, Text,* selected and trans. Stephen Heath (London: Fontana, 1977).

17. See Jacques Lacan, 'The Insistence of the Letter in the Unconscious' (1957) in Richard T. and Fernande M. De George, eds., *The Structuralists: From Marx to Lévi-Strauss* (Garden City, New York: Anchor Books, 1972).

Artists' Professional Societies:
Production, Consumption, and Aesthetics

Julie F. Codell

> The age of societies, however, must be measured by a different standard
> to that of individuals…we have not congealed too much to allow of being
> touched by new ideas, or too exclusive to admit the 'younger generation'
> always 'knocking at the door'—even if the women are excluded.
> *(Walter Crane in a letter to George Clausen, 14 January 1909, in the Royal Academy
> Library, on the 25th anniversary of the Art Workers' Guild)*

In an essay entitled 'Whence This Great Multitude of Painters?' in 1892,
Marcus Huish, editor of *The Art Journal,* lamented the excessive supply of
painters, the limited market for paintings, and the failure of the government
and the public to encourage the design schools:

> That a glut exists in the profession of Painting admits of no doubt—that
> this has arisen at a comparatively recent date is not less certain…now there
> is hardly a household of which one member does not belong either profes-
> sionally or as an amateur, to the artistic community. Fifty years ago the two
> hundred artists who exhibited at the Royal Academy and Water Colour
> Societies comprised almost every member of the profession; now the list of
> exhibiting artists extends to nearly five thousand names and it increases by
> hundreds yearly.[1]

Attributing these conditions to the fashionable status of painters compared
with the lower reputation of designers, Huish lamented the tendency of the
working classes to tie their rising ambitions to painting rather than design,
thereby losing the chance to 'benefit the classes equally with the masses'.
Between 1824 and 1893 the Society of British Artists exhibited 110,000 paint-
ings by 7,000 artists, mostly non-members. It has been estimated that during
the last century works by 25,000 artists were exhibited in London alone.[2]

While the period from 1840 to 1880 has been called the golden age of
painting, the period after 1880 was economically dismal for artists at the same
time as their numbers swelled. A plethora of artists' professional societies and
dealers' galleries appeared to regulate the market, and these were listed in each
volume of *The Year's Art* (edited and later co-edited by Huish), which chroni-
cled the activities of London and provincial galleries, societies, sketching clubs,
collectors' and dilettante societies. Huish's almanac contained an alphabetical
list of English artists, a section that grew from 100 pages in 1888 to 197 pages
in 1909. The extent of the popularity of societies is evidenced by Huish's

citations of such societies as the GPO Arts Club for Postal Workers, the Royal British Colonial Society for Artists, the Stock Exchange Art Society, the Royal Amateur Art Society, the Clergy and Artists' Association, and the Parson Painters Society.

In his article Huish also pointed out the changing patterns of consumption aggravating the rivalry between professionals and amateurs:

> Concurrently, with this increased crowd a continuous growth in art knowledge has arisen, so that productions which would have been acclaimed, and even found purchasers, as works of art not many years back, now only cumber the creator's studio. A change has also passed over the sentiments of society as regards commerce, and an amateur now considers it no degradation to compete with his professional brethren for the sale of his pictures, nor do his relations scruple to act as his agents and endeavour to foist off the emanations of his brush upon all their acquaintances.

Discussions of art in the 1880s and 1890s repeatedly refer to art in economic terms, reflecting artists' concerns with mass consumption and with art as a profession. Several scholars contend that after 1880 the professionalising of all skills was dominant. Harrison and Cynthia White argue that in France the Academy promoted social status at the expense of economic regulation which had been the major function of the guilds. Societies, too, were solicitous of the professional status of their members, a status often defined by that very membership which offered diplomas to signify professional status. In this context professional societies mediated between the social status inherited from the Academy, with its ties to wealthy patrons and privilege, and new economic ratios of supply and demand for artists and consumers.[3]

The growing numbers of artists necessitated a revised infrastructure with new networks, modes of production, and appropriate aesthetic rationalisations. Walter Benjamin points out that mass reproduction served a mass of spectators who could not be accommodated by the annual Royal Academy exhibition.[4] Societies, too, accommodated mass spectating by decentralising exhibitions, increasing their number and frequency throughout the year, and bringing artists and buyers into direct contact. The societies and new dealers' galleries refined market specialties by dividing the art-consuming public into small target audiences, in contradistinction to the crowds at the Royal Academy. Markets were created for a wide variety of media, sizes, subjects, and styles, reflecting a pluralism of taste and the commodification of art works as luxury items for mass consumption.

A few societies appeared early in the century. The Royal British Artists was established in 1819 'as a protest' against what was considered the Royal Academy's discrimination against landscape painters and the limitations of RA exhibition practices. The two water-colour societies appeared in 1804 and 1832,

a Society of Engravers in 1802, and the British Institution in 1805. The Graphic Society was founded in 1833 'to bring together artists of the different professional classes of painters, sculptors, architects and engravers…by the introduction of their friends and gentlemen who are conversant with the Fine Arts, and feel an interest in their advancement'. Insisting that meetings 'not degenerate into a bazaar', its rules forbade purchases or asking of prices. The Graphic Society promoted connoisseurship and did not exclusively serve professionalism.[5]

Specialisation, a prominent characteristic of professionalism, was largely determined by genre or medium. Media-determined societies included the Society of Pastellists (begun 1899), the two water-colour societies (1804, 1832), the Society of Oil-Painters (1898), and the Royal Society of Painter-Etchers (1880). These societies owed their existence to artists' rancour against the Academy for snubbing some of these media. Organised around a genre were such groups as the two societies of miniaturists (both founded in 1895), the Society of Medallists (1891), and the Royal Society of Portrait Painters (1891).

Beginning in the 1860s, Victorian artists felt the effects of an expanding internal art market. The first periodical to describe tensions between the new market and the Royal Academy was *The Fine Arts Quarterly Review*. Envisioning a state of war in the art world, its critics sided with the younger men against the Academicians, agreeing with the government's Royal Commission which investigated the restricted educational and membership practices of the Academy in 1863. *FAQ* critics recognised the peculiar professional position of artists: they did not necessarily require institutional training, and the final arbiter of their success was the non-professional public, unlike arbiters for law or medicine. These conditions kept artists from participating in the professional ideal of economic autonomy from the market based on esoteric knowledge or skills.[6]

In their drive toward professional status societies shared one motivation: to distinguish themselves from the Royal Academy. The most persistent complaints about the Royal Academy concerned its limited membership, the eight submissions allowed academicians, and the privileged status of oil painting. In reaction to what was often called the Royal Academy's monopoly, new societies, trying to appear eclectic and non-partisan, had open memberships, and older societies expanded their membership in the 1880s. The Old Watercolour Society maintained its membership of forty members; but, in 1881 upon receiving the designation 'Royal', it allowed a varying number of associateships.[7] The Institute of Painters in Water Colour in conjunction with the Dudley Gallery opened its exhibition to all water-colour painters.[8] In 1890 the RWS, experiencing a decline in memberships, allowed women to vote for election of members and associates and to attend general meetings. Women could not participate in other business matters until 1923. The expansion of membership

generally benefited women who became members and later, often years later, full participants in society business. In 1870 the new British Institution applied a universal suffrage method, whereby the committee for hanging and selecting works for exhibition was elected from a list of candidates by the contributors to the exhibition, and the candidates for election did not have to belong to the General Committee. Contributors were limited to two works. The Institution's gallery, located in the West End, was opened for winter exhibitions when no other galleries were exhibiting.[9] Membership in the New English Art Club was relatively open, with election possible without submitting a work, if an artist were proposed, seconded by club members, and then approved by a bare majority. Non-members could submit two works for one exhibition only.[10] The Society of Lady Artists expanded its membership in 1886, insisted that members be professionals, and charged non-professionals a fee to exhibit.[11]

Although correcting Royal Academy exclusion, open membership blurred the distinction between professionals and amateurs and diluted claims of expertise, one of the many contradictions in the professionalisation of artists. Open membership was often motivated by a need for funds. Most societies removed non-paying members. The Royal Society of Painter-Etchers had repeated financial problems: proceeds from public attendance and catalogue sales were reduced by almost half between 1889 and 1890.[12] Several societies had patrons and honorary members who contributed funds. The Royal Society of British Artists had five classes of donors, ranging in contributions from one hundred guineas to one guinea per year.[13]

Despite their intentions to offer alternatives to the Royal Academy, societies often replicated the Academy's organisational structures and practices and used the already existing networks of critics, dealers, and the press. Societies created hierarchies of officers, held private views, and actively sought academicians, well-known collectors, and peers as honorary members to ensure economic viability and social respectability for their members. W. J. Laidlay cited the narrowness of the Royal Academy and the shared training in France of the NEAC founders as motives for the formation of the Club. Yet, describing preparations for the NEAC's first exhibition, Laidlay listed its attempted collaboration with Martin Colnaghi, the prominent dealer in Old Masters; Laidlay's successfully persuading the critics Andrew Lang and R. A. M. Stevenson to write favourable reviews; and the management of *The Art Weekly* by two NEAC members.[14] The RWS kept a list of established buyers and picture dealers and invited them to its private views. The art press promoted these societies and gave free advertising to the galleries, as they did for the Royal Academy (a much debated practice).[15] In addition, critics who wrote for the press also wrote catalogue introductions for societies' exhibitions. Thus, the infrastructure of the late Victorian art world was tightly networked and consistent in personnel, despite the burgeoning of societies.

Societies also provided art education in various forms. The Society of Painters in Tempera included Roger Fry, Walter Crane, and Adrian Stokes and must have informed not only British painting and taste but art criticism as well.[16] Several societies created schools: in 1883 the Institute of Painters in Water Colours opened a free school in which instruction was given by society members 'to afford the same advantages to Painters in Water Colours that painters in Oil have derived from the Royal Academy'.[17] The New English Art Club advertised in 1896 that Walter Sickert would begin teaching life drawing classes for men and women, who would be instructed separately.[18]

Societies introduced the public to foreign artists by inviting them to show and by organising international exhibitions. New international societies also appeared. The Impressionists, Rodin, Käthe Kollwitz, Ferdinand Khnopff, James Ensor, and Edward Steichen were among the American and Continental artists exhibited by the societies and new galleries. Societies' presidents and secretaries formed the selection committee for the 1908 Franco-British Exhibition in Brussels, indicating how powerful societies had become in one generation.[19] This new internationalism further pitted many societies against the more insular and nationalistic Royal Academy. The Academician William Richmond expressed a loathing for French art shared by many other Academicians before the Select Committee in 1904 investigating the Chantrey Fund's purchases of paintings by Royal Academicians.

While societies encouraged specialisation by medium or genre, artists often joined several societies and thereby crossed limits of specialised production to fit expanding and increasingly international markets. Beginning in the 1880s, they could join societies *and* the Royal Academy, which changed its exclusivity rule to allow Academicians to become society members. John Lavery, for example, was RSA, RHA, ARA, HROI, RR, and a member of societies in Munich, Paris, Vienna, Brussels, San Luca, Rome, Milan, and Madrid. Lavery was not an exception; Whistler, much less conventional, had almost as many memberships both in England and abroad. Multiple memberships offered a broader market for artists.

Societies were registered with the Board of Trade[20] and served artists' economic interests by 'bringing the Public and the Artist into direct communication'.[21] The international United Arts Club intended 'to bring the patron and the art worker into touch with one another,…to act as agents for members of the Club in the sale and purchase of works of art', and to provide studios for artists and sitters, indicating the priority given to the lucrative practice of portraiture.[22] The Royal Society of Miniature Painters housed a library and rooms for rent by foreign and country members and for display of works in cases. The secretary's job was to show the works to clients and 'to arrange meetings between artists and clients'. The professionalism of its members was based on the paradigm of painters, and members were encouraged to express their 'own

definite characteristics in handling, technique, colouring, modelling', lest miniatures appear as 'merely coloured portraits of small size'.[23]

The complex tensions in reconciling economic promotion and professional self-definition were perhaps best exemplified by the Society of Painter-Etchers, whose tyrannical president Seymour Haden fought not only with the Royal Academy for professional status but also with the Printsellers' Association for economic autonomy. The Printsellers, claiming a desire to assure the public of high-quality prints, tried to limit the number of proofs endorsed by the Association's stamp. Through Haden's vigorous campaign in the press the Printsellers, whose members Haden dubbed 'tradesmen', lost its fight. Haden generally sought publicity for the society, arguing that 'the election of Associates *cannot be too freely advertised*…the insertion ought to be in the Times, three times and twice in the other papers'.[24] Despite his concern with publicity which had clear economic advantages, in his attack against the Printsellers Haden argued that their Association was a trade union inflicted upon 'intellectual production' and that his works were not in pursuit of sales but 'in the pursuit of Art for Art's sake'. According to Haden, etching

> is sensitive, rapid and suggestive in its execution, and produced so to speak, anyhow as a painter would produce it, and without any of that digging and delving of the burin which supposes an apprenticeship and which is intended to conduce to durability, a multiplicity of impressions, and a corresponding commercial return. The two things, in fact, have nothing in common.[25]

For Haden the painter's mode of production was paradigmatic and, if imitated, would guarantee the etcher's professional distinction from the copyist. Yet, in his letter to *The Times* Haden, a surgeon, described himself as finding a 'holyday occupation in the practice of etching', as if he were a gentleman amateur. However, Haden also argued that etching 'of all the arts, is the least fitted to the amateur'.[26] Resisting any commercial intention, Haden claimed that 'the market for etchings is too small to make it worthwhile to make them' and that he was too much an 'Englishman and an artist' to allow the printsellers to commercialise the fine art of original engraving.[27] While Haden's oscillations between claiming professional status and an amateur aloofness were strategies against the printsellers, they also reveal the contradictions many artists felt between professionalism's commercial implications and an amateur status, the residue of an earlier ideal of gentility.[28]

Societies had considerable control over their members' production. James D. Harding (who taught Ruskin) complained in 1828 to Henry Parker that he was compelled to 'produce a large Water coloured Drawing which the laws of our Society oblige each Member to produce in his turn and the annoyances

of this with other matters have so taken up my time that I have not had a moment to give to any other work in Water colours'.[29] The Painter-Etchers expected members' first impressions or proofs from their plates to be exhibited at the Society before any other exhibition.[30] The RBA exhibited only works not previously shown in London. Even societies broadly based along the lines of aesthetic politics—the Royal Society of British Artists (of which Whistler was President from 1888 to 1889), the New English Art Club, and the International Society of Sculptors, Painters and Gravers (whose president was Rodin)—functioned as economic agents for their members as did societies based on medium or genre. The Fine Arts Society appealed to the 'second order of middle classes', in Ruskin's words, encouraged the new taste for small drawings, originated the one-artist show, and promoted younger artists.[31] Walter Sickert called the FAS the 'best *shop* in London'.[32]

Societies also demanded strict allegiance. In 1907 John C. Dollman lamented that he could not send Sir Isidore Spielmann a water-colour for the Franco-British Exhibition because, as a member of the Institute of Painters in Watercolour, he had to abide by the recommendations of the society's president who had not suggested Dollman for the Brussels exhibition. Dollman noted, however, that such a rule did not apply to his oil paintings, one of which he would send.[33] In 1907 Ernest Waterlow, President of the Royal Society of Painters in Watercolour, rebuked Walter Bayes, Associate of the Society and art critic for *The Athenaeum,* for writing criticism which belittled the Society's members. In a series of heated letters Waterlow threatened to expunge Bayes's name from the roll of associates, to which Bayes replied that as an art critic he could both eat and paint, while as a society associate he could do neither, although he fought against expulsion just the same.[34] Usually artists were grateful for the opportunity offered by the societies to exhibit without juries.

Re-shaping and subdividing the market, societies created new ties between artists and the public. In 1892 the Decorative Art Guild had as its objectives 'to form a Central Art Bureau for the purpose of bringing artists and the public into business relationship. Many well-known artists form the consulting committee, and are prepared to accept service as art advisers in matters where special knowledge is demanded'.[35] This is coherent with the professional ambitions of other disciplines in combining the ideology of service with expert mastery of a body of knowledge.[36] The Whites distinguish between the Academy's emphasis on the painting as an object and the dealer's emphasis on the painter's career. In this context societies mediated the changing venues by serving as agents for exhibitions and as professional advisers for buyers. The giant Royal Academy was increasingly becoming inadequate for these economic tasks and for the dissemination of information and experience. Like the

Academy, however, exhibitions were determined by individual works, rather than by the specialised taste of a speculative dealer, such as Durand-Ruel who invested in Impressionist artists, not discrete works.[37]

The restructured market subsidised more equitably the numbers and diversity of artists, escaped the Academy's monopoly, and challenged the view that 'next to singers and actors, painters are the most uninteresting and least informed of professional men'.[38] Societies mediated social as well as economic conditions through the promotion of the Victorian ideology of work in the area of art production. They presented artists as reputable gentlemen and ladies in sharp distinction from the avant-garde, Bohemian image of the artist. Harry Furniss suggested that the critic should 'watch the artist while his work was in progress and would ascertain his aims more thoroughly, and his artistic code of morality far better, than he could learn them from the artist's exhibited work'.[39] In the press artists were interviewed and photographed in their studios, had their preparatory drawings published and their works-in-progress described, all transforming mysterious creation into commodity production open to competition with other luxury goods, public advertisements in the press, and consumers' speculative investment.

The nature and quantity of the artist's labour was a crucial issue, most sensationally in the Whistler-Ruskin trial, where, on the witness stand, Whistler was asked about the amount of time he spent painting a nocturne, i.e., about the exchange value of his labour. Such concerns were also prevalent in the societies' catalogues: Huish writing on Hokusai in 1890 asserted that 'no more honest a worker ever toiled in the field of Art';[40] Julia Cartwright hailed Burne-Jones for his 'vast amount of toil and effort', and Burne-Jones's life was described by Comyns Carr as 'a life of incessant labour spent in loyal service to the mistress [art] he worshipped';[41] Wedderburn regarded J. Bunney's paintings as products of 'hard and honest work' and the artist as a sincere man of 'enthusiasm and industry'. M. Phipps Jackson noted that the artist's 'professional life is to some extent public property…anything that may serve to throw light upon the means by which he attains his ends is instructive, and may be useful to those of his generation'.[42] Displaying their studios and drawings, artists revealed the conditions and quantity of work in their production. Critics and societies increased opportunities for middle-class empathy by endorsing the work ethic and clarifying the exchange value of artists' labour. Societies hoped to develop a more sympathetic public by conveying 'some acquaintance with the artist's intention and the conditions under which his labour has been performed'.[43]

Not surprisingly, the market for young, promising, and less costly artists became dominant, reflecting the intervention of speculation in the art market. Collectors and dilettantes formed their own societies and clubs to 'help to bring to notice new artists and promising amateurs', as the Dilettante Circle

described one of its intentions.[44] Art periodicals, such as *Magazine of Art,* had regular columns devoted to featuring rising artists. New aesthetic values of sincerity and simplicity justified the preference for new artists. Galleries, too, like the Dudley, assured its public that it would continue 'bringing forward the work of new and rising artists'. *The Times* in 1909 saw the market as an excellent opportunity for art buying because of the explosion of high quality art by 'talented young artists', enabling 'art lovers of moderate means' to buy 'at a time when it was the most helpful to the artists and at a price which enabled the patron to indulge his fancy without sacrificing many of the other luxuries of life'. *The Times* encouraged the rich to buy Old Masters of the future which would demonstrate the collector's connoisseurship more fully than the purchase of past Old Masters.[45]

The new dealers' galleries offered societies regular places to exhibit in exchange for a percentage of sales. Galleries also produced prints of paintings by the most popular Victorian artists. In some cases galleries like the Grosvenor fostered an elite style or aesthetic, although its exhibitors included prominent Royal Academicians, as well. The Grafton Gallery in 1894 declared its intention to exhibit 'artists who profess to be "in the movement"'.[46] On the other hand, the Dudley Gallery proclaimed its willingness to exhibit any artist without membership requirement to serve large numbers of unaffiliated artists. Its first call netted 1,700 works of which 519, mostly by amateurs, were hung.[47] MacLean's Gallery liked to show 'young artists, who are, no doubt, destined to occupy a prominent place in their profession'.[48]

Galleries like societies affected modes and quantity of production. Even the aesthete Grosvenor Gallery had a private sale room for year-round display at prices determined by the artists. Its offshoot, the New Gallery, exemplified the replication of modes of production and consumption. It was formed in 1887–88 by Joe Comyns Carr and Charles Hallé, formerly of the Grosvenor Gallery, partially in response to Burne-Jones's complaint that the new restaurant and rental of space at the Grosvenor commercialised the gallery and adversely affected his work. The New Gallery snatched up the most prestigious Grosvenor artists, G. F. Watts and especially Burne-Jones, who 'had many wealthy and enthusiastic admirers, who were delighted to provide funds for the establishment of an exhibition which would consider him its first patron and display his pictures to their best advantage'.[49] Funds were forthcoming and Comyns Carr was soon 'discovering' young artists, maintaining the gallery's reputation as truly new. Some painters feared that exhibiting at the New Gallery would ruin their chances at the Royal Academy, but generally the New Gallery prospered and in its short life entertained such notables as Gladstone, His Eminence Cardinal Vaughan, Sir Stuart Knill, Lord Mayor of London, Lily Langtry, the Prince of Wales, and Queen Victoria. Despite its being an aesthete offshoot of an aesthete gallery, the New Gallery was begun

by well-connected men who served wealthy and aristocratic patrons who, in turn, distinguished themselves from the philistines by patronising aesthete and symbolic art.

Critics writing in societies' catalogues urged the public to re-educate itself to a new aesthetics.[50] R. A. M. Stevenson distinguished the Royal Academy's conventional, literary art, epitomised by its presidents Millais and Leighton, from the new, French-influenced pictorial impressionism shown by societies and galleries. F. G. Stephens advocated the values of sincerity and simplicity in opposition to the excessive elaboration of academic art which he called mere display and 'laborious trifling'.[51] William de Morgan distinguished realist painting, defined economically, from the high-art tradition now fractured by photography and realism: 'Painting, *as a source of income,* turns on the desire of the purchaser for a visible record of created things, and just in so far as the New Realisms of the Camera and the Film satisfy that desire the Profession as practised hitherto must become extinct'. He accused Impressionism of being 'the optical school…that tries to fight in the enemy's country'. Against this strategy, the new artist was 'bent on the externalisation of his inward dreams' and thus the polar opposite of the economically determined artist as recorder.[52]

Critics described three pervasive creative approaches of artists—novelty (associated with French art), conventionality (as in the Royal Academy), and a much lauded middle path.[53] The *via media* allowed the artist to educate the public, gradually building an audience and patronage, as exemplified by the careers of Burne-Jones and Watts, who were repeatedly held up as artistic role models. Aesthetic values of the middle path were intimacy, sincerity, mystery, and lack of finish (finish, costly in time and materials, was frequently designated 'insincere'). Inexpensive media were hailed as more sincere or pure. Pencil or water-colour sketches were described as displaying 'delightful freshness and singleness of purpose, often lost in more finished work'.[54] The Society of Twelve declared itself against 'dull and ridiculous ideas of finish…imagined to have its ground in morality but rooted really in stupidity'. The Society's catalogue, written by Laurence Binyon, praised original wood engravings and lithography for attributes of suggestiveness and evocation of feelings and the imagination. The Society of Painters in Tempera in a 1905 catalogue praised tempera over oil: it avoided the 'false finish and smugness' and facile illusionism of oil.[55]

A passive, evocative decorativeness was most esteemed. The 1910 catalogue of an exhibition of pastels described pictures as 'agreeable spots on the wall'.[56] Walter Sickert wrote that a picture existed to decorate a room and praised Pissarro for painting light and shade 'without rendering the shadow so dark as to be undecorative'.[57] Stevenson praised art having 'no false finish, no restless ambition to express abstract thought…an easy art that never overreaches itself'

and can 'spread its influence over the whole side of a petty or indifferent room'.[58] One critic ruled that a landscape 'should hang on the wall calmly and comfortably, so that it falls into its place in the decoration of the rooms without asserting itself too strongly' and 'not force itself on the attention too persistently', hardly a prescription Turner would have followed. A painting's longevity was determined by a suggestiveness that outlasted changes in fashion: 'it is the picture which assists the imagination most that maintains its fascination longest'.[59]

Originality was problematic. The artist who was not entirely self-taught (an increasingly common case) but was alternatively not too sophisticated was the most commended. Technical skill was praised if it did not display trickiness or technical showiness. Critics, perhaps making a virtue of necessity, praised skill as a reflex of temperament, thereby 'naturalising' it to accommodate the uneven training of the armies of amateurs who made and bought art. 'Carelessness of seeming originality' was praised by one critic.[60] Malcolm C. Salaman praised James McBey's art for appearing to be 'entirely the outcome of his personality' without any 'striving after originality'.[61] A. L. Baldry, on the other hand, praised J. Buxton Knight for 'the very elimination of self from the pictures he produces, a most important rallying point for the sincere workers who wish to spend their lives in a protest against convention'.[62] The condemnation of artistic self-assertion and the demand for 'natural' skill in the small scale of sketches promoted an art of the ephemeral and mysterious, a writerly text, to borrow Roland Barthes's term, in which the reader or spectator has a wide latitude for interpretation and, in some ways, co-authors the work of art by ascribing to it a meaning at least equal to the artist's in its authority.[63]

As painting became reduced in scale and inscribed by the economics of consumption, these aesthetic statements asserted the priority of the patron over the artist, as the function of the artist approached the interior decorator. Laurence Binyon cited the new collector as determining evocative methods and media: 'unable to afford the ever increasing prices of the picture market, yet who desire for their walls original works of art'.[64] Stevenson, fearing the appeal to public taste would 'weaken the sincerity of painters', admonished English artists to resist public philistinism by refusing to paint, 'with a rule and measure where every trivial object ends and begins' and to paint instead, 'mysterious shapes growing out of abysses of lively unwonted colour'. In this way, Stevenson argued, 'buyers can form some idea of the real effect of a picture they feel inclined to purchase'.[65] One artist described pictures in terms of the public's desire for

> loopholes of escape to the soul, leading it to other scenes and spheres, as it were,…where the fancy for a moment may revel, refreshed and delighted. Pictures are consolers of loneliness…a relief to the jaded mind…windows

to the imprisoned thought; they are books; they are histories and sermons…and make up for the want of many other enjoyments to those whose life is mostly passed amidst the smoke and din, the hustle and noise, of an overcrowded city.[66]

Describing water-colour as offering a 'frail and singular beauty', Sickert argued that the medium was difficult by virtue of its 'stern limitations' which resulted in a 'language of extreme refinement'.[67] Such a 'cult of the ephemeral', to use Jean Baudrillard's phrase, encouraged the prestige aesthetic of spartan wealth, the cult of the slight, the nuanced, and the subtle, as signs of one's difference from the realist taste of the masses. Baudrillard has observed that 'the more the system is systematised, the more the fetishist fascination is reinforced' to increase 'the production of difference and of sign values'.[68] Societies and galleries clearly systematised the system further, attenuating the Royal Academy's structures and emphasis on painting and creating an aesthetic to justify new modes of consumption.

In light of this obsession with the consumer's role in the production of a modest, non-assertive art, the defense by Roger Fry and Clive Bell of Post-Impressionism which 'proclaims art a religion and forbids its degradation to the level of a trade' might be seen as an attempt to escape these market restrictions and consumer appeals. Bell claimed that Post-Impressionism was produced 'neither to please, to flatter, nor to shock', i.e., not for public consumption but autonomously asserting a new aesthetic emotion, formal rather than literary or narrative.[69]

Walter Benjamin thoroughly understood the significance of interiors for the collector and the ideological insistence on the afunctional passivity of decoration as a vehicle for empowering the collector:

> The interior is the retreat of art. The collector is a true inmate of the interior. He makes the transfiguration of things his business. To him falls the Sisyphean task of obliterating the commodity-like character of things through his ownership of them. But he merely confers connoisseur value on them, instead of intrinsic value. The collector dreams that he is not only in a distant or past world but also, at the same time, in a better one, in which…things are free of the drudgery of being useful.[70]

The catalogue of the 100th RIW exhibition in 1909 described courting the collector as a condition of the excess of supply over demand: 'Now less than ever can an artist afford to stand aside and wait to be discovered; some appearance in public is absolutely necessary if he would reap his reward'. The modern exhibition offered a chance

> to make a bid for the favour of the public—commercially of great value—and to give his opportunity to the professional critic—a matter

of notoriety or the reverse—but it also enables him to seek the appreciation of his brother-artists, the intrinsic value of which, only an artist can realise, holding within it, as it does, the incentive to higher aims, and to that 'passionate stretch' for the unattainable that has been such a powerful factor in the production of the masterpieces of art.[71]

This statement disguises art's commodification with quasi-religious ideological claims of art: 'intrinsic value', 'higher aims', 'unattainable'. Stating *and* denying the realities of competition for a speculative market, this statement reveals in its self-deconstruction the contradictions for art at the end of the century: subordinate to consumers' economics and taste for decoration and escape, the Romantic myth of artistic autonomy gives way to an assertion of artists' specialised skill at recognising 'intrinsic value'. The notion of a noncompetitive community of 'brother-artists' modelled throughout the century on pre-industrial paradigms (Pre-Raphaelite Brotherhood, Art Workers' Guild, and the Century Guild) was antithetical to modern art production, the mass of artists competing for buyers and venues, and the attributes of professionalism. Competition and market dependence were inscribed on art production—the attributes of small scale and the aesthetics of dreamy nuance. The dialectic between art's spiritualised vocational nature (which brotherhoods and, later, Bloomsbury hoped to restore) and its market conditions (economic regulation and consumer demands) were mediated by the new professional societies which segmented the market, targetted consumers, defined professional validation, and regulated production.

Pierre Bourdieu argues that the logic of the arts is an inversion of the logic of capitalism, a claim of disinterestedness distinguishing artistic production from other kinds of production under capitalism. In short, producers of art, especially the avant-garde, disavow economic interests.[72] Yet the artists' professional societies in England from 1880 to 1914 were explicit about their economic function, a transparency which distinguished them from the Royal Academy. Societies aimed at target audiences, reducing and controlling the mass spectating at the RA. Recognising the international nature of the art market, they worked to soften competition among artists in Britain and between artists at home and abroad. Societies overtly controlled production, demanding fresh works from their membership, another difference from the more sanguine RA, and they extended the exhibition season to the entire year to increase sales. Despite their repudiation of the RA, societies replicated its clubbiness, networks, and control of the press, but differed in their more open membership and less closed-shop admittance policies, control of production, accommodation of consumption practices, and creation of an aesthetic appealing to consumers' tastes.

Societies identified artistic production with consumers' interests. Their catalogues stressed the quantity of artists' labour to appeal to consumers' anxiety

about getting value for their money. This economic emphasis led logically to the fetishism of the work of young artists, a testing ground of a kind of ready-made connoisseurship for the casual art buyer for whom art was both private pleasure and investment. Consecrating a certain modest art consumers could afford, societies legitimated their professional role in economic *and* aesthetic terms. Societies mediated and aestheticised market forces without completely obliterating them. As Bourdieu points out, 'The production of discourse (critical, historical, etc.) about the work of art is one of the conditions of production of the work', and societies actively produced an art discourse, another difference from the RA.[73] Their catalogues became a vital vehicle for their discursive intervention in cultural economics.

Internally societies mediated members' individual egos and sustained their production and sales over time by insisting on regular exhibition participation, loyalty to the society, democratic self-governance, open memberships, and ready absorption of young artists. Making money was not a polluted antithesis of artistic worth for societies. On the contrary, for the Victorian public and academicians it had generally signified an artist's aesthetic worth. Among Bourdieu's models societies were most like the sales galleries—more flexible and eclectic and less partisan—than 'movements', which may explain the easy collaboration between societies and the new galleries.

The aesthetic of the consumer made ownership of art magical, interior, private, an escape or retreat from urban life best served by a writerly art of nuance and decorativeness. Societies' intervention in cultural production was 'directly determined by modification of the changes of access to the…field, and external changes which supply the new producers…and their new products with socially homologous consumers.'[74] Artists' societies created socially homologous producers for the new consumers and tried to monopolise consumers' fantasies, desires, tastes, and available economic means.

According to modern consumer theory the consumption of the arts is additive: the more art one buys, the more art one will buy in the future. This theory began to appear in England in the work of Alfred Marshall in the 1890s. Crucial to this new pattern of art consumption is the need 'to make the taste for the art dependent on past consumption.'[75] Arguing for small-scale works and year-round purchases, societies encouraged regular and frequent consumer purchases of art and regularised and increased artists' production of works. Societies responded, then, to new patterns of art buying emerging at the end of the nineteenth century by modifying artistic production practices vis-à-vis media, genres, labour value, distribution, sales, and marketing. For Bourdieu one of the dilemmas of the field of cultural production is 'the way in which the influx of newcomers is quantitatively and qualitatively regulated.'[76] Societies functioned to regulate patterns of production and consumption to accommodate newcomers, both artists and buyers, to the field. They provided

newcomers with a professional and collective economic mediator and an aesthetic discourse to satisfy buyers' late-century fantasies of collecting despite limited finances, and they provided artists with opportunities for approaching mass production of art.

Research for this essay was funded by a National Endowment for the Humanities Summer Stipend in 1988, which allowed me to examine material in the Victoria and Albert National Art Library, the British Library, the Royal Academy Library, and the archives of the Royal Painter-Etchers Society and the Royal Water-Colour Society, both located at 48 Hopton Street, London. I wish to thank Michael Spender for allowing me access to these archives. My research was further aided by a research grant and a mini-sabbatical from the University of Montana in 1989. I wish also to thank my colleague Professor Paul Burgess, Arizona State University, for his assistance on the subject of cultural economics.

1. In *Nineteenth Century* 32 (November 1892): 720.

2. Denys Brook-Hart's introduction in *Works Exhibited in the Royal Society of British Artists, 1824–93, and the New English Art Club* (Woodbridge: The Antique Collectors Club, 1975), n. p. The seminal study of artists' careers in nineteenth-century France is by Harrison C. White and Cynthia A. White, *Canvases and Careers: Institutional Change in the French Painting World* (New York: Wiley, 1965). See also Nicholas Green, 'Dealing in Temperaments: Economic Transformation of the Artistic Field in France during the Last Half of the Nineteenth Century', *Art History* 10 (March, 1987): 59–78. A recent study of artists who failed to achieve success is Christopher Kent, '"Short of Tin" in a Golden Age', *Victorian Studies* 32 (Summer 1989): 487–506.

3. Harold Perkin, *The Rise of Professional Society: England since 1880* (London: Routledge, 1989). On p. 86 Perkin mentions artists in analysing the organisations of intellectuals, but he does not cite any of their professional societies and considers such organisations as having served intellectual and cultural, not professional, purposes. On the formation of French societies, see the essays in the special issue of *The Art Journal* 48 (Spring 1989). See also T. R. Gourvish and Alan O'Day, *Later Victorian Britain, 1867–1900* (London: Macmillan Education, 1988), 13–35, on the rise of professions.

4. Walter Benjamin, 'The Work of Art in the Age of Mechanical Reproduction', *Illuminations,* trans. Harry Zohn (New York: Schocken Books, 1968), 219–53.

5. Rules and minutes of the Graphic Society are in the Royal Academy Library. Its total membership consisted of forty oil painters, twelve water-colourists, six sculptors, twenty architects, and twenty engravers. By 1878 membership had expanded to 128, of which seventy-six were painters (with no distinction of medium), ten sculptors, twenty-one architects, and twenty-one engravers, one indication of the excess of painters decried by Huish. See John Lewis Roget, *History of the Old Water-Colour Society,* 2 vols. (London, 1891); see also *The Old Society: A Hundred Years in Pall Mall, 1822–1922: A Retrospective* (London: RSW, 1922). Information on the founding of the RBA appeared in the 1899 catalogue of the RBA exhibition at South London Art Gallery. The RBA had twenty-three members in 1824 and fifty in 1876. See Christopher Newall, *Victorian*

Watercolours (Oxford: Phaidon Press, 1987), 23–29; Peter Fullerton, 'Patronage and Pedagogy: The British Institution in the Early Nineteenth Century', *Art History* 5 (March 1982): 59–72; Walter R. M. Lamb, *The Royal Academy: A Short History of Its Foundation and Development* (London: Alexander Maclehose and Co., 1951); Deborah Cherry, 'The Hogarth Club, 1858–61', *Burlington Magazine* (April 1980): 237–44.

6. These professional ideals are cited in Gourvish and O'Day, 17. For a description of the art politics of the 1860s, see Julie F. Codell 'The Fine Arts Quarterly Review and the Artpolitics of the 1860s', *Victorian Periodicals Review* 23 (Fall 1990): 91–97.

7. *The Old Society*, 9.

8. Catalogue of Guildhall Exhibition, 1919, introduction by Dr. George C. Williamson. See also Roget, 2:125. The RIW announcement of its open exhibition appeared in the catalogue of its 65th exhibition in 1883.

9. British Institution principles appeared in the 1870 catalogue of the First Spring Exhibition, 3.

10. The NEAC rules appeared in several catalogues; my citation is from the 1889 catalogue, 5ff., which printed the NEAC's constitution.

11. The Society of Lady Artists' changes in 1885–86 were cited in the catalogue of its exhibition in 1886; the Society increased its associateships from 10 to 24 and its members from 19 to 28. It had 20 members in 1880, and in 1899, as the Society of Women Artists, it had 35 members and 22 associates. In 1918 it had 36 members and 52 associates. I wish to thank the Women's Slide Library staff for making their files available to me. On the professional lives of women artists, see Charlotte Yeldham, *Women Artists in Nineteenth-Century France and England,* 2 vols. (London and New York: Garland Publishing, 1984); Pamela Gerrish Nunn, *Victorian Women Artists* (London: The Women's Press, 1987); Deborah Cherry, *Painting Women: Victorian Women Artists* (London and New York: Routledge, 1993).

12. In 1899 the RSPE exhibition had 1,499 visitors; in 1900 the exhibition drew 727 visitors and catalogue sales were about half, as well. This data is from the records of the Society now stored at 48 Hopton Street. See also Sir Francis Newbolt, *History of the Royal Society of Painter-Etchers and Engravers, 1880–1930* (London: The Print Collectors' Club, 1930).

13. Classes of donors for the RBA are listed in the 1883–84 catalogue of its Winter Exhibition.

14. W. J. Laidlay, *The Origin and First Two Years of the New English Art Club* (London: The Author, 1907), 6, 10, 53, 164, 193. See also Chris Mullen, *Dictionary of British Artists* (London, 1935), 9; and Alfred Thornton, *Fifty Years of the New English Art Club, 1886–1935* (Woodbridge: The Antique Collectors Club, 1976).

15. RWS references to dealers and purchasers appeared in the 1904 edition of the Society's laws, p. 37, rule 94. One example of the debate over the free advertising for societies and galleries appeared in George Moore's attack on the practice in *The Speaker* and the response by M. H. Spielmann in *The Graphic* 46 (December 3, 1892): 662, defending the practice.

16. Names of the members of the Society of Painters in Tempera are listed in its catalogues in the National Art Library.

17. RIW catalogue of the 65th Exhibition in January 1883, 4.

18. NEAC November–December 1896 catalogue, 29.

19. In 1899 Francis Bates, secretary of the NEAC, wrote to Isidore Spielmann on 25 September to ask if only societies were to be represented at the 1900 Exhibition or if individuals could apply for exhibition. Writing Poynter in 1903, Bates

complained that the NEAC was unrecognised in 1900 and that he hoped it would receive recognition in the 1904 St. Louis Exposition. Bates asked Spielmann for permission to use the initials of the NEAC after members' names, although the NEAC was unchartered. Apparently Spielmann assented, because Bates thanked him for the recognition in a letter on 22 May 1905. George Clausen, writing to Spielmann (undated), asked if a friend not in a society could exhibit in one of the many international exhibitions Spielmann organised. These letters are in the Isidore Spielmann collection in the National Art Library.

20. Francis Howard, Honorary Secretary of the International Society of Sculptors, Painters and Gravers, in a letter to Isidore Spielmann, 21 January 1908, on the organisation of the Brussels International Exhibition, in the National Art Library.

21. 1898 catalogue of the Society of Miniature Painters. This society guaranteed that at least three works by each member would be exhibited.

22. Marcus Huish, *The Year's Art,* 1907, 163.

23. George C. Williamson in catalogue of Guildhall Exhibition, 1919.

24. Seymour Haden's letter to John Beavan, Secretary of the Society, 12 January 1890, in the National Art Library.

25. Seymour Haden's letter to *The Times,* 25 August 1877.

26. FAS catalogue, 1878–79, on Old Master etchings, 18.

27. Seymour Haden's letter to *The Times,* 6 September 1877.

28. Norman N. Feltes, *Modes of Production of Victorian Novels* (Chicago: University of Chicago Press, 1986) describes the same dichotomous tensions and contradictions for writers, beginning earlier in the century.

29. Letter from James Duffield Harding to Henry Perlee Parker (Ju/10/239), dated 23 April 1828, in the Royal Academy Library .

30. See Seymour Haden's address to the RPE, located in the Society's archives at 48 Hopton Street, 1890, 16.

31. John Ruskin's preface to FAS catalogue for the exhibition of work by Samuel Prout and William Hunt, 1879–80, 4.

32. Sickert's remark is quoted in a number of places; see Wendy Baron, 'Sickert and the FAS', in the centenary exhibition catalogue of the FAS, 1976, 28.

33. Letter from J. C. Dollman, 1908, in Victoria and Albert Library, no. 25/7.

34. The Waterlow-Bayes letters are in typed form for distribution to members in the Society's archives at 48 Hopton Street.

35. The Decorative Art Guild's objectives are stated in Huish, *The Year's Art,* 1892, 109. W. J. Laidlay, *The R.A.: Its Uses and Abuses* (London, 1898), 124; Laidlay blames the RA for creating this commercial climate. The RPE created a 'permanent *Depot* having convenient accessory appliances for the publication and sale *at all times* of the works of Fellows and Associates' (cited in a letter to members from Beavan dated 15 November 1891). The Society hired Robert Dunthorne as its official publisher in 1891 in an attempt to control its own production.

36. Gourvish and O'Day, 17.

37. The Whites, 88ff. They examine the practices of Durand-Ruel on pp. 124–54. See also Raymonde Moulin, *The French Art Market: A Sociological View,* trans. Arthur Goldhammer (New Brunswick: Rutgers University Press, 1987), 9–17.

38. Harry Furniss, *Royal Academy Antics* (London, 1890), 40.

39. Ibid., 87–88. Furniss's suggestion originally came from M. H. Spielmann, critic and editor of *The Magazine of Art.* For further information on Spielmann see Julie F. Codell, 'The Artist's Cause at Heart: Marion Harry Spielmann and the Late Victorian Art World', *Bulletin of the John Rylands University Library of Manchester* 71

(Spring 1989): 139–63, and Codell, 'M. H. Spielmann and the Role of the Press in the Professionalization of Artists', *Victorian Periodicals Review* 22 (Spring 1989): 7–15.

40. Huish in Hokusai exhibition catalogue for Fine Art Society, 1890, 8, 14. Huish claims on p. 8 that 'little is known of his life save his industriousness'.

41. Julia Cartwright in Fine Art Society catalogue of exhibition of Burne-Jones, April 1896, 4. J. Comyns Carr's comment is in a catalogue of the New Gallery, 1898–99, 29.

42. Alexander Wedderburn on John W. Bunney in FAS catalogue of 1882, 3. M. Phipps Jackson on Davis in FAS catalogue of 1892, 8.

43. Roget, 1:v.

44. Huish, *The Year's Art,* 1881, 132ff.

45. *The Times,* 21 June 1909, 1, and 8 October 1909.

46. Huish, *The Year's Art,* 1894, 88.

47. Roget, 2:114.

48. MacLean's catalogue in 1866 for the second water-colour exhibition.

49. Chap. 12, 'New Gallery', in Eve Adam, ed., *Mrs. J. Comyns Carr's Reminiscences,* 2nd ed. (London: Hutchinson and Co., 1926), 157–71. See also Charles E. Hallé, *Notes from a Painter's Life* (London, 1909); J. W. Comyns Carr, *Coasting Bohemia* (London: Macmillan and Co., 1914); Barrie Bullen, 'The Palace of Art: Sir Coutts Lindsay and the Grosvenor Gallery', *Apollo* 182 (November 1975): 352–57. Clippings of letters by Burne–Jones, Hallé, and Carr which appeared in *The Times* in 1887 are in the National Art Library.

50. See Kate Flint, 'The "Philistine" and the New Art Critic: J. A. Spender and D. S. MacColl's Debate of 1893', *Victorian Periodicals Review* 21 (Spring 1988): 3–8. For a full list of Victorian and Edwardian critics, see Christopher Kent, 'Periodical Critics of Drama, Music and Art, 1830–1914: A Preliminary List', *VPR* 13, (Spring–Summer 1980): 31–55, and Kent, 'More Critics of Drama, Music and Art', *VPR* 19 (Fall 1986): 99–105.

51. FAS catalogue for exhibition of Bewick's drawings and woodcuts, 20.

52. 1909 catalogue for Carfax Gallery, 5–7.

53. Frederick Wedmore in FAS exhibition catalogue of J. J. Shannon, June 1896, 5: 'He is a modern of the moderns, but one who while he has never been enslaved by tradition, has likewise never violently revolted from it'.

54. Catalogue of the Royal Water-Colour Society, 1898, for an exhibition of sketches by John Gilbert. Comments written by Catherine A. Eggar, 4.

55. This Society was formed in 1901; the arguments for tempera cited here are from its 1905 catalogue, 7–8.

56. From 1910 catalogue for an exhibition of pastels of wild animals by Arthur Wardle, introduction by Arthur Hoeber, 6.

57. See Sickert's introduction to exhibition catalogue of Francis E. James for the Dudley Gallery, 1890, 4–5. Sickert's essay is also described in Thornton, 7–9. Sickert's comments on Camille Pissarro appeared in a 1911 catalogue for Pissarro's exhibition at the Stafford Gallery.

58. Stevenson's remarks appeared in a catalogue for the Goupil Gallery for an exhibition entitled, 'A Connoisseur's Treasures', May 1895, 3–5.

59. Catalogue introduction by D. C. T. for exhibition of work by Peppercorn for the Goupil Gallery, May–June, 1889, 3.

60. Letter from Frederick Wedmore to the editor of *The Standard,* reprinted in the catalogue of works by George Mason, a Scottish painter of domestic subjects, at the Dowdeswell Gallery, December 1881.

61. Salaman's comments appeared in the catalogue for the exhibition of McBey's water-colour drawings, February 1914.

62. Baldry in catalogue on Knight at Goupil Gallery, 1896, 4.

63. Roland Barthes, *S/Z* (New York: Hill and Wang, 1974), 5.

64. Society of Twelve catalogue, 1904, for its first exhibition; preface by Laurence Binyon, 1–4.

65. Huish, *The Year's Art,* 1897, 3–5, 10.

66. John Gilbert's introduction to a catalogue of British and foreign paintings for MacLean's Gallery, 1871.

67. Sickert's comments appeared in the 1890 catalogue of an exhibition of works by Francis E. James at the Dudley Gallery, 4, 7–9.

68. Jean Baudrillard, *For a Critique of the Political Economy of the Sign* (St. Louis: Telos Press, 1981), 52, 78, 93.

69. Clive Bell, 'The English Group', in the 1912 catalogue of the Post-Impressionist exhibition at the Grafton Gallery, 23–24. See also Raymond Williams, 'The Bloomsbury Fraction', *Problems in Materialism and Culture* (London: NLB, 1980), 148–69, for a discussion of the Cambridge base and upper-middle-class social world of Bloomsbury which Fry also used to bulwark Post-Impressionism against attack. Fry's 'revolt' in some ways parallels the 'revolt' of the New Gallery. See also Stella Tillyard, *The Impact of Modernism, 1900–1920* (London: Routledge, 1988) for an analysis of the receptions of Fry's exhibitions, especially the favourable disposition of the press.

70. Walter Benjamin, *Reflections: Essays, Aphorisms, Autobiographical Writings,* trans. Edmund Jephcott, ed. Peter Demetz (New York: Harcourt Brace Jovanovich, 1978), 155.

71. Catalogue of the Royal Institution of Water-Colour Painters, 1909, xvii.

72. Pierre Bourdieu, *The Field of Cultural Production: Essays on Art and Literature* (London: Polity Press, 1993), 75–81.

73. Pierre Bourdieu, 'The Field of Cultural Production, or: the Economic World Reversed', *Poetics* 12 (1983): 317.

74. Ibid., 336.

75. David Throsby, 'The Production and Consumption of the Arts: A View of Cultural Economics', *Journal of Economic Literature* 32 (March 1994): 3. Throsby cites Marshall's *Principles of Economics* (London, 1891).

76. Bourdieu in *Poetics,* 345.

The End of Victorian Art:
W. R. Sickert and the Defence of Illustrative Painting

Stella Tillyard

In 1930 *The Abandoned,* a marine painting by Clarkson Stanfield bought in 1856 for the princely sum of £500, was sold at Sotheby's for just £7. By then Victorian narrative painting had become both aesthetically reviled and virtually worthless, destroyed simultaneously by the strictures of a new modernist formalism and the collapse of the market with the Depression. But this double devaluation had been under way for two decades. By 1910 a love for illustrative painting was already fair game for middle-brow satirists publishing in daily newspapers, like the short story writer Saki, whose Lady Anne and her husband:

> leaned towards the honest and explicit in art, a picture, for instance, that told its own story, with generous assistance from its title. A riderless warhorse with harness in obvious disarray, staggering into a courtyard full of pale swooning women, and marginally noted 'Bad News', suggested to their minds a distinct interpretation of some military catastrophe. They could see what it was meant to convey, and explain it to friends of duller intelligence.[1]

That illustrative painting was the vehicle for social satire in 1910 certainly testifies to a weakening of its middle-class appeal. But it did not mean that formalism had replaced it. The two were not inseparably yoked together for a wide audience until after the two Post-Impressionist shows in 1910 and 1912.

The First Post-Impressionist Show of 1910 brought the work of Cézanne, Gauguin, Van Gogh, and younger French painters to the attention of large numbers of English viewers and critics for the first time. It demonstrated that there was a significant audience for Post-Impressionist art in Britain—25,000 people visited the show—and it provided the occasion for Roger Fry, who organised it, to put forward a tentative formalism. It wasn't until the second and much more up-to-date show of 1912, however, that form became a central component of the early modernism preached by Fry and his supporters.

This early modernism as it was put forward in England by Roger Fry, Clive Bell, and their acolytes was based on the twin notions of pure form and aesthetic emotion.[2] Aesthetic emotion would be felt when the sensitive viewer encountered pure form. Both notions were grounded in the premise that pre-modernist painting had become contaminated by rhetoric, by the literary, by

the non-visual, by representation and illustration. Thus it was at this point that illustrative painting was cemented in firmly behind modernist formalism.

In the lectures and articles that accompanied his Post-Impressionist shows, Fry sought to replace Ruskinian standards of judgement, which assessed paintings by their truth to nature and their success in putting across ideas to the viewer, with a new, normative terminology. Surface unity, coherence, 'plastic design', and pure form were, in Fry's schema, able to convey not a message or a story but an aesthetic emotion which was 'good in itself'. As Fry and Bell expressed it, painting became a struggle between the artist and his medium, a tussle whose material efforts were displayed on the surface of the canvas where design might cohere magnificently to create a tense formal unity.[3]

By 1912 Fry's programme had gained the support of most influential critics and he was able to sally forth and attack the last redoubt of illustrative painting, the Royal Academy itself. He chose the occasion of the memorial exhibition for Sir Lawrence Alma-Tadema in 1913 and delivered a devastatingly elitist analysis of Alma-Tadema's work which declared quite clearly with whom, and with what class, cultural authority was henceforth to reside. Alma-Tadema's work, he said, 'finds its chief support among the half-educated members of the lower middle classes. Its appeal to them is irresistible because it gives them in another "line" precisely the kind of article they are accustomed to buy and sell'.[4] Alma-Tadema's prices began soon afterward to join the downward spiral of his reputation. His painting *Spring,* for instance, now in the Getty Museum in Malibu, hit a market high in 1910, when it was sold to an American collector for $22,600. Thereafter, squeezed from above by the artist's savaged reputation and from below by the collapse of the art market in the thirties and forties, its value plummeted. In 1945 the picture was knocked down for $3,600, and in 1957 it was ignominiously sold in Beverly Hills for $2,500 to a collector whose interest in Alma-Tadema stemmed from the fact that he had been told that he was the worst painter in the world.[5]

By the beginning of the First World War academic painters and their supporters, who had been the most vitriolic of Fry's detractors in 1910, had conceded defeat and fallen silent. Illustrative painting did, however, find one vociferous supporter and from a seemingly unlikely quarter: the atelier of Whistler. He was W. R. Sickert, erstwhile pupil of Whistler and well-established critic of the status quo. Sickert's grumbling dismissal of Cézanne in 1914 on the grounds that he could not draw marked the beginning of a long, and largely fruitless, campaign on behalf of illustration, storytelling, and what he called 'gross material facts'.[6] 'All the greater draughtsmen tell a story', he declared in 1922,[7] and he unashamedly dubbed himself a storyteller too. Writing at the beginning of the thirties to Virginia Woolf about the pamphlet she was putting out on his work he said, 'I have always been a literary painter, thank goodness, like all decent painters. Do be the first to say so'.[8] By 1934 he

was still insisting that 'great painting is illustration', but he conceded that there had been a change in the way a critical audience actually saw painting. 'The great paintings of the world are got out of the way by the convenient anathema of "illustration"', he wrote bitterly in the *Burlington Magazine,* 'Mantegna, Michelangelo, Veronese, Canaletto, Ford Madox Brown, Hogarth, Leech, Keene, e tutti quanti falling certainly under the heading of "illustration" must, I am afraid, go. Rubens…can still be mentioned in decent company, but only, if you please, as the [ancestor] of Cézanne'.[9]

Sickert rightly noticed that early modernist critics canonised Cézanne precisely because they saw him as an artist whose formal concerns made him profoundly anti-literary. Cézanne was, in Bell's words, 'the Christopher Columbus of a new continent of form', a heroic explorer pushing out across the expanse of the canvas to discover a new painterly world.[10] More than this, though, for modernist critics Cézanne's search for form implied the rejection not only of the illustration of ideas but also of the foundations of that illustration. Illustration of ideas suggested a narrative, a plot, and a sequence. These associated art with change over time—with beginnings, middles, ends. Modernist aesthetic theory, taking Cézanne as its first and finest example, rejected all of this. Instead of story, sequence, and temporality, it demanded pictures that told no stories and declared that art was timeless, not temporal. Art existed, even for the cautious Fry, in what Woolf in her Sickert pamphlet called the 'zone of silence' away from words, sequences, time, the everyday.[11]

This rejection of the time-bound and the quotidian was in part a consequence of modernist commitment to the modernity of new art. Modernism was announced by its most ardent supporters as a new beginning, an arrival with no end. It could have no truck with ideas that involved plot, a necessary and temporal sequence of beginning, middle, end, birth, life, and death. Pure form, similarly, was a-temporal, non-referential, unplotted, and non-illustrative.

But it was in the notion of purity that the weak point of the modernist program was found. For the very idea of pure form was founded on a notion of impure form, form contaminated by illustrative representation. Thus there could be no pure form without impure form, and if impure form was associated with illustration and representation, then the very survival of formalism as a coherent aesthetic depended on the maintenance—somewhere—of its reviled opposite. If that was the case, then Victorianism, or the creation of Victorianism, was central to the modernist aesthetic in England. Indeed, the erection of a reviled Victorian past of tasteless downmarket prints and paintings must rank as one of the most important features and greatest achievements of Edwardian modernists.

Maintenance of the purity so necessary to the formalist programme depended on getting the dangers of words or illustration out of art and off

the canvas altogether. But, clearly, the lurking potential of literariness could not be destroyed without the simultaneous destruction of the idea of purity. Hence the modernist ridicule of illustration and hence, also, the constant seepage of the literary around the domain of art. Modernist manifestos, as rhetorical and bombastic as anything the Victorians produced, poured off the presses in the first two decades of the century; seeing formally required millions of words of explanation and instruction. And words jumped onto the canvases themselves; the site of seeing became the site of reading as well. Modernist artists, especially Picasso and Braque in Paris, painted and stencilled words onto and into their analytic Cubist work of 1910–12. Their collages often included scraps of newsprint, emissaries from the temporal, anecdotal, and plot-based world of the journalist.

The revolution of modernism created not just new ways of painting but also new ways of seeing and feeling as well. Formalism involved not only a transformation of painterly priorities but also a new kind of emotionally charged perception: it trained viewers to see form feelingly. It also, as a necessary consequence, demanded a kind of blindness.

Just as the notion of pure form was based on the repression of impure representation, so the seeing of that form had to be based on the suppression, the *not-seeing*, of non-formal elements within or surrounding paintings. Seeing form was grounded in a blindness to illustration. To put in another way, Fry's fabled perception of the figure of Christ in a Renaissance painting as 'this large mass' was founded on a learned ability to erase 2,000 years of Christian iconography from his apprehension.

We can see the operation of this blindness in modernist critics' response to Sickert's work, especially to his genre paintings, works like *Ennui* and the *Camden Town Murder* series. Obviously, if blindness was a criterion necessary to the formalist vision, we would expect to find it in the response to a painter who was formalism's antagonist. Such, indeed, was the case. And it meant, I believe, that Sickert's noisy espousal of the cause of illustration did his own painterly reputation no good at all, because it demanded from modernists a blindness to just those qualities in his work that show him to have been an artist of intellectual subtlety as well as a draughtsman of skill.

Both Robert Emmons, Sickert's first biographer, and Wendy Baron, author of the most comprehensive catalogue of his work, describe the artist as a man primarily interested in formal and painterly problems. They base their case for his achievement on his experiments with the operation of light upon related masses. Sickert, they suggest, painted people because he was interested in the formal problems posed by the human figure. Wendy Baron says of *The Camden Town Murder* and its related drawings and etchings, in which a clothed man is posed with a naked woman, that 'the location and poses of his figures were chosen not so much for their suggestive innuendos as for their pictorial

[that is, formal] possibilities'.[12] Robert Emmons, Sickert's earliest memorialiser, confidently asserts in similar vein that when *The Camden Town Murder* was originally shown in 1911, 'a good deal of blood was spilt by critics showing that Sickert's style was not adapted to bloody murder. Only a few appeared to realise that this title, like so many of his, was no more than a peg to hang the study of two related figures under a given form of light'.[13] The critic R. H. Wilenski agreed that the pictures were, 'just a technical experiment', and Roger Fry declared in 1911, the year that *The Camden Town Murder* was shown, that things for Sickert 'have only their visual values, they are not symbols, they contain no key to unlock the secrets of the heart and spirit'.[14]

This view was challenged from the mid-seventies onwards, particularly after the Hayward Gallery's *Late Sickert* show of 1981 and the return to figuration celebrated by the Royal Academy's *New Spirit in Painting* exhibition of the same year. Richard Morphet championed Sickert as an artist 'obsessed' with subject matter and placed him in the company of Bacon and Warhol. Simon Watney has taken issue with Baron's formalism and argues that Sickert's titles did hold keys to meaning and that the painter had a 'tragic vision'.[15] It remains true, however, that Sickert, popularly known for his genre painting, is still critically regarded as much as a draughtsman and painter of form as an artist concerned with subject matter.

What did it take, then, for critics like those I have quoted to see formally? How, in other words, does such formalism work? There are, I think, at least three operations of blindness, three exclusions of the wordy and the literary necessary to create the conditions for a purely formal seeing of works like the *Camden Town Murder* series.

In the first place it took a disregard of Sickert's repeated public pronouncements that the best painters are all makers of plots, tellers of tales. When Sickert told Woolf that he had 'always been a literary painter', she took him seriously. Her brother-in-law, Clive Bell, the most uncompromisingly formalist of early modernist critics in England, did not. He saw Sickert's assertions of his literariness as dandified, anti-modernist posing, something on a par with his penchant for dressing up and impersonation. It was outside—beside, as he put it—his work as a painter. In his memoirs Bell declared that 'Sickert was a poseur besides being a great painter'.[16] Bell's neat separation of Sickert's 'posing' from his painterly business once again attempted to push his extra-painterly work, especially his written journalism, apart from his artistic activities and thus to take painting into the wordless, uncontaminated 'zone of silence'.

If the first act of blindness in formalist sight involved disregarding what Sickert had to say about himself, and his journalistic pronouncements on the merits of literary and illustrative painting, the second involved a disregard for his first critics. When the *Camden Town Murder* painting was shown in 1911,

fig. 32
Walter Sickert
The Camden Town Murder, 1908
Chalk heightened with white
10 x 9¾ in. (25.4 x 24.8 cm.)
Private collection

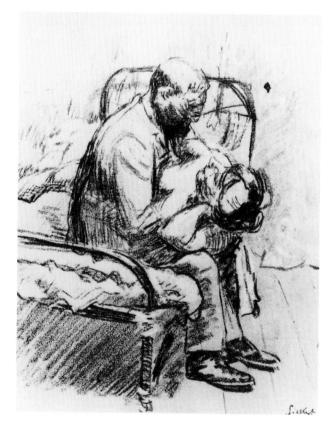

fig. 33
Walter Sickert
The Camden Town Murder
La Belle Gâtée, 1908
Chalk heightened with white
10½ x 8 in. (26.7 x 20.3 cm.)
Private collection

most critics had barely digested the incipient formalism that characterised Fry's description of modern art in *Manet and the Post-Impressionists,* which had introduced Post-Impressionist painting to British audiences a year before. In 1911 many critics were still using old descriptive and normative categories: they were likely to talk about the content of paintings and to judge them on whether or not that content was fine and accessible. That meant, inevitably, that they paid a good deal of attention to titles as clues to paintings' meanings. Critics who saw Sickert's *The Camden Town Murder* in 1911 clearly thought that its title—the most obviously literary part of the work—was significant. They believed, as later critics did not, that a work called *The Camden Town Murder* had something to do with a murder in Camden Town. If they tried to show, as Sutton has said, that 'Sickert's style was not adapted to bloody murder', it was perhaps because low-life murder was more often described by engravings in *The Police Gazette* than in oils on the walls of a London gallery.

The third act of blindness, and perhaps the most startling, was to the painterly context of Sickert's genre pictures. It seems to me that Sickert was, with this group of works, making two separate references which demonstrated his affiliation with artists he regarded as both masterly and literary. The first reference, made through his titles and through gestures like the inclusion of paintings within paintings, was to the great cartoonists and graphic artists he so admired, men like Keene, Leech, Daumier, Gillray, and Hogarth. The second, particularly overt in the *Camden Town Murder* series, was to the genre painting of his mentor Degas.

The work now called the *Camden Town Murder* series is a group of drawings, paintings, and etchings which Sickert made between 1907 and 1909. Wendy Baron says that 'Sickert made several independent series of drawings from 1907–1909, each of which includes compositions called *The Camden Town Murder*'.[17] Because she is not interested in the implications of Sickert's titles, Baron thinks that the drawings and paintings are independent, unconnected. I would like to suggest that they are related not only by title but by the use of the same model. Sickert used the same man to pose for all these compositions and, in virtually every case, the same clothes. If these drawings and paintings were made over two or three years, the artist must have had a good reason to call the same model back to his studio several times.

I think he had a very good reason: he was assembling studies into a story. It is a story that we can reassemble. A man dressed in cheap working clothes comes into a sordid room and sits down next to a prostitute (fig. 32). We know the woman is a prostitute—and so would contemporary viewers—because in academic painting the presence of a clothed man and a naked woman together on the canvas invariably indicates a relationship that is commercial rather than amorous. Soon, he is holding her in his arms on the bed (fig. 33). This iron bedstead is the abiding hallmark of Sickert's paintings of this period. It is a bed

that indicates a whole milieu and way of life. It is emblematic of both sordid sexuality and the poverty and squalor that was typical of Camden Town at the turn of the century.

Shortly afterwards the deed is done. The victim lies stretched out on the bed, and the murderer sits by the body (fig. 34). Finally, the murderer glances at his victim before he makes his escape, his arms crossed as he looks down at her (fig. 35). The chamberpot—always symbolic of licentiousness, waste, and prostitution in the eighteenth-century caricatures Sickert so admired—adds a note of squalor to the scene.[18]

Sickert seems, with this group of works, not to be illustrating so much as telling a story, in much the same way that his beloved Hogarth told the story of his hero's decline in *A Rake's Progress*. A sequence of images enables the reader to follow a plot from beginning to end. And this plot is not concentrated in one work, as is the case with most narrative paintings, but spread out between at least four. The passage of time involved in the notion of plot is thus incorporated in the sequence. Individual works function like episodes of a traditional plot: first, and then, and then, and then. In telling rather than simply illustrating his story, Sickert emphasises both the literariness of his work and his interest in and concern for temporality, time passing. He incorporates into his sequence the opposite of modernist timelessness.

And yet Sickert was also illustrating a story in the sense that his sequence had an outside referent. That was an actual murder in Camden Town in 1907. A young prostitute, Emily Dimmock, was brutally murdered in a rooming house. The affair was christened by the press 'The Camden Town Murder'. So, like the nineteenth-century graphic artists he so much admired, Sickert provided illustrations of a real event to go along with the headlines. In so doing, he put himself forward as, in some sense, a reporter, a man presenting the reality of life, not a decorous interior in the Bloomsbury style or a studio nude of the kind so frequently painted by continental modernists.

Indeed, Sickert went even further in blurring the boundaries between 'reality' and representation. He chose as his model a man who had been a prime suspect in the case. He was a commercial artist from Camden Town—and thus a kind of double for Sickert himself—who had been arrested and interrogated by the police.

As I have said, Sickert's explicit use of a press headline for his title was a tribute to men who had made their livings illustrating the news, the graphic artists of the nineteenth century. These draughtsmen, and Charles Keene especially, Sickert championed as men who had mastered the difficult art of the ordinary. Their training was an apprenticeship far removed from the hothouses of the Slade or the Royal Academy Schools. Keene, Sickert said, 'learnt his trade "on the job", doing drawings for a threepenny comic paper to make his living. It was on this diet that he became one of the master draughtsmen

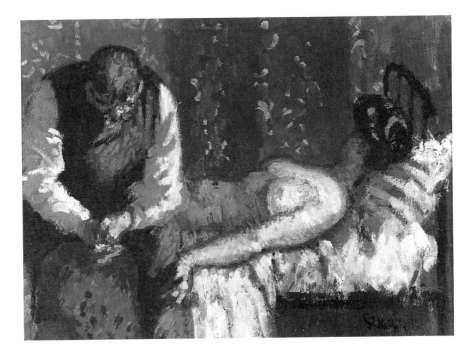

fig. 34
Walter Sickert, *The Camden Town Murder or What Shall We Do for the Rent?*, c. 1908–9
Oil on canvas, 10 x 14 in. (25.6 x 35.5 cm.), Yale Center for British Art, Paul Mellon Fund

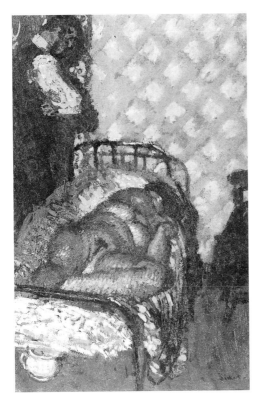

fig. 35
Walter Sickert
L'Affaire de Camden Town, 1909
Oil on canvas, 24 x 16 in. (61 x 40.6 cm.)
Private collection

of the world'.[19] Keene was a man who made a living at street level, as it were, with cartoons—mainly in *Punch*—that were topical, humorous, and satirical. For Sickert, his art may have been the 'low' art of illustration, but it was far better than the 'high' art beloved of the critics: 'pages were written, under the reign of her late Majesty, on such nonsense as Watts' "Physical Energy" or Millais' "Speak, Speak", while the art of the day was being poured out, undiscussed, in the columns of *Punch* over the signature C. K.'.[20] Sickert's titles, then, were a gesture of appreciation towards these unsung heroes. They represented an act of filial piety as well, however, for Sickert's father was himself a commercial artist who earned his living working for illustrated newspapers. But Sickert's titles had a polemical as well as a pious intent. When he referred, in his *Camden Town Murder* series and other enigmatically titled works, to illustrators like Keene, he was enlisting them in his own struggle against the 'critical pontiff, who dines out for Art with a capital A' and the apologists of modernism.[21]

The second reference in the *Camden Town Murder* series to which modernist critics have necessarily been blind is to the genre painting of Edgar Degas. It seems to me that the series in general, and the final painting in particular, makes an explicit genuflection to Degas' famous and controversial canvas *Le Viol* (fig. 36). This painting, produced in 1868 or 1869, was called by Degas 'my genre painting', and sometimes it is referred to as *The Interior*. Be that as it may, it was conventionally known at the turn of the century, when it was still in Degas' own studio, as *The Rape*. Because it stayed with the artist's own collection, it was well known in his circle, which included the young Sickert, and excited continuous controversy from the moment Tissot saw it in Degas' studio in the early 1870s.

Critics have disagreed about what *Le Viol* portrays and means. It is said to refer perhaps to a novel by Degas' friend Duranty, perhaps to Zola's *Madeleine Férat* or to *Thérèse Raquin*.[22] It is less important for our purposes to identify a literary source than to note common elements between the *Camden Town Murder* series and *Le Viol*. There is, in the first place, a similarity of ambience, of claustrophobia and tension. This is partly formally created. In *Le Viol* Degas brings the frame of the painting beyond the ceiling line and close to the standing figure's head. Sickert adopts and exaggerates this device in his painting, thus creating an immediate sense of confinement. There are other similarities between the works: both show the man in the doorway, both show the woman undressed—Degas' dishevelled in her petticoat, Sickert's completely naked. Moreover, Degas puts the iron bedstead in a prominent position on the canvas. It demands attention as an emblem of sexuality in exactly the same way as do Sickert's more downmarket versions in his Camden Town paintings.

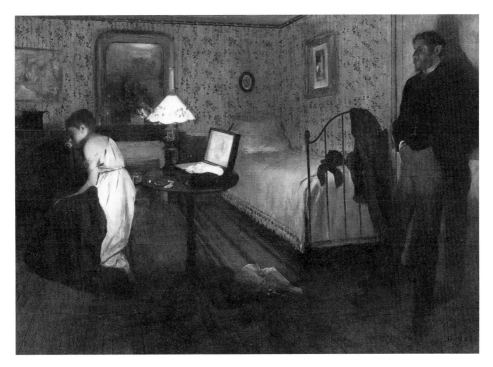

fig. 36

Edgar Degas, *Le Viol,* 1868–69, oil on canvas, 31⅞ x 45⅝ in. (81 x 116 cm.)

Philadelphia Museum of Art, The Henry P. McIlhenny Collection in memory of Frances P. McIlhenny

For Sickert, Degas was not only the 'greatest painter of the age',[23] he was also, despite his haut-bourgeois origins and conservative politics, a no-nonsense depicter of the everyday, a man who loved Keene and scorned the art world. Sickert declared that Degas 'hated the "arty" and all exaggerated manifestations of aesthetic sensibility, real or affected'.[24] His homage to Degas, then, like his homage to Keene, was intended to declare his artistic allegiances.

Formalist critics seem to have been blind to Sickert's painterly gestures as well as to his written statements. They had very good reasons for their lack of sight. For Sickert was using his painting to show that he was intent on telling stories; he was parading and acknowledging his 'literariness'.

It wasn't just the display of literariness that ran counter to the formalist programme, however. The content of Sickert's work was also in direct opposition to the thrust of the modernist aesthetic and its definitions of and claims for art. As I have said, early modernist aesthetic theory elevated art not only to the 'zone of silence', the 'still point of the turning world' beyond language, but also into timelessness. In *Art* Clive Bell put forward a panoply of great painters that constituted the artistic equivalent of T. S. Eliot's 'ideal order' of poets. These geniuses, Bell suggested, rose above the prevailing concerns of their times to consort with one another in a kind of heaven of pure form. Their art was also beyond the pettiness of ordinary time. It was something eternal and changeless. To laugh at Van Gogh, said Fry, in a passionate outburst 'is to forget how rare it is to see God and yet live. To Van Gogh's tortured and morbid sensibility there came revelations fierce, terrible, and yet at times consoling, of realities behind the veil of things seen'.[25]

Sickert would never have written about painting in this way. The more elevated and mystical early modernist pronouncements became, the more he stuck to the gutter. Moving away from the decorous urban scenes of his French and Italian sojourns, he established himself as a painter of the lodging houses and immigrants of Camden Town, Euston, and Fitzroy Square. There he explored in his work day-to-day life, time passing, the poor of the district old and dying—dying brutally in the *Camden Town Murder* series.

This concern for the transitory, for the movement of time and people, is especially evident in Sickert's portraits of the very old. Just before he returned to England in 1903 or 1904, he painted several studies of his mistress's very old mother, and after he came back he made numerous paintings and drawings of the old model Hubby, sometimes alone and lonely, sometimes with his wife. One of them became *Ennui*. As he himself got older, he painted a remarkable series of self-portraits, appearing as himself, as Lazarus, or as The Servant of Abraham.[26]

Formalist critics were not simply blind to the time-bound and the plotted as themes of Sickert's work. They also closed their eyes to the context within

which his subject matter was understood. Once again, there were good reasons for them to do so. Sickert's sequence of *Camden Town Murder* paintings was the story of an end, a narrative of extinction that summoned up memories of the pre-modernist era at the end of the nineteenth century when the murder story first became a popular genre. It was, of course, a literary genre. Sickert, ever literary, was, I believe, the only painter to transfer this genre to the canvas. And so it comes as no surprise to know that Sickert, along with many Englishmen of his day, was fascinated by gruesome murders, particularly those of Jack the Ripper. He went so far as to claim both that he knew the Ripper's identity and to paint the Ripper's portrait, which was actually a self-portrait. In the *Camden Town Murder* pieces Sickert showed an artist as a murderer. In his Ripper portrait he identified the artist-murderer as himself, attesting both to the Wildean dictum that art and law-breaking go together and to a personal fascination with violent, sexual crime. Sickert was also, inevitably, a devout Holmes reader and had a large collection of books on crime.

Crime fiction was a newly popular and characteristic literary form of the fin-de-siècle. And one reason why it was so popular was that it mirrored the preoccupation of the fin-de-siècle with endings. Just as the fin-de-siècle was itself a narrative of ending, a story of decline with an implied beginning, middle, and end, so was popular crime fiction. Sickert's own crime story was thus doubly literary. Inscribed within the painting of the story of the crime was the narrative of the fin-de-siècle with its half-serious fantasy of destruction, disaster, and dissolution.

Such murder stories as Sickert or Conan Doyle told, however, were not merely double narratives of the end. They were painted, written, and received in a climate of intense and rising anxiety about crime. Exemplified by murder and epitomised by the depredations of gruesome murderers like Jack the Ripper, crime seemed to offer grisly evidence of the depravity of modern society. Paintings like *The Camden Town Murder* provoked extreme reactions because they called forth viewers' anxieties not just about escalating crime but also about the decline of society to which it seemed to testify. Crime was seen as part of a wider social malaise, the phenomenon of degeneration.

Degeneration was a disease identified in the 1860s and 1870s by French and Italian psychiatrists working with the insane and with criminals. It was defined as a pathological response to modern life, a decay of the nervous system—and with it the moral faculties—that could eventually lead to paralysis and death. Doctors and scientists believed that it might be both hereditary and regressive. If so, it would spread through generations and worsen as time went on. And, although degeneration was identified as a disease of the poor, the criminal, and the insane—those who were lowest down the evolutionary scale of the class system—it could, in theory, spread to destroy or incapacitate whole national populations.

It was at this theoretical juncture, and sometime in the late 1860s, that degeneration theory moved beyond the laboratory and the lunatic asylum and into government reports, political and social commentaries, and everyday speech. From about 1885 onwards in England—as well as in European competitor nations, especially France, Italy and Germany—discussion at all levels of the condition of the nation, of poverty, sexuality, class division, and imperial weakness was dramatically recast in the biological and medical language of the degeneration theorists. Existing metaphors of the national condition were, it seemed, not only underwritten by scientific fact but also given a dramatic teleological twist. The Biblical notion of the Fall was translated from metaphor to possibility in the notion of atavism. The time-honored description of the state or 'body politic' as an organism whose health depended on the healthy cooperation of its parts was reworked as the idea of the progressive degeneration of parts and then the whole of society.

Although degeneration was a disease it was also, necessarily, a narrative, a true story of potential decline. And like the narrative of the fin-de-siècle within which it was inscribed, it was a story of ending, a plot which incorporated the simplest, most easily understood of plots, a beginning, middle, and end. Thus the *Camden Town Murder* series reminded viewers of a narrative of decline very much in keeping with the millenarian mood of the fin-de-siècle. To add a story of murder to this was to triple the narrative of endings.

Modernist critics dismissed the early reception of *The Camden Town Murder,* then, not just because it hinted that the painting was received as literary, but because it was plotted at three interconnected levels. The tale of murder was part of a much larger story. And that story of degeneration and the fin-de-siècle referred back to the late nineteenth century, the pre-modernist era which critics thought about only in a selective and teleological fashion.

For confirmation that Sickert's hand was so firmly on the pulse of public anxiety in the years before the First World War, we can turn to what is perhaps his best known work, his *Ennui,* painted in 1914 (fig. 37). This, too, partook of narratives of degeneration and decline. To contemporaries ennui was not boredom or alienation, but rather an early stage of degeneration. One commentator called ennui a 'progressive deterioration of every organ and portion of the body and tissues' which ended in dissolution and death.[27] Produced by the cramped and unhealthy conditions of life in the city, it was exacerbated by alcohol and tobacco. Sickert's painting shows all these things. Again, the frame encroaches on the figures, shutting them into the corner of the room. Tobacco and alcohol feature prominently—the sherry is on the mantelpiece, the beer is on the table, and the old man leans back to puff on his cigar.

Ennui, then, told an elaborate story. It represented not just individual tragedy but a story of the national condition. Put side by side with other works of its period it conveyed a bleak message. Academic painters like

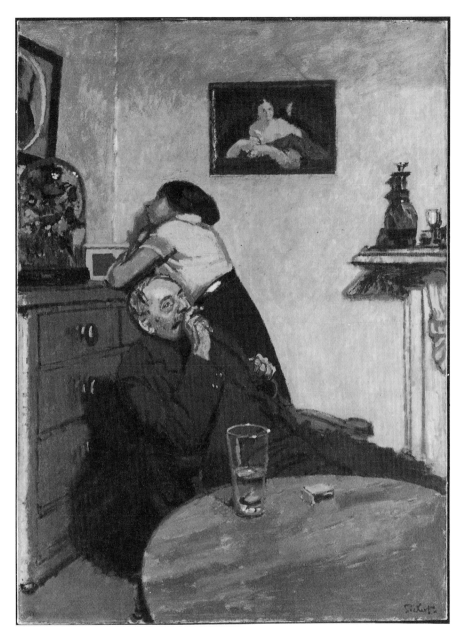

fig. 37
Walter Sickert, *Ennui,* c. 1914
Oil on canvas, 60 x 44¼ in. (152.5 x 112.5 cm.)
London, Tate Gallery

Frank Brangwyn were painting a heroic working class, the very opposite, that is, of the degenerate poor whom Sickert showed. Sickert's Camden Town colleague Spencer Gore was portraying the suburban optimism of the Garden City Movement, while the young Wyndham Lewis was drawing a eugenically created super-race. Finally, Bloomsbury painters were escaping from representation altogether with their abstract experiments.

Sickert persisted in painting old age, sterility, degeneration, poverty, and murder. Epitomised by the *Camden Town Murder* series, his pre-war painting stood as a nasty reminder both of what early modernists rejected and what their aesthetic of pure form demanded for coherence: the literary, the time-bound, the anecdotal, and the quotidian.

1. Saki, 'The Reticence of Lady Anne' in *Reginald in Russia and Other Sketches* (1910), reprinted in *The Complete Works of Saki* (Garden City, New York: Doubleday, 1976), 46–49.
2. Here I am perforce both simplifying and summarising Fry's hesitant, Quakerish, and never wholly complete formalist development. A fuller version can be found in my book, *The Impact of Modernism* (London: Routledge, 1988).
3. For the formulation of early modernism, see Charles Harrison, *English Art and Modernism, 1900–1939,* 2nd ed. (New Haven and London: Yale University Press, 1994) and Simon Watney, *English Post-Impressionism* (London: Studio Vista, 1980), 75–78, 93–94.
4. Roger Fry, 'The Case of the Late Sir Lawrence Alma-Tadema, O.M.', *Nation* (18 January 1913): 666–67.
5. My thanks to Louise Lippincott for information on Alma-Tadema's prices.
6. Walter Richard Sickert, *A Free House! Or, The Artist as Craftsman,* ed. Osbert Sitwell (London: Macmillan, 1947), 208.
7. Ibid., 176.
8. Quoted in Quentin Bell, *Virginia Woolf* (1972; reprinted New York: Triad/Paladin, 1987), 2:174.
9. Wendy Baron, *Sickert* (London: Phaidon Press, 1973), 187.
10. Clive Bell, *Art* (London: Chatto and Windus, 1914), 207.
11. Virginia Woolf, *Walter Sickert. A Conversation* (London: Hogarth Press, 1934), 11.
12. Baron, 184.
13. Robert Emmons, *The Life and Opinions of Walter Richard Sickert* (London: Faber and Faber, 1941), 146. See also Denys Sutton, *Walter Sickert: A Biography* (London: Michael Joseph, 1976), 149: 'despite the intrinsic interest of the theme, the effect of such paintings lies predominantly in their visual qualities—their rich, dark colour and to lesser extent their composition'.
14. R. H. Wilenski, quoted in Anthony Bertram, *Sickert* (London and New York: Studio Publications, 1955), 4, and Roger Fry, quoted in Baron, 186.
15. Richard Morphet, 'The Modernity of Late Sickert', *Studio International* (August 1975): 35–38; 'Late Sickert, Then and Now' in *Late Sickert, Paintings 1927 to 1942* (London: Arts Council, 1981), 10. Watney, 32.
16. Clive Bell, *Old Friends* (London: Chatto and Windus, 1956), 22.
17. Baron, 103.

18. This essay, keeping to the brief of the volume, is about Sickert's use and defence of narrative devices and their contexts. However, I am uncomfortably aware that placing Sickert's story amongst the stories and anxieties of contemporaries, I have (half) closed my eyes to the fact that he was showing a sexual murder. The *Camden Town Murder* series is one of many depictions of rape and sexual violence in turn-of-the-century painting. The art historian Beth Irwin Lewis concludes that they represent an angry response to the growth of feminism. (See Thalia Gouma-Peterson and Patricia Mathews, 'The Feminist Critique of Art', *Art Bulletin* 69 (1987): 340–41.

19. Sickert, 311.

20. Ibid.

21. Ibid., 99.

22. See Theodore Reff, *Degas: The Artist's Mind* (New York: Metropolitan Museum of Art, 1976), 200–38, and Quentin Bell, *Degas: Le Viol* (Newcastle upon Tyne: University of Newcastle upon Tyne, 1965), passim. Bell notes that Degas was 'the first of the enigmatic painters, those who, while shunning anecdote, give us mood without narrative. "Ennui", "What Shall We Do For the Rent?" [an alternative title for the last of the Camden Town Murder paintings]…stem directly from Degas and above all from *Le Viol*.…*Le Viol* marks a turning point in European art after which painting becomes silent'.

23. Sickert, 153.

24. Ibid., 150.

25. Roger Fry, 'The Post-Impressionists', *Nation* (3 December 1910): 403.

26. As he got older, Sickert turned to photographs as sources for his work, and his self-portraits were painted from snapshots of himself. His use of photography represents, I believe, another gesture towards nineteenth-century illustration as well as towards a tremendous technical advance. News photographers were the twentieth-century equivalent of the graphic artists of a hundred years before. By 1930 Sickert's appreciation took the form, very often, of painting from newspaper photographs themselves. He also declared his allegiances by making a few of his late portraits look like photographs, even when they were squared up from pencil drawings. Sickert's use of photography, then, is not just the discovery of a new method; it is also the reworking of his oldest themes and beliefs. It is a method of the consistency of his stand on illustration that he hired a newspaper photographer to take his pictures for him: 'His name is Woodbine and he is one of the Herald's best…instantaneous light photographers' (quoted by Penelope Curtis in *W. R. Sickert: Drawings and Paintings, 1890–1942* [Liverpool: Tate Gallery, 1988], 38.

27. Gordon Stables, OM, MD, RN, *The Cruise of the Land Yacht 'Wanderer'* (London, 1886), 314.

UNIT 1

THE MODERN MOVEMENT IN ENGLISH ARCHITECTURE PAINTING AND SCULPTURE

EDITED BY HERBERT READ

CASSELL AND COMPANY LTD
LONDON · TORONTO
MELBOURNE · SYDNEY

fig. 38
Title page of *Unit One*
Edited by Herbert Read
Cassels, 1934
London, Tate Gallery Archive

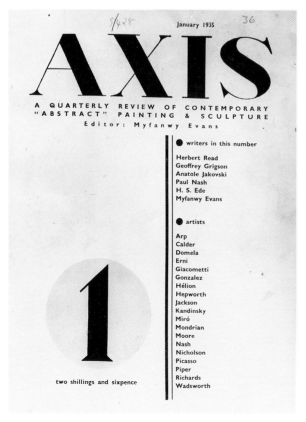

January 1935

AXIS

A QUARTERLY REVIEW OF CONTEMPORARY
"ABSTRACT" PAINTING & SCULPTURE
Editor: Myfanwy Evans

● writers in this number

Herbert Read
Geoffrey Grigson
Anatole Jakovski
Paul Nash
H. S. Ede
Myfanwy Evans

● artists

Arp
Calder
Domela
Erni
Giacometti
Gonzalez
Hélion
Hepworth
Jackson
Kandinsky
Miró
Mondrian
Moore
Nash
Nicholson
Picasso
Piper
Richards
Wadsworth

1

two shillings and sixpence

fig. 42
Cover of first issue of *Axis*
January 1935
London, Tate Gallery Archive

England's Climate

Charles Harrison

The title of this paper picks up various echoes from the literature of modern British art.[1] I take it explicitly, however, from an article published in the avant-garde journal *Axis* in the Autumn of 1936. That was the seventh issue in a total run of eight. The joint authors of the article were Geoffrey Grigson, a poet and critic, and John Piper, a thirty-two-year-old artist with various forays into art and architectural journalism already to his name.[2] I do not mean to single this text out as a notable intervention. It is its very ordinariness which makes it apposite—or rather it is the conjunction of its ordinariness with its timing, for if I am right in my reading of the art history of the period, the latter part of 1936 saw the turning of a cultural tide which had been flowing for almost exactly three years. I mean to maintain a relatively close focus upon this brief period of time, but my aim in doing so is to generate material for more wide-ranging inquiry and for generalisation about that modern British art world which these proceedings are to be 'towards'.

There are various references one might use to establish the commencement of this three-year period. In a letter to *The Times* in June 1933, the painter Paul Nash announced the formation of Unit One, an avant-garde group composed of modern painters, sculptors, and architects, Barbara Hepworth, Henry Moore, and Ben Nicholson among them (fig. 38). In Nash's words Unit One stood 'for the expression of a truly contemporary spirit, for that thing which is recognised as peculiarly of today in painting, sculpture and architecture'.[3] A month later another letter announced the formation of the Modern Architectural Research Society.[4] Yet another possible indication is the meeting held early that autumn which led to the formation of an Artists International in London, its purpose to establish the artistic grounds of unity 'against Imperialist War, War on the Soviet Union, Fascism and Colonial Oppression'.[5] Or we might refer to the testimony of Anthony Blunt, according to whom 'quite suddenly, in the autumn term of 1933, Marxism hit Cambridge…I found that almost all my younger friends had become Marxists and joined the Communist Party; and Cambridge was literally transformed overnight…'.[6]

However we may explain it, it is certainly true that two discernible and interconnected changes occurred in the language of art and art criticism during the course of our three-year period. Firstly, a number of English artists and critics declared their commitment to the modern and did so in terms which suggested that some more ethically fundamental process was envisaged than the mere stylistic modernisation of English art. And secondly, a new term

came to prominence in the litany of critical enthusiasm: the way to call attention to the positive modernism of a work was to call it revolutionary. I should make clear that I am not implying any actual meshing of the artistic with the political—not at least in any form which could be systematically described. For the moment I merely wish to note the coincidence of two resonant terms in the critical discourse of the early thirties—a coincidence, incidentally, which had for some while had its equivalent in the splutterings of those for whom Modern and Bolshevik were virtually interchangeable animadversions.[7]

In seeking to define and to characterise the three-year period I have in mind, I should of course not ignore the evidence of the practice of art. In the period from the summer of 1933 to the end of 1934, critically interesting developments occurred in the work of Barbara Hepworth, Henry Moore, and Paul Nash, while in December 1933 Ben Nicholson carved the first of those reliefs which were to constitute the major contribution by an English artist to the international modern movement of the 1920s and 1930s. Besides the formation of Unit One the period in question also saw the emergence of the Seven & Five Society as a plausible avant-garde group. This status was affirmed in the autumn of 1935 by the staging of what was seen at the time as the first all-abstract art exhibition in England,[8] an exhibition which included white reliefs by Nicholson, Hepworth's *Discs in Echelon,* now in the collection of the Museum of Modern Art in New York, and Moore's four-part reclining figure in Cumberland alabaster, now in the collection of the Tate Gallery (figs. 39, 40, 41).

Axis (fig. 42) had been launched at the beginning of 1935 under the editorship of Myfanwy Evans, soon to become Myfanwy Piper. It announced itself as 'A quarterly review of abstract painting and sculpture', and it was clear from both style and contents that its editorial thrust coincided with those interests which were dominant in Unit One and in the Seven & Five. English artists illustrated in the first number included Nicholson, Moore, and Hepworth, who were members of both groups. There were articles by Nash and by Herbert Read, who had recently edited a Unit One publication, and by H. S. Ede, who had already identified himself as a supporter of the Seven & Five. John Piper was responsible for the layout of *Axis* and was also the secretary of the Seven & Five. Of course, it is hardly surprising that there should have been this overlap of personnel. On the most generous of estimates, and numbering artists and writers together, the British avant-garde in 1935 comprised fewer than fifty persons, most of whom lived in that part of Hampstead which Herbert Read was somewhat mawkishly to refer to as 'A Nest of Gentle Artists'.[9]

One significant characteristic of this community in the early thirties was its enthusiastic cosmopolitanism. According to the testimony of Tristram Hillier, who was a tangential member of Unit One, 'We regarded ourselves as the

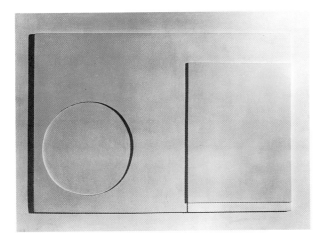

fig. 39
Ben Nicholson, *White Relief,* 1935
Oil on carved board
22 ½ x 31 in. (57 x 79 cm.)
Private collection

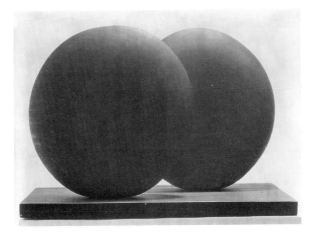

fig. 40
Barbara Hepworth, *Discs in Echelon,* 1935
Padouk wood, height 12 ¼ in. (31.1 cm.)
The Museum of Modern Art, New York
Gift of W. B. Bennet
Photograph © 1994

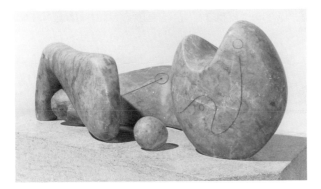

fig. 41
Henry Moore, *Four-Part Reclining Figure,* 1934
Cumberland alabaster, length 20 in. (50.8 cm.)
London, Tate Gallery

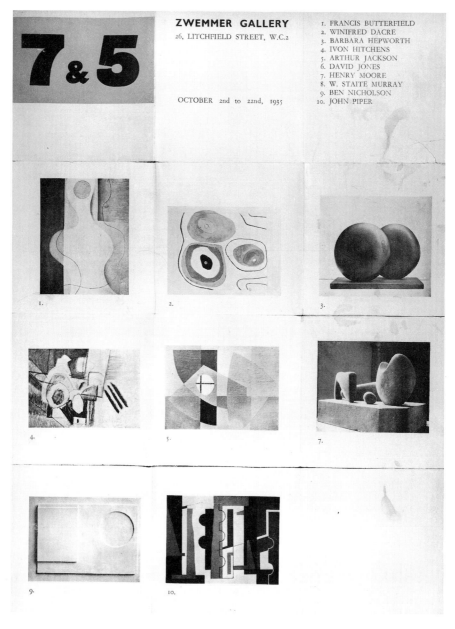

ZWEMMER GALLERY

26, LITCHFIELD STREET, W.C.2

OCTOBER 2nd to 22nd, 1935

1. FRANCIS BUTTERFIELD
2. WINIFRED DACRE
3. BARBARA HEPWORTH
4. IVON HITCHENS
5. ARTHUR JACKSON
6. DAVID JONES
7. HENRY MOORE
8. W. STAITE MURRAY
9. BEN NICHOLSON
10. JOHN PIPER

fig. 43
Broadsheet for 7 & 5 exhibition
Zwemmer's Gallery, October 1935
Private collection

spearhead, as it were, of contemporary European painting and sculpture which, at that time, had scarcely penetrated to England'.[10] From the first issue in January 1935 through the fifth, published in the Spring of the following year, *Axis* was a determinedly internationalist magazine. I wish to stress this sense of shared cosmopolitan adventure, though not because I think it explains the development of critically interesting painting and sculpture during the years 1933–36. I am aware that co-occurence is not of itself a causal relationship. On the contrary, my suspicion is that the internationalist rhetoric and the avant-garde art were coincident consequences of the same set of underlying causal conditions.

To adopt a cosmopolitan position is, of course, to view the culture of British art with a critical regard and thus to step outside the business-as-normal of the insular art world. I should be more precise about this. The British art world of the inter-war years did not entirely exclude the European modern movement—not at least those aspects of it which were consistent with what Roger Fry had dubbed 'Post-Impressionism'. On the contrary. That taste in early modern French art for which Fry and Clive Bell had been the most articulate spokesmen was well catered for and well exploited in the London art market of the 1920s. The point is rather that modernism itself was still seen as an exotic commodity in the British art world of the 1920s and early 1930s. Though Fry and Bell (and later R. H. Wilenski) had been concerned to propagandise a modern movement and to locate a number of native artists within its ranks, in the larger art world normal British art was on the whole dealt with in different terms and to different people, and it was evaluated by reference to an unbroken insular tradition. Indeed those younger artists who had not been recipients of the patronage of Bloomsbury strongly resented the part which they believed Fry and Bell had played in fostering a kind of exclusiveness and snobbery about continental modernism. In 1933 the editor-to-be of *Axis* paid a visit to the Lefevre Gallery in London. Her purpose was to view an exhibition by the young English artist Ivon Hitchens, a founder-member of the Seven & Five. She was told by the director, 'You don't want to look at that stuff.... Come up and see my Derains'.[11] In the early 1930s a native artist aspiring to a cosmopolitan modernism was an artist who started without credibility in the market. I want to emphasise that during the three-year period we are considering this circumstance was to change.

The evidence is quite clear, I think, that the change was one which the principal figures of the emergent avant-garde were consciously determined to effect. In 1932 Paul Nash had written a speculative essay on the dubious possibilities of 'Going Modern and Being British'.[12] His organisation of Unit One was an attempt to realise those possibilities. In his own words 'Derainism' and 'Post-Cézannism' were to give way to 'the contemporary spirit...the adventure, the research, the pursuit in modern life'.[13] Ben Nicholson's avowed ambition

for the Seven & Five was that it should be transformed into a vehicle by means of which he and a few others could break through those barriers which kept the modern and the British apart. He believed that that aim had been achieved with the 'all-abstract' show of 1935 (fig. 43) and the society disintegrated thereafter; or rather, to favour Nicholson's own account, it had its apotheosis in the spring of 1936 in the exhibition 'Abstract and Concrete'—an *international* exhibition of abstract painting, sculpture, and construction for which the fifth edition of *Axis* provided the catalogue (figs. 44, 45).[14] That same summer the International Surrealist Exhibition opened in London. Nash, Moore, and Herbert Read were among the members of the organising committee. It was apparently due in part to the initiatives taken within the small English avant-garde of the early 1930s that the art world of London had by the autumn of 1936 been widely exposed to the art of the European avant-gardes—art from which it had for the most part been isolated until 1933. It was to be expected that various members of the same English avant-garde should be well represented in both the international exhibitions of 1936, nominally at least on equal terms with such European counterparts as Picasso, Léger, Mondrian, Giacometti, Miro, Klee, Ernst, and Gabo.

Between 1934 and 1938 a number of modern movement refugees migrated from Paris to London, Mondrian and Gabo among them. Naum Gabo had been a member of the Russian avant-garde in the early 1920s and a member of the abstract artists' group Abstraction-Création in Paris in the early thirties, and he was an exhibitor in 'Abstract and Concrete'. Asked why he had chosen England, he replied that the new English art he had seen in Paris—and I think he must have had Hepworth's and Nicholson's abstract work in mind—had convinced him that a modern and cosmopolitan art world had developed in Britain.[15] We should be clear that this was not simply a matter of artistic fraternity and enthusiasm. On his arrival in England Gabo sold a small construction to the architect Leslie Martin. It was the first work he had sold since his departure from Russia fourteen years previously.

This, then, is the three-year background of avant-gardism and cosmopolitanism and catching-up against which I believe that the 'England's Climate' of Grigson and Piper should be read. In fact I am not going to offer a close reading of the text, nor do I mean to elaborate upon its conclusions, which are less than straightforward. I shall merely describe the essay and say what I think it stands for. It opens with a quotation from Blake:

Spirit, who lov'st Britannia Isle
Round which the Fiends of Commerce smile…

It is illustrated with a copy of a medieval stained glass panel from Salisbury Cathedral and with works by Constable, Fuseli, Palmer, and Christopher Wood. The voices of Grigson and Piper alternate. Grigson tends to concern

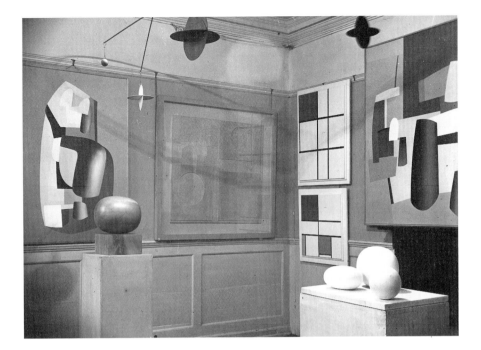

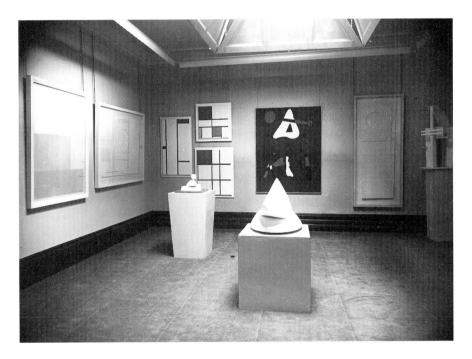

fig. 44 and fig. 45
Installation photographs by A. J. Hepworth of *Abstract and Concrete* exhibition
shown in Oxford, Liverpool, London (at the Lefevre Gallery), and Cambridge
between February and June 1936

himself with the art of past centuries. He celebrates Fuseli, Blake, and Palmer as artists in whose work the traditions of painting and literature are gathered together. Piper is concerned with the inadequacies of abstract art and surrealism and with the need for absorption in 'the tradition'. The tradition is exemplified largely by reference to English artists from the eighteenth and nineteenth centuries. Expressed in both voices is a concern for 'life' and for 'our common humanity'. It is implied, though not explicitly stated, that current avant-garde art, and particularly abstract art, is devoid both of life and of common humanity. The tone is admonitory and assertive. The essay as a whole is marked by that confidence about judgements of taste within the wider culture of art which, in England at least, carries the stamp of a class. 'The last century was one of declining good', Grigson writes. 'Consider Poussin, Blake, Rossetti'. And Piper: 'Cotman, Wilson, Girtin, Turner—it is a sad list that can be made, from our point of view'. Grigson concludes with a warning and with a form of projection which recalls the near-to-fascist dream of Yeats's 'Second Coming'. 'The fiends are busy, desperate and fierce'—he means Blake's 'Fiends of Commerce'—

> but outside ourselves, we can at last allow our common humanity to rule us, or give us advice. Great art comes from great living; great living comes from our common humanity promising or filling out or still defining a high social shape to which each peculiar person can decently relate himself. I believe that men may have to wait a hundred years before such a shape is renewed.

As I said at the outset, 'England's Climate' appeared in the penultimate issue of *Axis*. The eighth and last issue was published, after more than a year's delay, in the winter of 1937. By then there were a number of galleries in London showing both abstract and surrealist work. As for the avant-garde, though its overall population was increased, it had already split into a number of distinct and divergent factions. By 1938 rival teams of abstract artists and British surrealists were playing each other at cricket. Conventional wisdom defines a period of English absorption in the international modern movement during the later thirties—a period marked by international exhibitions, by avant-garde publications, and by the immigrations from modern-movement refugees. In the same conventional wisdom the closing of this period is finally effected by the outbreak of war in 1939, by which time most of the refugees have continued their migrations to the safety of America. In a retrospective statement of 1952 Barbara Hepworth appeared to be looking back over just this period: 'Everywhere there seemed to be abundant energy, and hope, and a developing interest in the fusion of all the arts to some great purpose. But just when we felt the warmth and strength of this new understanding it eluded us'.[16] And Nicholson, writing still later: 'One foresaw a new world—and alas

what a very different kind of world it has proved to be'.[17] In Herbert Read's retrospect on the later thirties, 'There were no polemics and no programme.... There was a prevailing good temper, an atmosphere in which art could grow. The war came and destroyed it all'.[18]

I wish to question the conventional wisdom which these statements appear to support, and in doing so to challenge its underlying assumption of historical cause and cultural effect. For I believe that the moment of closure came not with the outbreak of war in 1939—though of course the circumstances of war were decidedly hostile to the pursuit of avant-garde art—but rather three years earlier at the moment and in the fashion which 'England's Climate' serves to mark. I quote one further retrospect. This is Myfanwy Piper writing in 1965 in an essay called 'Back in the Thirties':

> For Hepworth and Nicholson at least, art had crystallised into space and the history of art was in the future. For most of the rest, modern art, abstract art, with its life-lines to Cubism or primitive painting or sculpture or pre-history or Cézanne or Surrealism, was a means of dealing with the remnants of the object, of nature left to us; not a new world but the old world in new and shattered circumstances.[19]

The language is something of a giveaway. The rhetoric about the remnants of the object and of nature derives not from the artistic soul-searchings of wartime, but from an anthology called *The Painter's Object* which Myfanwy Piper put together in 1937.[20] The anthology contained an essay by John Piper, Grigson's co-author, and by then her husband. It was called 'Lost—a Valuable Object'. The object was the one which Cubism was supposed to have destroyed. 'It will be a good thing', Piper wrote, 'to get back to the tree in the field that everybody is working for. For it is certainly to be hoped that we shall get back to it as a fact, as a reality. As something more than an ideal'. It would be hard to conceive a more thoroughly English form of the *rappel à l'ordre* than this, hung as it is on the rhetorical token of the tree in the field. Though *The Painter's Object* included contributions from European members of the modern movement, its principal interest now is as a document of the entirely insular Romantic Revival, within which the Pipers played a central role. Whatever one's view may be on the artistic merits of the Romantic Revival in English art, there can be no question of its incompatibility with the values of a wider and more cosmopolitan modern art.

What can be read out of the later issues of *Axis* and the various materials anthologised in *The Painter's Object* is that two divergent and, I think, competing discourses were being conducted within the modern British art world in 1936 and 1937. The first was the continuing discourse of a would-be cosmopolitan modernism. Its principal points of historical reference were Post-Impressionism, Cubism, and Abstract Art. The discourse of modernism

was also preoccupied with the virtues of the so-called 'primitive', which it found displayed in pre-classical Greek art, in pre-Renaissance Italian art, in tribal sculpture, in the productions of children, and in the work of such unschooled artists as Alfred Wallis and Douanier Rousseau. In the discourse of cosmopolitan modernism the autonomy of art was associated with a critical avoidance of the literary. It was not that artistic modernism was inimical to literature as such. It was rather that it was opposed to the culture of the *littérateur*. Under modernism the aesthetic was seen as a resistant and a potentially universal value and was associated with an equal imaginative freedom for all. This freedom was vaguely associated with a revolutionary quality in modern art, though it was not clear how any actual emancipation was to be effected for any actual constituency.[21]

The second discourse, while it assumed or pretended that many of the achievements of modern art could be taken for granted, dwelt upon the idea of a native genius. In the identification of this native genius it consistently stressed the necessity of certain attributes and tendencies: an attachment to the landscape, an empirical regard, a romanticism towards the past, a sense of moderation sometimes associated with a virtuous amateurism, a tendency towards the literary, and, most important of all, a determined individuality. In the final number of *Axis* Myfanwy Piper crowned Paul Nash (fig. 46) as the paradigm modern English artist.[22] She began, 'Paul Nash has absorbed the English climate…'. In his work, she continued, 'the contour of things past is given the aura of things present, so the reality *and* the romanticism of both is intensified…. More than most other English painters Paul Nash has developed a personal idiom…. In these sectarian days' he is able 'to hold an apparently middle course without suffering for it'.

There follows a revealing passage in which the interests of a historically specific conflict are camouflaged in generalisation:

To-day we are conditioned more and more into being not so much individuals as parts of something else; of a school, a movement, a mass, a class. The individual is subjected to the class every time. This fact has to be reckoned with before anything else. And it is true of painters as well as civil servants and schoolmasters and engine drivers and typists. For those with a herd instinct it is a grand thing; for the others there are only two possible courses; to become a leader (if necessary start a group of their own to be leader of) or, to fight for individuality and justify it. It is a very curious fight, because it is an ethical one between two kinds of individualists and all the morals have been cleverly acquired by the movement side: the other side has either to redefine morality or be content to be labelled anti-social and therefore vicious.

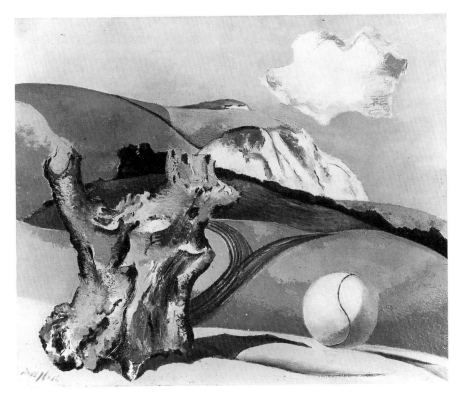

fig. 46
Paul Nash, *Event on the Downs,* 1933, oil on canvas, 20 x 24 in. (50.8 x 61 cm.)
By permission of the Paul Nash Trust and the Government Art Collection

It was Nicholson that Myfanwy Piper had in mind, I am sure, as the individualist of the 'movement side', Nicholson who was in 1937 at the centre of that small group of abstract artists from which John Piper had recently defected. Clearly, it was not only in the idle journalism of the right-wing press that abstract art was associated with socialism and with the loss of individuality. In face of the priorities she declared in 1937, it is interesting and curious that Myfanwy Piper should have come to see Nicholson and Hepworth as the virtual victors of the fight she alludes to—that it was they, in her retrospective account of 1965, who had discovered a route to the future of art, while she and her associates were left to struggle with the fragments of the post-Cubist object and the remnants of nature in the old world. Given that Nicholson and Hepworth were to be virtually excluded from the modern British art world of the 1940s and 1950s, what exactly was the nature of their supposed triumph in her eyes? I shall leave this question hanging for a moment while I offer some recapitulation.

What I have claimed so far is that a form of cosmopolitan art world had developed in Britain—or to be more specific, in London—by 1936; that the initiatives of a small avant-garde group were apparently instrumental in this development, but that the coincidence of events during 1933 suggests that we should look to some larger causal conditions for explanation of the artistic tendencies of the period. I further suggest that the historically specific coincidence of 'modern' and 'revolutionary' as valuations provides us with some indication of where to look for that explanation. I do not mean to confirm the myth that all abstract artists were socialists—though there were very few of the inter-war generation who were not determined anti-fascists. I mean rather to suggest that the equation of modernism with internationalism and the concurrent importation into criticism of the language of left-wing politics both may have been impelled by a perception of events in Europe: by the gathering evidence that the stitched-together peace of 1918 was breaking down, by the increasingly inescapable evidence of the rise of fascism, and even, however indirectly, by so specific an event as Hitler's inauguration as Chancellor of Germany, which took place early in 1933, at the beginning of our three-year period. I realise that that 'however indirectly' is a weakening qualification. It needs to be made, however, in recognition of the fact that we do not yet know—and may never know—just how to read history out of art. I do not mean to say that we should avoid the attempt; on the contrary, it seems to me possible that those historical processes which bear most significantly upon persons and societies are sometimes revealed in art before they are easily discerned anywhere else. They are revealed, however, not as pictorial narratives but through formal and technical effects and through the negative retrodictions of other effects—if only we knew just how to read them.

However it may be explained, I believe that the historical location of this avant-garde moment in British art is a relatively uncontroversial matter. I now further suggest that the second voice we have noted developed concurrently and within this same modern art world, not simply as an alternative point of view upon the culture of the modern but rather as a form of denial or annulment of its cosmopolitan predicates. By 1936 this second voice had become clearly effective in such texts as the one which furnishes my title. If it is defensible to contextualise the avant-garde initiatives of 1933 by reference to political events in Europe, I believe the effectiveness of this second discourse in 1936–37 may in some way be explained in terms of a kind of fastidious disengagement: a drawing back in face of various forms of political unsightliness—the Spanish Civil War, Stalin's show trials, Cable Street—from the historical unfolding of those same events. The autumn of 1936, after all, saw the establishment of another Axis in Europe. Though the authors of this second discourse are careful to distance themselves from the Academy, behind the screen of familiarity with the modern their critical rhetoric is determinedly insular and conservative. To the excitements of modernist abstraction this rhetoric counterposes the specificity of the British landscape; in face of the elaboration of theory it asserts the virtues of a dogged empiricism; against the single-minded professionalism of the committed modernist it asserts the virtues of dilettantism and amateurism; in response to the semblance of collective endeavour it proposes a nostalgic individualism; the more urgently modernist theory asserts the autonomy of artistic effects, the more elaborately it traces the literary ramifications of pictorial imagery.[23] During the three years before the outbreak of war England's inhospitable Climate effaced the artistic vision of a modern and international culture.

I promised some generalisation on the basis of my small-scale case study. I have been attempting to characterise the development and function of a form of dialectic. Readers may rightly have suspected that I take this dialectic to be a characteristic and structural feature of the modern British art world as a whole. Before I elaborate on this claim, though, I should return to the question I left hanging earlier: On what grounds did Nicholson and Hepworth succeed in Myfanwy Piper's eyes? What is the nature of that triumph which she acknowledges more through the disappointed tone of her retrospect than through any explicit judgement? The answer, I think, is that she cannot finally escape the conviction—or threat—that a significance attaches to the art of Nicholson and Hepworth which is not matched in the work of those they left behind. I don't think it matters much what we take to be the measure of that significance, or whether we agree or disagree with the implicit judgement. The point is that the grounds upon which Myfanwy Piper defined culture as authentic or inauthentic in 1937 were not the grounds upon which the

authenticity of culture was in the end decided. Forms of art which appear figuratively disconnected from historical events may turn out to be resolute in other ways in their facing of history. Works of modern art which illustrate local themes and dramas, on the other hand, are for the greater part historically vacuous, however transparently readable they may be.

I don't mean to make too much of Myfanwy Piper's apparent change of perspective. If a unity of theory and practice is not achievable in thought, let alone in practice, it is most certainly not achievable in art criticism. But I think there is a further moral to be drawn. It is this: that whenever the discourse of British art has refused the equation of modernism with internationalism and of both with artistic merit, it has tended inexorably to pick out the aesthetically reassuring and the parochially modern—which is to say the second-rate.[24]

I have used the moment of 1933-36 as a form of case study, but in fact it does seem to have been a kind of historical crux. From this moment for some thirty years the modern British art world was to develop as a place in which the modern and the British were held in a kind of stasis. As much of the modern would be allowed into the conversation of that world as could be accommodated to an unquestioned value for the British. Common humanity, it transpired, was a common British humanity, and it was cast in the mould of a responsible class—or rather of the small responsible fraction of a supposedly responsible class. It was in the later 1930s that Kenneth Clark's taste became a powerful agency within the insular art world. Clark supported John Piper and Graham Sutherland. The troika which was to carry a gentrified British art into the war was completed in 1938 when Clark paid his first visit to Henry Moore's studio (figs. 47, 48, 49). During the 1940s and early 1950s, commitment to a form of international modernism was kept marginally alive in, of all places, St. Ives, where Nicholson and Hepworth had taken their children at the outbreak of war. But so far as we can identify the operations of an art world during this period, it was one in which neither they nor the interests they represented had any very significant presence. Business was again British art business, while the contingent organisations of war-time culture set the pattern for a far less contingent post-war administration of art. Under Clark's direction the War Artists Advisory Committee nourished a form of romantic home-guard art, with Piper, Sutherland, and Moore as its dominant figures, while the enlightened amateurs of the Council for the Encouragement of Music and the Arts mapped out the ground for the post-war Arts Council. In 1947 the British Council published a report on British painting since 1939, commissioned two years previously. Its author Robin Ironside pronounced the triumph of parochialism in the now familiar terms of Britain's artistic *littérateurs*:

The best British painting relies, for its final justification, upon an amateur stimulus, that is to say, upon a stimulus that may be ethical, poetic or

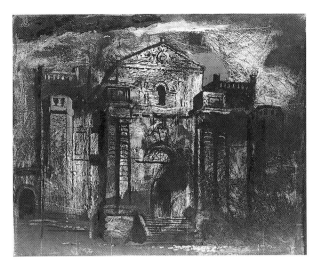

fig. 47
John Piper, *Seaton Delaval,* 1941
Oil on plywood
28 x 34¾ in. (71 x 88.5 cm.)
London, Tate Gallery

fig. 48
Graham Sutherland, *Devastation, 1941: An East End Street,* 1941
Ink and gouache on paper mounted on cardboard, 25½ x 44¾ in. (64.5 x 114 cm.)
London, Tate Gallery

fig. 49
Henry Moore, *Project for a Family Group,* 1944
Bronze, 5⅜ x 4½ x 2⅝ in. (13.5 x 11.5 x 6.5 cm.)
London, Tate Gallery

philosophic but not simply plastic, not a stimulus transmitted by any pure, inflexible aesthetic perception of the external world…[as if any aesthetic perception could ever be pure or inflexible].The barrenness that Nicholson has cultivated has no pictorial interest…. It has become a naturally accepted convention to link the names of John Piper, Graham Sutherland and Henry Moore as the chief protagonists of the contemporary school, especially in so far as British painting now exhibits neo-romantic tendencies…. There is at present no likelihood of the alternative of a reaction towards abstraction.[25]

Within a few years Ironside was to be proved wrong on this last point at least. But it was not until the 1960s—opinion will differ on this but I believe not until the mid to late sixties—that a form of cosmopolitan modernism was again seriously to threaten the predicates of British art. This time the developing avant-garde oriented itself by reference to American rather than to European art, the metropolitan centre of the modern tradition having meanwhile shifted from Paris to New York. This second phase of internationalism lasted longer than the first—perhaps for ten years. There is no space here to pursue an inquiry into the historical conditions of this later artistic moment, but we should at least be alert to the possibility that a similar pattern is there to be discovered. The response was correspondingly strident and no doubt also historically impelled. By the end of the seventies the familiar anti-modernist rhetoric was in place again, trumpeting the values of the landscape, the object, the tradition, the climate. In 1987 the Royal Academy's survey of *British Art in the Twentieth Century* provided the purveyors of this rhetoric with a kind of headquarters, one in which the avant-garde tendencies of English art were literally marginalised, while a supposedly central tradition of British individualism and British humanism was located along the implausible nexus of Moore, Francis Bacon, Lucien Freud, and Gilbert & George. The recent fashion for talk of the Postmodern has provided a further opportunity for the conservative to masquerade as the critical. A supreme historical irony attends upon the suggestion made by Peter Fuller in 1988 that John Piper's recent work 'points one way beyond Postmodernism'[26]—the same John Piper, this is, he of 'England's Climate'. Half a century later, in the Postmodern world of British art, we find ourselves redirected to the tree still dessicating in the field.

My original aim for this paper was that I should examine how the predicates 'modern' and 'British' were typically related in the English culture of the twentieth century. I intended, that is to say, to show how that relationship might be historicised and its contingency exposed. I took this to be the most efficient means to satisfy my brief. I had in mind a point made by Tom Mitchell in his book *Iconology,* that lines of demarcation between the visual and the verbal tend to be historically specific and culturally relative.[27] My suspicion was that a common pattern was there to be uncovered: that the

reciprocating relations within the pair 'modern' and 'British' on the one hand and the pair 'artistic' and 'literary' on the other might be seen to fluctuate according to the same historical rhythm. I was being ludicrously ambitious. To support such a hypothesis adequately would require a lengthy book, and it's not a book that I shall ever write. But I do believe that this small examination of England's climate in the mid-thirties will justify three conjectures which might usefully be addressed by a more sustained inquiry along such lines.

The first conjecture is that in the modern art world control of the symbolic order is fought out not between the representatives of different classes but between modernists and those other members of the bourgeoisie to whom modernism is threatening. Indeed, it could be said that conflict along such lines is the very mark of that world's modernity. The second conjecture is that the threat which modernism poses is in virtue of its quasi-theoretical status. It functions like a theory of reading—but one which constantly displaces the lines of demarcation between the verbal and the visual. In turn the practice of modernist art destabilises the figure-ground relations between reading and seeing. Its tendency is to downgrade the competences of those accustomed to see themselves as the responsible arbiters and taxonomists of meaning. Control of concepts of meaning in culture is an important control, and those in whose hands it has generally been vested can be expected to respond accordingly to the threat to their preeminence—though they are most unlikely to be able to acknowledge that this is what they are doing. The third conjecture is that some form of coincidence may be found between the reassertion of control over meaning in high culture and the political signs of a fear of revolutionary change. It is in 1936, and not in 1946, that the dichotomies of the Cold War are first articulated in the discourses of modern art.[28] In 1936 the conjunction of the modern and the British was dangerous to a dominant constituency among those concerned with the high arts in England. I believe the evidence shows that the same conjunction is still dangerous to their heirs. I am far less sure, however, about the aetiology of this disturbing conjunction. How far back into the history of British art can we trace the trauma of the modern? Of course to ask this question is to return to the beginning. It is to ask how the predicate 'modern' is to be defined in the light of the predicate 'British'. If the theme of *Towards a Modern Art World* is to be the substance of purposeful inquiry, I take this to be a question which we cannot sensibly ignore.

1. For example, the following from the 'Vorticist Manifesto' in *Blast,* 1914, p. 11: 'Blast first (from politeness) England/curse its climate for its sins and infections…'; or from 'Manifesto II' in the same publication, p. 36: 'We assert that the art for these climates…must be a northern flower'.

2. The echo of *Blast* and of Wyndham Lewis's voice is likely to have been a deliberate device on the part of Geoffrey Grigson. He was in contact with Lewis during the 1930s and had quoted him with approval in a 'Comment on England' in *Axis* 1. It is a feature common to the work of both writers that the criticism they have to offer of the insularity of others fails either to touch or to trouble their own deep and patrician cultural nationalism.

3. Paul Nash, letter to *The Times,* 12 June 1933.

4. Wells Coates, letter to *The Listener,* 12 July 1933.

5. From a definition of aims published in *International Literature,* April 1934.

6. Anthony Blunt, 'From Bloomsbury to Marxism', *Studio International,* November 1973.

7. For an early example see Father Bernard Vaughan, writing in *The Graphic,* 14 February 1920, on Epstein's *Risen Christ:* '…if Mr Epstein's horror in bronze were to spring to life and appear in a room, I for one should fly from it in dread and disgust, lest perhaps he might pick my pockets, or worse, do some deed of violence in keeping with his Bolshevik appearance'. For a later example see the review of Henry Moore's one-man show in 1931, published in *The Bournemouth Echo,* 12 May 1931: '…this kind of art represents nothing more or less than Bolshevism in art. It aims, as Bolshevism in politics aims, to bring us back to the level and standards of the caveman…'.

8. See, for example, the discussion of this exhibition by J. M. Richards in 'London Shows', *Axis* 4 (November 1935).

9. See Herbert Read, 'A Nest of Gentle Artists', *Apollo* (September 1962). Read was referring to Turgenev's *Nest of Gentlefolk.*

10. Tristram Hillier, letter to the author, 24 November 1966. See my *English Art and Modernism, 1900–1939,* 2nd ed. (New Haven and London: Yale University Press, 1994), 242.

11. As recorded by Myfanwy Piper in her essay 'Back in the Thirties', *Art and Literature,* no. 7 (Winter 1965).

12. *The Weekend Review,* 12 March 1932.

13. Paul Nash, 'Unit One', *The Listener,* 5 July 1933.

14. Nicholson's account is given in an undated letter to Ronald Alley, probably written in 1962. The account is circumstantially supported by a letter of 31 January 1935 written by Paul Nash to Conrad Aiken. See my *English Art and Modernism,* 376 nn. 28, 29. 'Abstract and Concrete' was organised by Nicolete Gray and shown in Oxford, Liverpool, London, and Cambridge.

15. In conversation with the author in 1966, at the time of a Tate Gallery retrospective exhibition of his work. Gabo gave an additional—and no doubt stronger—reason for coming to England: 'There was a woman'.

16. From a statement published in *Barbara Hepworth: Carvings and Drawings,* intro. Herbert Read (London: Lund Humphries, 1952).

17. From a letter to the author, undated, but written in 1969.

18. Read, 'A Nest of Gentle Artists'.

19. Piper, 'Back in the Thirties'.

20. Myfanwy Evans [Piper], ed., *The Painter's Object* (London: Gerald Howe, 1937).

21. See, for example, the statement by Hepworth published in J. L. Martin, Ben Nicholson, and Naum Gabo, eds., *Circle: International Survey of Constructive Art* (London: Faber and Faber, 1937): '…these formal relationships…can be the solution to life and to living…. The language of colour and form is universal and not one for a special class…it is a thought which gives the same life, the same expansion, the same universal freedom to everyone'.

22. Myfanwy Piper, 'Paul Nash, 1937', *Axis* 8 (Early Winter 1937).

23. The pattern of these competing predicates has been well analysed by David Masters in a dissertation on 'The Englishness of British Art', written in 1987 as part of the requirement for the fourth-level Open University course, A403, 'Arts and Society in Britain since the Thirties'.

24. It is an implicit ethical claim of modernist criticism that vigilance vis-à-vis this tendency is commensurate with vigilance in the face of other tendencies of a more explicitly political nature. I would not be dismayed if this paper were read as offering support for that claim.

25. Robin Ironside, *Painting since 1939* (London: British Council, 1947).

26. Peter Fuller, 'John Piper: Neo-Romanticism in the 1980s', *Modern Painters* 1, no. 2 (Summer 1988).

27. W. J. T. Mitchell, *Iconology: Image, Text, Ideology* (Chicago: University of Chicago Press, 1986).

28. Consider, for example, the respective positions represented by Alfred H. Barr Jr.'s introduction to *Cubism and Abstract Art* (New York: Museum of Modern Art, 1936) and by Meyer Shapiro's critique of that text in his 'The Nature of Abstract Art', *Marxist Quarterly* 1, no. 1 (January 1937).

List of Contributors

Dr. David Solkin is Reader in the History of Art and Deputy Director of the Courtauld Institute of Art, University of London.

John Brewer is Professor of History in the Department of History and Civilisation at the European University Institute in Florence.

Ronald Paulson is Mayer Professor of the Humanities at the Johns Hopkins University in Baltimore.

Ann Bermingham is Professor of Art History and Women's Studies at the University of California at Santa Barbara.

Professor Marilyn Butler is Rector of Exeter College, University of Oxford.

Ludmilla Jordanova is Professor of History at Vanbrugh College, University of York.

Dr. Andrew Hemingway is Reader in the History of Art at University College, London.

Dr. John Gage is Head of the Department of History of Art at the University of Cambridge.

Dr. Martin Postle is Director of the London Centre of the University of Delaware.

Dr. Peter Funnell is Curator (Victorian Period) at the National Portrait Gallery in London.

Dr. Caroline Arscott is Lecturer in the History of Art at the Courtauld Institute of Art, University of London.

Dr. Julie F. Codell is Director of the School of Art and Professor of Art History at Arizona State University.

Dr. Stella Tillyard taught at Harvard University and at the University of California at Los Angeles. She currently lives in London and Florence.

Dr. Charles Harrison is Reader in the History of Art at the Open University.